Marc Chagall

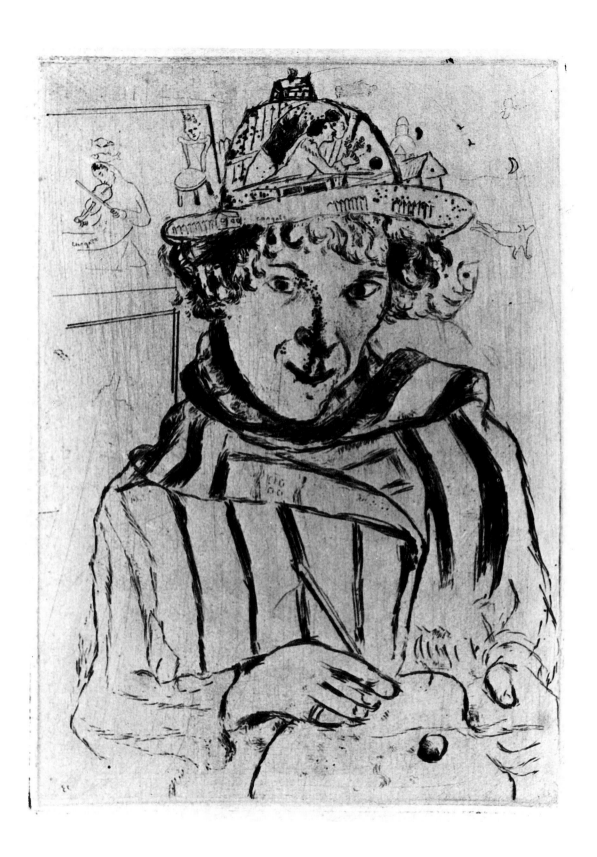

Susan Compton

Marc Chagall

My Life – My Dream

Berlin and Paris, 1922-1940

Prestel

This book originally appeared in German as the catalogue to the exhibition
'Marc Chagall: Mein Leben – Mein Traum, Berlin und Paris 1922–1940',
organized by the City of Ludwigshafen am Rhein and the BASF Aktiengesellschaft
and held at the Wilhelm-Hack-Museum, Ludwigshafen am Rhein,
7 April – 3 June 1990.

© Prestel-Verlag, Munich, 1990
© of illustrated works by Marc Chagall:
COSMOPRESS, Geneva, 1990
Photographic Acknowledgments: p. 268

Cover:
Clown with Horse (Cat. 96)
Frontispiece:
Self-Portrait in an Ornate Hat (Cat. 92)

Prestel-Verlag, Mandlstrasse 26, D-8000 Munich 40,
Federal Republic of Germany

Distributed in continental Europe by Prestel-Verlag,
Verlegerdienst München GmbH & Co KG,
Gutenbergstrasse 1, D-8031 Gilching, Federal Republic of Germany

Distributed in the USA and Canada by te Neues Publishing Company,
15 East 76th Street, New York, NY 10021, USA

Distributed in Japan by YOHAN-Western Publications Distribution Agency,
14–9 Okubo 3-chome, Shinjuku-ku, J-Tokyo 169

Distributed in the United Kingdom, Ireland and all other countries by
Thames & Hudson Limited, 30–34 Bloomsbury Street, London WC1B 3QP, England

Offset lithography by Reproduktionsgesellschaft Karl Dörfel mbH, Munich
Composition by Max Vornehm, Munich
Printing and binding by Universitätsdruckerei Stürtz, Würzburg

Printed in the Federal Republic of Germany

ISBN 3-7913-1064-X (English edition)
ISBN 3-7913-1049-6 (German edition)

Contents

Acknowledgments

Thanks are due to the following, who have contributed in so many different ways to this book and to the exhibition which it originally accompanied:

Ruth Apter-Gabriel

Caroline Compston

Michael Compton

Marjorie Delpeche

Sylvie Forestier

Michael Foster

Gabriele Gassen

Nehama Guralnik

Renilde Hammacher-van den Brande

Joop Joosten

Christian Klemm

Jeremy Lewison

Edna Moshenson

Michael Pächt

Jurrie Poot

Jean-Louis Prat

Stephanie Rachum

Angela Rosengart

Margit Rowell

Irena Subotic

Martin Weyl

Mimi Wilms

Foreword

Scarcely another artist in our century has attained such widespread popularity as Marc Chagall. The public imagination has been captured by an art which, as the title of this book indicates, fuses the reality of everyday life with the world of dreams into a harmonious whole. Chagall's magical imagery lifts the viewer off his feet without transporting him into another world. It is an art which, via the eye, strikes directly at the heart of the beholder.

In contrast to a widely held view, the 'feast for the eye' in Chagall's pictorial world is not the result solely of his brilliant use of colour. His extensive graphic oeuvre shows how skilfully he used the technique of etching in a painterly way. Chagall produced a particularly large number of etchings in the 1920s and 1930s, and the art of these decades, which the artist spent in Berlin and Paris, forms the subject of this book.

A significant and fascinating aspect of Chagall's work is the repetition of certain themes. Thus, nearly all his etchings were preceded by drawings, watercolours, gouaches or oil paintings on related subjects. A comparison of works in colour created at the same time as, or prior to, their translation into graphic media schools the eye in a quite specific way. This forms the conceptual basis of the present book.

This book originally appeared in German as the catalogue to an exhibition organized by the City of Ludwigshafen am Rhein and BASF Aktiengesellschaft. Held at the Wilhelm-Hack-Museum in Ludwigshafen, the exhibition marked the tenth anniversary of the museum's foundation and the 125th anniversary of BASF. Both the City and BASF are pleased that the fruits of their cultural commitment will reach a wider audience through the publication of the catalogue in English.

An undertaking of such magnitude as this book and the exhibition it originally accompanied requires the co-operation of a large number of individuals. We extend our warmest thanks to all concerned, not least to the public and private collectors who consented to part with their treasures for the duration of the exhibition. Special thanks are due to Madame Forestier, the Director of the Musée Nationale Message Biblique Marc Chagall, for the first loan of Bible gouaches since they were given to the museum in Nice by the artist in 1973, and to the Sprengel Museum in Hanover for the loan of the four cycles of Chagall etchings. We owe the greatest debt of gratitude to the Guest Curator, Susan Compton, from London, without whose unflagging commitment the exhibition would not have been the memorable experience it was and whose study of Chagall is enshrined in the present book.

WERNER LUDWIG
Oberbürgermeister
City of Ludwigshafen am Rhein

DETLEF DIBBERN
Member of the Board
BASF Aktiengesellschaft

Introduction

Marc Chagall: My Life – My Dream reminds us of the interweaving of fact and fantasy which lies at the heart of this artist's world. His eventful life, begun in provincial Russia in the restricted world of Jewish tradespeople, was nurtured by love from his remarkable family and by their piety and devotion. Yet his spirit was cramped by everyday hardship and he planned to escape, not via the usual route of scholarship, but via the unlikely one of art. He studied painting with formidable tenacity, first in Vitebsk and then in St Petersburg, finally, in 1910, reaching his goal, Paris. He told the story in his autobiography, *My Life*, including his feelings of despair at the deaths of his parents, his joy in his love and marriage. It is a poetic narrative which haunts his poems, his drawings, his paintings, his etchings and, later in his long life, his lithographs, stained glass, pottery, sculpture, mosaics and even tapestries.

From 1922 to 1940, years when Chagall lived in Berlin and again in Paris, we find an explosion of his creativity in colour and in black and white. The variety of his work in these years is astonishing. He expanded his horizons, painting scenes in Germany, in many regions of France – his adopted country – and further afield, in Palestine, in Poland and other countries of Europe. He painted fantastic visions of the circus, with caricatured clowns creating a colourful yet uncomfortable parody of the everyday world; sometimes he conjured scenes wholly from his dreams. He painted commissioned portraits and carefully contrived narrative compositions, in which he blended reality and imagination. Above all, he made an astonishing number of etchings, over three hundred and fifty in those eighteen years.

Chagall did not learn etching until the age of thirty-five, in Berlin, but he soon became the foremost exponent of the art in this century. Compared to drawing with pen or pencil, scratching on a varnished copper plate with needles and bathing it in acid is a laborious process, but Chagall found it congenial and he created page after page of illustrations, without slavery to the text. The variety of marks to be seen on the paper captures the viewer, who is able to 'read' the story without recourse to the words from which Chagall derived his inspiration. From the dots and dashes which bring alive the nineteenth-century world of Gogol's *Dead Souls*, to the remarkable painterly effects which seem magically to colour the black and white of La Fontaine's *Fables*, Chagall went on to capture the momentous drama of the biblical prophets in subtle gradations of black and white.

These commissions provided the artist and his family with a means of livelihood in Paris. More significantly, the range of Chagall's imagination was stretched by this constant background of disciplined production. Today it is easy to forget that by 1940 he had almost completed these three series of etchings – from which only a selection is included here – without any of them having been published. His reputation depended on the twenty or so that he made in his year in Berlin, which had been issued as the portfolio *Mein Leben* (My Life). Only a few proofs were pulled from the copper plates for *Dead Souls*, the *Fables* and the *Bible*, few were exhibited and he hand-coloured one or two as presents for friends. Ambroise Vollard, the eccentric dealer who

paid Chagall regularly for each plate as it was completed, kept them in his cellar, where they were found piled up and covered with dust when he died in an accident in 1939. The three books were finally published with Chagall's etchings as illustrations in the 1950s, and his reputation as an illustrator was established. Although he had also learned lithography in Berlin in 1922, it was not until he lived in the United States in the 1940s that Chagall took up colour lithography, the medium through which his fantasy was so widely distributed in the last years of his life.

Chagall's images are therefore by now well known, but in the 1920s and 1930s he was still developing a range of subject-matter which reaches far beyond the still lifes, landscapes and nudes of more conventional artists. His lovers are entwined in a riot of colour as they revel in their unlikely poses in moonlight or flowers; his animals cavort in an excess of freedom, losing a head or a foot but still asserting their exuberance; his angels and prophets command a degree of solemnity, with an authority and sobriety unusual in our pagan world. In the two decades he built up his repertory of forms in oil paintings, gouaches and pastels, as well as black and white illustrations, elaborating a great variety of marks. Sometimes he relies on an expressive line, sometimes on areas of mingled colour; he might lay the oil or gouache on thinly with his brush or pile it up until it threatens to break loose from the canvas or paper. The marks on his copper plates vary from unbroken to dotted lines and scratching, from large areas of white to a dense black, nearly always created by a repetition of lines. His people and animals are always recognizable, though distorted, and he tempts his viewer to follow him into a world transformed. He breathed a spirit of child-like adventure into his work, borrowing the expressive awkwardness of 'primitive' artists, unexpectedly combining it with a genuine love and understanding of the classical art of the past.

In these years, against all odds, the boy from a provincial town in Russia realized his dream of unparalleled success. By the end of the 1920s he had become an acknowledged leader of the Ecole de Paris, even though he shocked staid Frenchmen when he illustrated La Fontaine, whose fables they had committed to memory in childhood. In the artistic capital of the world he was proclaimed the painter of the heart, rivalling that other émigré, Picasso, who was dubbed the painter of the head. By the end of the 1930s Chagall's message had become more urgent, his work embodying more and more the threat to survival of an ancient way of life. He had left Russia when he felt the stifling arm of a renewed authoritarian approach; he was obliged reluctantly to flee Europe in 1941, when he realized that even as far south as Marseilles he was not exempt from the force of hatred of his ancient people. He went into exile with a host of modern artists, Jews and Gentiles alike, an exodus of talent which brought new vitality to the art world of New York.

Marc Chagall: My Life – My Dream allows a detailed study of his years of expansion. Through his art he draws us closer to a world of fathers and mothers, of grandparents, of heroes and prophets. It is a world of birth and death, of summer and winter, of homes and hotels, of synagogues and churches, of man and his animals, seen always as the creation of God, with angels or devils never far away. It is a world as distant as the myths and fairy-tales of childhood, and as close as the memories and fears deep within each of our hearts. Through Chagall we can draw near to our loves, our hatreds, our hopes and our terrors; all are spread before us in his world of art. He continues to hold our attention because his art is so direct; he states his message without moralizing, in symbols inspired by the force of his love.

From Commissar to Citizen

Marc Chagall's Years in Berlin and Paris, 1922-1940

1 *Self-Portrait*; reproduced on the cover of Chagall's autobiography, *Ma Vie*, Paris, 1931

1 Marc Chagall, reply to André Breton and Paul Eluard, 'Enquête', 'Pouvez-vous dire quelle a été la rencontre capitale de votre vie? Jusqu'à quel point cette rencontre vous a-t-elle donné, vous donne-t-elle l'impression du fortuit? du nécessaire?' *Minotaure*, Nos 3-4, 1933, p. 106.

2 Marc Chagall, trans. Dorothy Williams, *My Life*, Oxford, 1989, p. 114.

3 Marc Chagall, *Mein Leben: 20 Radierungen*, Berlin, 1923.

4 Marc Chagall, *Ma Vie*, preface by André Salmon, in the collection 'Ateliers', ed. G. Charensol, Paris, 1931.

5 Ibid., p. 8.

6 Salmon indicates that this is a song by Béranger quoted as an epigraph by Edgar Allan Poe; ibid., p. 13.

7 *My Life*, op. cit., note 2, p. 113.

8 Marc Chagall, *Poèmes*, Geneva, 1975. Philippe Jaccottet made French versions from translations by Moshe Lazar from the Yiddish and Russian originals; ten had been published previously with woodcuts by the artist, Geneva, 1968.

In 1933 Chagall was asked to describe the most important meeting in his life. He replied in a typically unpredictable way: 'When I opened my eyes for the first time in my life I met a whole world, the town, the house, which little by little became fixed in me for always. Later I met a woman.' This was his wife, Bella, 'who crossed my heart and sits on my canvases'. After these he named the poets Blaise Cendrars and Guillaume Apollinaire who, he said, had solaced him in his sojourn in Paris before the 1914-18 war. Last, and still potent for him, was the Russian Revolution, which had swept away his illusions.[1]

Chagall's seemingly irrational choice affirms his constant identification with the dream and reality of his own life, which forms the principal subject of his art. Apollinaire may have recognized this when, at that confrontation with Chagall's work in Paris in 1914, he had pronounced his verdict, 'Supernatural',[2] but it became fully apparent in 1922 in Berlin when Chagall made etchings for the portfolio entitled *Mein Leben* (My Life).[3] These etchings had been intended to illustrate his autobiography, though this was not published until 1931, in his wife's French translation, with the title *Ma Vie*.[4] Surprisingly, none of the etchings made in Berlin was used for illustrations in the 1931 edition; instead, the more recent print *The Apparition I* (Plate 24, Cat. 28), showing the artist inspired by an angel, was used as a frontispiece, and the cover carried a mischievous self-portrait (Fig. 1). The remainder of the illustrations were reproductions of early drawings, some of them made in Paris in 1911, when Chagall had begun to write *My Life*. These sketches reflect Chagall's intimate dialogue with his past more eloquently than the often contrived designs of *Mein Leben*.

In his preface to *Ma Vie*, André Salmon, a French writer of Russian parentage, tried to pin down the originality of Chagall as author and painter: '[his] every work, even the slightest, is a total expression of all that Chagall carries within him of the mythical, fabulous incarnation of a type of Poetry that perfect innocents and people ravaged by culture can receive and conceive'.[5] Salmon resorted to poetry himself and quoted: 'Son cœur est un luth suspendu,/Sitôt qu'on le touche il résonne' (His heart is a hanging lute;/it sounds when it is touched). '"That's it", said Chagall, delighted at the encounter.'[6] His own text is redolent with seemingly inconsequential phrases, which convey feelings that most people would find hard to express. He identified as purest: 'that soul which of its own accord has reached the level that men call literature, the illogical.'[7]

Although remembered for his art rather than his writing, Chagall wrote poetry as well as prose throughout his life[8] and his gift for words helped him to use the powerful images which welled up from his memory and fertilized his imagination. This is the essence of Chagall's life-dream, which was not, he asserted, the result of reading Freud, but a poetic distillation of the truth. His life-dream was not the outpouring of his unconscious, but an evocation of day-dreams woven from tradition and experience. His inspiration certainly included what he had read as well as what he had seen. In particular, he had absorbed much of the vitality of the Yiddish writer Sholem Aleichem, who

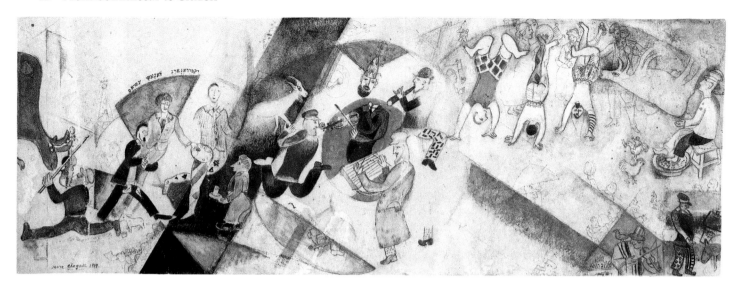

had immortalized life in a small Russian town in fantastic stories and in an autobiography which he described as a 'biographical novel'.[9] Aleichem's favourite hero, Tevye the Dairyman, is a mythical creation who embodied a rich, but fast disappearing culture; his counterpart is Chagall's levitating milkmaid (Plate 20, Cat. 21), a theme which he once described as his speciality.[10] According to one writer, Aleichem's hero is 'seen in the round, in his social relations, in his accustomed gestures, in his inimitable speech, and above all in his typical situations; but not in his inner reflections, not in those moments of exposed consciousness or dream life when he has no defense against the observing eye'.[11] Chagall risked a more dangerous line; over and over again he balanced the general against the particular, placing himself in a vulnerable position with no 'defense against the observing eye'.

Chagall was thus a veritable clown, performing a balancing act which can be seen – literally – in a monumental canvas painted before he left Russia. It was part of the decoration of the Jewish State Theatre, for which Chagall had designed three of Aleichem's short plays for the opening in Moscow early in 1921.[12] The huge canvas *Introduction to the Jewish Theatre* (see Fig. 2) included portraits of the actors, the theatre director and Chagall himself, with clowns standing on their hands and with symbolic animals, the goats, cows and chickens that continued to haunt Chagall's paintings. The group of clowns – wearing their traditional phylacteries (see Plate 99, Cat. 105) – was surely also inspired by the men's round dance, a hall-mark of Hasidic celebrations, which often turned into impromptu acrobatics. By his intense dedication to this 35-feet-long canvas, painted in a year of famine and civil war, Chagall perpetuated his memories of his own upbringing in the sect which preserved some of the joyous ardour of its eighteenth-century founder.[13] When he left his native land for good in 1922, he thus carried within him the imprint of his early life in Vitebsk and Lyozno, the village where his grandfather had lived. Throughout the 1920s the picture of one grandfather, the violinist – who was also the butcher – and the other, the scholar, reappeared in scenes as actual as those of Chagall's current life in France. His memories, real and embroidered, continued to stimulate his imagination and provide him with subject-matter. The circus scenes of 1927-28, the biblical gouaches from the early 1930s, even the everyday subjects of flowers and lovers, share the ecstatic vitality which Chagall remembered from his early years.

2 Study for *Introduction to the Jewish Theatre*, 1919-20; pen and ink, gouache, watercolour and pencil on paper, 17.3 x 49 cm. Musée national d'art moderne, Centre Georges Pompidou, Paris

9 Sholem Aleichem, real name Sholem Rabinovits, b. 1859 Russia, d. 1916 New York. Chagall paired himself with Aleichem in a portrait for an English translation of Sholem Aleichem's autobiography, *The Great Fair: Scenes from My Childhood*, New York, 1955.

10 Letter to W. Grosshennig belonging to the Sprengel Museum, Hanover, quoted in *Marc Chagall: Druckgraphische Folgen 1922-1966*, Hanover (Kunstmuseum Hannover mit Sammlung Sprengel), 1981, p. 14.

11 *A Treasury of Yiddish Stories*, ed. Irving Howe and Eliezer Ginsberg, New York, 1954. p. 33.

12 *The Agents, The Lie* and *Mazeltov*; the 'Sholem Aleichem Soirée' was often repeated during the lifetime of the theatre.

13 The founder of modern Hasidism (the Pious) was Rabbi Israel ben Eliezer, the Baal Shem Tov, b. 1700 Okup, d. 1760 Medzibuz. See Meyer Levin, *Classic Hassidic Tales*, New York, 1975 (who, in a note on p. xix, comments on the various spellings in common use: Hasidism, Chassidism and Hassidism).

14 Franz Meyer, trans. Robert Allen, *Marc Chagall: Life and Work*, New York, n.d. [1964], p. 313.

15 The relationship of these writers to Chagall is discussed by Jean-Claude Marcadé, 'The Russian Element in the Work of Chagall', in *Marc Chagall: 100th Anniversary of his Birth – The Marcus Diener Collection*, Tel Aviv (The Tel Aviv Museum), 1987, p. 180.

16 Vasily Kandinsky, 'Rückblicke', published in Berlin, *Der Sturm* album, autumn 1913.

17 See Susan Compton, *The World Backwards: Russian Futurist Books, 1912-16*, London (The British Library), 1979, pp. 70-9.

18 See Julien Cain, *The Lithographs of Chagall*, introduction by Marc Chagall, notes and catalogue by Fernand Mourlot, Monte Carlo and London, 1960, p. 26. For information on Budko, see Hans Friedeberger, *Joseph Budko*, Jüdische Bücherei, Vol. 19, Berlin, 1920.

19 See *Vladimir Favorsky*, ed. Yuri Molok, Moscow, 1967. Chagall would have known the work of Favorsky, who had been appointed Professor in the Faculty of Graphic Art at Vkhutemas in Moscow in 1921. Abram Efros, joint author of a monograph on Chagall (Moscow, 1918), published 'Favorsky and Modern Xylography', extolling Favorsky, in *Russkoe Iskusstvo*, No 1, 1923; extracts in English trans., Molok, op. cit., pp. 23-7.

As well as a fund of memories, Chagall brought to Berlin writings which filled nine notebooks, about three-quarters of the text published in 1931. Much of it dated from 1915-16, because time had hung on his hands while he was doing 'war work' in the office of his lawyer brother-in-law, Yakov Rosenfeld, in Petrograd.[14] At that time he had met many poets, among them Aleksandr Blok, Sergei Esenin, Vladimir Mayakovsky and Boris Pasternak. Their writing was diverse, covering a wide spectrum of contemporary Russian poetry: Blok was a Symbolist, Esenin an Imagist, Mayakovsky a Futurist and Pasternak an Acmeist.[15] The diversity of these styles contributed to Chagall's idiosyncratic autobiography, which may have been prompted by Vasily Kandinsky's autobiographical notes, published in 1913.[16] In 1918 Gauguin's *Noa-Noa* had been published in Russian translation with a title page by Chagall's then friend El Lissitzky. This provided another precedent for artists' writing combining memory and imagination.

Chagall's text fascinated those who heard him read aloud from it in Berlin, and a gallery owner, Paul Cassirer, wanted to publish it with illustrations. He first encouraged Chagall to make woodcuts and then gave him lithographic chalk for transfer lithographs, a method often used for the illustrations in hand-made artists' books in Russia.[17] However, these had generally been on a small scale and, in Berlin, Chagall experimented with bigger sheets of paper. The largest lithograph that he made, *Man and Pig* (Cat. 25), is a transcription of a motif in the bottom right corner of the canvas for the Jewish State Theatre (see Fig. 2). He followed the usual practice of Russian book illustrators, giving his drawing on lithographic paper to the printers for them to transfer to the stone and take care of the printing.

Another lithograph, *On the Oven* (Fig. 3) – showing his father asleep on top of the capacious stove – anticipates the style of some compositions in the portfolio *Mein Leben*, for which Chagall used etching rather than lithography or woodcut. His surviving woodcuts, made in the studio of a great exponent, Joseph Budko,[18] remained for the most part unprinted and Chagall soon abandoned the medium. The few surviving examples (see Fig. 4) fall somewhere between the Expressionist woodcuts made earlier in the century by German artists of the group *Die Brücke* and traditional wood engravings by Chagall's compatriot Vladimir Favorsky (who, in 1925, won the Grand Prix at the 'Exposition des Arts Décoratifs' in Paris).[19] Budko knew the German master etcher Hermann Struck, who undertook to teach Chagall the art. The meeting proved an event of the utmost importance for Chagall, and the publi-

3 *On the Oven*, 1922-23; lithograph, 11.9 x 19.1 cm

4 *Goat with Violin*, 1922; woodcut, 20.2 x 28 cm

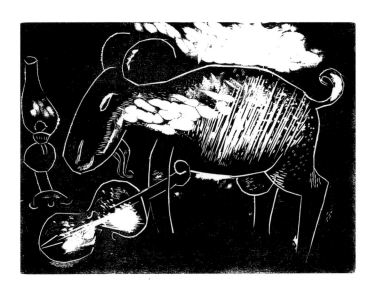

cation of the portfolio *Mein Leben* was seminal for Chagall's succeeding years in Paris, where he was to make a living by using the etching techniques that he had learned in Berlin.

The name of his teacher, Hermann Struck, has gone down in biographies of Chagall simply as the author of *Die Kunst des Radierens* (The Art of Etching), which included a wide range of finely reproduced prints.[20] There has been little discussion of the debt that Chagall owed his well-educated teacher, whose compendium provided an education in the history of engraving and etching. The preparation of the fifth edition took place while Chagall was Struck's pupil. This edition was substantially larger than the earlier ones, and, with its reproductions of engravings by Dürer, Mantegna and Schongauer, etchings by Rembrandt, aquatints by Goya and landscape etchings by Corot and Whistler, it must have provided a counterbalance to the modernist approach that El Lissitzky had practised in the thriving graphics department at the art school in Vitebsk which Chagall had set up three years before.[21] Chagall did not himself revert to the art of the past; indeed, he seems to have noticed the ideas of Paul Klee, whose *Creative Confession* had been published in Berlin in 1920. There Klee had suggested that his reader should accompany him on a 'walk': 'We start off from a point: that gives us a line. We stop once or twice; the line has been broken or articulated. . . . A flash of lightning on the horizon (a zigzag line). There are still stars overhead (scattered dots).'[22] Klee's poetic language seems especially appropriate for Chagall's *Mein Leben* etchings *At Mother's Grave* (p. 219, *Mein Leben,* sheet 19) and *Lovers on the Bench* (Fig. 5), with their uncompleted lines and zigzags, but echoes can also be found in his Gogol etchings.

Chagall experimented with a wide range of marks, also exploiting the possibilities of drypoint technique. In drypoint an artist works directly on a copper plate with his needle, instead of first varnishing it and then using acid to deepen the marks he has made in the layer of varnish. Drypoint is more like the engraving techniques used by the earliest printmakers, in the fifteenth century, though they used a burin rather than a needle, afterwards

20 Hermann Struck, *Die Kunst des Radierens: Ein Handbuch von Hermann Struck,* 5th edn, Berlin, 1923.

21 For Chagall's art school in Vitebsk, see Susan Compton, *Chagall,* London and New York (Royal Academy of Arts / Philadelphia Museum of Art), 1985, p. 40. In the Graphics Department, Lissitzky was responsible for the publication of *O Novykh sistemakh v iskusstve* (On New Systems in Art), Vitebsk, 1919, and *Suprematizm: 34 risunka* (Suprematism: 34 Drawings), Vitebsk, 1920, both by Chagall's rival, Kazimir Malevich.

22 Quoted from G. di San Lazzaro, trans. Stuart Hood, *Klee: A Study of his Life and Work,* London, 1957, pp. 105-8.

23 Struck, op. cit., note 20, p. 192, translated in Franz Meyer and Hans Bolliger, *Marc Chagall: The Graphic Work,* London, 1957, p. xxxvi.

24 The portrait is described as a 'drypoint from life'; Struck, op. cit., note 20, p. 287; the etching is included after p. 109.

25 Reproduced ibid., p. 289.

26 Chaim Aron ben David or, sometimes, Hermann Strucks den Davidsschild; see Adolph Donath, *Hermann Struck,* Jüdische Bücherei, Vol. 18, Berlin, 1920, p. 15.

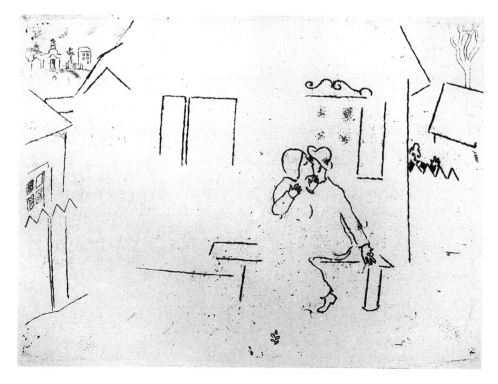

5 *Lovers on the Bench, Mein Leben,* sheet 15; etching, 13 x 18 cm

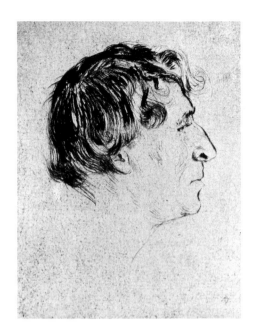

6 Hermann Struck, *Portrait of Marc Chagall*;
etching from Struck's *Die Kunst des Radierens,*
5th edn, Berlin, 1923

smoothing the burred edges of their lines. Struck expressed admiration for his pupil, describing Chagall as 'The most important symbol of the artistic and spiritual evolution of new Russia. A wild enthusiast who races like lightning, with the unconscious energy of genius, through all the different stages; from that of naturalistic mastery of his everyday surroundings to that of mystic formulation....'[23]

Among several original prints in *Die Kunst des Radierens* is Struck's portrait of Chagall (Fig. 6),[24] and he reproduced three of Chagall's etchings, two of them closely related to other compositions in the manual. For instance, in *Dining-Room* (Plate 5, Cat. 6) Chagall posed his figures overlapping one another like those in Edvard Munch's lithograph *Death in the Sick-Room* (Fig. 7). The borrowing seems deliberate, for Chagall transformed Munch's expression of acute anxiety into one of suffocating boredom. The comparison brings out Chagall's wit and an unexpected humour; it also demonstrates his ability to take a source and make subtle changes which disguise his borrowing completely.

The second pairing shows the marked contrast between Struck's approach and that of his pupil. Struck's *Polish Jew*[25] is an earnest and kindly view of his sitter, a portrait rather than an invention. In contrast, Chagall's *The Rabbi* (Fig. 8), reproduced by Struck, was based on an oil painting which Chagall had brought to Berlin from Russia. So his Rabbi holds the emblems of the Feast of Tabernacles, a citron in one hand and a palm branch tied with myrtle and willow in the other. Only a viewer who understood the symbolism of *Feast Day* (Kunstsammlung Nordrhein-Westfalen, Düsseldorf) could make the connection; otherwise the profile figure standing before a doorway seems truly 'supernatural'.

Chagall's symbolism would have been entirely clear to Struck, who often signed his work with his Hebrew name;[26] although a native of Berlin, he moved to Haifa in 1923. Struck and another friend of Chagall, the Zionist poet Chaim Bialik, left Berlin in the early 1920s for Palestine, the ancient land of Israel, but Chagall was determined to return to Paris, the artistic capital of

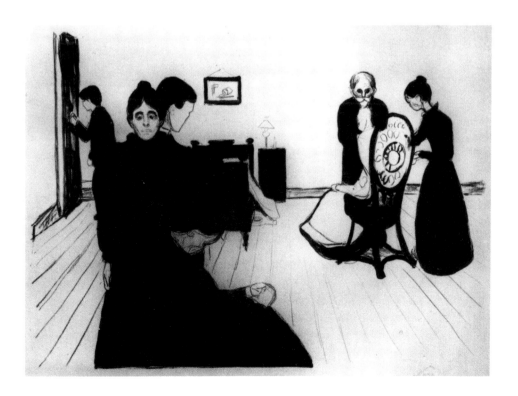

7 Edvard Munch, *Death in the Sick-Room*, 1896;
lithograph, 41.3 x 57.2 cm

Europe, where he had already spent four years from 1910 to 1914. In 1914 he had visited Berlin for the opening of a large exhibition of his work at the Galerie Der Sturm and then travelled on to Russia, expecting to return within the three months of his official permit of exit from France. The outbreak of war had stranded him in Russia, and, although he had tried to leave in 1915, he had had to wait until 1922 to get a passport for Germany. In 1923 the train from Berlin to Paris was on the point of departure when he discovered he needed a visa. The French consulate at first refused to give him one, but when he produced the 1914 certificate from the Paris prefecture, which he had fortunately preserved, he was taken for a Paris resident and his passport and Bella's were stamped with the correct visas.[27]

While living in Berlin, Chagall and his family had found the means to have country holidays in the Black Forest and Thuringia – where Chagall made a few factual watercolours – but when they arrived in Paris they lived in some squalor at a clinic, the Hôtel Médical, which took foreign artists *en pension* when there were not enough patients. Waldemar George recalled: 'In the corridors of this haunted house, one met doctors in overalls spotted with blood. Nurses pushed metal trolleys on which recently operated patients were lying!'[28] Chagall had hoped to return to his studio in La Ruche, which he had left safely locked in 1914, with his paintings inside. But in 1915 all the empty rooms had been requisitioned for refugees from north-eastern France and his pictures had been taken by friends and neighbours and mainly sold. Although Chagall was furious when he found out their fate, some had been bought by the critic Gustave Coquiot, in whose apartment Ambroise Vollard had seen them, and, as a result, conceived the idea of commissioning Chagall to make book illustrations.

Chagall's meeting with Vollard soon after he arrived in Paris proved to be a second turning point in his life, even more advantageous than his introduction to Struck in Berlin. The conversation must at first have seemed unpropitious, for Vollard proposed that Chagall should illustrate *Le Général Dourakine* by La Comtesse de Ségur.[29] Chagall replied that he knew her works less well than those of Gogol, and, fortunately, Vollard agreed to Chagall's suggestion to illustrate Gogol's *Dead Souls*.[30] Chagall was able to reassure his patron that he was already familiar with Gogol's writing, having made designs for Gogol's plays *The Gamblers*, *The Wedding* and *The Inspector General* before he left Russia.[31]

Gogol's preposterous tale, which he described as a 'poem', is a series of closely observed verbal pictures of real life, spun into a web of intrigue. The hero, Chichikov, planned to make money from the purchase of 'dead souls', that is, serfs who, though dead, were still names entered on the censor's register and therefore still a tax liability for their owners. By acquiring lists of 'dead souls', Chichikov hoped to become a property owner, at least on paper, and then mortgage his strange 'property' in order to acquire an estate. His adventures and final unmasking provided Gogol with the means of affectionately lambasting all the shortcomings of provincial nineteenth-century Russia in a novel which is outstanding for its vivid evocations of people and places. Vollard thus commissioned Chagall to illustrate a Russian classic rather than a French children's book by a Russian-born aristocrat. La Comtesse de Ségur's moral tale had been pioneering in 1863 because it described the life of real children, whose good-natured uncle, Général Dourakine, returned from France to Smolensk in Russia, where his nieces brought their families to stay. Vollard may have expected that Chagall, who came from Vitebsk – not far from Smolensk – would improve on Emile Bayard's illustrations for the

27 Jean-Paul Crespelle, *Chagall: L'Amour, le rêve et la vie*, Paris, 1969, p. 175.
28 Quoted by Crespelle, ibid., p. 176, without source.
29 Mme la Comtesse de Ségur, née Rostopchine, *Le Générale Dourakine*, Paris, 1863. The volume is in the series 'Bibliothèque rose illustrée' for 'children and adolescents' together with nine further books by La Comtesse de Ségur and works by Grimm, Perrault, Hans Andersen, Swift, and the like. Ségur's books continued to be reprinted; see Mme la Comtesse de Ségur, née Rostopchine, *Comédies et proverbes*, new edn, Paris, 1917. This has nineteenth-century illustrations by Emile Bayard.
30 Crespelle, op. cit., note 27, p. 182.
31 The first of these plays is also translated as *The Card Players*; a scene design for this is in the collection of the Los Angeles County Museum of Art (reproduced Compton, op. cit., note 21, p. 198, with the date 1917, instead of 1919). Chagall was invited to design the first two plays for the Hermitage Studio in Petrograd, founded in 1919 by Vsevolod Meyerhold; see Pierre Provoyeur, *Marc Chagall: Œuvres sur papier*, Paris (Musée national d'art moderne, Centre Georges Pompidou), 1984, cat. no. 54, p. 92; also Compton, op. cit., note 21, p. 42. Chagall was commissioned to design *The Inspector General* by the director of the Moscow Theatre of Revolutionary Satire on his visit to Vitebsk later in 1919; see Meyer, op. cit., note 14, p. 289.

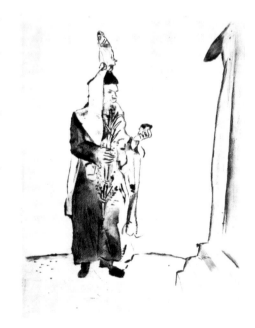

8 *The Rabbi*, 1922, supplementary sheet to *Mein Leben*; etching and drypoint, 25.1 x 18.7 cm

original edition. His suggestion may also have been prompted by the books that Chagall had illustrated in Russia: the first children's book in Yiddish, containing two stories by the writer Pinchas Kaganovich, who used the pseudonym Der Nister (the Invisible), and *The Magician*, a story by Isaac Peretz.[32] Chagall, however, no doubt preferred not to be classed as an illustrator of children's books, even though he preserved the freshness of a child's vision in many of his Gogol illustrations.

On receiving the commission, Chagall threw himself into illustrating *Dead Souls*, making use of his newly learned etching techniques to create dramatic counterparts to the story. Thirty-eight prints were exhibited in Paris in December 1924, though this was not necessarily the total number completed by then, as they were described in the catalogue as 'various engravings for Gogol's *Dead Souls*'.[33] Although Gogol had written his novel in Italy, he had captured the essence of Russia; indeed, an early adaptation of *Dead Souls* bears the English title 'Home Life in Russia'.[34] Equally far from 'Mother Russia', Chagall, in France, drew on his own memories as well as on Gogol's descriptions. His friend Ivan Goll recorded:

> Marc sits there like a cobbler hammering away at his copperplates, an upright craftsman of God. His wife, who ministers to his art as a nurse ministers to a sick man's fever, reads the chapter aloud to him. They keep on laughing. Ida, their seven-year-old daughter, jumps down from the piano and wants to hear the story as well, and now the fantastic situations are re-created to the accompaniment of laughter by a strange family, with all the humour and tragedy of Russia.[35]

From the first plate, Chagall revealed his nostalgia for Russia, filling his dramatic scenes with activity. They are a veritable caricature of Russianness in a unique blend of present and past in imagination and technique. He closely identified himself with the writer, for he paired himself with Gogol in a plate used as the frontispiece of the second volume (Cat. 26) when the etchings were finally published with Gogol's text in 1948.[36] (Confusion may arise because only two parts of Gogol's projected three-part book were ever published and Chagall illustrated only the first of them, though text and plates are in two volumes because of the bulk.)

Chagall's first illustration (p. 220, Gogol, sheet 1) has an affinity to the narrative scenes of *Mein Leben*, though the physiognomy of the characters is more Russian than Jewish. He faithfully depicted the opening sentences of the book, in which Gogol introduced Chichikov, whose arrival in a small town is noticed by two peasants. Chagall's second etching (Fig. 9) shows the public room of the inn with its 'smutty ceiling' and 'equally smutty chandelier' and 'a selection of oil paintings'. One is a nude, described by Gogol as a 'nymph... possessing breasts of a size such as the reader can never in his life have beheld'.[37] Chagall remembered the nudes that he had painted in 1910,[38] and also the Venuses which his compatriot Mikhail Larionov had painted in various styles in 1912, some of them based on popular art.[39] Although in 1923 Larionov was also living in Paris, Chagall and Bella were not especially friendly with him or with Nataliya Goncharova, who shared his studio.[40] Unlike Larionov, Chagall revitalized his art by frequent visits to the French countryside. With his wife and daughter he spent much of the summer of 1924 in Normandy and Brittany, where the distinctive country folk, who still lived so intimately with their animals, inspired some of the illustrations by providing Chagall with models to bring Gogol's dreams to life.

32 Der Nister (pseud. Pinchas Kaganovich), *A Mayse Mit a Hon: Dos Tsigele* (A Story about a Rooster: The Little Kid), Vilnius, 1917, nine drawings; the originals, belonging to the Russian Museum, Leningrad, are reproduced in *Chagall*, Tokyo, 1989, cat. nos 53-61, pp. 99-102. The second book was Isaac L. Peretz, *The Magician*, Vilnius, 1917, three drawings; Chagall's drawing for the title page belongs to the Musée national d'art moderne, Centre Georges Pompidou, Paris. Both books were printed in Petrograd because Vilnius was occupied territory in 1917.

33 Galerie Barbazanges Hodebert, nos 77-115: 'diverses gravures pour "Les Ames Mortes" de Gogol (edition A. Vollard) 1924 app. à M. Ambroise Vollard.' Meyer misread the catalogue, saying that 115 etchings were completed by 1924; see Meyer, op. cit., note 14, p. 607, n. 9.

34 London, 1854; cited in Nikolai Gogol, trans. D. J. Hogarth, *Dead Souls*, Everyman's Library, No 726, London, 1943, p. xii. English translations here are taken from this edition.

35 Quoted without source in Walter Erben, trans. Michael Bullock, *Marc Chagall*, London, 1957, p. 88.

36 By the time of Vollard's accidental death in 1939 he had printed none of the books, and the copper plates were piled up in his cellar. Tériade acquired them and finally published them with text in 1948: Nicolas Gogol, *Les Ames Mortes*, trans. Henri Mongault, Paris, 1948.

37 *Dead Souls*, op. cit., note 34, p. 7.

38 See Compton, op. cit., note 21, cat. no 6, p. 57.

39 For example, Mikhail Larionov, *Venus*, in the background of a photograph, reproduced Compton, op. cit., note 17, p. 32. By 1924 Larionov had lived in Paris for eight years and, like Chagall, had painted new versions of earlier paintings – for instance, *Soldiers Dancing*; both versions are reproduced in Waldemar George, *Larionov*, Paris, 1966, p. 121.

40 Larionov and Goncharova (who did not marry until many years later although they had been living together since about 1912) worked for Diaghilev in the 1920s, an opportunity that never came Chagall's way. A number of fancy-dress balls in aid of Russia were organized in Paris in the early 1920s and provided a meeting place for émigrés.

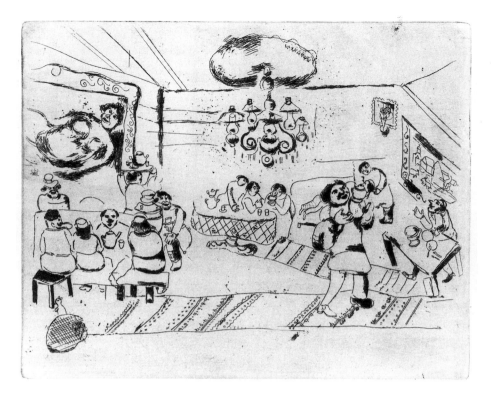

9　*The Inn*, Gogol, sheet 2;
etching, 22 × 28.5 cm

10　*Madame Korobochka*, Gogol, sheet 15;
etching, 30 × 22.6 cm

This is particularly obvious in the amusing etching of a farmyard scene (Plate 31, Cat. 35):

> [Chichikov] approached the window to look at the view. It appeared to comprise a poulterer's premises. At all events, the narrow yard in front of the window was full of poultry and other domestic creatures – of game fowls and barn door fowls, with, among them, a cock which strutted with measured gait, and kept shaking his comb, and tilting its head as though it were trying to listen to something. Also, a sow and her family were helping to grace the scene....[41]

Chagall's farmyard animals are more naturalistic than the ones he had created for *Mein Leben* (for example, Plate 19, Cat. 20), and the scene gives the general effect of having been observed, perhaps from a window. In another etching made in Normandy[42] the figure of Madame Korobochka (Fig. 10) could have been inspired by a French landlady, and the Russian bedroom by the rooms so often rented by the Chagalls on their travels in France (pp. 222, 223, Gogol, sheet 16, 21). Likewise, Pelagea, a barefooted girl of eleven struggling up on to the coachman's seat to guide Chichikov, probably found her origin among French peasants (Plate 29, Cat. 33), though Chagall has not made her into a stereotype.

By choosing to stay at Ault in Normandy and the island of Bréhat in northern Brittany, he avoided the southern coast, where, in the last decades of the nineteenth century, Gauguin and his friends had invented a pictorial formula of peasants dressed up in the traditional costumes of the region of Pont-Aven.[43] Chagall was not interested in stylized folk-lore; he was looking for particular types to enrich his Russian tale. This is especially obvious in the huddle of peasants who gathered round when Chichikov's horses became embroiled with those of an oncoming vehicle (Plate 37, Cat. 41). The stocky peasants in the foreground – perhaps the same model seen from the front and the rear – have a fierce look, almost as though they were borrowed from

41　*Dead Souls*, op. cit., note 34, pp. 46-7.
42　See Meyer, op. cit., note 14, p. 338.
43　Caroline Boyle-Turner points out that peasants never wore their Sunday and festival clothing for daily chores; see her *Gauguin and the School of Pont-Aven: Prints and Paintings*, London (Royal Academy of Arts), 1989, p. 24.

44 See Meyer, op. cit., note 14, p. 341.

45 Op. cit., note 2, p. 80.

46 In 1924-25 Chagall painted new versions of several of his early canvases. The small version of *I and the Village* can be seen on the wall in a photograph of Chagall's studio in the Avenue d'Orléans; see Chronology, p. 261.

47 The two versions of *I and the Village* are fully discussed in Compton, op. cit., note 21, cat. no 19, pp. 167-8, and cat. no 65, pp. 203, 205.

48 *Peasant Life* bears the date 1925, but this, like Chagall's other dates, is certainly approximate.

49 Op. cit., note 2, pp. 153-4.

11 *I and the Village*, 1923-24; oil on canvas, 55.5 x 46.5 cm. Philadelphia Museum of Art, Gift of Mr. and Mrs. Rodolphe M. de Schauensee

12 *Peasant Life*, 1925; oil on canvas, 100 x 81 cm. Albright-Knox Art Gallery, Buffalo, New York

sixteenth-century Flemish art. This may be no coincidence, because Chagall had come to know the Belgian critic Florent Fels, who had a house at Septeuil in the country west of Versailles, and, in 1925, Chagall took rooms at the house of a policeman in the neighbouring village of Montchauvet.[44] He must have felt reminded of an earlier episode described in *My Life*, for, when Bella was 'almost his fiancée', he had had a studio in Vitebsk in a policeman's house.[45]

While he worked on the Gogol etchings Chagall continued to paint canvases, and the evocative composition *Peasant Life* (Fig. 12) was made at Montchauvet. It is a reinterpretation of the theme of *I and the Village* (The Museum of Modern Art, New York), of which he had recently made a small version (Fig. 11).[46] *Peasant Life*, with its little folk dancing in the background near their hut, was certainly inspired by scenes from Gogol, but the hero's transformation from the archetypal 'holy fool' of *I and the Village*[47] also reflects Chagall's admiration for the work of the poet Esenin. Esenin was of peasant extraction and had identified himself as a 'hooligan poet'; his suicide in December 1925, brought on by his struggle against alcoholism and his frustration with the Soviet regime, came as a shock to the artistic world and may well have inspired Chagall to depict his own fierce yet joyful peasant.[48] In *My Life* he described Esenin, 'whose broad smile touched me. He shouted too, intoxicated with God, not with wine.... His poetry may not be perfect; but isn't it the only cry from the soul in Russia, apart from Blok's?'[49]

Chagall experienced a burst of creative energy at Montchauvet, where he etched two remarkable self-portraits (Cat. 59, 107). The second includes aquatint as well as etching, and at Montchauvet the artist introduced the same technique into two Gogol illustrations, *Escape in Nature's Garb* and *The Swiss Footman refuses to allow Chichikov to enter* (pp. 233, 234, Gogol, sheet 69, 76). Chagall did not often use aquatint, a technique which gives to a print

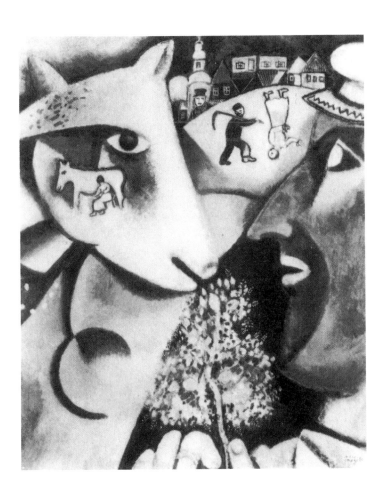

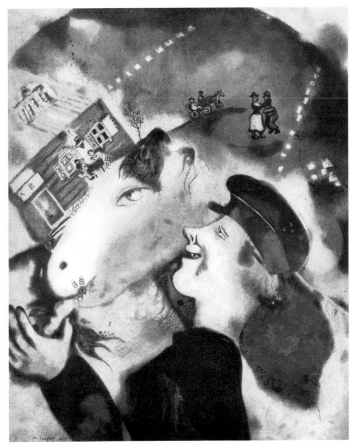

areas of soft, grey tone by the use of a porous ground of minute particles of resin which, when fused to the plate, allows the acid to seep through. The aquatinter achieves varying effects by allowing the acid to bite to different depths; the resin is cleaned from the plate before it is printed. Aquatint cannot produce lines, so it is often used as a second step in a process which begins with an initial etching using acid to bite lines scratched into impermeable varnish. After this first stage Chagall preferred to create tones between black and white by using drypoint, that is, by working directly on the copper plate with needles of different thicknesses.[50] Occasionally, he marked the backgrounds with savage lines – employing a tradition for cancelling an unwanted plate – thereby creating an equivalent to the frustration experienced by Chichikov when he is ill (p. 233, Gogol, sheet 74), or he used scratches on clothes and faces to build tension when *Our Hero is getting ready* (p. 234, Gogol, sheet 77). In *Troika at Night* (Plate 53, Cat. 57) Chagall shows passenger and coachman asleep, as the horses advance in a leisurely way across a landscape made indistinct by the softening grey of aquatint. The particular character of a drive across the vastness of the Russian countryside can be imagined only with the help of Gogol's text.

As well as representations of such generalized memories and illustrations where the inspiration had come from direct observation in France, some scenes are specifically Russian. For his view of the outside of an inn Chagall closely followed Gogol's description of any *Traktir* in the Russian countryside: 'the little wooden tavern, with its narrow, but hospitable, curtain suspended from a pair of rough-hewn doorposts like old church candlesticks... was a hut of larger dimensions than usual, and had around its windows and gables carved and patterned cornices of bright-coloured wood which threw into relief the darker hue of the walls and consorted well with the flowered pitchers painted on the shutters.'[51] This etching (Plate 27, Cat. 31) was destined to be used as the frontispiece to the book, and, unusually for him at this time, Chagall painted a related gouache (Plate 28, Cat. 32); he may have felt the need to create a preparatory model for his truly Russian building, with its style so unlike the typical Hôtel de la Poste, which he often painted on his travels in France (see Plate 40, Cat. 44).

From 1926 onwards Chagall journeyed further south; that year he spent several months at Chambon, beside a lake filling the crater of an extinct volcano, high in the Doré mountains, south of Clermont-Ferrand. There is a beautiful view from Lake Chambon, which was a good centre for walking in the high grasslands, where herds of grazing animals were guarded by fierce dogs in the summer months.[52] The rural life provided the inspiration for a new project, for, as soon as the plates for *Dead Souls* were completed, Vollard asked Chagall to begin work on illustrations for La Fontaine's *Fables*. This time the plan was to incorporate colour, and Chagall's task was to make gouaches for the printers, who were to create coloured etchings from them. Out of the projected one hundred, he made thirty gouaches at Chambon,[53] where he also painted several views (see Plate 38, Cat. 42, and perhaps Plate 42, Cat. 46).

The pairing of etchings and gouaches in the plates section of this book reflects this contrast in Chagall's work. Whenever he stayed in the country he seems either to have sat at a table making his etchings or to have painted the view from the window; he rarely painted out of doors. While etching, he allowed his imagination free play as he recreated his author's scenes; while painting views, he recorded a more straightforward account of what he could see. This study of the immediate locality must have given Chagall the oppor-

50 See Antony Griffiths, *Prints and Printmaking: An Introduction to the History and Techniques*, London, 1980. He discusses the technique of aquatint on pp. 91-3 and that of etching on pp. 56-9.

51 *Dead Souls*, op. cit., note 34, pp. 60-1.

52 For a fuller description of the region, see Freda White, *Three Rivers of France: Dordogne, Lot, Tarn*, London, 1962, pp. 66-7.

53 See Meyer, op. cit., note 14, p. 350.

54 Crespelle, op. cit., note 27, p. 188.

55 Meyer, op. cit., note 14, p. 365, records the visit
 to Collioure 'to visit Maillol' as part of the
 motoring trip undertaken by Chagall and
 Delaunay; Crespelle, op. cit., note 27, pp. 224-5,
 quotes Sonia Delaunay and says the two artists
 visited Maillol at his home at Banyuls. Banyuls
 is the last French seaside resort before the
 Spanish border, some ten kilometres south of
 Collioure. The trip is attributed to autumn
 1927 by Meyer, but to November 1926 by Cres-
 pelle, following Sonia Delaunay.

56 Michel Sageloly, 'Marc Chagall et Céret',
 foreword to *Marc Chagall – Eté 1978*, Céret
 (Musée d'Art Moderne), 1978, unpaginated.

57 An account of Chagall and Dobuzhinsky is
 given in Compton, op. cit., note 21, pp. 32-4.

tunity to watch people and animals going about their everyday lives, which afterwards fertilized his illustrations. Even today, as one sits in a railway train on a long journey across Europe – as Chagall did so often in the 1920s and 1930s – or at a table in a German *Weinstube* or a French café, one still encounters the exaggerated facial types which appear in Chagall's illustrations. His is not the art of caricature; his skill lies in capturing human features that were at the same time unusual and everyday, in order to give weight to the characters in a story.

Chagall sometimes stayed at spa towns, such as Châtelguyon in 1927, where he met his compatriot Chaim Soutine,[54] but he generally avoided areas of France which were already closely associated with the Impressionists and Post-Impressionists. He did not stay in Arles, the region associated with Van Gogh, or in Aix or Annecy, which had been immortalized by Cézanne; he only went to Collioure, where the Fauves had painted, on his way to visit the sculptor Aristide Maillol,[55] preferring to stay inland, at Céret. This small town at the foot of the Pyrenees is still known as the 'Mecca of Cubism' because Picasso and Braque made some of their most arcane Cubist compositions there on visits between 1911 and 1913. The work that Chagall did in Céret was, of course, far removed from theirs. An acquaintance records that, in 1929, Chagall prepared twenty-eight copper plates for the *Fables* there, at the same time working on a still life (Plate 78, Cat. 83) treated as a 'window painting'.[56]

Chagall often used a window as a framing device, sometimes confining the scene to a view seen through the window, and sometimes including part of the room as well. In the Céret still life, outside and inside are linked by a fantastic flying goat or cow, which peers through the glass of the open window at a flying artist, taking the place of the winged angel in other pictures. As well as those of Chagall's friend Robert Delaunay, the best-known twentieth-century window paintings are by Henri Matisse, and Chagall's use of the device has occasionally been seen as following this model. However, the more likely source was the work of his teacher in St Petersburg, Mstislav Dobuzhinsky.[57] In 1905 Dobuzhinsky had painted a scene with a doll, roughly

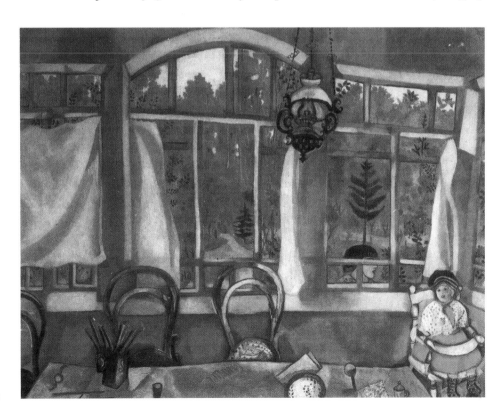

13 *Country Interior, c.* 1917; oil on canvas,
46.5 x 61 cm. Collection Isaak Brodskii, Leningrad

cast aside, lying on a window seat in the room from which the spectator shares the artist's view of the world through the window.[58] A few years later Chagall had loaded his *Paris through the Window* (The Solomon R. Guggenheim Museum, New York) with symbols, but, on his return to Russia in 1914, he had painted several window pictures with evocative naturalistic symbols very like Dobuzhinsky's doll (see Fig. 13). Franz Meyer interpreted Chagall's need for the window frame to separate the interior from the exterior world as 'an allegory of the relationship of the soul and world'.[59] Meyer's interpretation extends our reading of a painting such as *Landscape at Peïra-Cava; The Cloud* (Plate 84, Cat. 89); the cloud of the title may have inspired lines in a poem by one of Chagall's closest friends, Raïssa Maritain: 'Un nuage dans le ciel/L'équipage d'Ezechiel' (freely translated: A Cloud in the sky/ Ezechiel's chariot/Flashing by).[60]

After 1928, when Chagall and Bella regularly joined Sunday gatherings at the home of Raïssa and Jacques Maritain, with the poets Jules Supervielle, Paul Eluard and René Schwob, Chagall profited from his friendship with these writers without being a 'literary' painter. For instance, Supervielle's dedication for his 1923 novel would be equally suitable for Chagall's *My Life*: 'Dream and reality, farce, anguish; I have written this little novel for the child that I was and who still demands stories from me. They are not always from his age nor from mine....'.[61] As far back as 1910 Supervielle's poem 'Un Doux Village' evoked the village rising up within him, paralleling the titles of some of Chagall's paintings (see Plate 2, Cat. 3).[62] In 1930 Chagall provided a portrait frontispiece to poems by Pierre Reverdy, and lines from one of them, 'Les pointes blanches de la montagne', evoke the views that Chagall painted in 1929: 'Un nuage marche/Par la fenêtre passe un cri' (A cloud goes by/ Through the window passes a cry).[63] Such quotations do not indicate an influence, but show that Chagall shared motifs with poets in his circle.

Some of Chagall's gouaches suggest a more matter of fact interpretation; one now belonging to the Koninklijk Museum voor schone Kunsten in Antwerp, in which a window separates a woman and a cat from a mountain scene (Plate 76, Cat. 81), may be connected with his contemporary work on the *Fables*. The cat in *The Window* can jump indoors or outside, whereas the solitary one in *The Cat transformed into a Woman* (Plate 58, Cat. 63), sitting in boredom at a table, seems to yearn for the lost freedom of the window-sill. This fable gave Chagall the opportunity to invent a chimera; usually, the heroes of La Fontaine's pithy rhymes are either human or, more often, animals. Chagall had already demonstrated his sharp wit in *The Trough*, with its combination of a human with an animal, in a lithograph and related gouache (Plates 25, 26, Cat. 29, 30), as well as in two versions in oil. When he began work on the *Fables* in 1926 he made more factual gouaches of farmyard beasts: *The Cow*[64] – now called *Maternity* (Plate 32, Cat. 36) – the close-up *The Cow* (Plate 34, Cat. 38) and the frenetic *The Peasant and the Cow* (Plate 72, Cat. 77), where man and his domestic animal are seen in exaggerated conflict.

Chagall approached the *Fables* in an idiosyncratic way, picking out from La Fontaine's twelve books one hundred stories with elements that he felt he could illustrate. He was evidently not always interested either in following the text literally or in representing the animals realistically. For example, although the animals in *The Monkey and the Leopard* (Plate 77, Cat. 82) seem anatomically correct, in *The Rat and the Elephant* (Plates 67, 68 , Cat. 72, 73) the beast is a lumpy creature, more like a cart horse with a long neck than an elephant observed in a zoo. In this fable he left out La Fontaine's 'exceptionally small rat', who, 'Seeing an elephant who was exceptionally fat,/Scoffed/

58 Mstislav Dobuzhinsky, *Kukla* (The Doll), reproduced in colour in *M. V. Dobuzhinskii: Vospominaniya*, ed. G. I. Chugunov, Moscow, 1987, following p. 96.

59 Meyer, op. cit., note 14, p. 338.

60 Quoted from *Patriarch Tree/Arbre Patriarche*, 30 poems by Raïssa Maritain in French, with English trans. by a Benedictine monk of Stanbrook Abbey, Worcester, Stanbrook, 1965, unpaginated.

61 'Rêves et verité, farce, angoisse, j'ai écrit ce petit roman pour l'enfant que je fus et qui me demande des histoires. Elles ne sont pas toujours de son âge ni du mien...', Jules Supervielle, *L'Homme de la Pampa: Novel*, Paris, 1923.

62 'Un doux village en moi s'élève/Et ton sourire est en clocher...', Jules Supervielle, *Comme des Voiliers*, Paris, 1910.

63 Pierre Reverdy, *Pierres Blanches*, Carcassone, 1930.

64 Waldemar George, *Chagall*, Paris, 1928; the reproduction, on p. 17, is captioned '*La Vache*, 1925, Musée du Luxembourg'.

65 *La Fontaine: Selected Fables*, trans. James Michie, introduction by Geoffrey Grigson, Harmondsworth, Middx, 1989: La Fontaine, Book VIII, 'The Rat and the Elephant', Fable xv, pp. 110-1.

66 Ibid., La Fontaine, Book VII, 'The Priest and the Corpse', Fable xi, pp. 89-90.

67 See Meyer and Bolliger, op. cit., note 23, pp. xxxvi-xxxvii.

68 Aleksandr Pushkin, *Tsar Saltan*, French prose translation by Claude Anet, printed by Louis Kalder, Paris, 1922; it contains twelve full-page illustrations by Goncharova. Apart from the text, only the red outlines of the illustrations and border ornaments were printed; the rest of the work was done by hand. See Mary Chamot, *Goncharova: Stage Designs and Paintings*, London, 1979, p. 89. The technique of *pochoir* resembles that of stencilling.

69 For an account of Gauguin's Volpini prints, see Boyle-Turner, op. cit., note 43, pp. 37-45.

70 Transcription of the gouaches into coloured etchings was undertaken in the atelier of Maurice Potin, but proved unsatisfactory. Chagall then produced one hundred etchings in black and white in Louis Fort's atelier, but these were also unsatisfactory. After another printing in the atelier of Roger Lacrourière, Chagall remade all the copper plates in the atelier of Maurice Potin. See Meyer and Bolliger, op. cit., note 23, pp. xxxvi-xxxvii.

At the somewhat leisurely pace/Of that beast of honourable and ancient race.' In a gouache of remarkable colouristic freedom Chagall contented himself with the most notable details in the story, such as the 'massive tackle' made of wicker which the elephant was carrying 'aloft./A sultan in all his glory,/Pilgrimage-bound, in a three-storey/Howdah, was *en voyage*, complete/With household slaves, sultana....'[65] He also omitted La Fontaine's 'parakeet/Pet monkey, dog and cat' because he always left out the moral, which, in this case, was provided by the cat jumping down from the Howdah and chasing the rat, who was forced by this means to admit that an elephant is more important than a rat. If, however, the story is as well known to the viewer as it is to many Frenchmen, who learn the fables by heart at school, he can sometimes infer the moral.

This is the case with *The Priest and the dead Man* (Plates 65, 66, Cat. 70, 71), where the corpse is being trundled to its last resting place, escorted by 'a curé with a cheerful face' who has been 'running through his routine patter/Of hymns and psalms and exhortations/And prayers and scriptural quotations' and has just dropped his book. He might be saying: 'My dear dead friend, leave it to me... I'll bury you in style – /Providing I receive my fee.' Closer inspection shows that the horse is not pulling the hearse along, but rearing *towards* its load; indeed, a wreath and a bouquet of flowers have already fallen off the coffin, so it must be the moment before 'the shock of an accident. From the funeral wagon/The dead man in his box of lead/Came crashing on his curé's head,/And so parishioner and pastor/Went hand in hand to meet their Master.'[66]

Vollard's original plan for reproduction from Chagall's gouaches involved using methods common in the second half of the eighteenth century, when copiers and watercolourists working for the printer had etched the outlines and then hand-coloured them. To do this specialized work for the *Fables*, Vollard had brought together a group of artists in an atelier supervised by the printer Maurice Potin.[67] There was a more recent precedent for making a book in a workshop, for, in the early 1920s in Paris, Goncharova had assembled a team of artists in her studio to make *pochoirs* for an elaborate, largely hand-produced book, *Tsar Saltan*,[68] a modern equivalent of an illuminated manuscript. For his *Fables* gouaches Chagall did not, however, make a faithful recreation of an earlier style, though some of his designs are not unlike those of Gauguin, who had hand-coloured some of his Volpini prints.[69] Also like Gauguin in his prints, Chagall often emphasized a strong diagonal and used close-ups and cut-off humans and animals in the foreground of his designs.

Chagall finished all one hundred gouaches in about two years and handed them over to professionals to make the etchings. The attempt to make prints failed, not only with colour, but also, when that had been abandoned, twice with black and white. Finally, Chagall himself drew the images again on to copper plates.[70] Had he made a direct copy of the gouache, the image would have been reversed when printed. However, comparison of the two versions of *The Priest and the dead Man* (Plates 65, 66, Cat. 70, 71) shows the composition the same way round in both, though the gouache is much larger. Colour is not an important part of this composition, but in others Chagall intensified the colour by painting on coloured paper – for instance, in *The Drunkard and his Wife* (Plate 60, Cat. 65), for which he chose a black sheet. He did not use simple watercolour, presumably because it lacks sufficient intensity; for his inventions he needed the opacity of gouache (a mixture of colour – including white – ground in water and prepared with a gum base), though it certainly presented an insoluble problem to his printers.

14 *The Drunkard*, 1911-12; oil on canvas, 85 x 115 cm. Collection Hans Neumann, Caracas

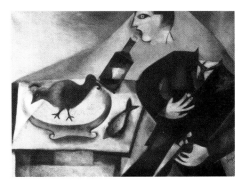

15 Karl Girardet, *The Bird wounded by an Arrow*; vignette in *Fables de La Fontaine*, Tours, 1858, Book II, Fable vi, p. 67

16 Karl Girardet, *The Lion and the Gnat*; vignette in *Fables de La Fontaine*, Tours, 1858, Book II, Fable ix, p. 78

17 *The Lion and the Gnat*, La Fontaine, sheet 18; etching, 25.9 x 24.2 cm

Sometimes Chagall's imagination ran away with him. This is especially true of *The Drunkard and his Wife.* One day, when her husband was inebriated, the wife shut him in a cellar and appeared to him as the Fury Alecto. Instead of La Fontaine's 'Death's apparatus all around, / Down to the tapers and the winding-sheet',[71] which Chagall could have taken from his own *Dead Man*,[72] he repeated another motif from his early years in Paris, *The Drunkard* (Fig. 14). So Chagall seated La Fontaine's 'slave of Bacchus' at a table with an empty bottle keeling over, and his wife does not 'Advance towards the bier', as the writer intended, but towards a table, to offer her '"dead" / Husband some gruel hot enough for Satan'. Sometimes Chagall turned elsewhere for inspiration. For instance, he based *The Bird wounded by an Arrow* (Plate 56, Cat. 61) on an engraved vignette by Karl Girardet, the illustrator of a 'New' edition of La Fontaine, published in Tours in 1858 (Fig. 15).[73] In the gouache version Chagall has greatly enlarged the wounded bird and imagined it on a brightly coloured background. Unlike Girardet, he has included the hunter, whose winged arrow merges with the bird's plumage to illustrate La Fontaine's short verse in which the bird complains at the hunter's cruel use of bird's feathers to wing his destroying arrows. Chagall's attention may have been drawn to the publication by the words on the title page: 'New edition in which the moral of the fable is instantly perceived.' By basing some of his images on those of Girardet, Chagall may have expected to counter criticism that he always left out the moral. For whatever reason, he borrowed Girardet's vignettes several times; the similarity between his own version of *The Lion and the Gnat* and that by Girardet is particularly striking (Fig. 16, 17).[74]

Before finishing the *Fables*, Chagall represented animals in a fantastic way in a series of circus subjects, now entitled *Cirque Vollard* because Vollard intended them to form a portfolio of etchings. One of them, *Woman-Donkey* (Plate 98, Cat. 104), appears to be equally related to a fable, not by La Fontaine but by the Russian fabulist Ivan Krylov. In his *Parnassus* Krylov tells how the ancient home of the Greek gods was given to a farmer, who put donkeys out to graze there. The asses somehow knew they must rival the Muses: '... louder than the sisters nine, / We'll form the asses' choir and raise our hymn divine.'[75] Although Krylov disguised contemporary Russian history in his fables, written at a time of harsh censorship in the first half of the nineteenth century, it would be a mistake to place weight on the similarity between Krylov's 'portioning out the land to folks of common kind' and the situation in the 1920s, when the Russian countryside had lost its former landlords. Chagall remained inspired by the ideals of the Russian Revolution, even though he had found that he could not live in Soviet Russia.

Another gouache, known as *Lovers / Lady with a Bird* (Plate 92, Cat. 98), suggests both the circus and, in a general way, fables. Two characters, dressed in circus attire, share the woodland space with a bird. The most rele-

71 La Fontaine, op. cit., note 65, Book III, 'The Drunkard and his Wife', Fable vii, pp. 41-2.

72 *Le Mort*, 1908, reproduced Compton, op. cit., note 21, cat. no 3, pp. 31-2.

73 *Fables de La Fontaine, précédées de la vie d'Esope et accompagnées des notes de Costes*, Tours, 1858, Book II: vi, p. 67. The author is indebted to Michael Compton for drawing her attention to the similarity.

74 In addition to 'The Lion and the Gnat', La Fontaine, op. cit., note 73, Book II, Fable ix, p. 71, Chagall used Girardet's vignettes for 'The Hare and the Frogs', Book II, Fable xiv, p. 73, and 'The Two Goats', Book XII, Fable iv, p. 348. See also Cat. 78.

75 *Krylov's Fables*, English verse translation by Bernard Pares, London, 1926; *Parnassus*, I. 8, pp. 34-5.

76 La Fontaine, op. cit., note 73, Book XII, Fable xxvii.

77 Aleksandr Blok's one act drama *Balaganchik* (The Fairground Booth) was produced by Vsevolod Meyerhold during the 1906-7 season, when Chagall arrived in St Petersburg, and may have inspired his *Village Fair* (La Kermesse); see Compton, op. cit., note 21, cat. no 2, p. 155.

78 The ballet *Petrushka*, with its tragi-comic hero, was produced by Diaghilev for *Les ballets russes* in June 1911 in Paris, when Chagall was living there.

79 See Compton, op. cit., note 21, pp. 14-5.

80 Struck, op. cit., note 20, 'Picasso, *Circus*, courtesy Querschnitt Verlag', p. 177.

81 Reproduced in colour, Meyer, op. cit., note 14, p. 239. This work has more recently been dated *c.* 1915; see Aleksandr Kamensky, *Chagall: The Russian Years 1907-1922*, London, 1989, p. 233.

82 E. Tériade, 'Les peintres nouveaux, 1: De la formation d'une plastique moderne', *Cahiers d'Art*, No 1, 1927, pp. 30-1, trans. P.S. Falla in *A Picasso Anthology: Documents, Criticism, Reminiscences*, ed. M. McCully, London, 1981, pp. 164-5.

83 Ibid., p. 165.

84 Ibid.

85 *Le Rêve* is titled 'Le lapin' and reproduced upside-down in 'Marc Chagall', *Sélection*, 3rd series, Vol. 8, No 6, April 1929, p. 128. See Cat. 56, Fig.

86 Lewis Carroll, *Alice's Adventures in Wonderland*, first published London, 1865, with illustrations by John Tenniel.

vant fable is La Fontaine's 'Daphnis and Alcimadure',[76] though this lacks a bird; some other story, read by Bella, or even by the Chagalls' daughter, Ida, may have prompted the conceit.

For Chagall, who was familiar with the tragi-comedy of Blok's *The Fairground Booth*[77] and the traditional *Petrushka*,[78] the clown was almost a religious symbol.[79] None the less, some of his circus compositions are simple observations of the Cirque d'Hiver, which Chagall watched from the comfort of Vollard's box. *Clown with Horse* (Plate 96, Cat. 102) picks up a theme which Picasso had used in an etching of two nudes standing on a circus horse, reproduced by Struck.[80] Chagall, however, gave his own figure such a pronounced lean that it no longer seems to be merely an elegant circus turn; he suggested an emotional as well as physical balancing act by provoking fear of the figure toppling over into the vibrant blue background.

Chagall is best known for his use of colour throughout his life and, in the late 1920s, he made some of his most brilliantly coloured works on paper. *Lovers with Half-Moon* (Plate 50, Cat. 54) is outstanding for the intensely blue background; he had already painted a gouache of lovers' heads on a blue background in Russia,[81] but now he extended the view, with three-quarter-length figures bending over in passionate embrace. He achieved a saturation of colour unrivalled in his contemporary oil paintings, though he pushed blue to its limits in the background of *The Dream* (Plate 52, Cat. 56).

This major oil of 1927 fulfils many of the hopes expressed in an article on new painters, published at the beginning of the year in the influential Parisian art journal *Cahiers d'Art*. The author, E. Tériade, had taken as his point of departure Picasso's latest exhibition, which marked, he felt, the inauguration of his 'poetic period': 'This, beyond all doubt, is to be the great immediate future of modern painting, a glorious renascence, if true painters respond to his appeal.'[82] One paragraph would have been particularly poignant for Chagall, who was always conscious of rivalling Picasso; as he was then involved in the attempt to create coloured prints from his *Fables* gouaches, it must have seemed especially relevant: 'As the means of reproduction become more and more varied and perfected, modern man once again comes to realize more fully the true significance of art. He seeks to free it from false ideas of naturalism and, by isolating it in a plastic and abstract form, to rediscover the fresh, spontaneous, inventive poetry of the age of simplicity.... It is for the young to be singers, poets and above all painters.'[83]

Chagall could no longer count himself among the young, since he had reached the age of forty in 1927, but he could hope to rival Picasso in leading the young and showing them, in Tériade's words, 'what has already been gained; poetic liberty in the conception of a picture, plastic liberty in its execution, the architectural value of a powerful, concentrated, vibrant equilibrium, answering to our present aesthetic needs and our thirst for poetry.'[84]

Answering the call, Chagall developed *The Dream* directly from poetic ideas. Its title when first exhibited, *The Rabbit*,[85] suggests Lewis Carrol's *Alice in Wonderland*[86] as a possible source, because Alice follows a white rabbit into a make-believe land. Certainly, the animal – more like an ass than a rabbit – and its human burden inhabit a topsy-turvy world where the moon has changed places with the landscape, from which small trees drop down into the 'sky', a blue background with cloud-like forms. It has often been repeated that Chagall worked on paintings from every direction, but the 'illogicality' here is a reminder of the 'beyond-sense', so special to Russian Futurists, which was extended by Raïssa Maritain, who argued for the close relation-

ship of the 'mystical order and the poetic order': 'The poem is a vehicle of poetic inspiration as the flute is an instrument of music, the painter's brush a vehicle of vision.'[87] For anyone more familiar with European art, Chagall's *The Dream* evokes a traditional 'Rape of Europa' – with Europa being abducted by an ass rather than a bull. This interpretation may have been intended by Chagall, as Tériade had also stated the aim: 'To concentrate the aesthetic, pictorial, architectural and poetic value of a Renaissance painting into the proportions of a modern one....'[88] Incidentally, Chagall used the subject for a gouache about this time.[89]

In the 1920s Chagall painted many flower pictures, with or without human adjuncts. Paintings of flowers were popular with buyers and, according to one of the artist's dealers, they provided Chagall with a regular income.[90] By the late 1920s he was enjoying a modest success. For two years – until the stock market crash in 1929 – he had a contract for his oil paintings with the established dealers Bernheim-Jeune. Three monographs were devoted to him in 1928 and 1929, as well as numerous articles in the press.[91] He must have felt well established in Paris, though not all the articles were favourable. He was hailed as a leading member of the Ecole de Paris, the name increasingly used for Jewish émigré artists living in Paris,[92] rather than for all émigrés, of whom the most famous was certainly Picasso.

In the press the Ecole de Paris was often contrasted with the Ecole Française, which included André Derain, Dunoyer de Segonzac, Maurice Vlaminck and Othon Friesz, native French artists who had made their names before the 1914-18 war. This group was not so avant-garde as the Cubists, and in the 1920s they liked to be seen as continuing a line of French painting which reached back through Cézanne to Courbet and Corot and, further, to the Le Nain brothers, Poussin and Fouquet.[93] Chagall was not unaware of this tradition himself, because, by-passing Cézanne, he turned to Courbet for the example of using a palette knife and to Corot when etching plates for La Fontaine's *Fables*.[94] He even drew upon less familiar works, such as the Caravaggesque *Guardian Angel* in Narbonne (Fig. 18),[95] which appears to have inspired Chagall's monumental *Angel with a Palette* (Fig. 19).[96]

87 Raïssa Maritain shared the Chagalls' Russian-Jewish background. She argued for the religious quality of poetry in this essay, published in Jacques and Raïssa Maritain, *Situation de la Poésie*, Paris, 1938, trans. Marshall Suther, *The Situation of Poetry*, New York. 1955.

88 Tériade, English trans., op. cit., note 82, p. 165.

89 Reproduced in colour, Sotheby's, New York, Sale Catalogue, 12 November 1988, lot 159.

90 Klaus Perls in conversation with the author, 1984.

91 The three monographs were Waldemar George, *Marc Chagall*, Paris, 1928; André Salmon, *Chagall*, Paris, 1928; and Paul Fierens, *Marc Chagall*, Paris, 1929. Among the articles were Pierre Courthion, 'Marc Chagall', *Revue Hebdomadaire*, April 1928, pp. 107-9; G. Aronovich, 'The Artists of Paris: Marc Chagall', *Krasnaia Panorama*, No 47, 23 November 1928, p. 13 (in Russian); and *Sélection*, op. cit., note 85.

92 Most generally cited were Moïse Kisling, Jacques Lipchitz and Jules Pascin. See Romy Golan, 'The "Ecole Française" vs. the "Ecole de Paris"', in Kenneth Silver and Romy Golan, *The Circle of Montparnasse: Jewish Artists in Paris 1905-1945*, New York (The Jewish Museum), 1985, p. 89.

93 See also Golan, ibid.

94 See especially Camille Corot, *Normandy Landscape*, from *Sonnets et eaux-fortes*, Paris, 1869, containing forty-two sonnets illustrated with forty-one etchings and one drawing; this etching reproduced *The Art of the French Book*, ed. André Lejard, London, n. d., plate 119, p. 112.

95 Narbonne is north of Perpignan and was included in the itinerary of Chagall's motoring trip with Robert Delaunay (see note 55). Chagall had used a French primitive painting, *The Meeting at the Golden Gate*, c. 1500 (Musée Carpentras, formerly in St Siffrein Cathedral), as inspiration for *Le Mariage*, 1917 (Tretiakov Gallery, Moscow); see Mira Friedman, '*Le Mariage* de Chagall', *Revue de l'art*, No 52, 1981, pp. 37-40.

96 Meyer, op. cit., note 14, p. 331, dates *Angel with a Palette* 1926, but ascribes the study for it (reproduced ibid., cat. no 490) to 1927-28.

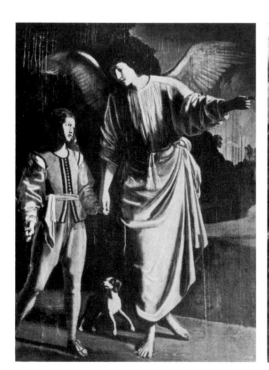

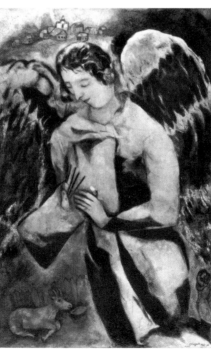

18 *Guardian Angel* (detail), 17th century, Cathedral, Narbonne

19 *Angel with a Palette*, 1927-36; oil on canvas, 131 x 90 cm. Musée national d'art moderne, Centre Georges Pompidou, Paris

20 *Creation of Eve*, 1931; gouache, 58.5×42 cm. Musée National Message Biblique Marc Chagall, Nice

97 Chagall had finished forty etchings for Genesis by 1934, when an article by Jacques Maritain appeared in *Cahiers d'Art*, No 4, pp. 84-92. Sixty-six copper plates were made by the time of Vollard's accidental death in 1939, and the remaining thirty-nine were finished by Chagall between 1952 and 1956. The etchings were published in 1956 in two volumes by Tériade, accompanied by excerpts from the French Protestant Bible published in Geneva in 1638, which was a translation of a Hebrew text.

98 *Adam and Eve*, 1912, St Louis Art Museum; see Compton, op. cit., note 21, cat. no 26, p. 72. *Cain and Abel*, 1911, reproduced *Marc Chagall: Œuvres sur Papier*, Paris (Musée national d'art moderne, Centre Georges Pompidou), 1984, cat. no 33, p. 53.

99 See also Compton, op. cit., note 21, cat. no 8, reproduced p. 55, text p. 159.

The next project agreed to with Vollard – the *Bible* – was conceived by the artist as a set of black and white illustrations for the Books of the Prophets.[97] Nevertheless, Chagall decided to begin by making preparatory gouaches in colour – as he had done for the *Fables* – because he felt that this was the best way to establish the balance of tones for the subsequent etchings. There is, however, a very great difference between the diversity of approach in Chagall's gouaches for the *Fables* and the comparative uniformity of the forty or so that he made for the Bible. In the latter the colours are moderated and the images more faithful to nature than the *Fables* inventions. Dark backgrounds give unity to a large number of the Bible gouaches: against a deep, blackish green, the whiteness of angels and the flesh-tones of newly created man and woman mark a new departure in Chagall's work, as do the intensely observed faces of Abraham and Moses, seen in close-up in moments of despair and hope.

After the creation of Adam (Plate 108, Cat. 115) and the creation of Eve (Fig. 20) from the second chapter of Genesis, Chagall by-passed two dramatic stories which he had treated in very different styles before 1914 – the Fall of Man and Cain and Abel[98] – and proceeded directly to the covenants that God made with the patriarchs. He devoted five gouaches to Noah, seen here releasing the dove from the ark to test whether the flood waters had subsided (Plate 110, Cat. 117) and in the culmination of the story, the rainbow, the sign of God's alliance with man after the flood (Plate 114, Cat. 121). Chagall appended the more light-hearted scene of Noah's drunkenness (p. 251, Bible, sheet 5), suggesting the human weakness of even the most holy.

For Abraham, the next patriarch, he chose to depict the physical sign which God had commanded to distinguish Abraham and his children as the people of the one God (Plate 118, Cat. 125). Chagall had made paintings of this subject, the circumcision, before he left St Petersburg for Paris (Fig. 21),[99] but in the gouache he exaggerated the wrinkles on Sarah's face to emphasize the miracle of the birth of a son to a woman past child-bearing age. The three angels who foretold the birth (Plate 116, Cat. 123) are shown in a variant of a well-known Russian prototype, an icon of 'The Old-Testament Trinity', though Chagall subverted the imagery by changing the relationship of the

21 *Circumcision*, 1908; chalk and watercolour on paper, 22.5×33.3 cm. Private Collection

angels to the viewer. Instead of the type established by Andrei Rublev,[100] with the three angels facing forwards, Chagall turned their backs, leaving the third looking at Abraham. He was moved by the obedience of Abraham, who was ready to sacrifice his long-awaited son, Isaac, and the gouache of Abraham on the way to the sacrifice (Plate 120, Cat. 127) was one of his most tender representations. In contrast, *Abraham weeps over Sarah* (Plate 122, Cat. 129) conveys the bitterness of grief, enhanced by the dark background characteristic of Chagall's depictions of the Genesis stories.

These backgrounds cannot be dismissed as a way of indicating intended blackness in the engraving, because Chagall used bright colours for many of the *Fables* and the resulting etchings are often blacker than any of the illustrations for the *Bible*. The characteristic greenish-black hue may well have derived from Delacroix, whom Chagall affirmed as 'one of the gods' on the occasion of the major retrospective at the Louvre in spring 1930.[101] Delacroix's small but dramatic *Self-Portrait* in to the Louvre[102] has a green background similar to those used by Chagall, and the new colour scale that Chagall adopted for his biblical gouaches, with terra-cotta, blues and yellows as well as greens, is much more like that of Delacroix than the primaries of the *Fables*. A still life in the foreground of Delacroix's *Jacob Wrestling with the Angel* in the Parisian church of St Sulpice demonstrates the connection particularly well.[103] There are echoes of Delacroix's skill in composing his figures in dramatic scenes in many of Chagall's biblical gouaches, but here, as elsewhere, Chagall used his gift for transforming his sources; it is as though he saw the next moves of, for instance, Delacroix's Jacob in his struggle with his heavenly adversary, and imagined the final position, when the angel pushes Jacob to the ground. One cannot press the relationship too far, because in his own *Jacob and the Angel* etching (p. 253, Bible, sheet 16) Chagall completely altered the facial types. None the less, the face of Rebecca (Plate 155, Cat. 162), amongst others, is closer to the faces in Delacroix's *Women of Algiers*[104] than to those in Chagall's own earlier work. When he saw a large number of Delacroix's paintings hanging in the Louvre with their preparatory drawings and sketches, he must also have recognized the special quality of the light in North Africa, which pervaded so much of Delacroix's work.

In 1931 Chagall took the opportunity to visit the Middle East with his family at the invitation of Meir Dizengoff, who, as mayor of Tel Aviv, was planning a museum for the city. Chagall had written enthusiastically to Dizengoff in January, supporting the idea for a museum of Jewish art which might contribute to the improvement of the image of Jewish people in the world.[105] It must have been an extraordinary voyage, for his travelling companions from Marseilles to Haifa were the Zionist poet Bialik – who was returning from Paris to Tel Aviv – and the prolific writer Edmond Fleg.

Fleg, a French-speaking Jew, was forced to stay in hotels in Palestine, because he found it difficult to communicate freely. He envied Chagall his Russian and Yiddish, which had enabled him in Jerusalem to go 'to live with an artist whom he had casually met. He enjoyed a terrace which looked down from a studio on cupolas, and a dining room decorated with Byzantine images. Every evening when he went out he was welcomed everywhere.'[106]

In Jerusalem Fleg's evocations of the past and his feelings in the present seem to have been much stronger than Chagall's response to the same scenes. Describing his visit to the Wailing Wall, Fleg quoted the Thomas Cook travel guide, who had explained to the sightseers: ' "This is the western wall, in Hebrew *Kothel Maarabi*, where the Jews wail over the ruin of their Temple.

100 Andrei Rublev, *The Holy Trinity*, c. 1425, Tretiakov Gallery, Moscow, 'Where the Trinity appears in the guise of the three angels who visited Abraham, which the Council of the Hundred Chapters declared in 1425 would be the model for all future depictions of the Trinity which throughout Byzantine art was always pictured as the angels visiting Abraham.' Philipp Schweinfurth, *Russian Icons*, London and New York, 1953, p. 42 and plate IX.

101 'En marge d'une exposition: Delacroix et nos peintres', *L'Intransigeant*, 9 June 1930, p. 6.

102 Eugène Delacroix, *Self-Portrait as Ravenswood*, c. 1824, Musée du Louvre, Paris; reproduced Phoebe Pool, *Delacroix*, London, 1969, plate 3.

103 Eugène Delacroix, *Jacob Wrestling with the Angel*, 1854-61, Chapelle des saintes anges, St Sulpice, Paris. A detail is reproduced in colour in Lee Johnson, *Delacroix*, London, 1963, plate 67, p. 108; see also plate 60, p. 97, and plate 68, p. 109.

104 Eugène Delacroix, *Women of Algiers*, 1834, Louvre, Paris, reproduced ibid., plates 24-6, pp. 43-5; and study, plate 23, p. 42.

105 An account of Chagall's involvement with the founding of the museum is given by Tami Katz-Frieman, 'Founding the Tel Aviv Museum 1930-1936', *The Tel Aviv Museum Annual Review*, Vol. 1, 1982, pp. 25-9.

106 Edmond Fleg, trans. Louise Waterman Wise, *The Land of Promise*, New York, 1933, p. 175.

107 Ibid., pp. 81-3.
108 Chaim Bialik, 'Megillat ha-Esh' (The Scroll of Fire), 1905, excerpt trans. David Aberbach, *Bialik*, London, 1988, p. 75.
109 Fleg, op. cit., note 106, pp. 124-5.

The stones of the first course measure five meters by four; above these there are fifteen courses....' ' He contrasted this bare account with his own moving survey of the past, which concluded: 'Meanwhile the Jews continue to moan: "Over the palace which is destroyed we weep; over the Temple which is laid waste, we weep; over the rampart which is torn down, we weep." And I felt the vertebrae of my spine shiver down my back.'[107] Fleg's vision was no doubt coloured by the spectacular account of the destruction of the Second Temple in 70 A.D. at the beginning of one of Bialik's most celebrated (and often translated) poems, 'The Scroll of Fire': 'All night seas of flame boiled and tongues of fire leaped about the Temple-mount. Stars flew from the charred heavens and fell to earth in showers of sparks.'[108] Chagall was probably even more familiar than Fleg with Bialik's poem, which had been first published in Russia in 1905. None the less, his oil painting *The Wailing Wall* (Plate 104, Cat. 111) is singularly lacking in violent emotion, although even his apparently factual record looks subjective compared with the photograph published by Fleg (Fig. 22).

Fleg described how he encountered Chagall one day near Jerusalem:

> standing before his easel, between his wife and his daughter, for this Bohemian of the Ghetto always paints in the midst of his family. He had told me many times on the boat, with his malicious smile: 'I am a little Jew of Vitebsk. All that I paint, all that I do, all that I am, is just the Little Jew of Vitebsk. So what am I to do in Palestine?' And then pointing out to me with the end of his brush, the cactus, the towers and the cupolas, all the splendors of Jerusalem, he cried: 'There is no longer a Vitebsk!'

In retrospect, Fleg added his own perceptive comment: 'My dear Chagall, I know your humor; I know there will always be something of Vitebsk in your painting and in you. But however good Zionists we may become, shall we ever say, even in jest, there is no longer a Paris?'[109]

Neither Fleg nor Chagall would ever have become a Zionist, but Fleg was probably thinking once more of Bialik, who, by 1931, had been recognized as the poet laureate of Palestine. Strangely, when Chagall and Bialik had met in

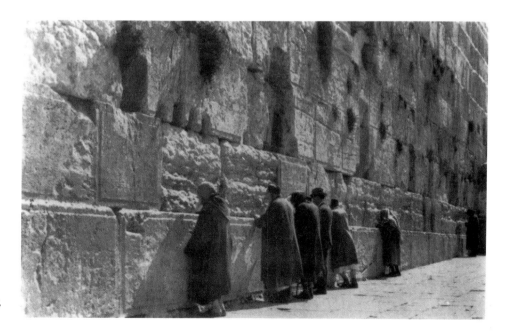

22 The Wailing Wall; illustration in Edmond Fleg, *The Land of Promise*, New York, 1933

Berlin[110] the publication of Chagall's *Mein Leben* etchings had coincided with the publication of the first chapter of Bialik's autobiography,[111] and their meeting in 1931 occurred just before the publication of Chagall's autobiography. Although both had been born to Hasidic parents in Russia, Chagall's memories of his childhood in a large family were profoundly different from those of the orphaned Bialik. The pages of Chagall's *My Life* overflowed with detailed everyday events, whereas Bialik's generalized memories of his childhood were loaded with intimations of the divine, through which he had attempted to come to terms with his sense of abandonment: 'Every stone and pebble, every splinter of wood was an inexplicable text, and in every ditch and hollow eternal secrets lurked.'[112] Other passages resounded with echoes from biblical texts, and this private side of Bialik – found also in his lyrical poetry – would have appealed to Chagall, who had plenty of opportunity to renew his friendship with Bialik on this journey. On the ship they no doubt discussed art, especially the problem of Jewish art (since Bialik was Honorary President of the Provisional Committee for the Tel Aviv Museum), and it is likely that this affected Chagall's subsequent work, not only the Bible illustrations, but also his choice of subject-matter in the 1930s. The unusual composition *Solitude* (see Plate 152, Cat. 159) may have been partly inspired by Bialik's unexpected death from a heart-attack in 1934.[113] Twenty years later the artist gave this picture of a solemn figure, incongruously sitting in a field in front of a Russian town, to the Tel Aviv Museum. There it may remind the viewer not only of Chagall's visit to Palestine, but also of the importance of Russian history for the growth of Zionism.[114] Without persecution, neither Bialik, nor even Chagall, would have idealized the ancient home of Israel.

On the whole, Chagall played down his own experience of pogroms, and memories of his early years led to a joyful and positive attitude to his work. In Palestine he recorded the interior of the synagogue at Safed (Plate 106, Cat. 113), which he depicted glowing with light provided not only by the sun, but also by the sacredness of a place intimately connected with his Hasidic upbringing. Hasids had adopted and modified theories about the Creation developed at Safad in the sixteenth century by a renowned scholar, Isaac Luria.[115] The dark backgrounds which Chagall adopted for the Creation gouaches (connected above with Delacroix) may thus have been additionally inspired by some of Luria's ideas about the Creation, which have been tellingly summarized by a writer on *The World of Marc Chagall*:

> God's initial act of Creation was represented as being... a diminishing of His light in certain areas, partly in order to adapt it to the capacity of endurance of His creatures. 'Holy sparks' were therefore said to be still present in everything in nature, organic and inorganic, and in every person, good or bad. Evil in the world was merely a lower grade of good, and there was no real separation of the sacred and the profane.... Every man had, without waiting for the Messiah, a role to play in the redemption of the world, for whenever he made use of matter in a holy way – by working with it honestly, for instance... – he consecrated it and lifted it close to the light of God; in the cabalistic phrase, he 'caused the sparks to ascend'.[116]

Chagall, in his lifetime, was quick to deny or even suppress statements about himself and his background with which he disagreed, so, since he allowed this one to be printed, it should be accepted for the insight it gives into his faith as well as into his attitude to his work.

110 See p. 15.

111 Chaim Bialik, *Safiah*, Berlin, 1923. Bialik had been writing his autobiography for most of the century; chapters 2-8 had been published in 1908, and 9-15 in 1919.

112 Trans. D. Patterson, 'Safiah ch. 1', *The Jewish Quarterly*, Vol. 20, No 4, 1973, p. 17; quoted from Aberbach, op. cit., note 108, pp. 91-2.

113 Bialik died in Vienna, 4 July 1934. This interpretation is flawed if Chagall's dating of *Sketch for 'Solitude'* to 1933 is correct; the author is generally sceptical of the dates on Chagall's paintings.

114 This is dealt with by Aberbach, op. cit., note 108, pp. 33-6.

115 Isaac Luria, b. 1534, d. 1572 Safed.

116 Izis Bidermanas, photographs, Roy McMullen, text, *The World of Marc Chagall*, London, 1968, p. 65.

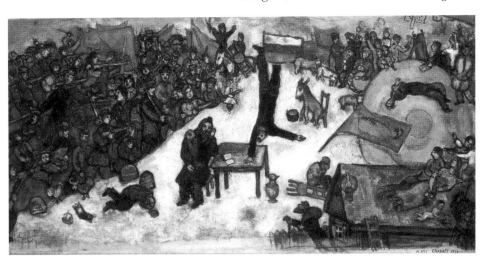

23 *The Revolution*, 1937; oil on canvas, 50 x 100 cm. Musée national d'art moderne, Centre Georges Pompidou, Paris

117 Marc Chagall, 'Voyage en Hollande', *L'Intransigeant*, 3 May 1932, p. 6.

118 Ibid.

119 Pierre Courthion, 'Impromptus Marc Chagall', *Les Nouvelles Littéraires*, 30 April 1932, p. 7.

120 A series of these drawings belongs to the Victoria and Albert Museum, London; see Larissa Salmina-Haskell, *Catalogue of Russian Drawings*, London (Victoria and Albert Museum), 1972, plates XXII-XXIV. For Bronislava Nijinska, see Arnold Haskell, *Ballet*, Harmondsworth, Mddx, 1938, p. 99.

121 See Meyer, op. cit., note 14, p. 398.

122 One, reproduced Meyer, op. cit., note 14, cat. no 611, evidently formed the basis for a setting by Georges Annenkov, who replaced Chagall as the designer. Annenkov's settings for Nijinska's *Beethoven Variations*, 1932, are reproduced in Cyril W. Beaumont, *Ballet Design Past & Present*, London, 1946, pp. 122-3.

Although Chagall's visit to Palestine provided inspiration for his Bible illustrations, it did not inhibit him from continuing to find inspiration in the work of European precursors on his return to Paris. He never hid his admiration for Rembrandt – who had, of course, made a cycle of Bible etchings – and in May 1932 he visited Rembrandt's house in Amsterdam and wrote about his experience afterwards in the newspaper *L'Intransigeant*.[117] He found his visit especially poignant, for in the 1930s the house was still surrounded by the Jewish quarter of the city: 'Opposite, … huge merchants were selling fish, chickens, as in pictures by the old masters…. Rembrandt only had to go into the street to secure the first Jew to come along as a model. King Saul, prophet, merchant, beggar, are the same Jews, his neighbours.'[118] Writers have recognized an overall debt to Rembrandt in Chagall's monumental patriarchs, though Chagall's transformations meant that particular likenesses were not very obvious. None the less, soon after his visit to Amsterdam he told the writer Pierre Courthion that Rembrandt had remained his master and spiritual guide.[119]

There is a trace of another, unexpected influence on one or two biblical figure compositions, particularly *Miriam dancing* (Plate 140, Cat. 147). This is from groups of dancers drawn by Goncharova for Stravinsky's ballet *Les Noces*, produced in 1924 for Diaghilev's *Les ballets russes* by Bronislava Nijinska.[120] The connection came about in 1932, because Nijinska invited Chagall to design, for her own company, the ballet *Beethoven Variations*, which she planned in three parts, devoted to the French Revolution, the Russian Revolution and Greece respectively. Chagall made several watercolour sketches of scenery and costume designs 'in delicate pale tints – cool watery blue, light grey, delicate crimson'.[121] They were not used in the production,[122] but for Chagall the opportunity to design again for the stage must have brought back memories of working on a large scale in Moscow. For the remainder of the decade he attempted oil paintings far larger than any since his 1920 canvases for the Jewish State Theatre (see Fig. 2). In particular, the scene designs inspired him to make a more detailed celebration of the Russian Revolution, which he set about in a traditional manner by making a number of compositional studies, including a large oil sketch (Fig. 23); but he could not resolve this painting and eventually cut up the large version. The idea of portraying Lenin as an acrobat standing on his hand in the centre of a circus ring was bold at a time when Communism had so many adherents among artists and intellectuals in France. Chagall's emotions must have been

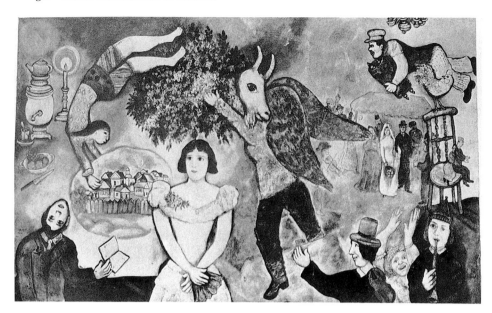

24 *Circus People,* 1934, altered 1935; reproduced as *Composition* in *Cahiers d'Art,* Vol. 10, Nos 1-4, 1935

confused because he was denied French citizenship when he first applied, for the reason that he had held office as a commissar under Lenin; he was granted French nationality only through the intervention of the writer Jean Paulhan in 1937.

The increase in scale in Chagall's work was also a reflection of his feelings of maturity, prompted by the major retrospective of his work organized in Basle in 1933. A photograph of the artist in his Paris studio, taken just after his work had come back from Switzerland, shows him in front of a large painting which he was about to send to the Salon des Indépendants.[123] This was the second state of *The Falling Angel* (Kunstmuseum, Basle), which he altered to its present state in 1947. He had moved from the suburbs back into Paris in 1936, to an address near the Trocadéro, the site for the 'Exposition Universelle' of 1937. He spent a great deal of that year travelling, though he was quick to write from the south of France to the organizer of a large exhibition, 'Maîtres de l'Art Indépendant', to make sure that he was well represented, with his pictures occupying an advantageous position. Seventeen of his paintings were lent from private collections to this exhibition, which caused many problems to the organizers; owing to general dissatisfaction, many of the fifteen hundred works were changed between the press view and the opening to the public.[124] Four more of Chagall's works were hung the same summer in an ambitious exhibition of the origin and development of independent international art held at the Musée du Jeu de Paume. It was a survey exhibition, including Fauvism, Cubism, Abstraction and Surrealism, as well as African and Oceanic sculpture,[125] so Chagall was recognized as a key figure in twentieth-century art. However, his work did not fall into those categories and his large paintings in particular must have seemed out of keeping with their time in the 1930s. He was not wholly sure of them himself, and kept altering canvases such as *Circus People* (Fig. 24); in 1945 he cut the picture in two and revised both halves to form *Around Her* (Musée national d'art moderne, Centre Georges Pompidou, Paris) and *The Wedding Candles* (Plate 159, Cat. 166).

Significantly, in a book on twentieth-century French painting published in 1937, the director of the Petit Palais grouped Chagall, Modigliani and Pascin not in the usual L'Ecole de Paris but in L'Ecole Juive.[126] As Modigliani had died in 1920 and Pascin in 1930, this left Chagall as the only living representative

123 'Chagall devant la toile qu'il vient d'achever pour le Salon des Indépendants'; Raymond Cogniat, 'Visite d'Atelier: Marc Chagall', *Beaux-Arts,* 26 January 1934, p. 3.

124 Bernadette Contensou, 'Autour de l'exposition des Maîtres de l'art indépendant en 1937', in *Paris 1937: L'Art indépendant,* Paris, 1987, pp. 11-8.

125 See Michel Hoog, 'Origine et développement de l'art international indépendant', ibid., p. 28.

126 Raymond Escholier, *La Peinture française: XX siècle,* Paris, 1937; cited by Catherine Amidon-Kayoun, 'Raymond Escholier, ses écrits, et l'exposition du Petit-Palais', in op. cit., note 124, pp. 29-34.

127 Sonia Delaunay, Louis Marcoussis, Chaim Soutine and others are included by Silver and Golan, op. cit., note 92.

128 Jacques Maritain, 'L'Impossible Anti-sémitisme', in *Les Juifs*, Paris, 1937.

129 Jacques Maritain, *Antisemitism*, London, 1939, p. 56.

130 From Chagall's lecture 'Quelques impressions sur la peinture française', given at Holyoke College (USA) in 1943; published in *Renaissance*, II and III, 1945, this quotation, p. 52; English trans., Marc Chagall, 'The Artist', in *The Works of the Mind*, ed. Robert B. Heywood, Chicago, 1947, p. 34.

131 'Les expositions', *Cahiers d'Art*, Vol. 15, Nos 1-2, 1940, pp. 33-6.

of a group which could have been extended to include many more names.[127] His acquiescence to this title no doubt stemmed from a growing recognition of the danger that was increasingly facing his race. By 1937 his friend Maritain was writing passionately against anti-semitism.[128] His material on Jews in Poland probably came from Chagall, who had been horrified at the lack of respect shown to Jewish scholars in Vilnius (then Polish territory) when he had gone there in 1935 for the opening of the Yiddish Institute. The visit revived Chagall's memories of Vitebsk, tantalizingly close across the border, in a country where Jews had lost all rights to practise their religion. In 1938 Maritain could already write: 'The immense clamour which arises from the German concentration camps, as well as from the Russian, is not perceptible to our ears, but it penetrates the secret fibres of the life of the world, and its invisible vibration tears them apart.'[129] It is against this background that Chagall's large works from the late 1930s, especially the powerfully tragic *White Crucifixion* (see Fig., p. 267), must be seen.

Chagall was not, however, paralyzed by political events: as usual, he removed himself regularly from the distractions of the Paris art world and continued the task which provided a regular means of support up to 1939, the Bible etchings. He etched fifteen copper plates in Tuscany in 1937; later he remembered: 'In Italy I found the peace of the museums, but illuminated by a sun that announces life.'[130] In the uncertain political climate of 1938 and 1939 he did not leave France, but spent the summers in the countryside south of Orléans. After the outbreak of war he courageously returned to Paris in May 1940 for a major exhibition of his work. In photographs of the installation,[131] among smaller, unidentifiable paintings, shine out the monumental *White Crucifixion* and *Bride and Groom of the Eiffel Tower*; near them hang *Time is a River without Banks* (Plate 158, Cat. 165) and the magical *A Midsummer Night's Dream* (Plate 156, Cat. 163) which reveal the full poetry of his imagination.

Chagall's response to the enquiry about the most important meeting in his life, quoted at the beginning of this essay, had been printed in 1933 below Man Ray's depiction of 'the chance meeting on a dissection table of a sewing

25 View of the exhibiton 'Marc Chagall' at the Galerie Mai, Paris, 1940; illustration in *Cahiers d'Art*, Vol. 15, Nos 1-2, 1940.

machine and an umbrella' which the poet Lautréamont had coined as a defi-
nition of beauty.[132] Though food and drink to the Surrealists, such combina-
tions could not satisfy Chagall. The Russian Jew from Vitebsk, who had spent
the 1920s illustrating classics of Russian and French literature and the 1930s
illustrating a large part of the Bible, not surprisingly found the antics of the
Surrealists too cerebral. His own work, after all, had been dubbed 'super-
natural' by Apollinaire – a term with deeper connotations than 'surreal'.
Chagall could never have been satisfied by dredging his unconscious or by
marking canvases with unpremeditated signs. His meetings on canvas were
not of chance objects: the fish and the clock of *Time is a River without Banks*
were emblems for his father, whose work involved carrying barrels of
herrings, and his father-in-law, who owned three stores selling clocks;
Chagall linked them above the young lovers – himself and Bella – on the river
bank at Vitebsk. The meeting of himself and the world which he had
described in *My Life* was not, he had insisted in 1932, to be viewed as his
memoirs; he had needed to tell certain events 'in their *tonality* [sic.], under
the various illuminations of memory'. He continued in words which captured
the delicate balance of his creativity, poised between dream and reality: 'I
cannot differentiate between the book and my pictures....It's all by
Chagall.... You see, what is essential is not to know everything, but to pulse
with life's touch, not to oppose daily actions – which are often the most
moving – with a scornful spirit.'[133]

132 Op. cit., note 1, p. 101.
133 Courthion, op. cit., note 119, p. 7.

Plates

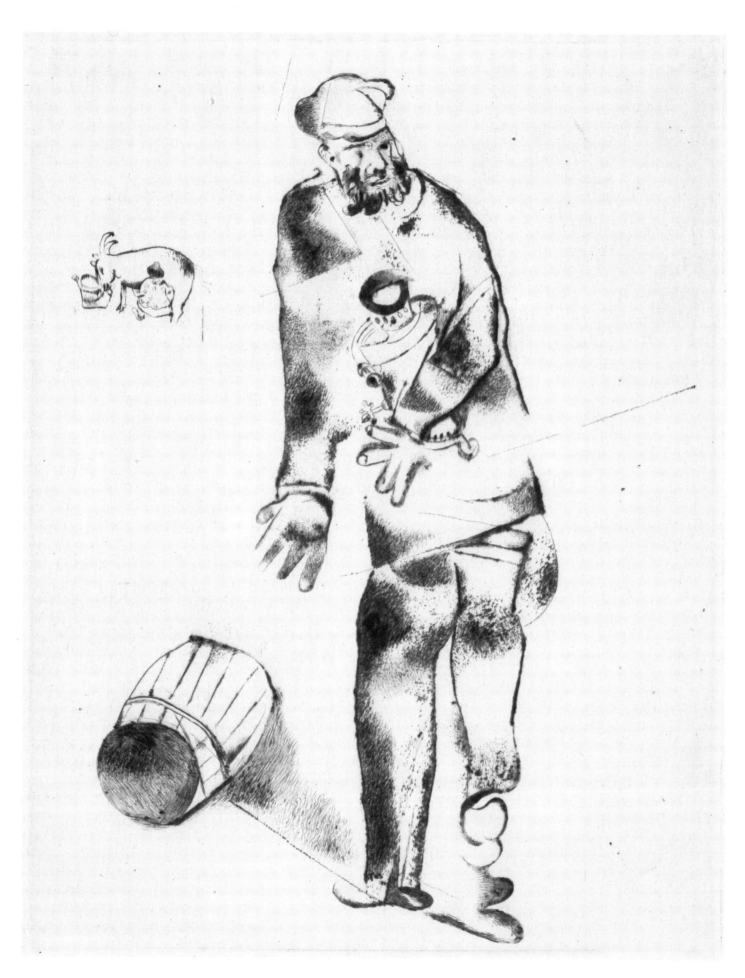

1 **Father,** Mein Leben, sheet 1. *Cat. 2*

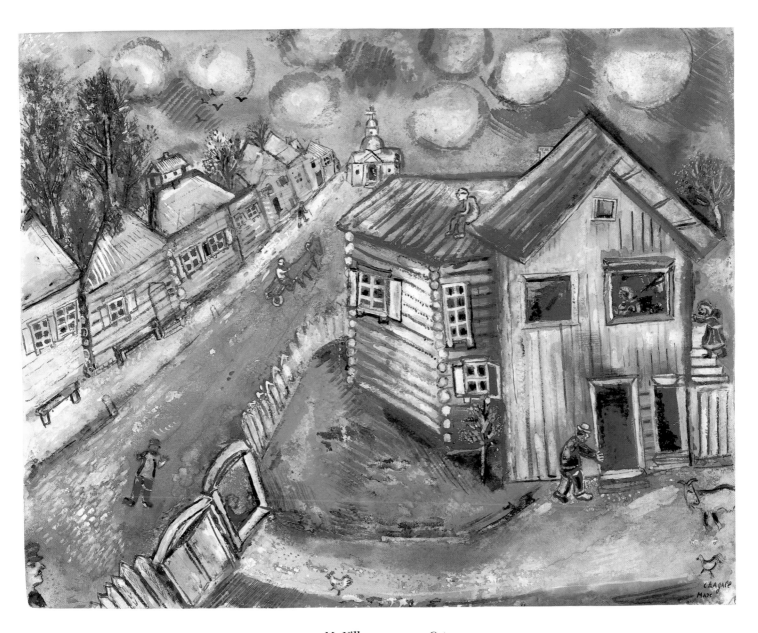

2 **My Village,** 1923-24. *Cat. 3*

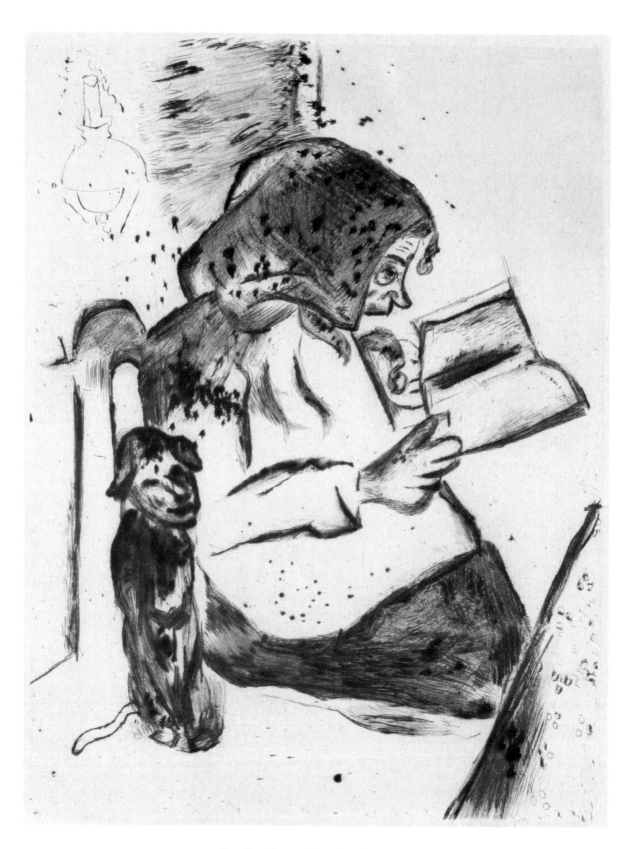

3 **Grandmother,** Mein Leben, sheet 4. *Cat. 4*

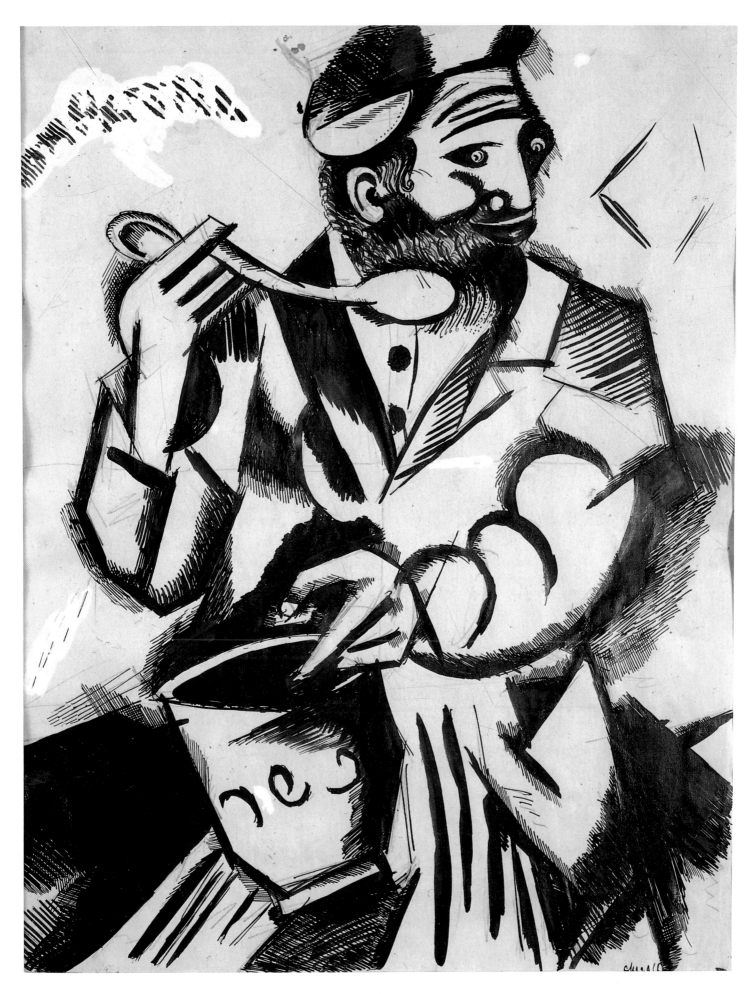

4　Peasant Eating, *c.* 1913. *Cat.* 5

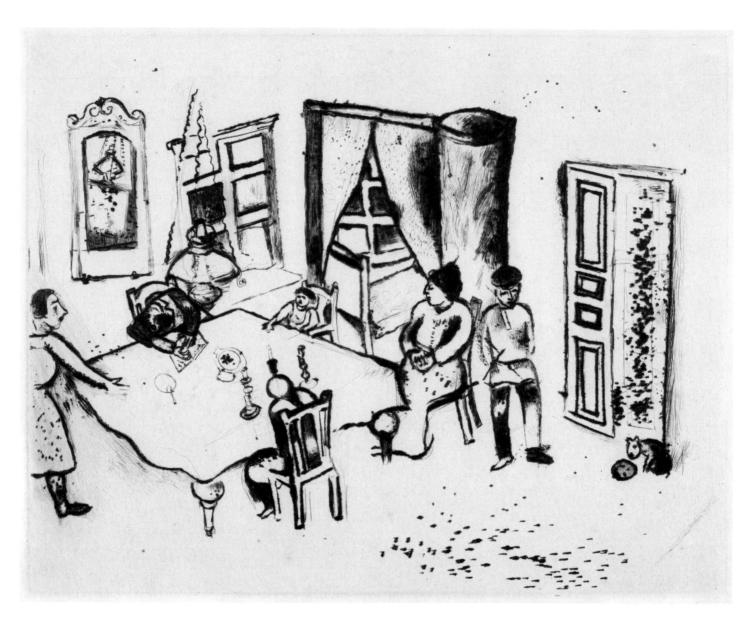

5 **Dining-Room,** Mein Leben, sheet 10. *Cat. 6*

6 **In the Prison**, 1914-15. *Cat.* 7

7 **Mother and Son,** Mein Leben, sheet 2. *Cat. 8*

8 **Baby-Carriage Indoors,** sketch for mural, 1916-17. *Cat. 9*

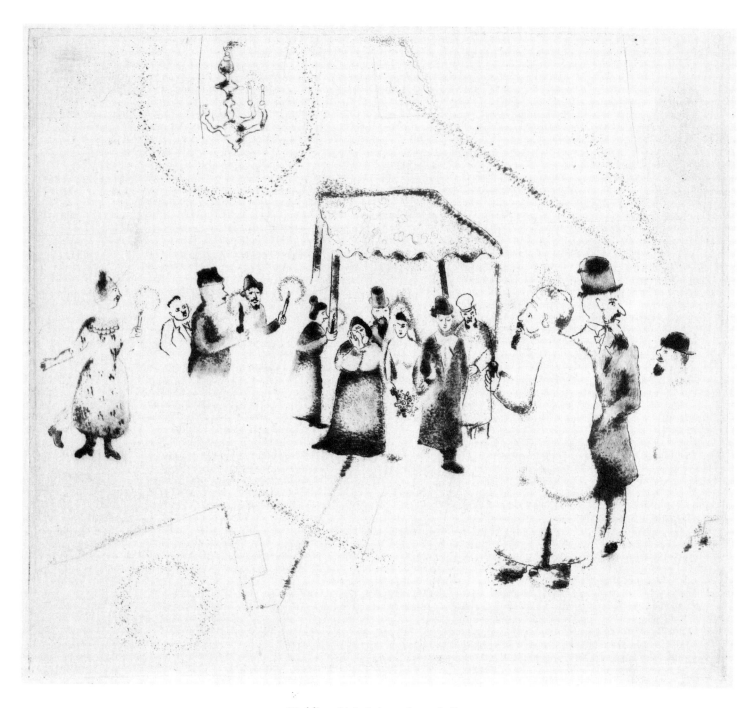

9 **Wedding,** Mein Leben, sheet 16. *Cat. 10*

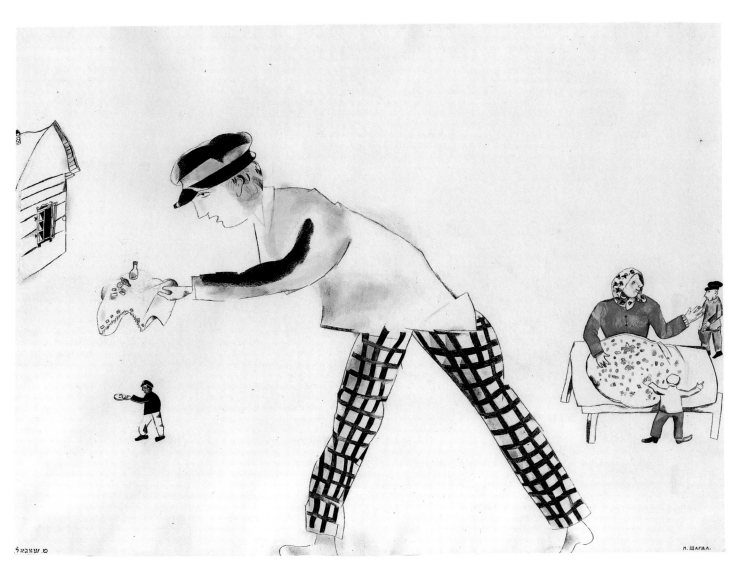

10 **Purim,** sketch for mural, 1916-17. *Cat. 11*

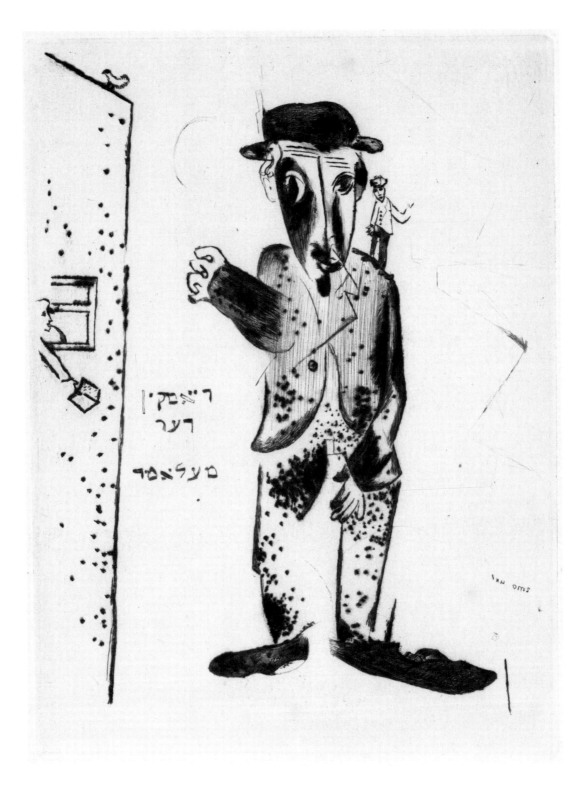

11 **The Talmud Teacher,** Mein Leben, sheet 9. *Cat. 12*

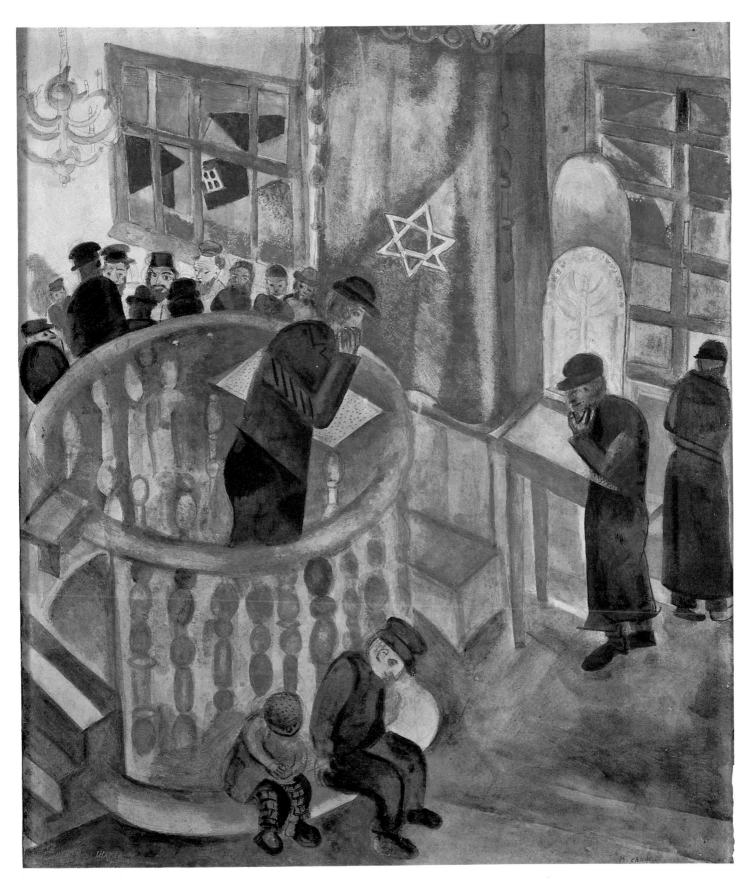

12 **The Synagogue,** 1917. *Cat.* 13

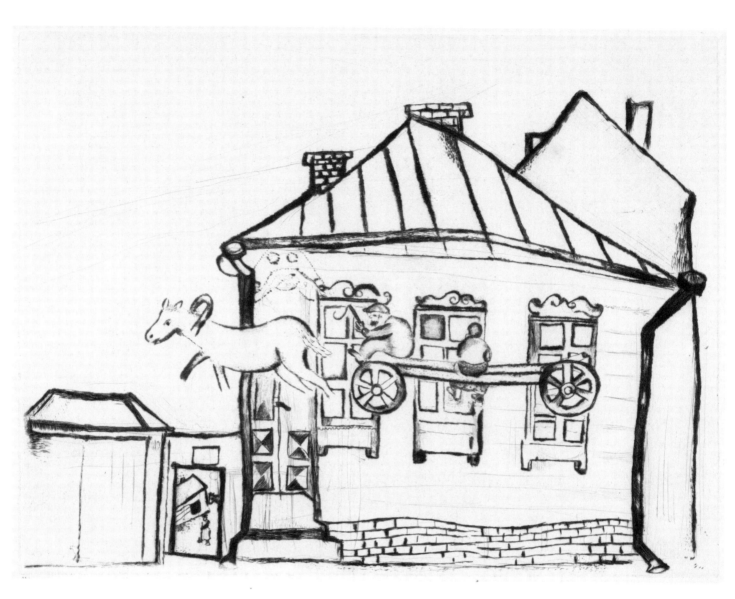

13 **House in Vitebsk,** Mein Leben, sheet 11. *Cat. 14*

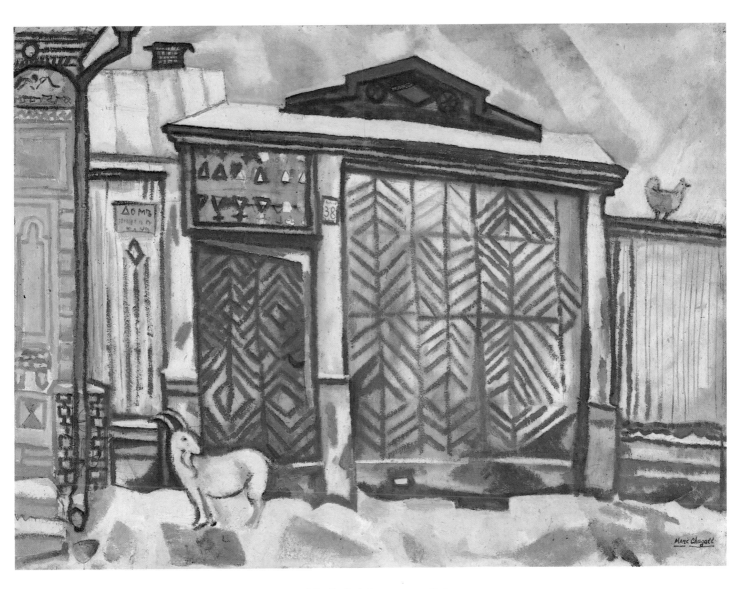

14 **The Red Gateway**, 1917. *Cat. 15*

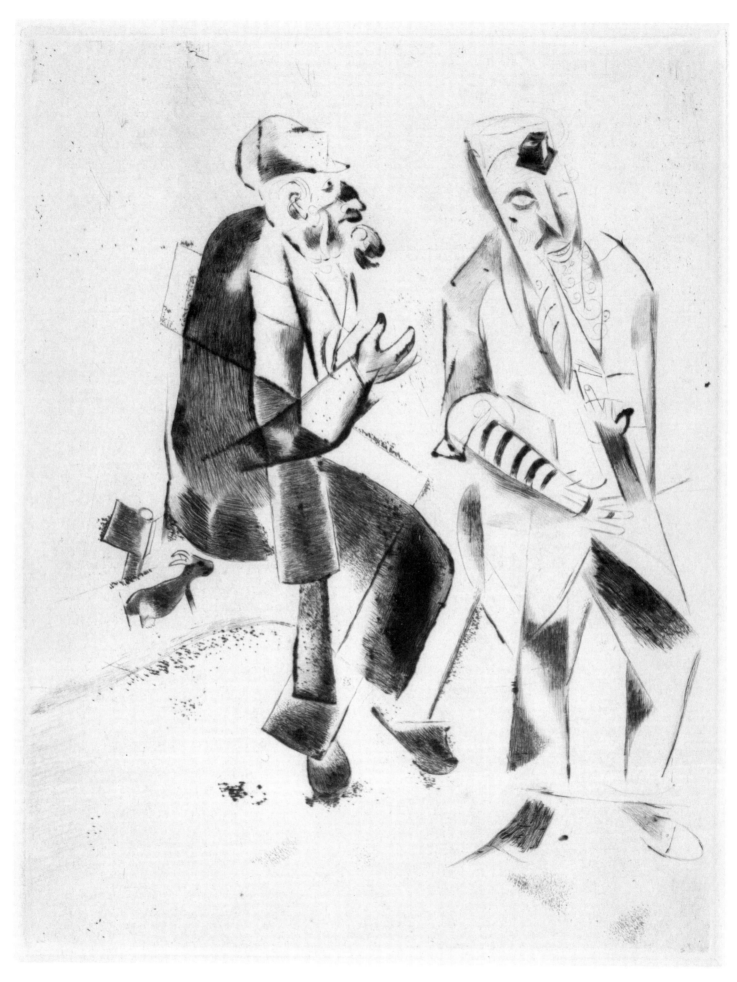

15 **The Grandfathers,** Mein Leben, sheet 3. *Cat. 16*

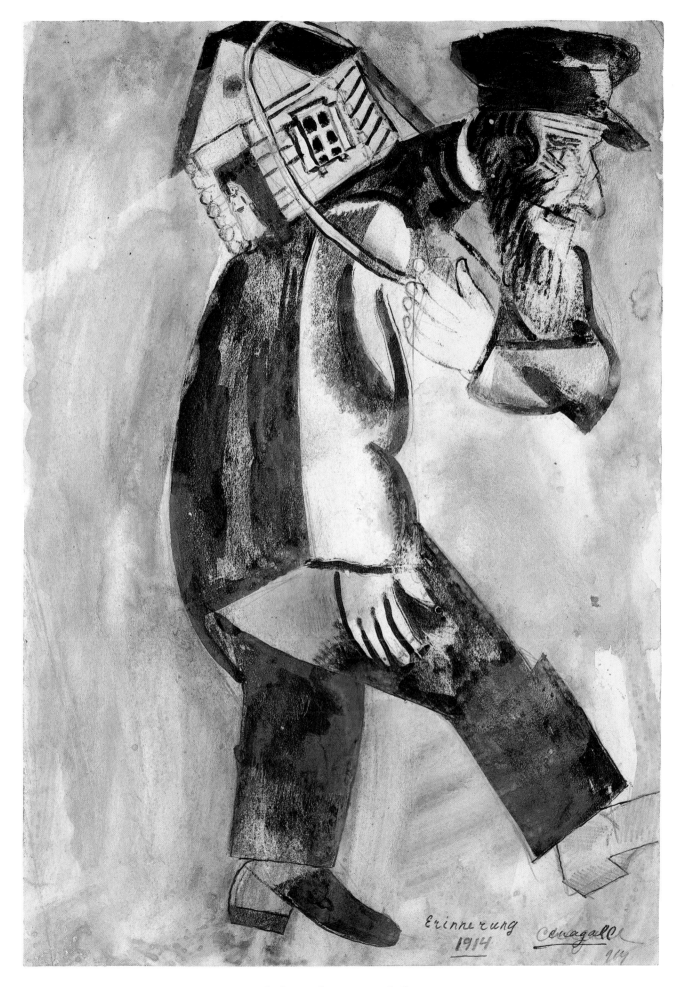

*Erinnerung
1914*

Chagall
1914

16 Remembrance, *c.* 1918. *Cat. 17*

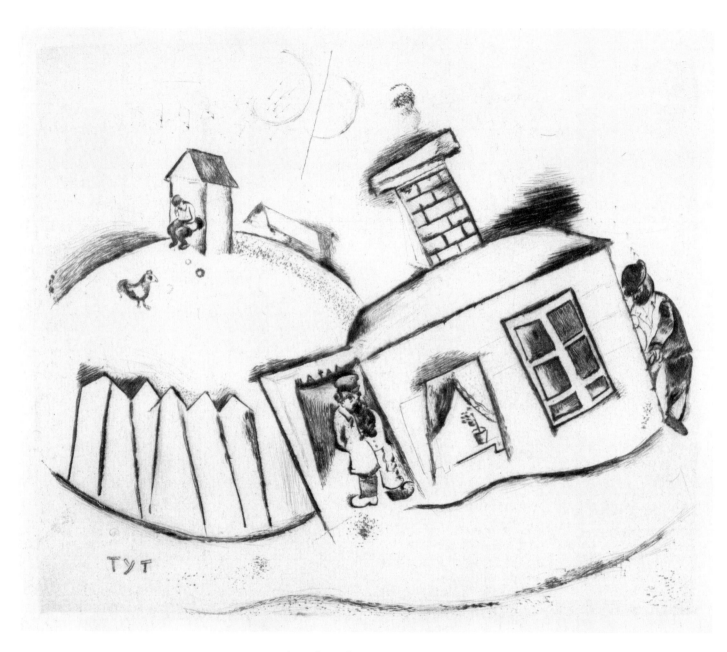

17 **House in Peskovatik,** Mein Leben, sheet 8. *Cat. 18*

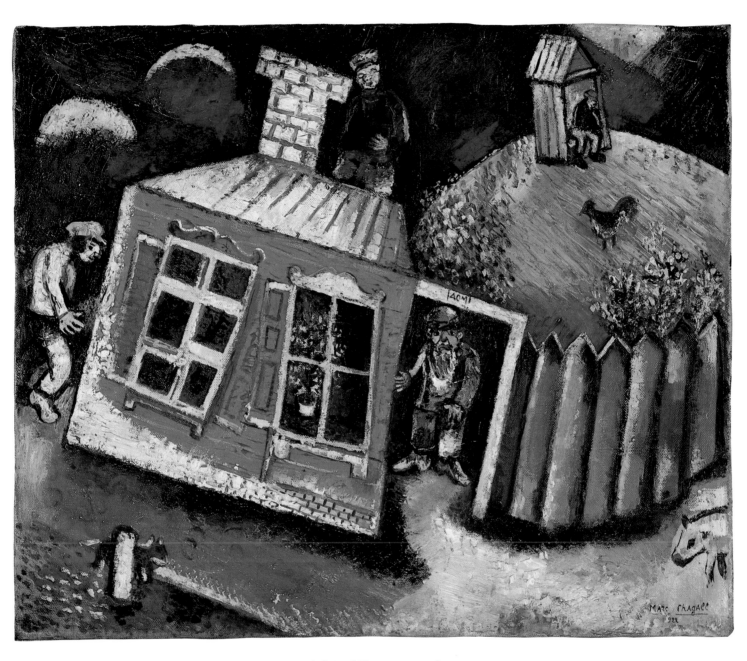

18 **Little Red Houses,** 1922. *Cat. 19*

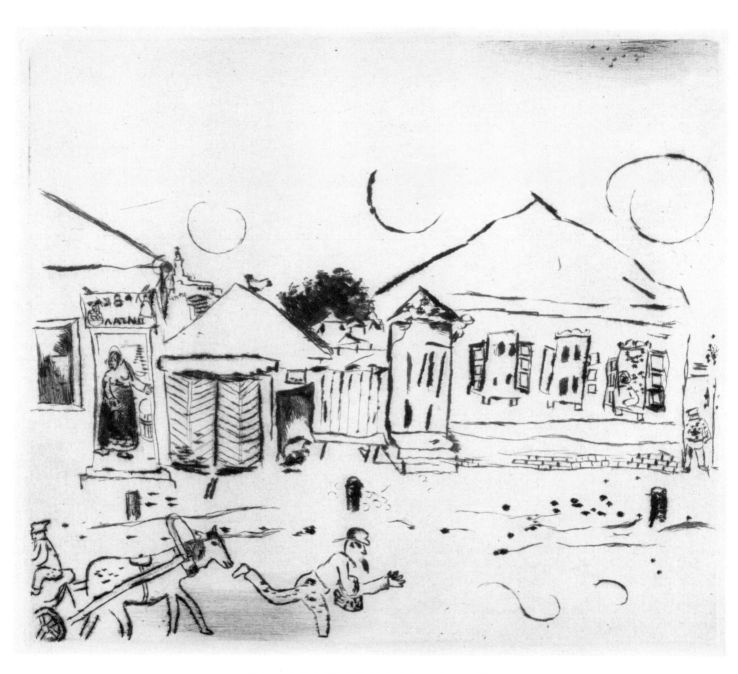

19 **Pokrovskaia in Vitebsk,** Mein Leben, sheet 5. *Cat. 20*

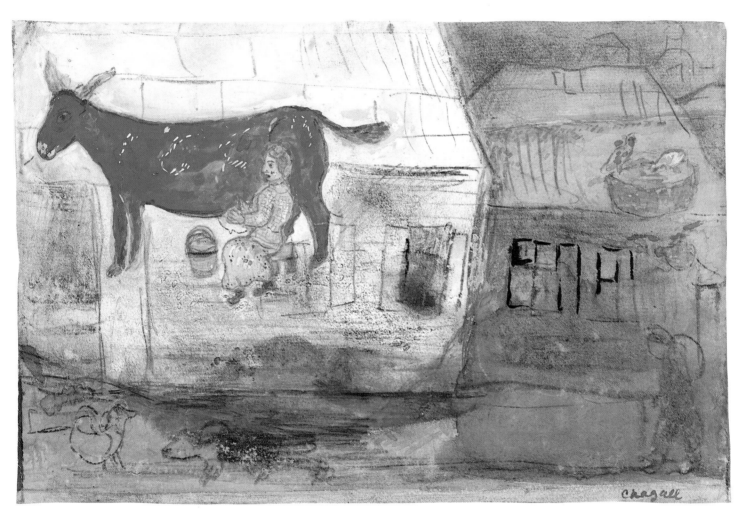

20　Blue Cow in front of White House, *c.* 1923-26. *Cat. 21*

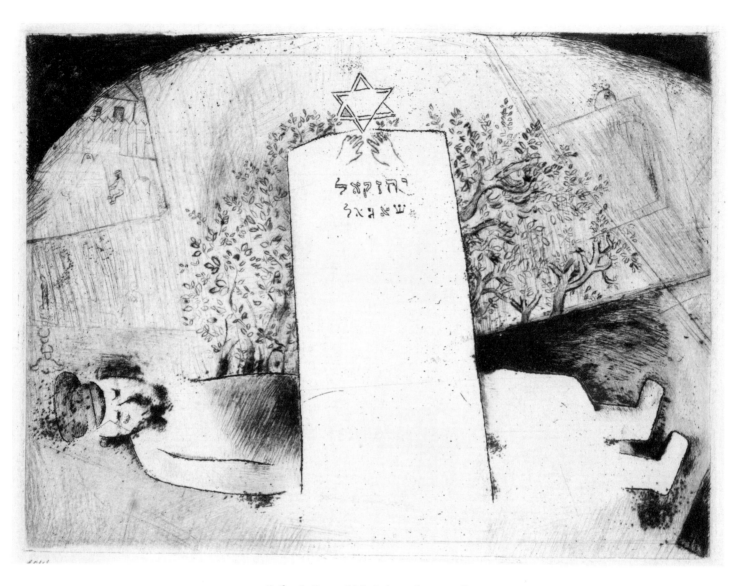

21　**Father's Grave,** Mein Leben, sheet 20. *Cat. 22*

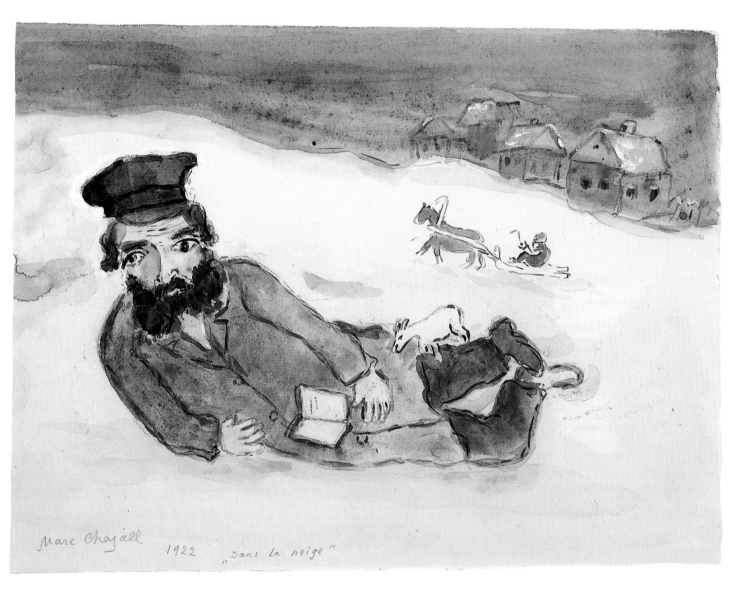

Marc Chagall 1922 „Dans la neige"

22 **In the Snow,** 1922/*c.* 1930. *Cat.* 23

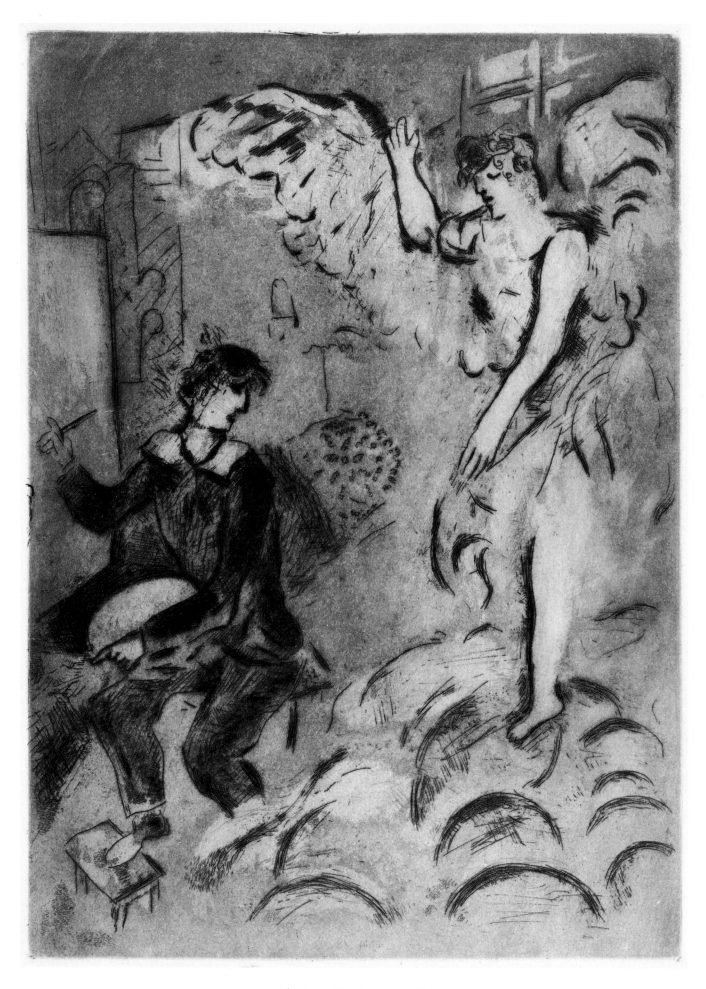

23 The Apparition I, 1924-25. *Cat. 27*

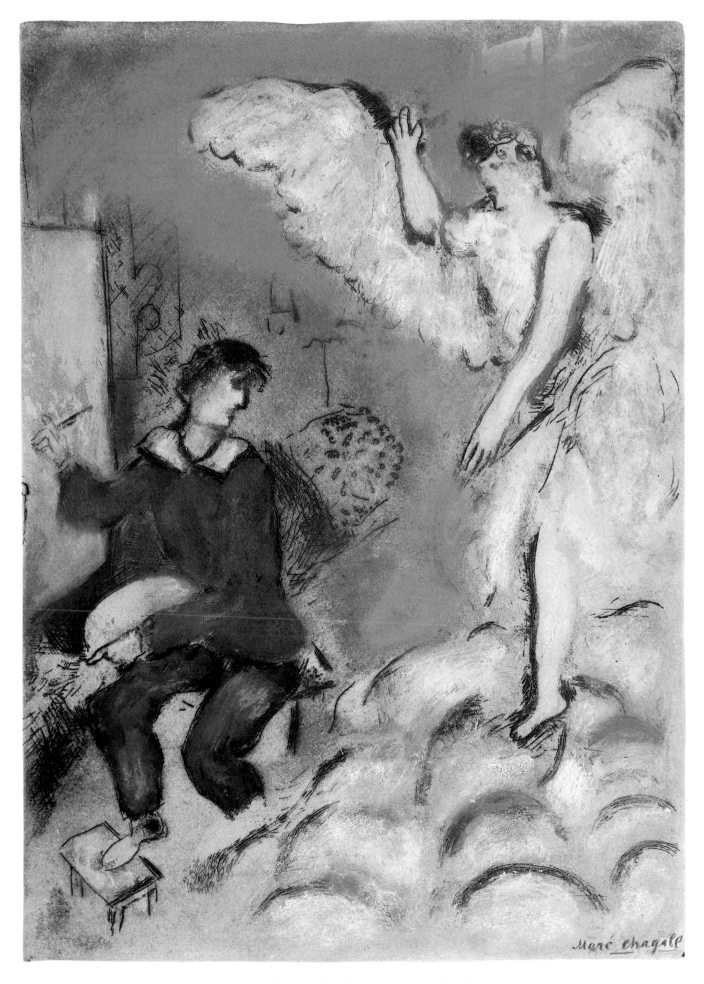

24 **The Apparition I,** 1924-25/ *c. 1937. Cat. 28*

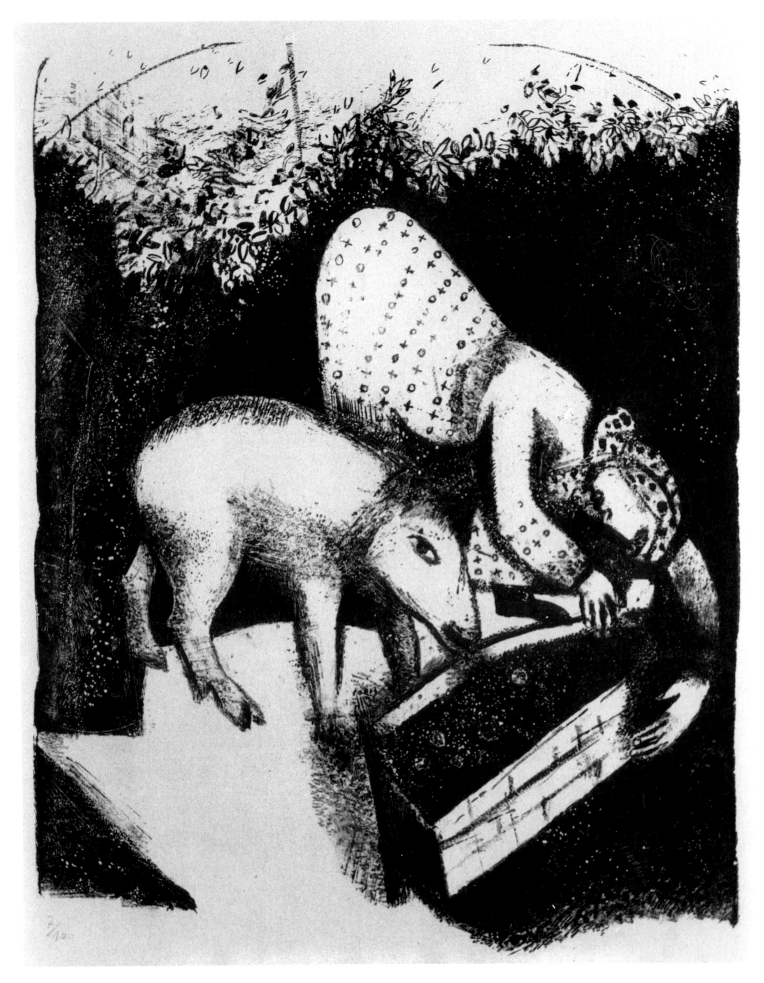

25 **The Trough,** 1924. *Cat. 29*

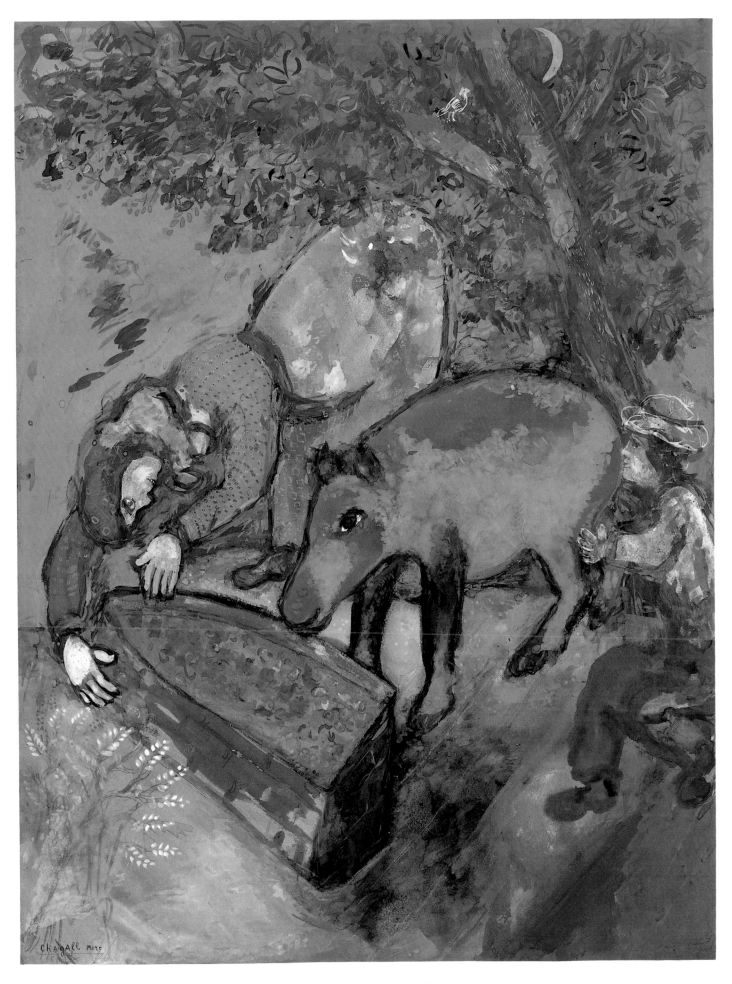

26　**Drinking Pig**, *c. 1925. Cat. 30*

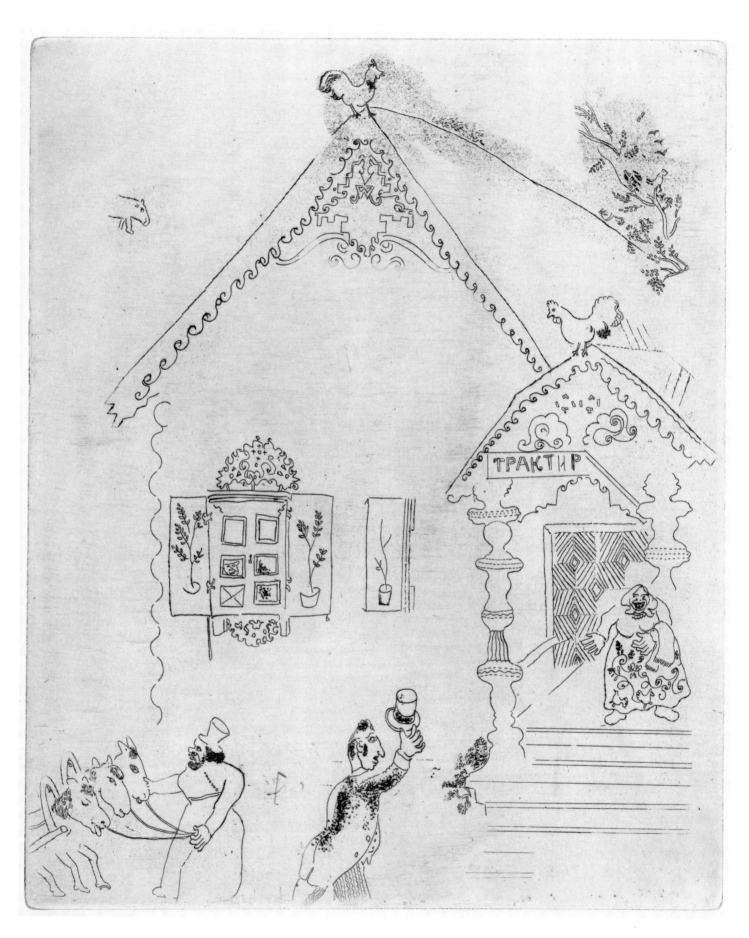

27 **Entrance to the Inn,** Gogol, sheet 20. *Cat.* 31

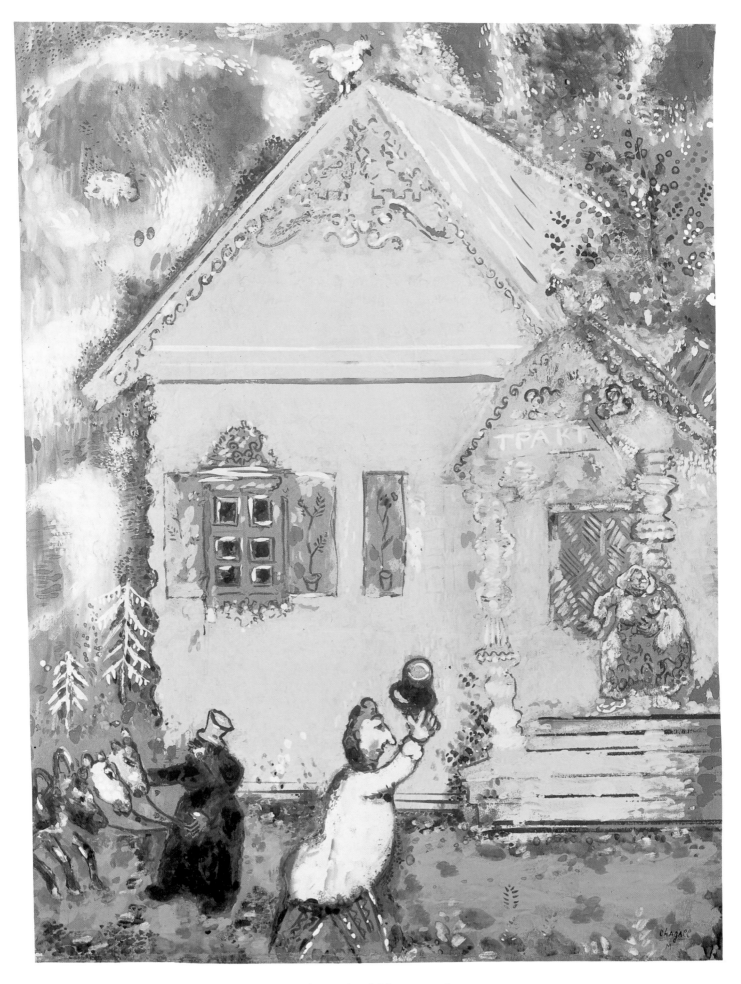

28 **The Inn (Traktir)**, 1923-24. *Cat. 32*

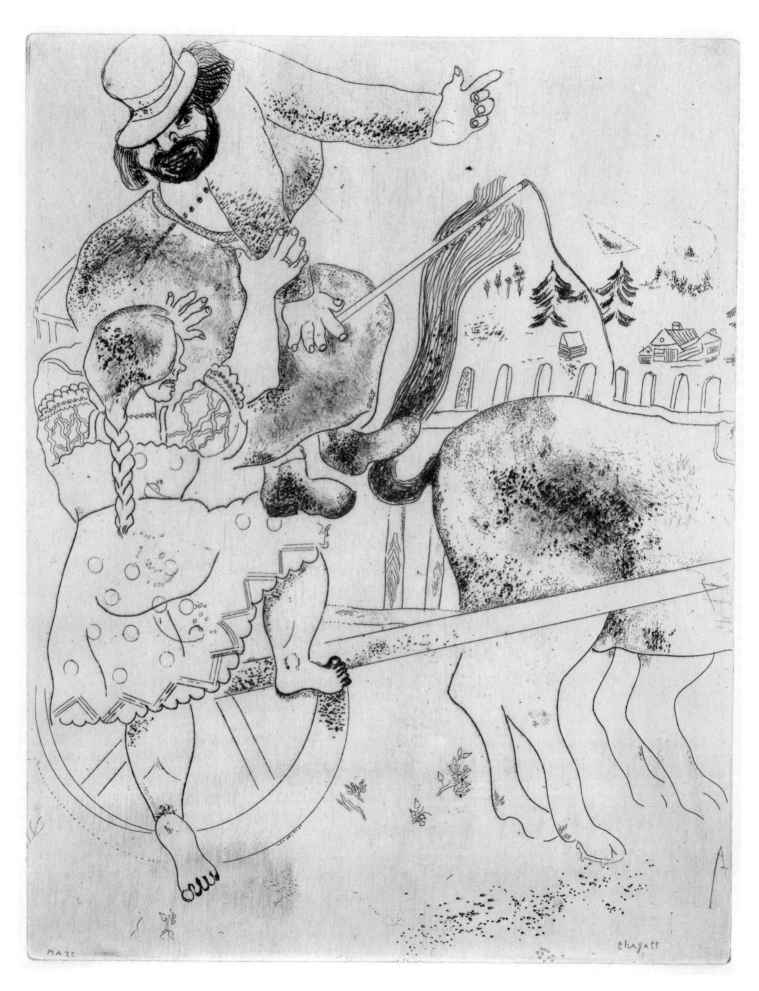

29 **Asking the Way,** Gogol, sheet 19. *Cat. 33*

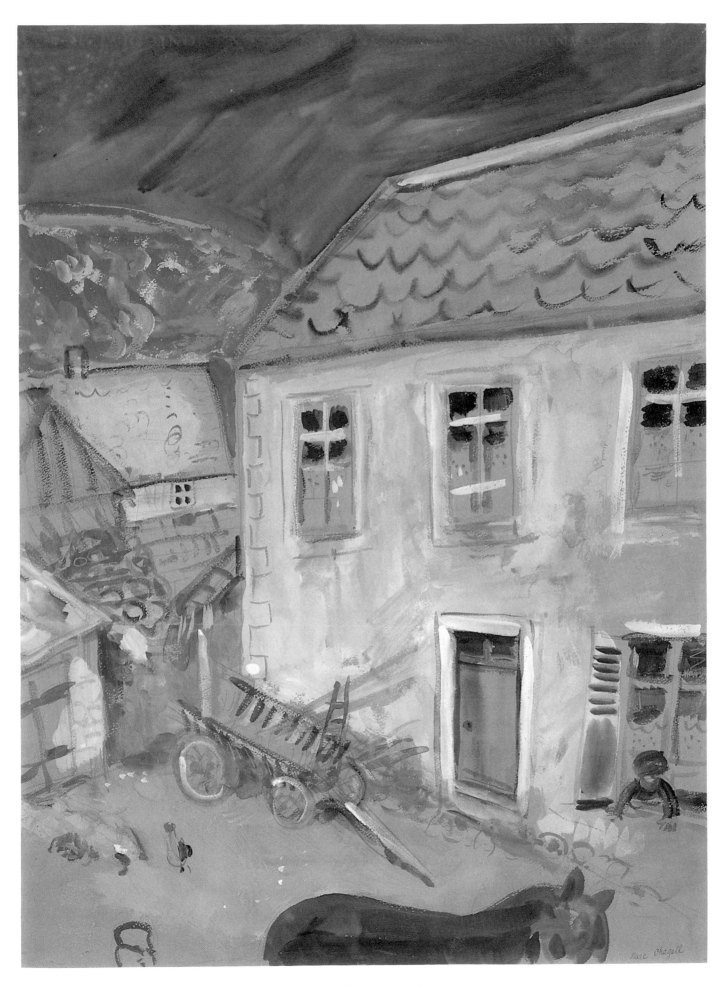

30 Montchauvet, 1925. *Cat.* 34

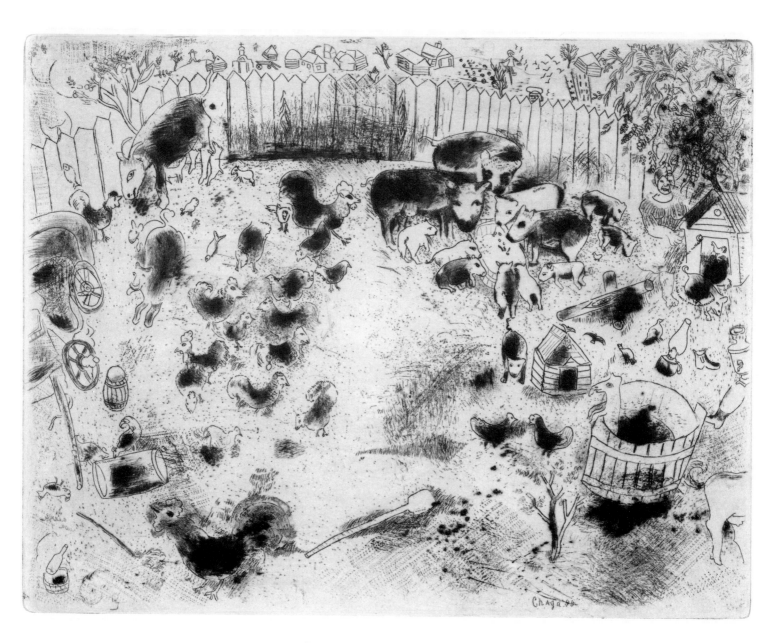

31 **The Barn Yard,** Gogol, sheet 17. *Cat.* 35

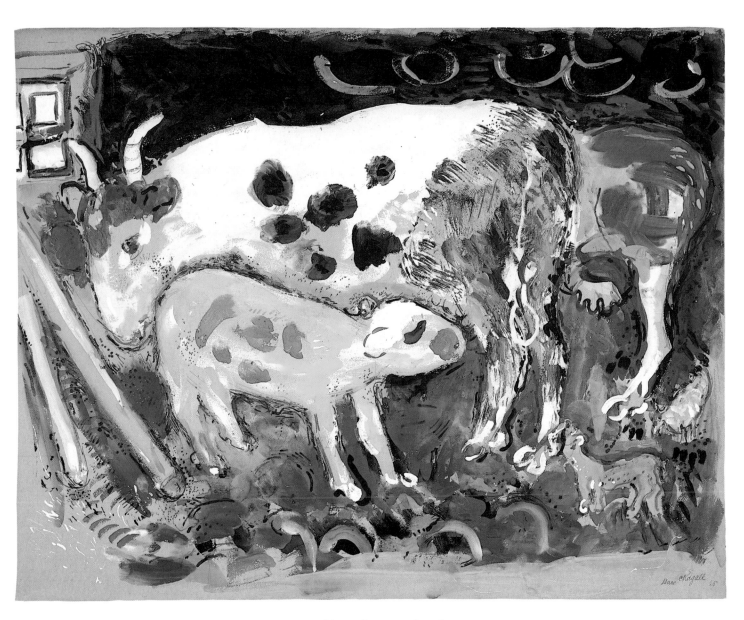

32 **Maternity**, 1925. *Cat. 36*

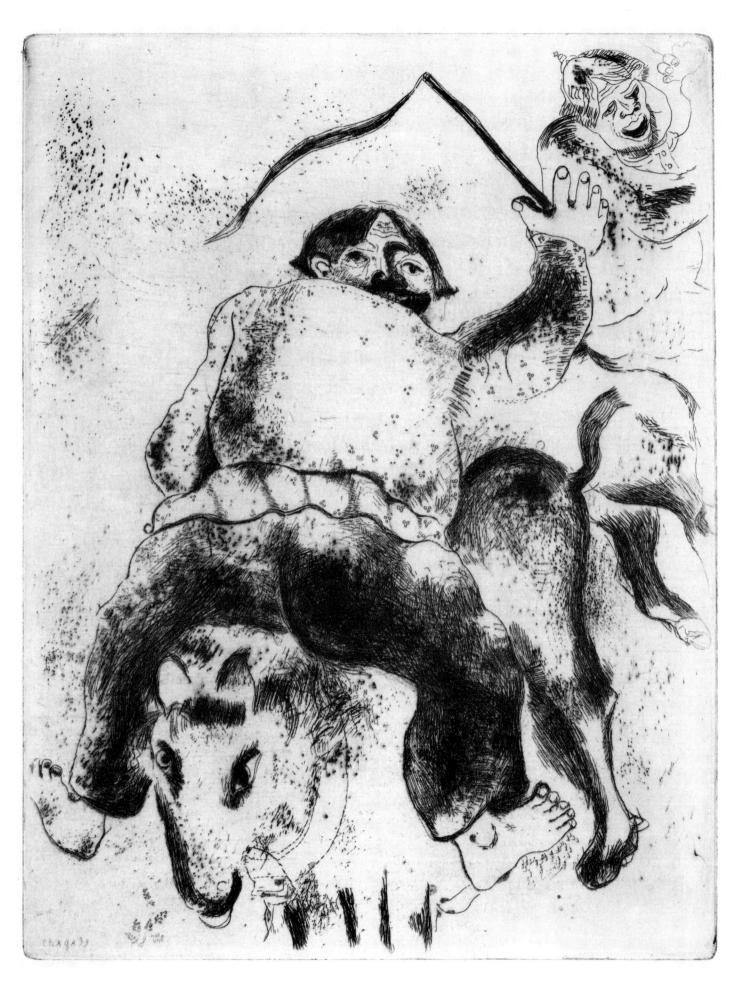

33 **Uncle Mitiai and Uncle Miniai**, Gogol, sheet 29. *Cat. 37*

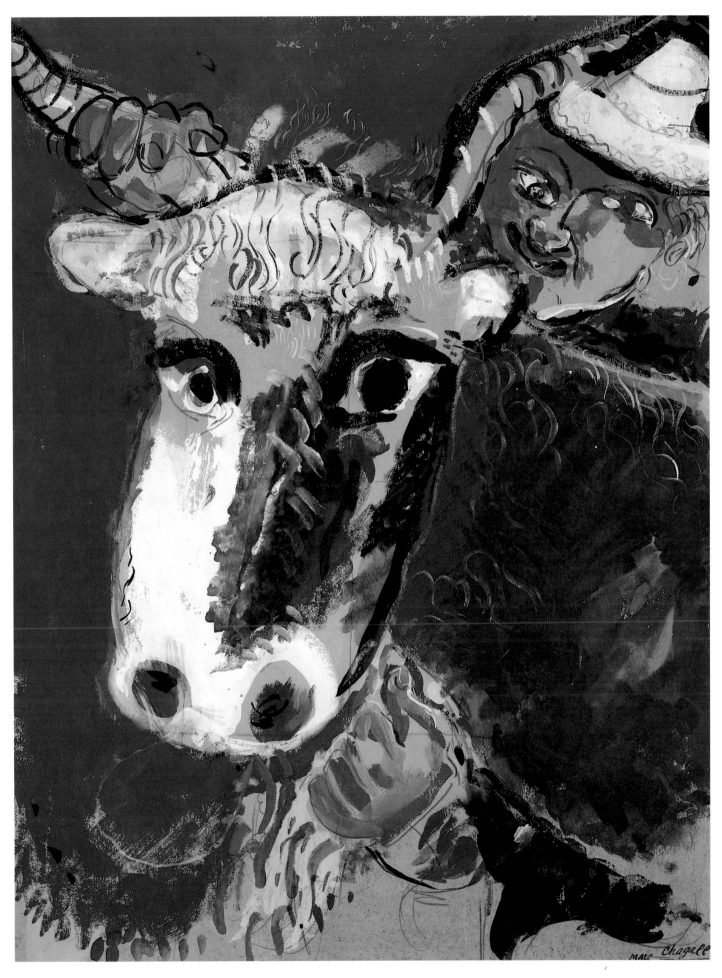

34 **The Cow**, 1926. *Cat. 38*

35 **They meet a Peasant,** Gogol, sheet 37/4. *Cat. 39*

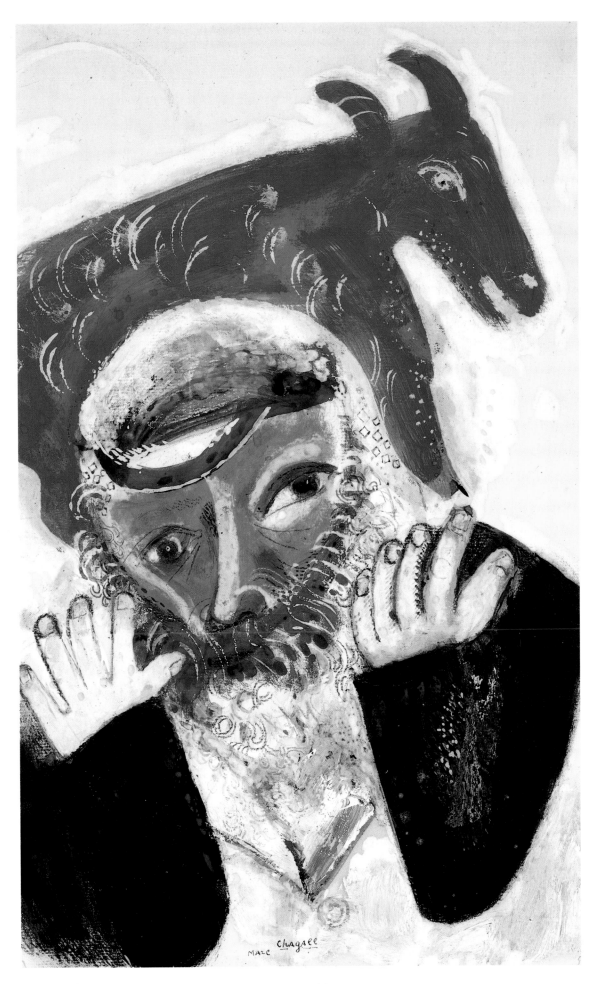

36　**The Goat on the Shoulders**, 1926-27. *Cat. 40*

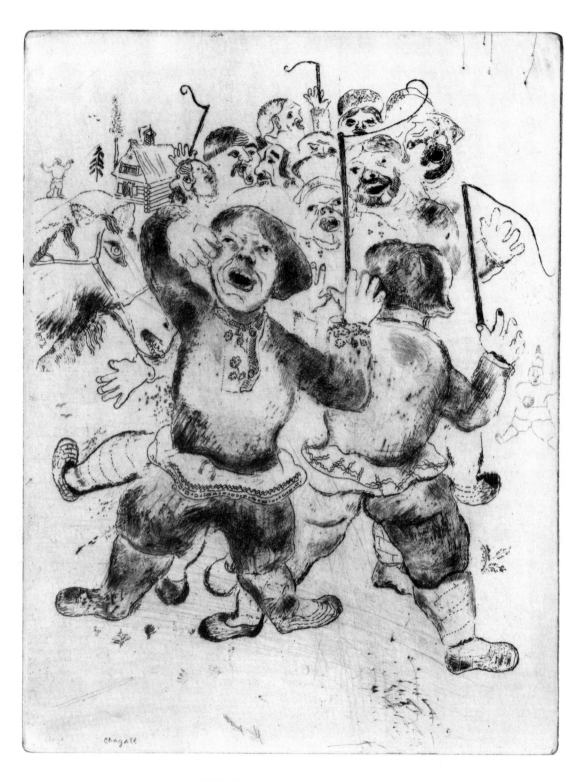

37 **A Mob of Peasants,** Gogol, sheet 28. *Cat. 41*

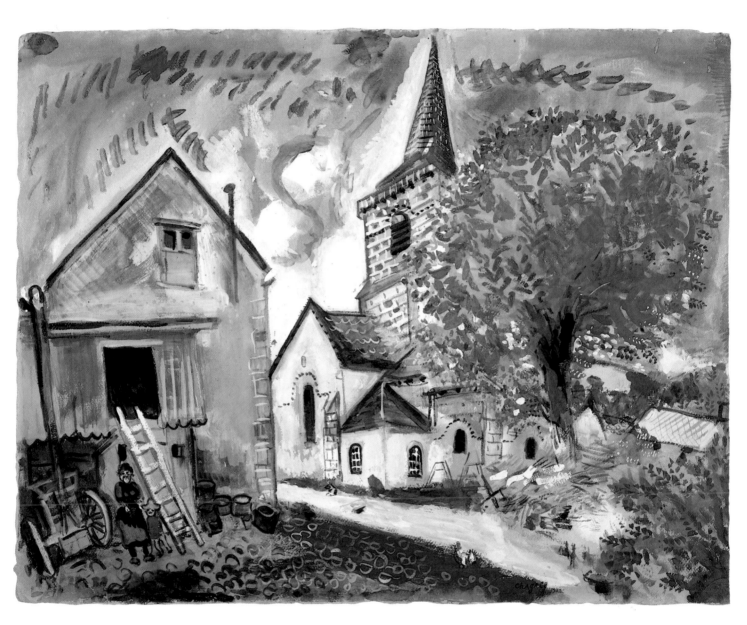

38 **French Village,** *c. 1926. Cat. 42*

39 **Prochka,** Gogol, sheet 43. *Cat. 43*

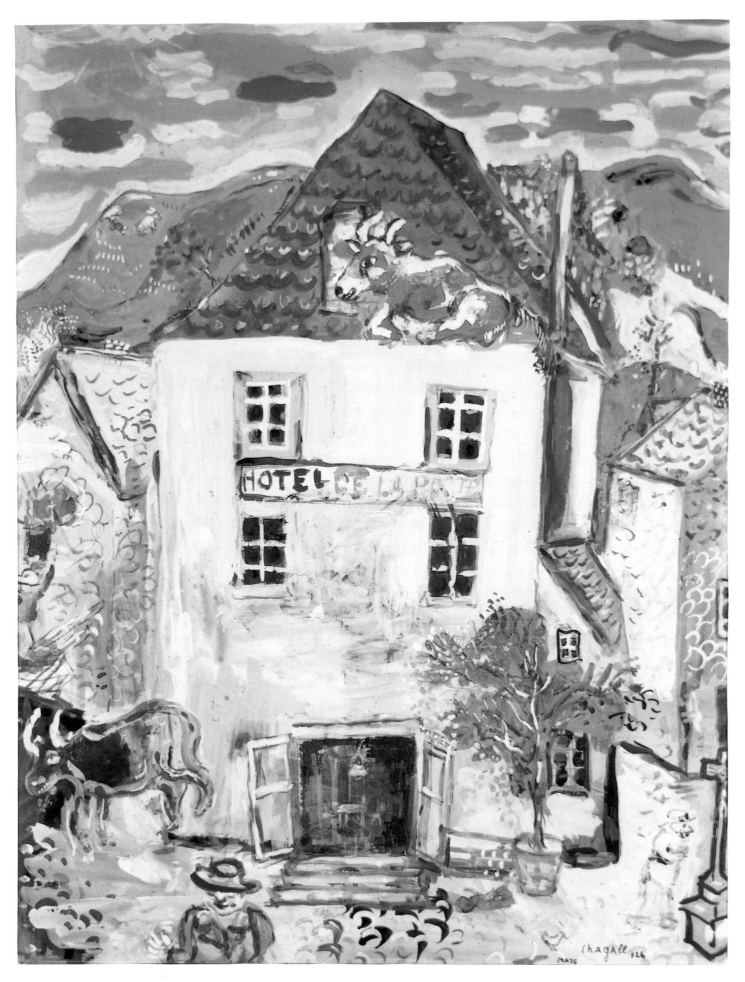

40 Hôtel de la Poste, 1926. *Cat. 44*

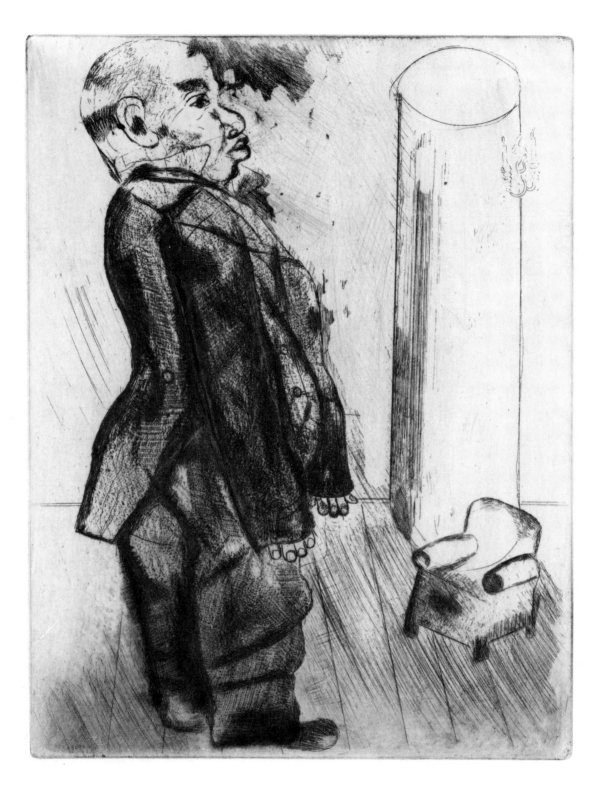

41 Sobakevich near an Armchair, Gogol, sheet 37/2. *Cat. 45*

42 **Church,** 1926. *Cat. 46*

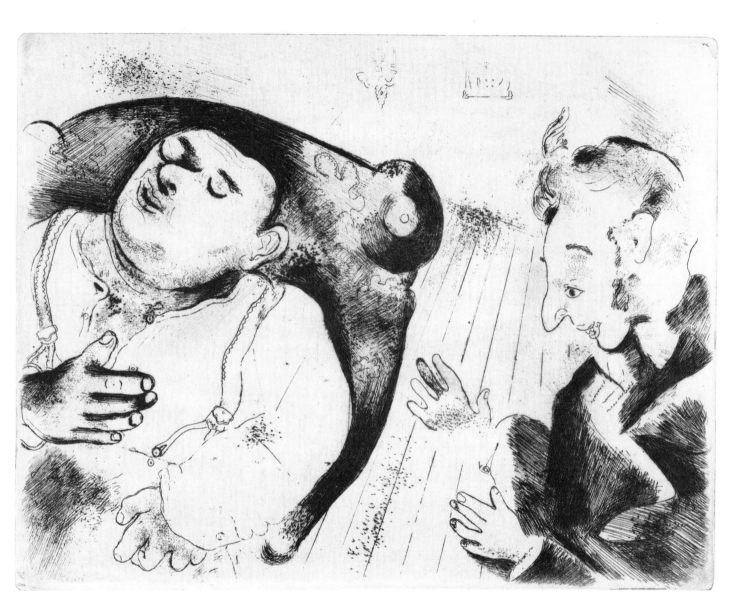

43 **Chichikov and Sobakevich discussing Business,** Gogol, sheet 37. *Cat. 47*

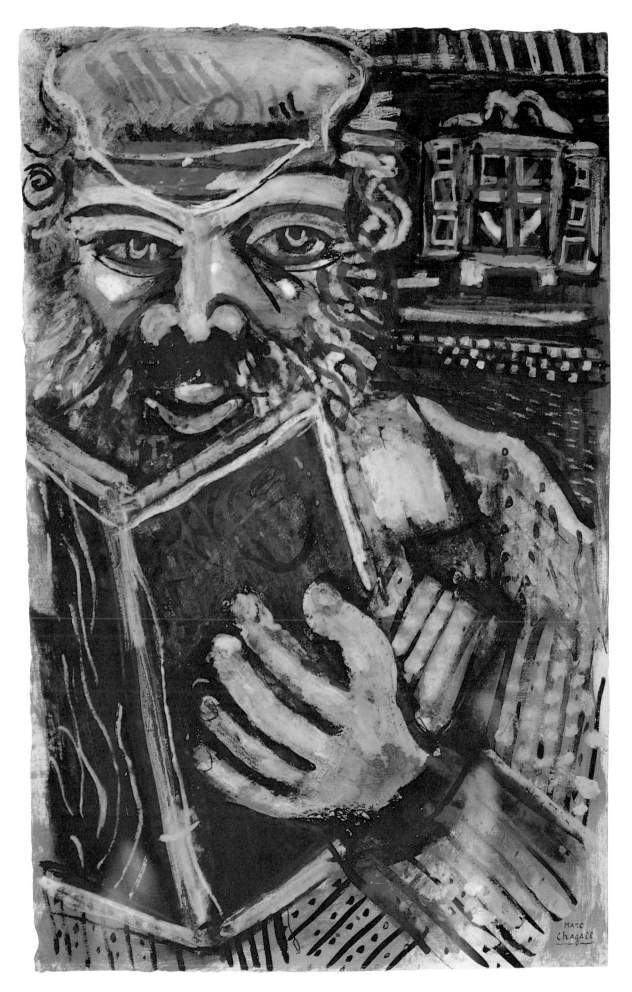

44 The Reader, 1925. *Cat. 48*

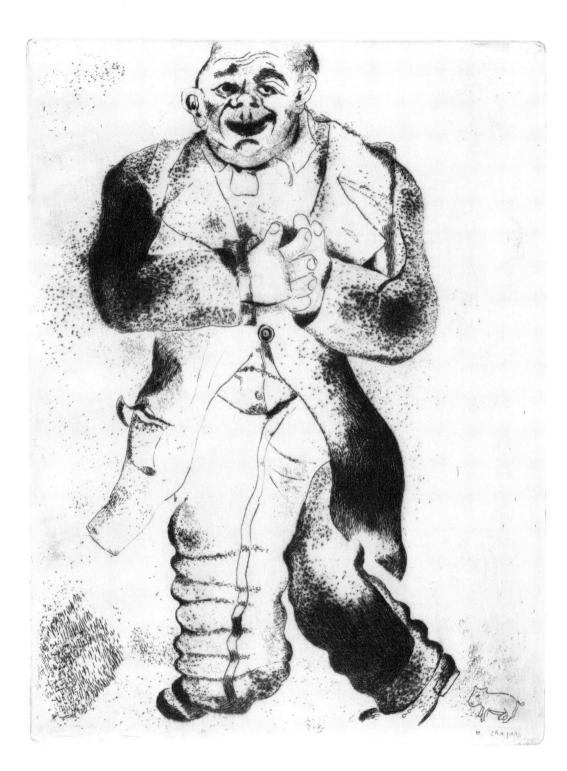

45 **Sobakevich,** Gogol, sheet 32. *Cat. 49*

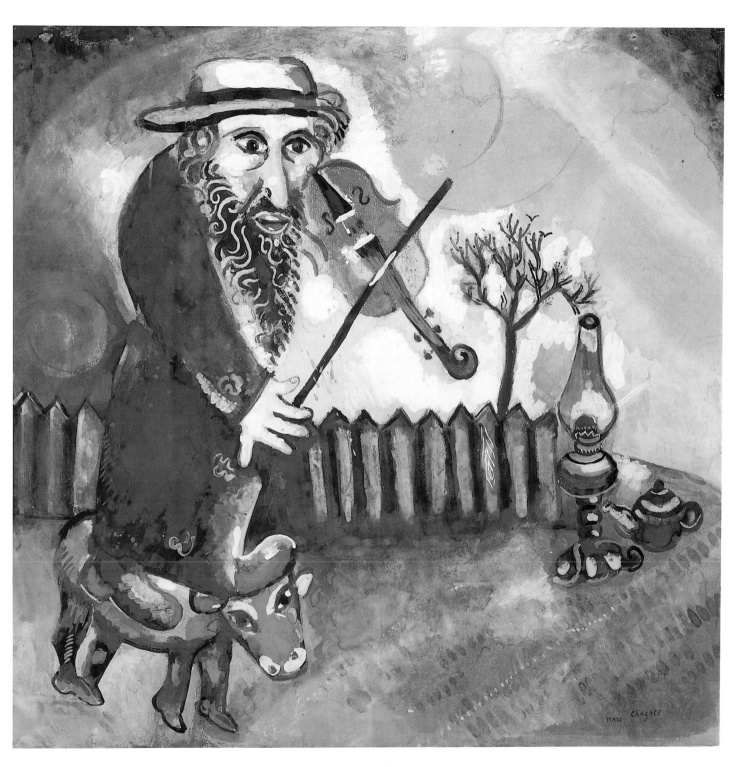

46 The Violonist, 1926. *Cat. 50*

47 **Sobakevich's House,** Gogol, sheet 31. *Cat. 51*

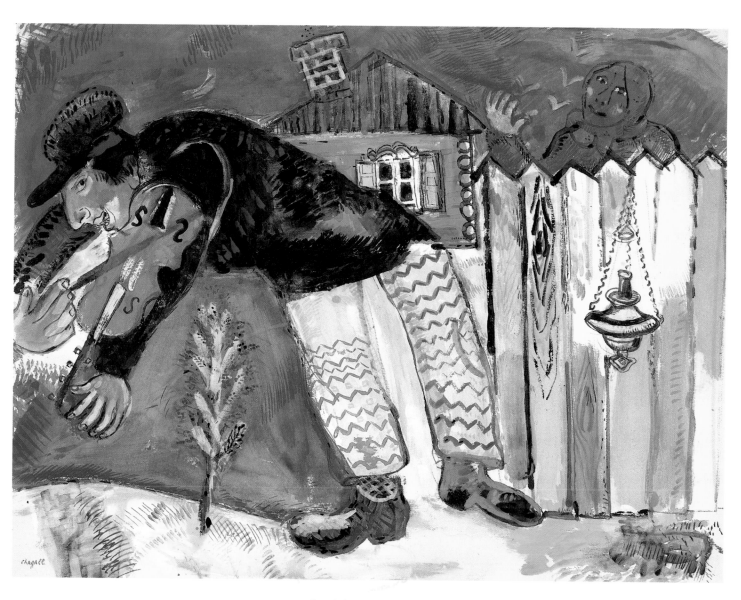

48 The Violonist, 1926-27. *Cat. 52*

49 **Pliushkin's old Garden,** Gogol, sheet 39. *Cat.* 53

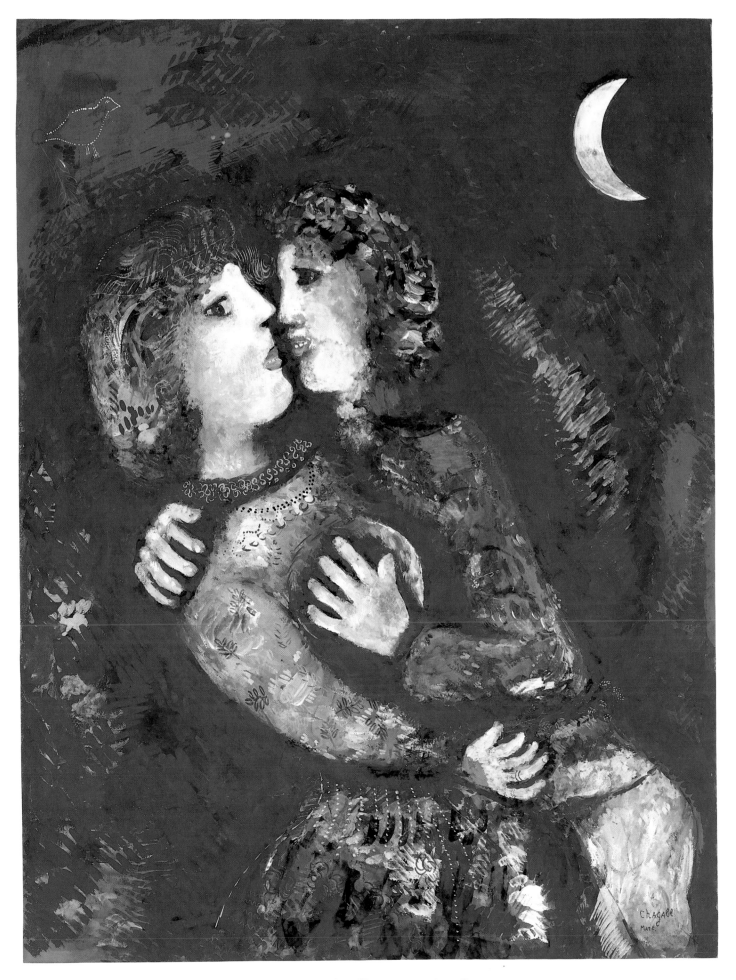

50 **Lovers with Half-Moon,** *c. 1926-27. Cat. 54*

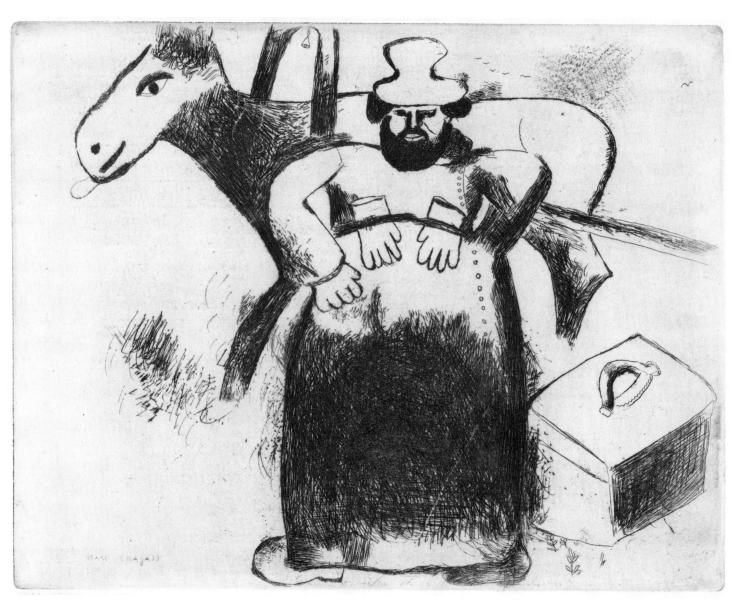

51 **Selifan the Coachman,** Gogol, sheet 6. *Cat. 55*

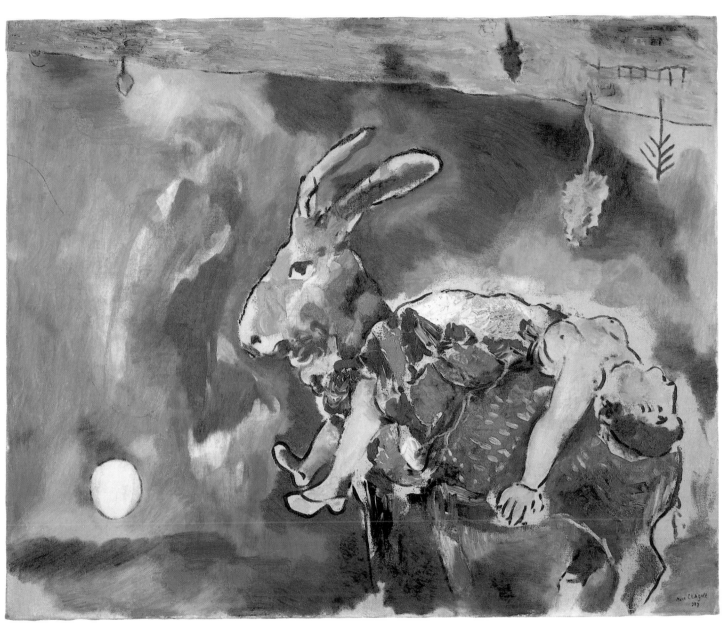

52 **The Dream,** 1927. *Cat. 56*

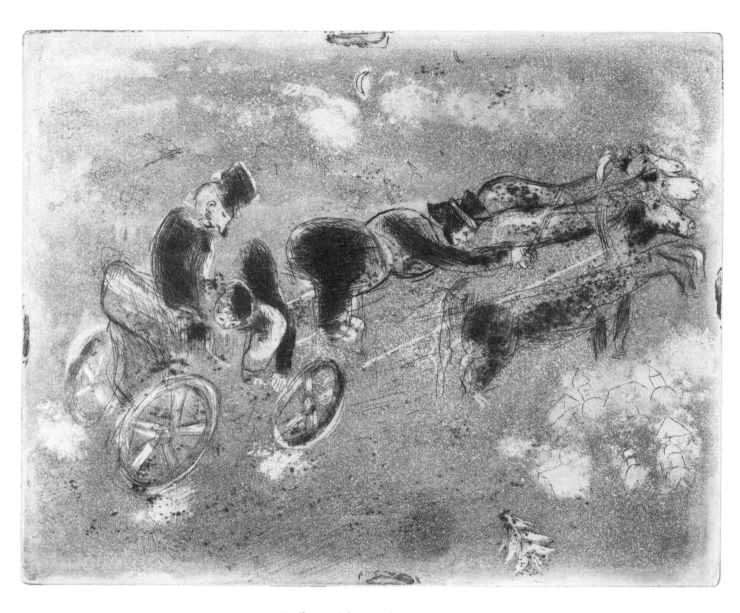

53 **Troika at Night,** Gogol, sheet 85. *Cat. 57*

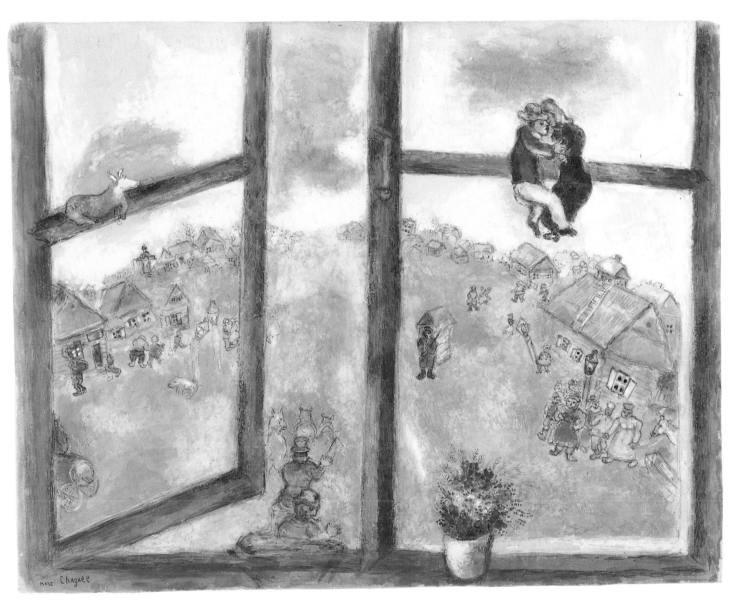

54 **Celebration in the Village,** 1929. *Cat. 58*

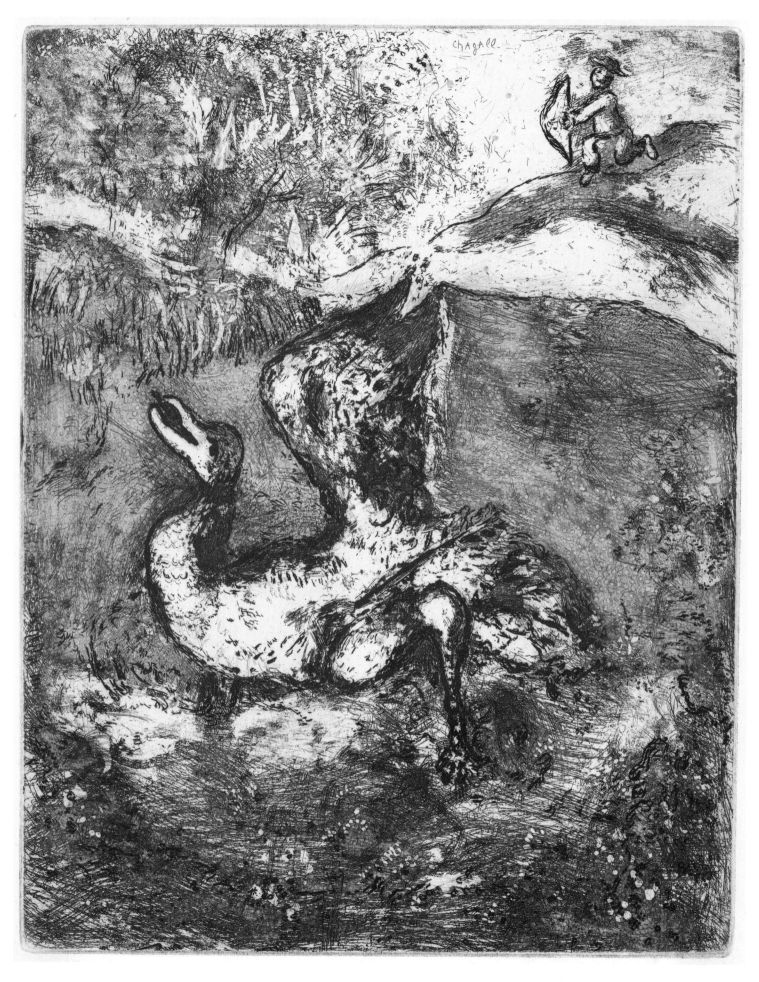

55 **The Bird wounded by an Arrow,** La Fontaine, sheet 15. *Cat. 60*

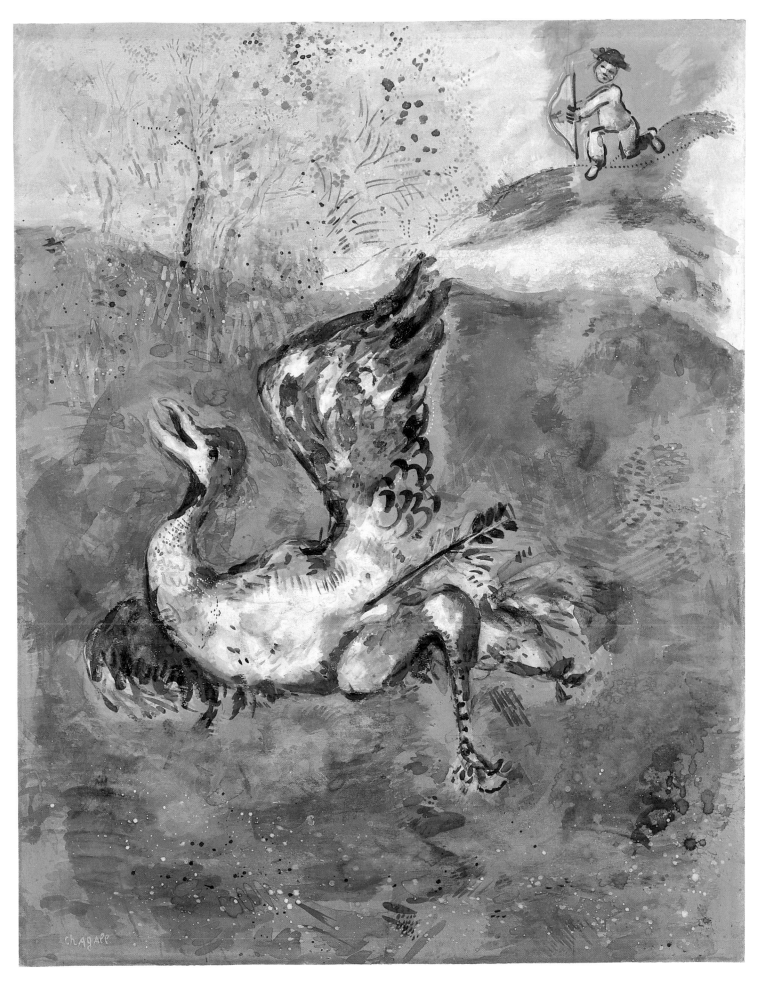

56 **The Bird wounded by an Arrow**, *c. 1927. Cat. 61*

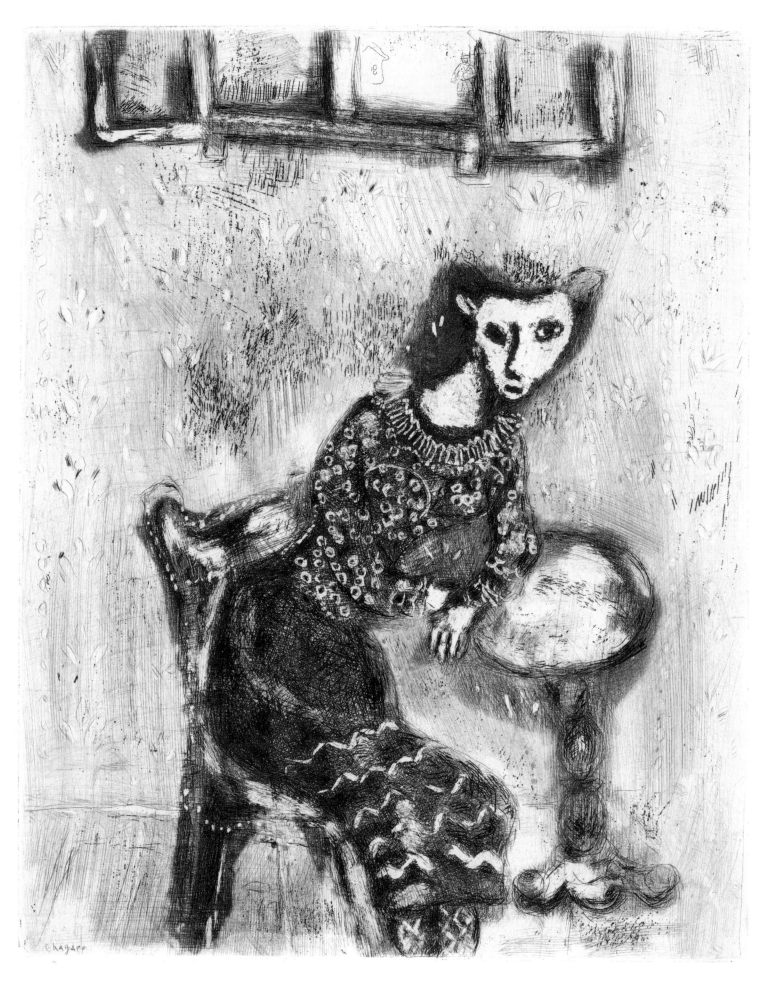

57 **The Cat transformed into a Woman**, La Fontaine, sheet 25. *Cat. 62*

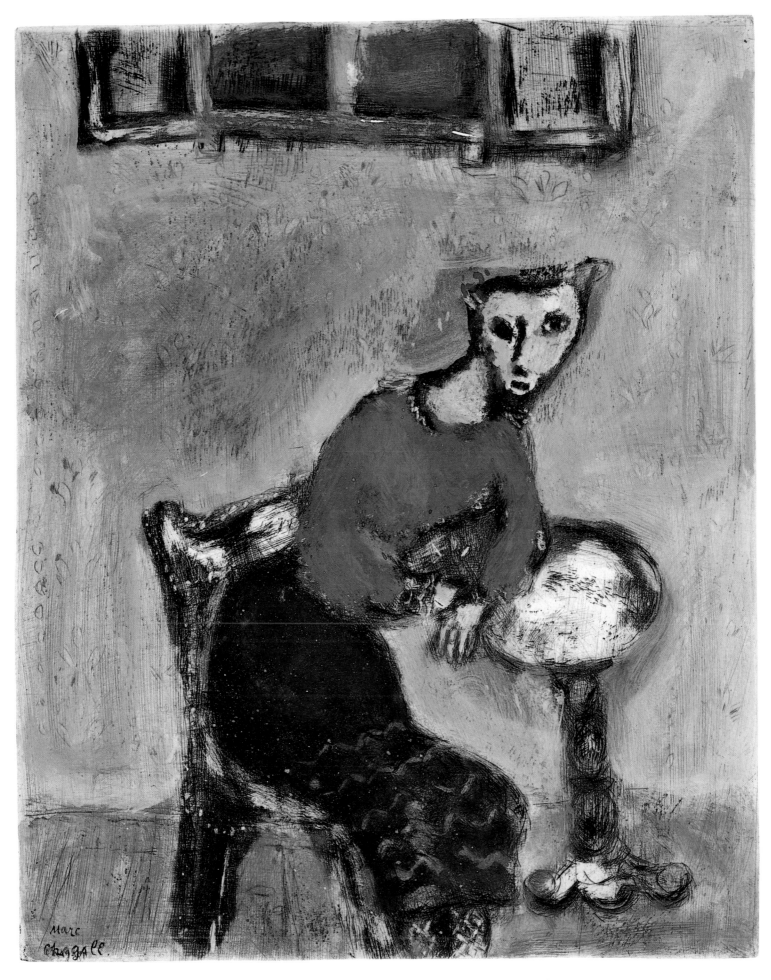

58 The Cat transformed into a Woman, *c.* 1928-31/1937. *Cat. 63*

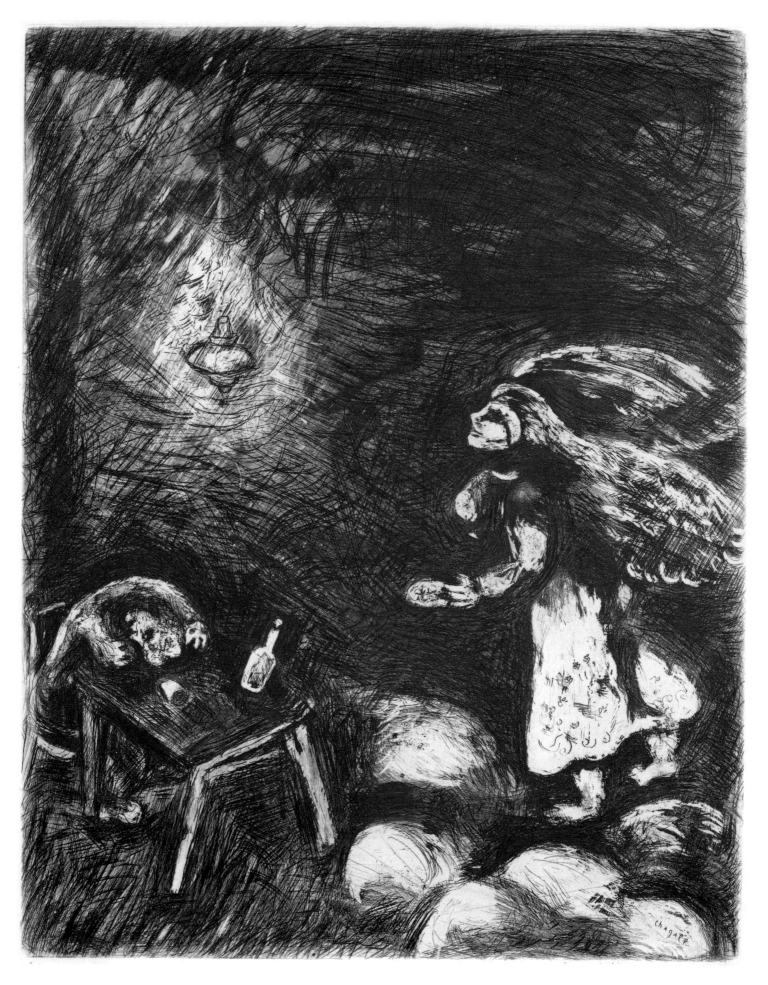

59　**The Drunkard and his Wife,** La Fontaine, sheet 33. *Cat. 64*

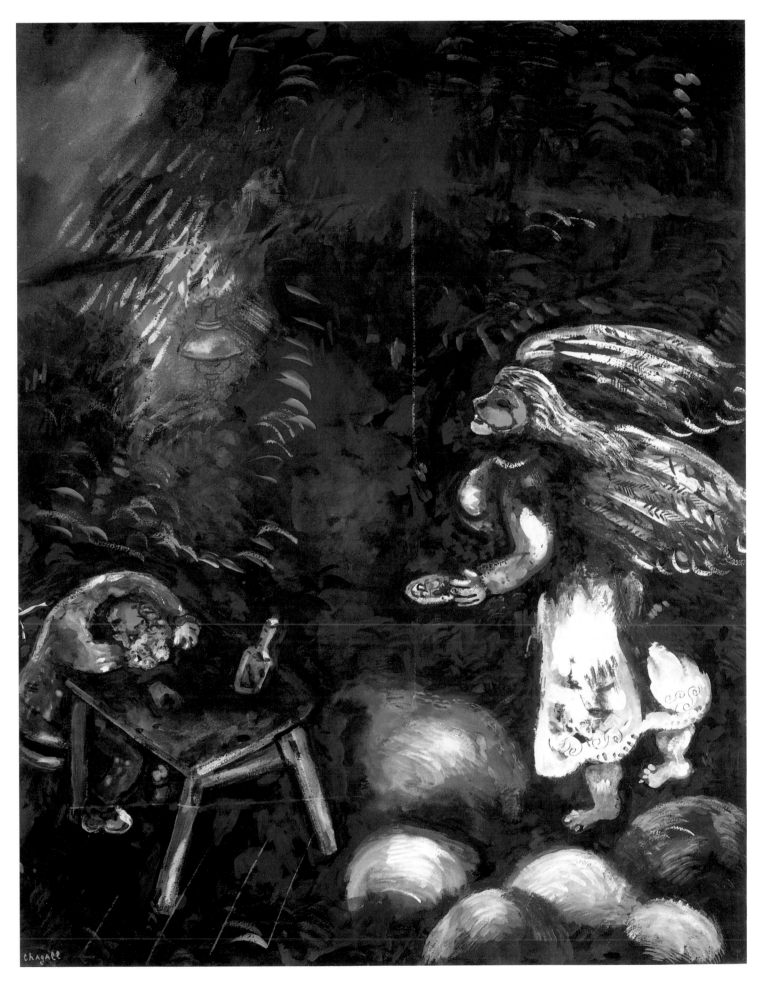

60 **The Drunkard and his Wife,** *c.* 1926-27. *Cat.* 65

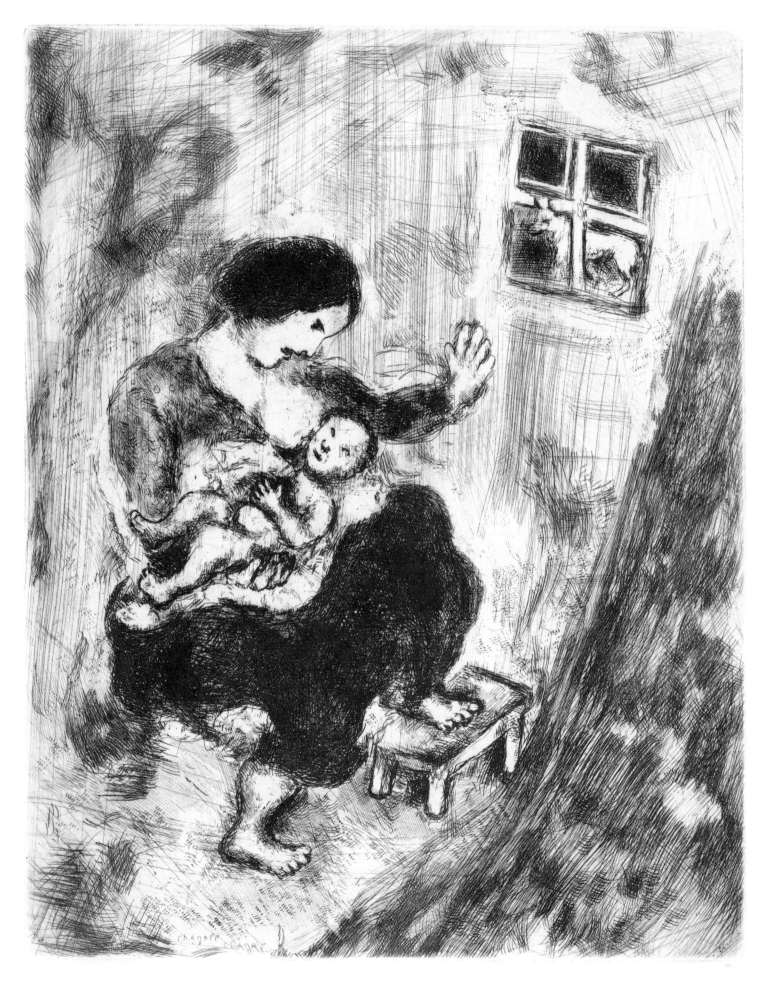

61　**The Wolf, the Mother and the Child,** La Fontaine, sheet 48. *Cat. 66*

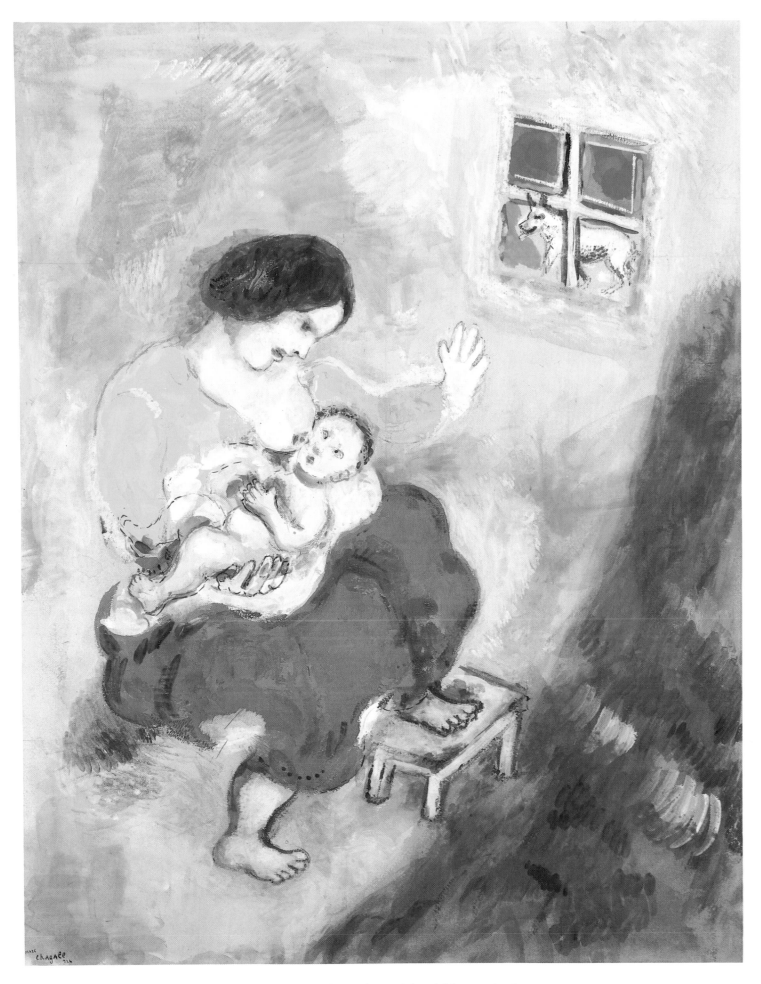

62 The Wolf, the Mother and the Child, 1926. *Cat. 67*

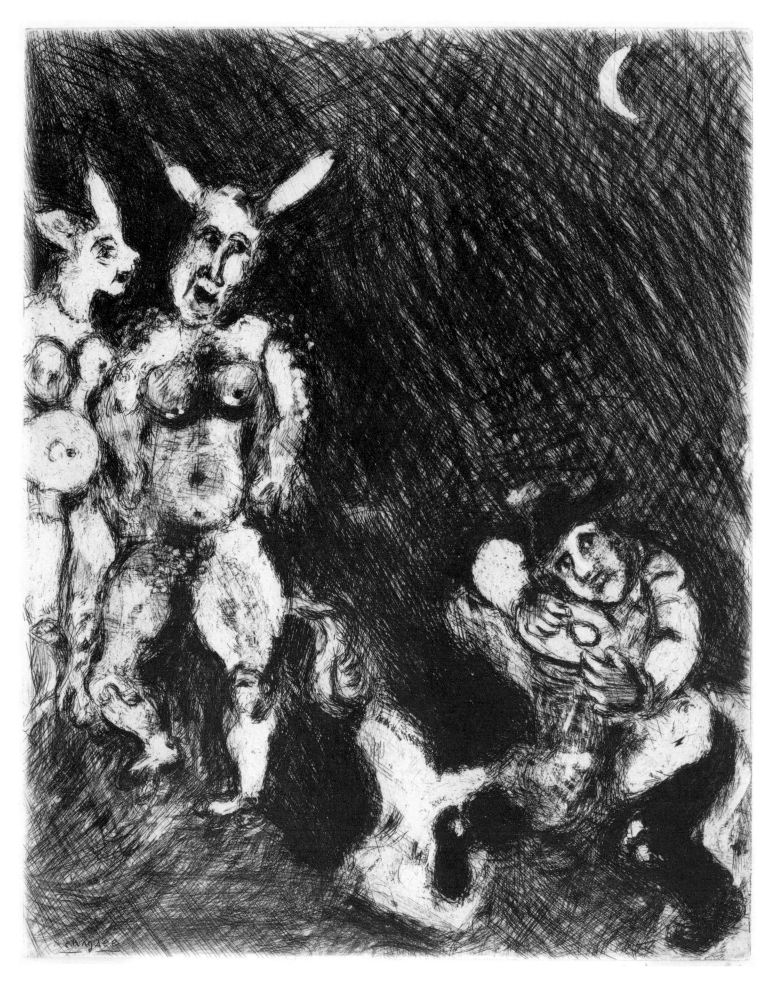

63 **The Satyr and the Wanderer,** La Fontaine, sheet 57. *Cat. 68*

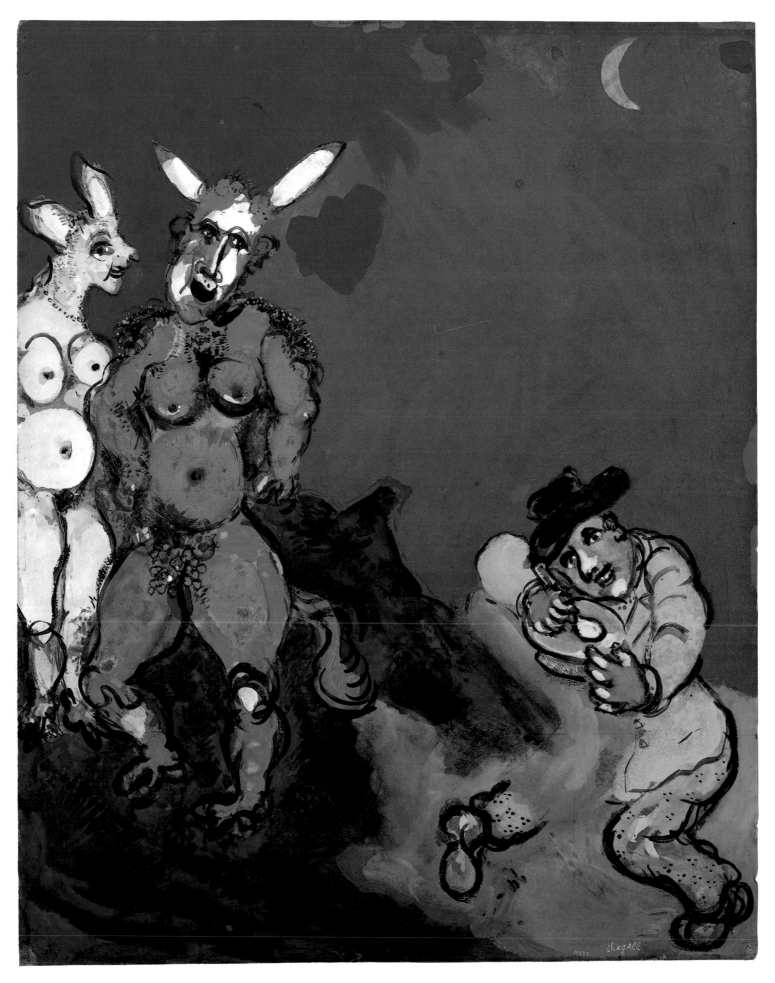

64 **The Satyr and the Wanderer,** 1926-27. *Cat. 69*

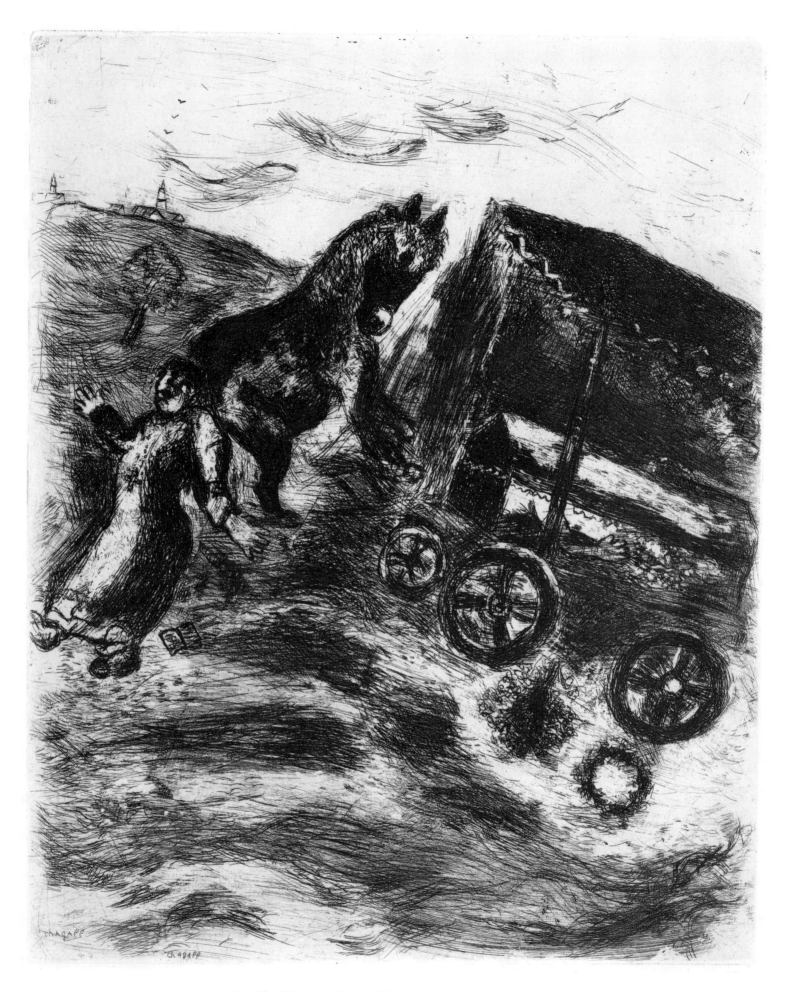

65 **The Priest and the dead Man,** La Fontaine, sheet 76. *Cat. 70*

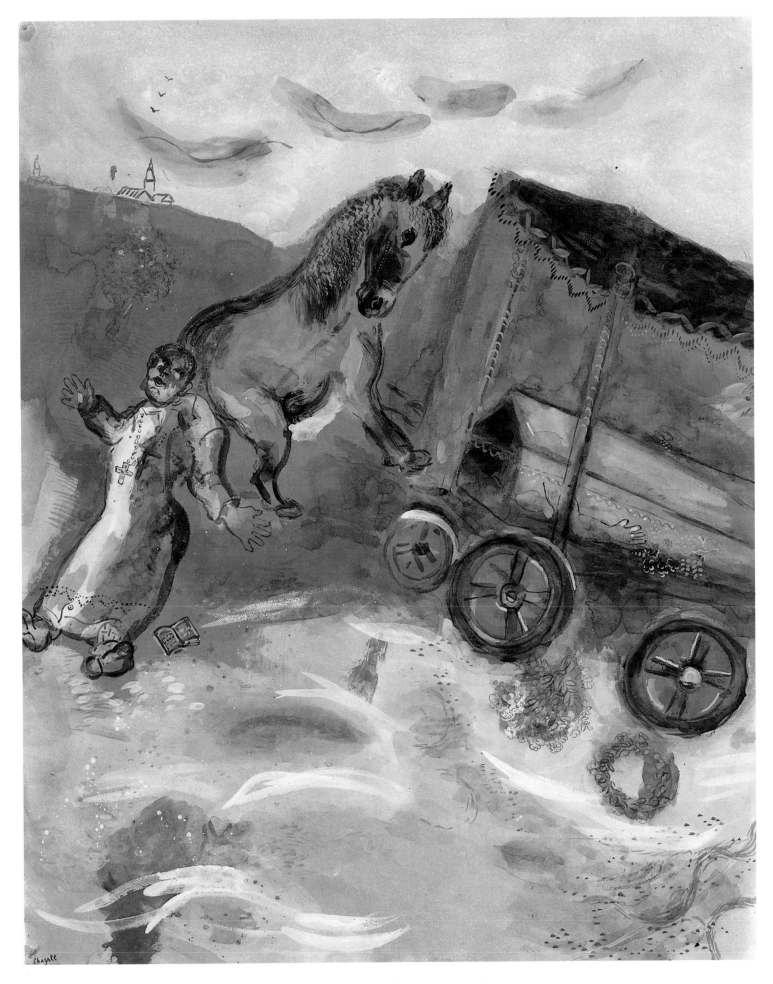

66 **The Priest and the dead Man,** 1926. *Cat. 71*

67 **The Rat and the Elephant,** La Fontaine, sheet 85. *Cat.* 72

68 **The Rat and the Elephant,** *c. 1926-27. Cat. 73*

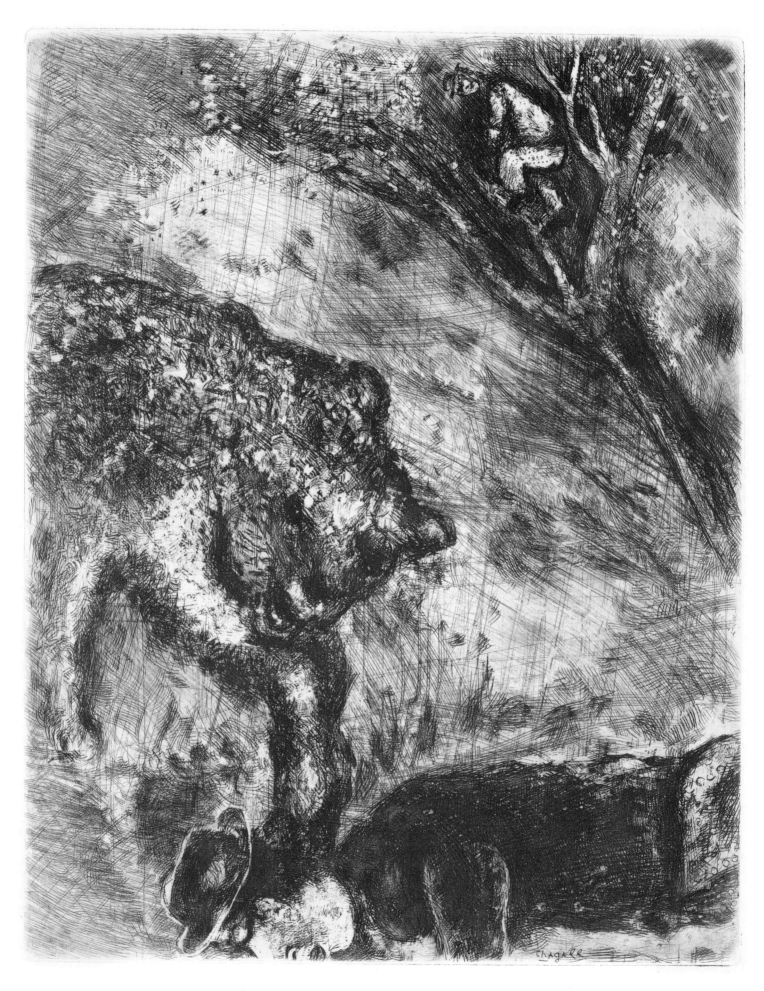

69 **The Bear and the two Schemers**, La Fontaine, sheet 63. *Cat. 74*

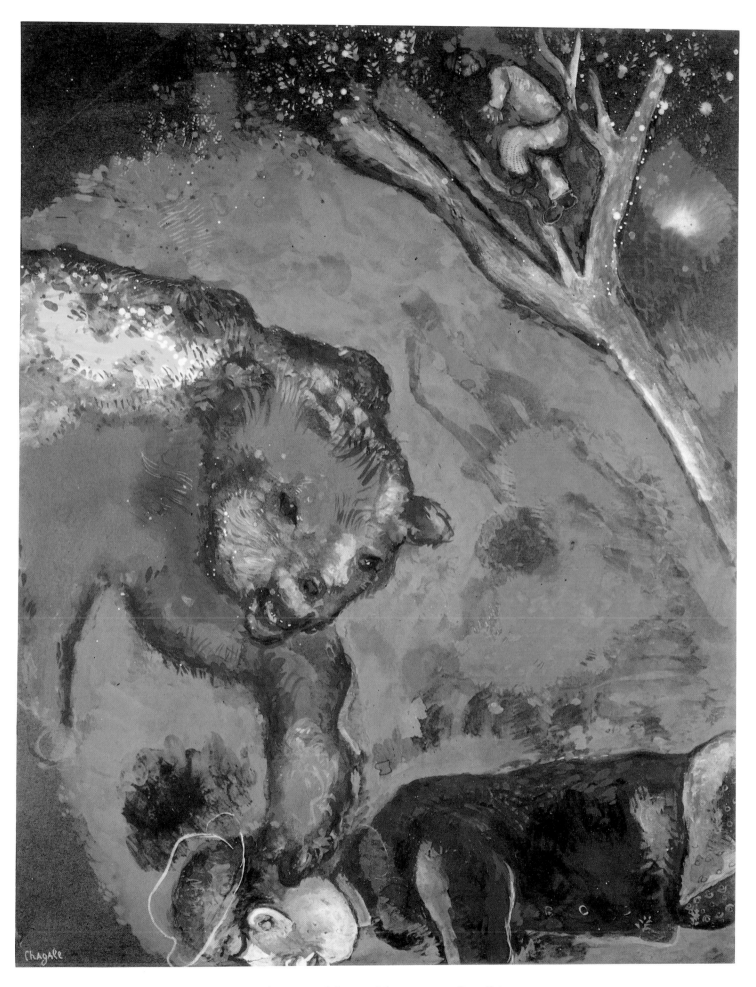

70 The Bear and the two Schemers, *c.* 1926-27. *Cat.* 75

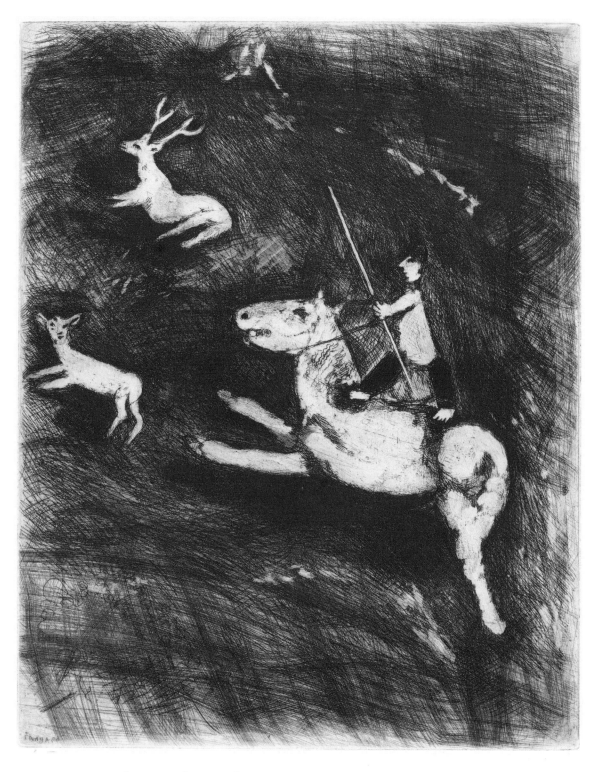

71 **The Horse who wanted Revenge on the Stag,** La Fontaine, sheet 45. *Cat. 76*

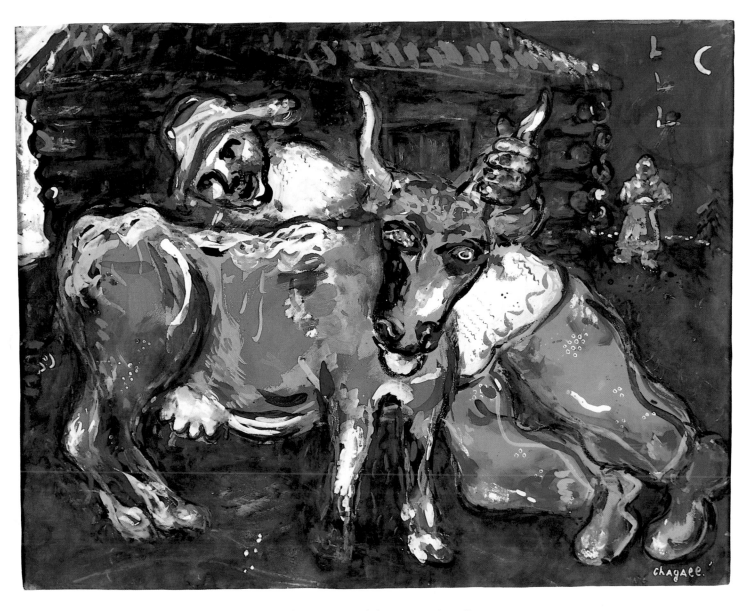

72　　The Peasant and the Cow, 1926-27. *Cat.* 77

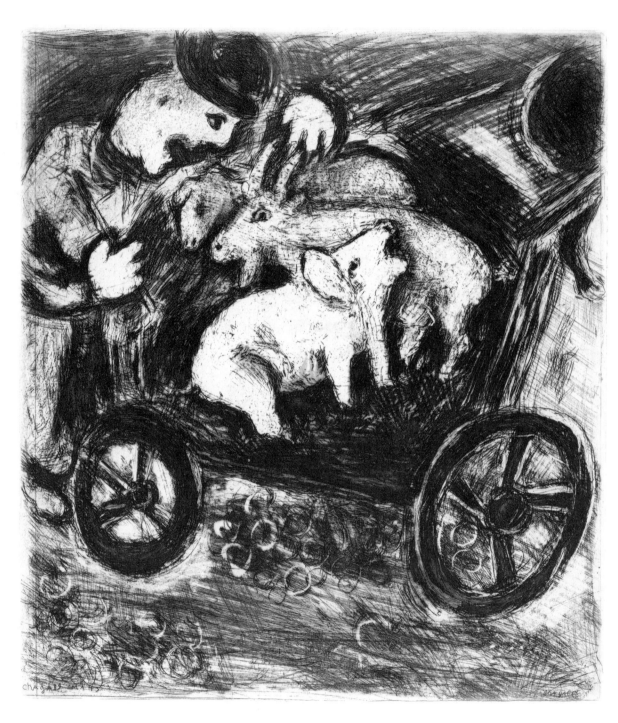

73　The Shepherd and his Flock, La Fontaine, sheet 92. *Cat. 78*

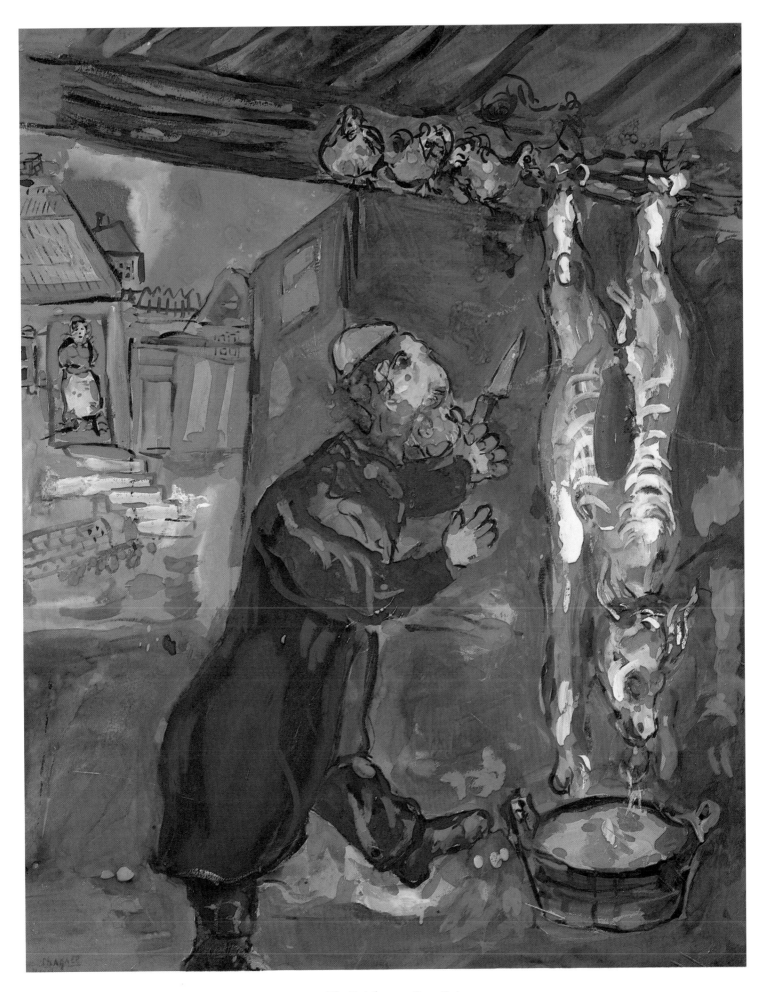

74 **The Butcher**, 1928-29. *Cat. 79*

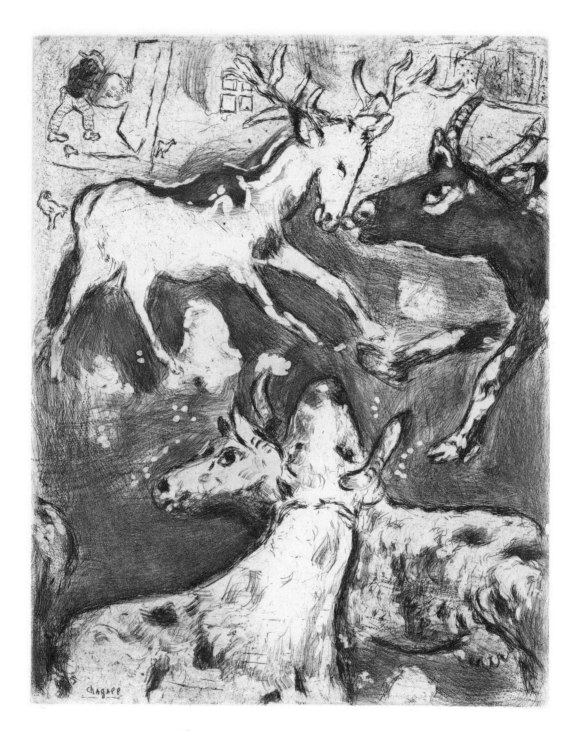

75 **The Master's Eye,** La Fontaine, sheet 50. *Cat. 80*

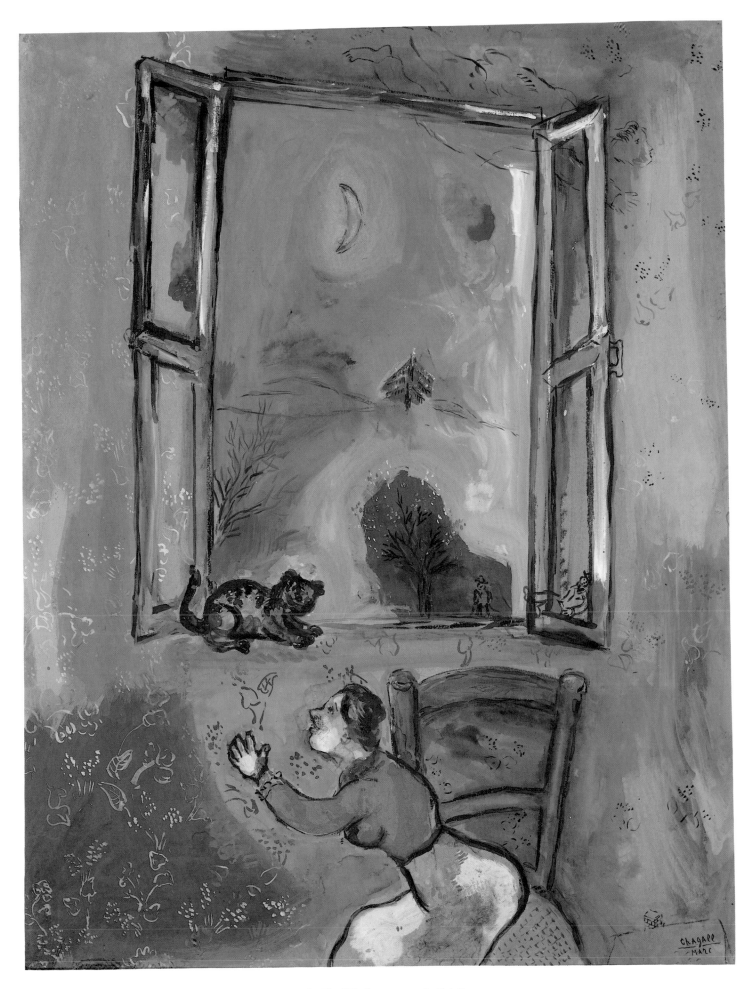

76　The Window, 1927-28. *Cat. 81*

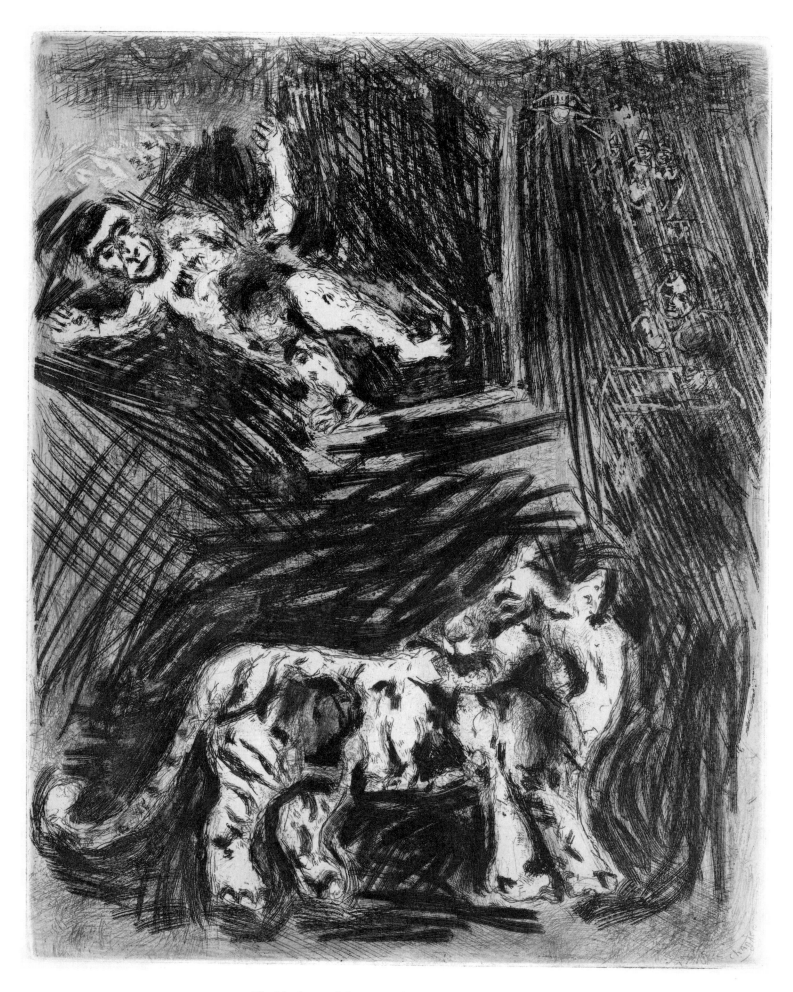

77 **The Monkey and the Leopard**, La Fontaine, sheet 88. *Cat. 82*

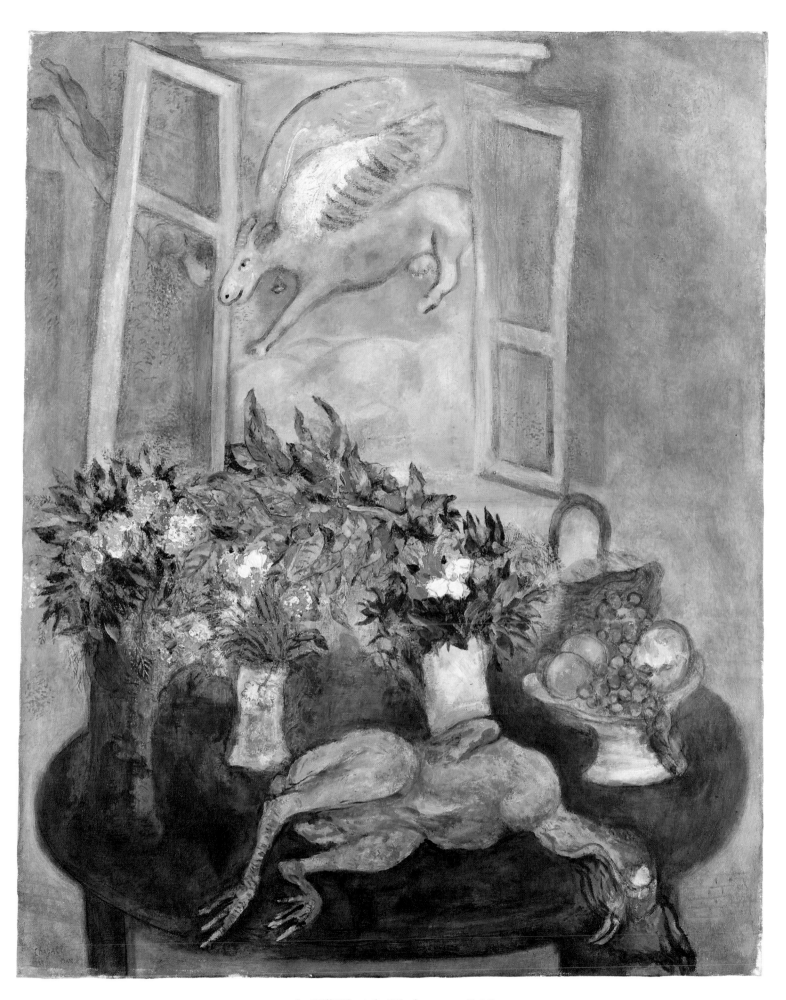

78 **Still Life at the Window,** 1929. *Cat. 83*

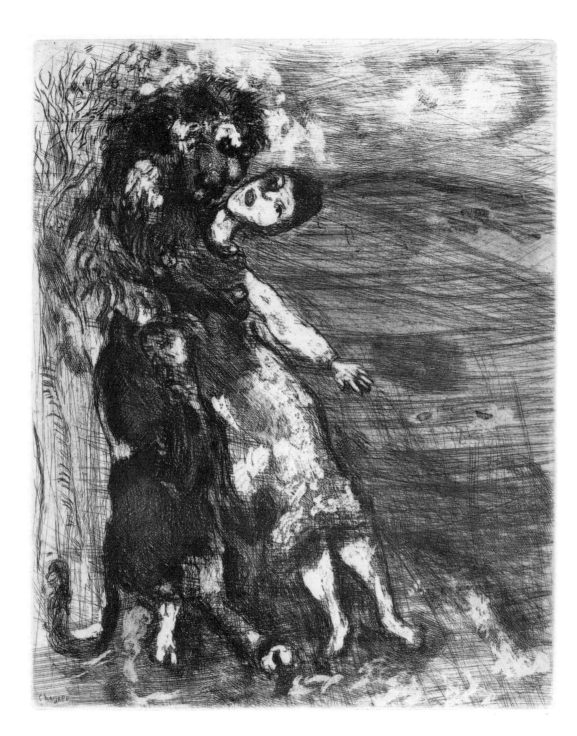

79 **The Lion in Love,** La Fontaine, sheet 40. *Cat. 84*

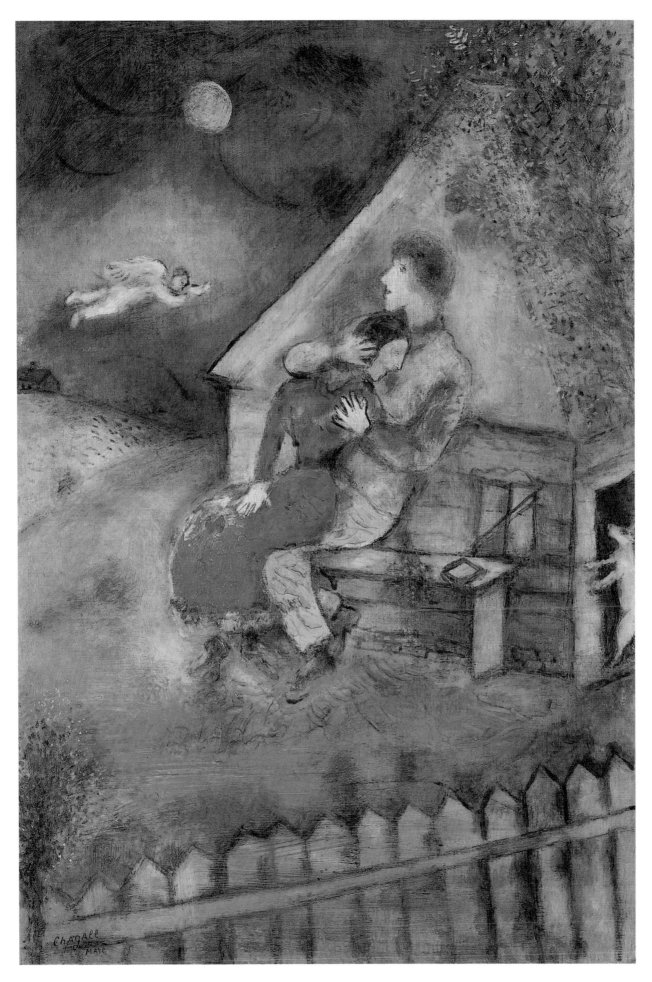

80 **Lovers**, 1929. *Cat. 85*

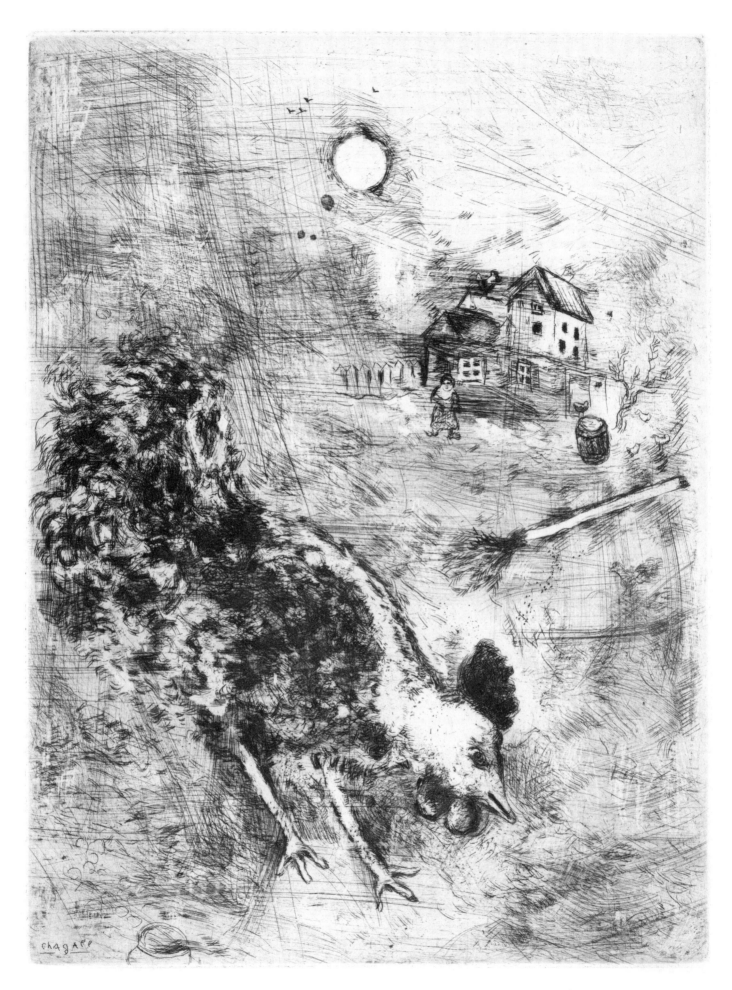

81 **The Cock and the Pearl,** La Fontaine, sheet 11. *Cat. 86*

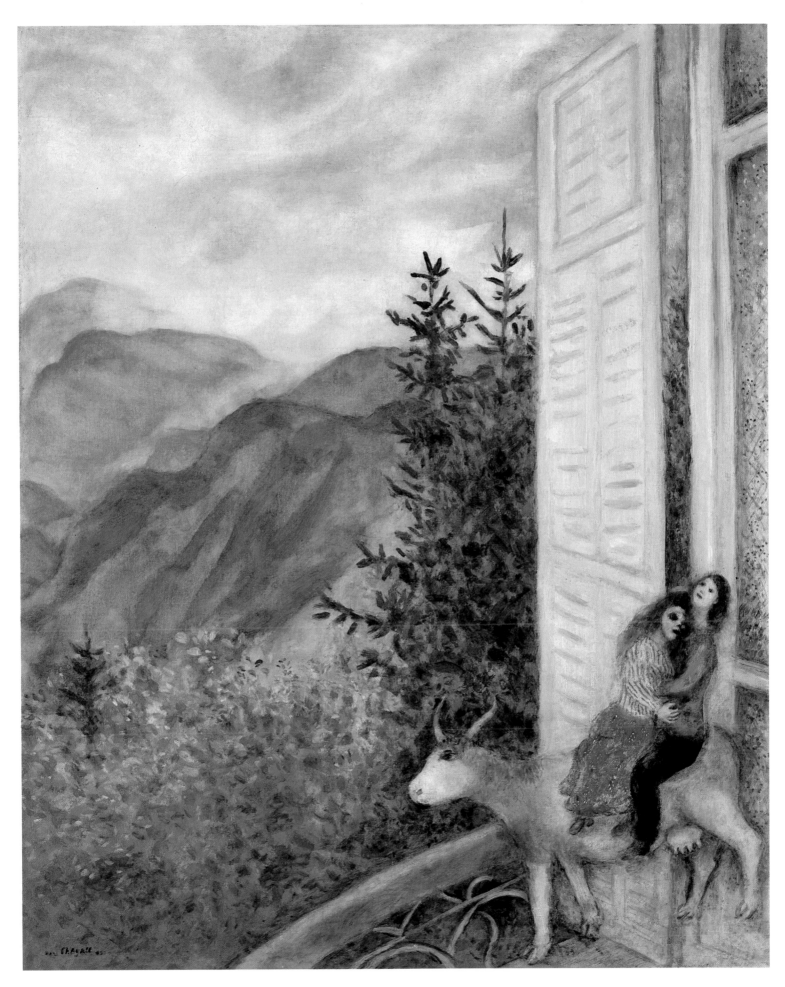

82 In the Mountain, 1930. *Cat. 87*

83 **The two Parrots, the King and his Son,** La Fontaine, sheet 96. *Cat. 88*

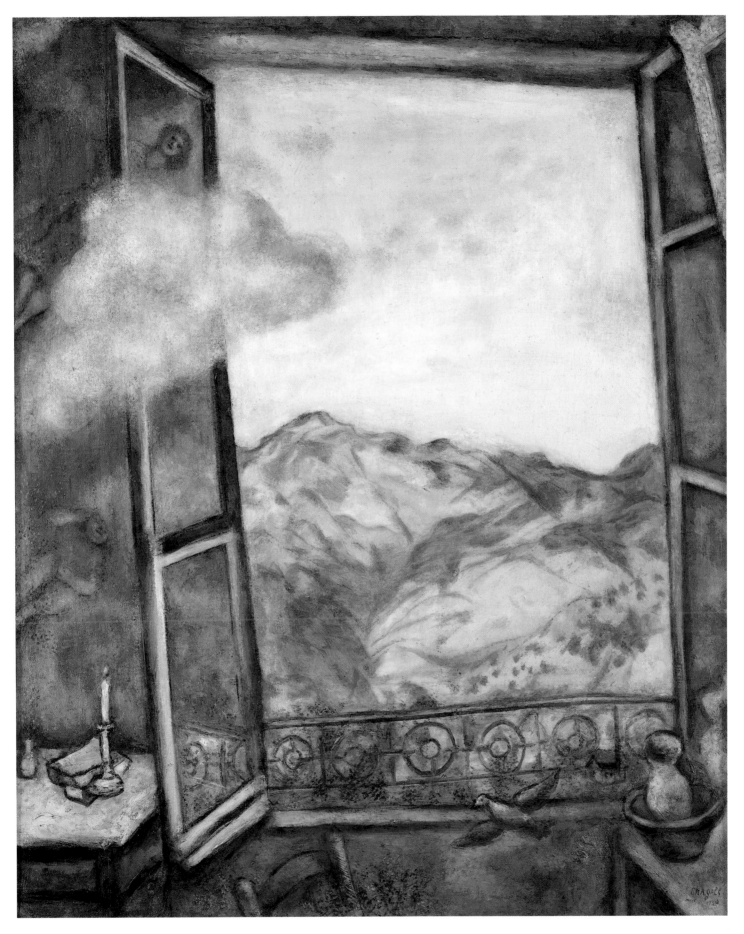

84 Landscape at Peïra-Cava; The Cloud, 1930. *Cat. 89*

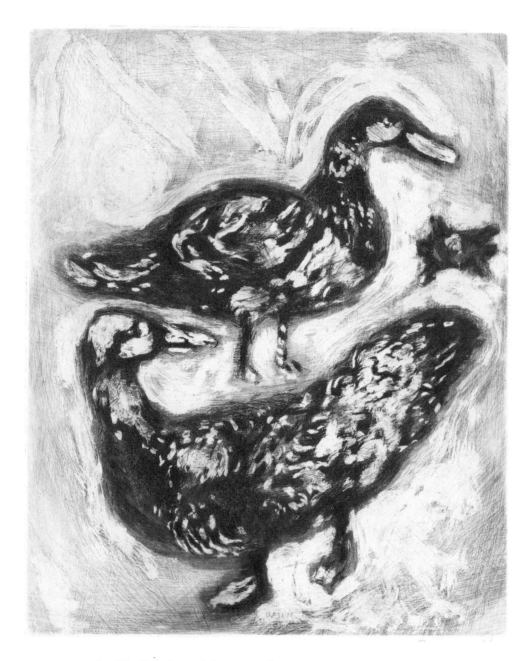

85　**The Tortoise and the two Ducks,** La Fontaine, sheet 93. *Cat. 90*

86 **Bella and Ida at Peïra-Cava,** 1931. *Cat. 91*

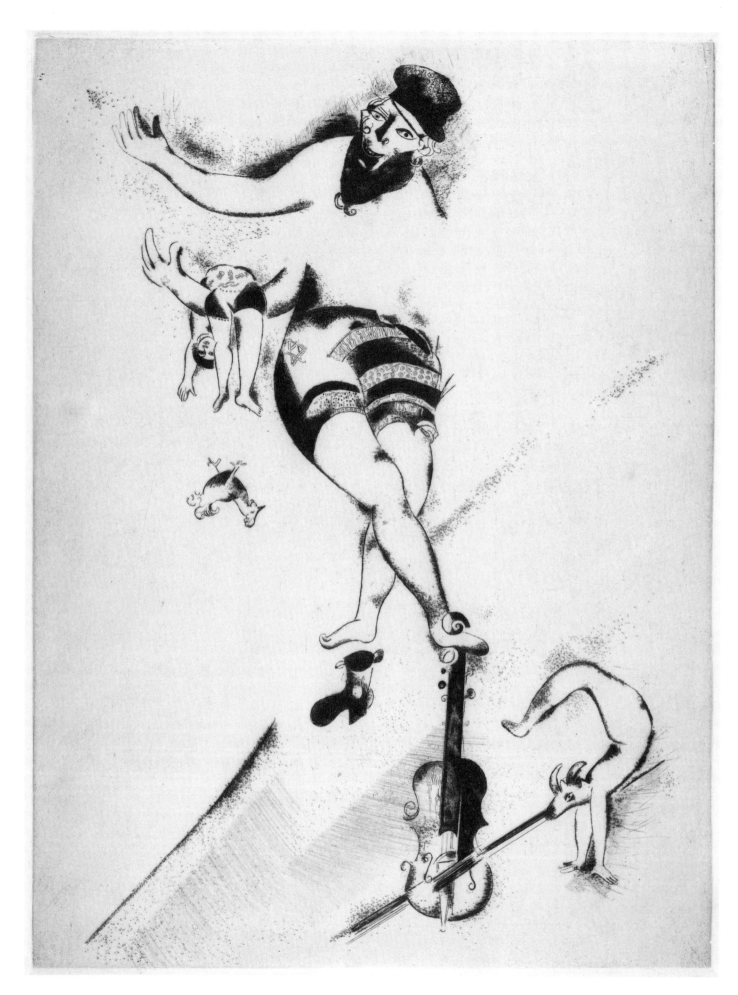

87 Acrobat with Violin, 1924. *Cat.* 93

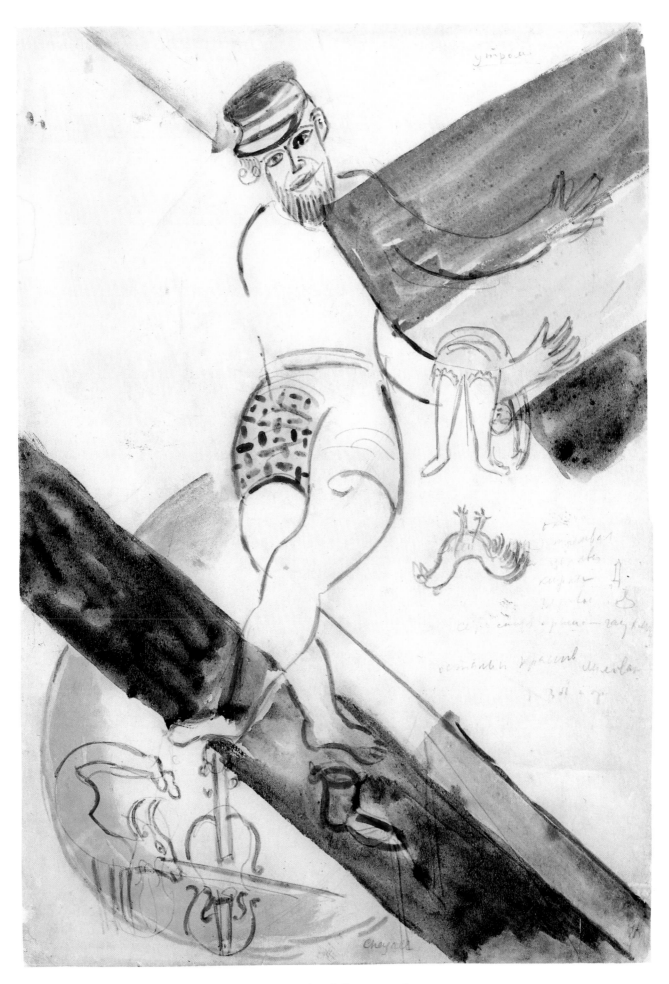

88 **Man with a Violin,** *c. 1920. Cat. 94*

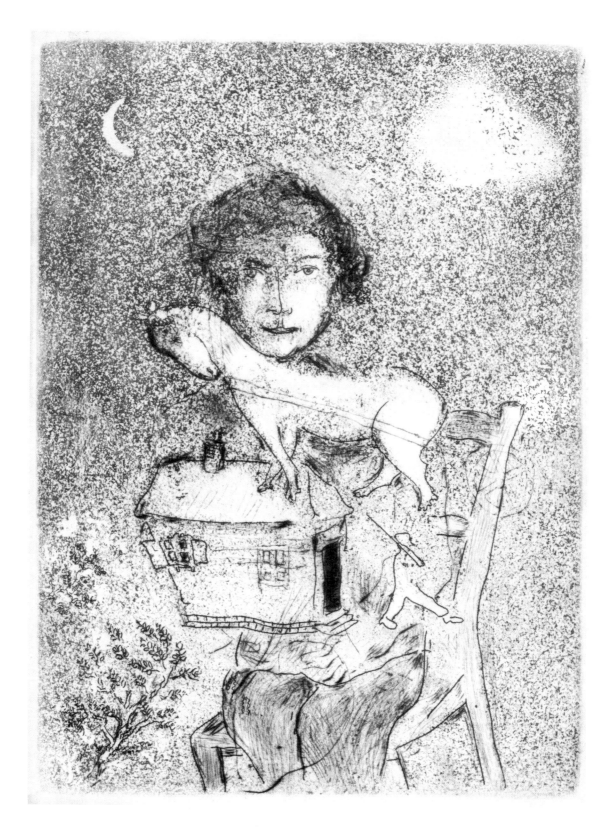

89 **The Sentry,** 1923-24. *Cat. 95*

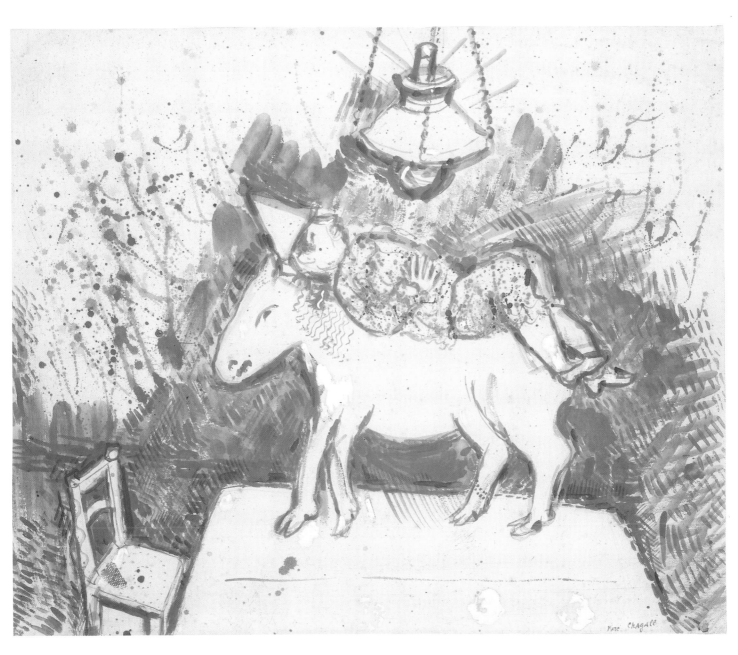

90 **Clown with Horse**, 1925. *Cat. 96*

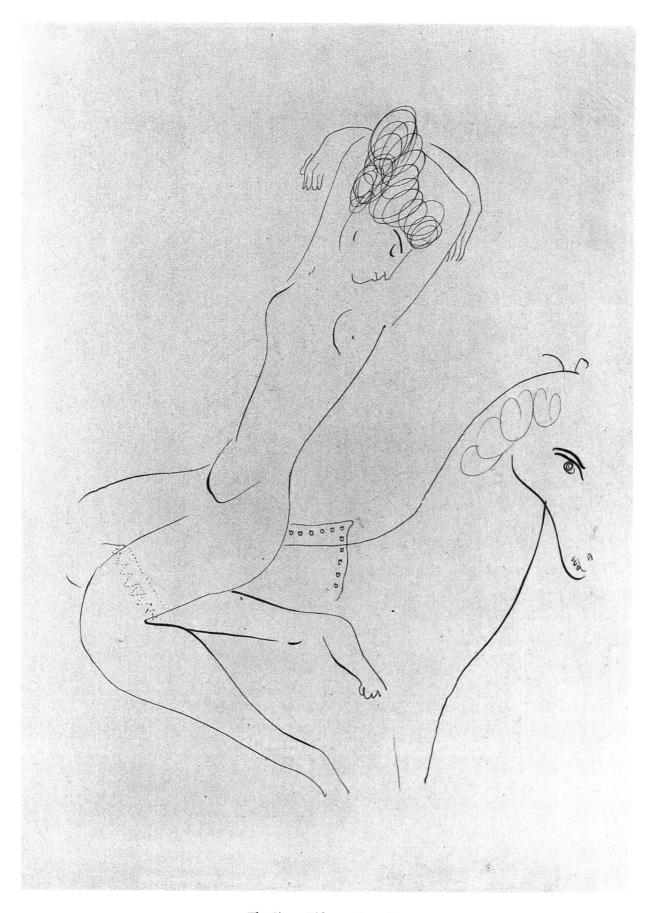

91 **The Circus Rider,** *1926-27. Cat. 97*

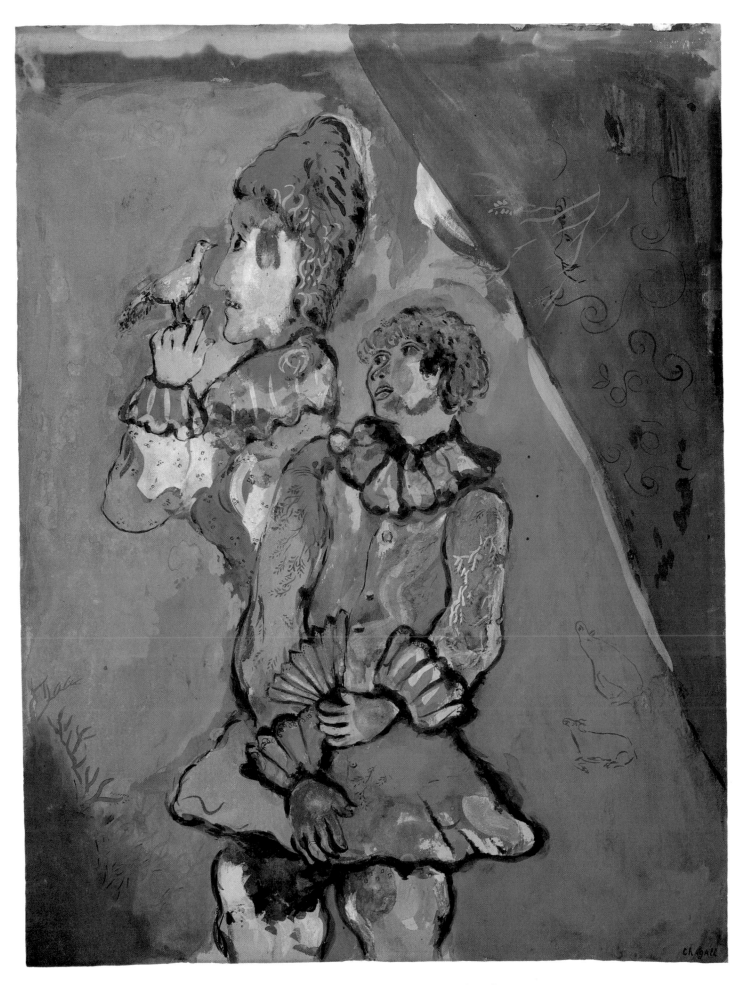

92 **Lovers/Lady with a Bird,** *c. 1926-27. Cat. 98*

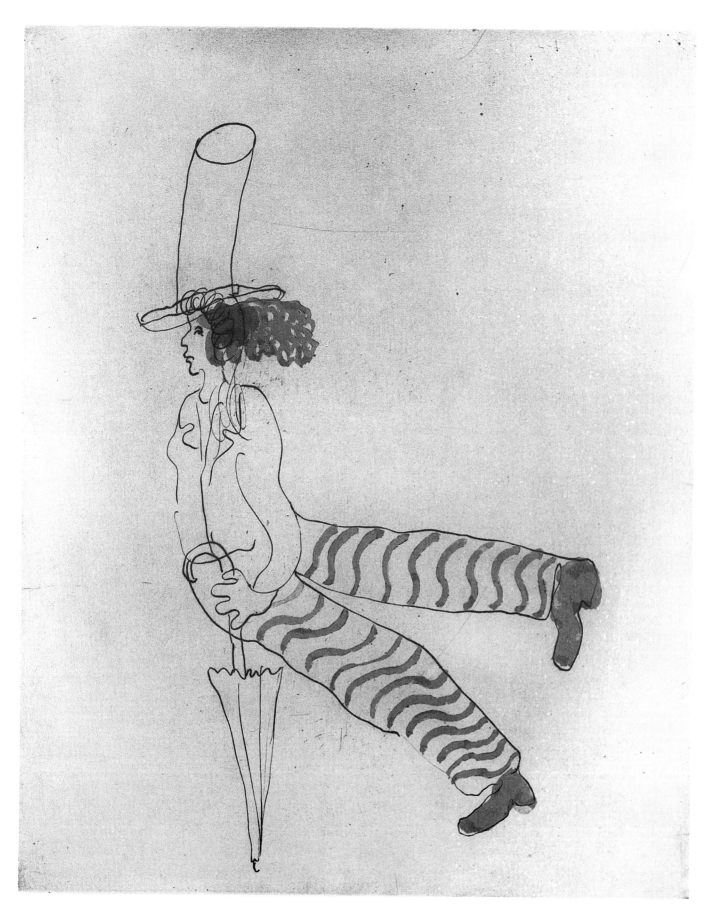

93　**Man with Umbrella,** 1926-27. *Cat. 99*

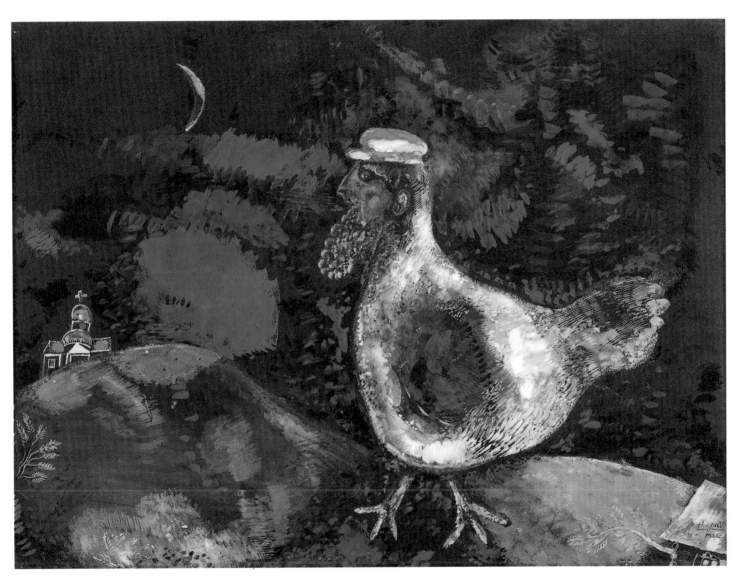

94 **Chicken (Cirque Vollard),** 1926-27. *Cat. 100*

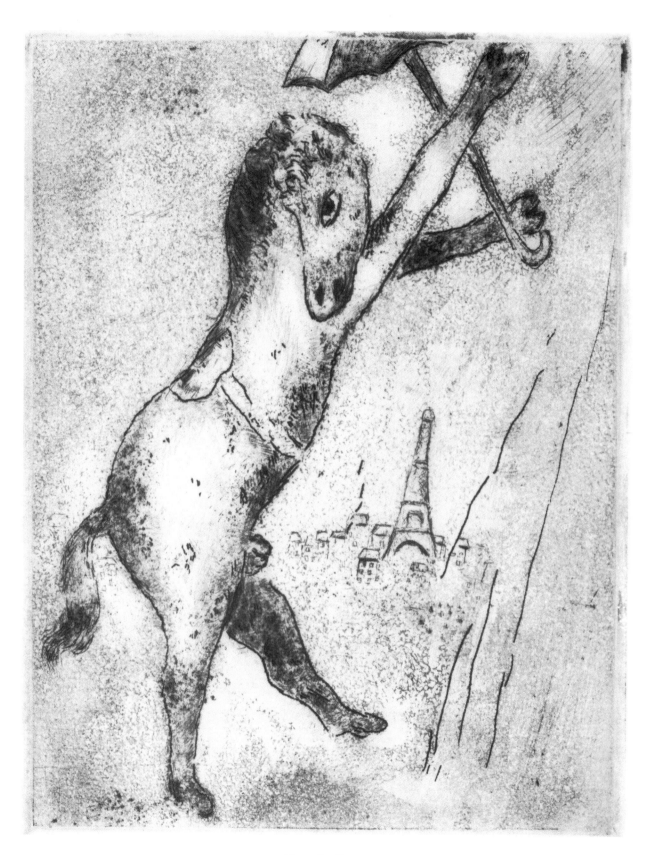

95 **Horse with Umbrella,** 1930. *Cat. 101*

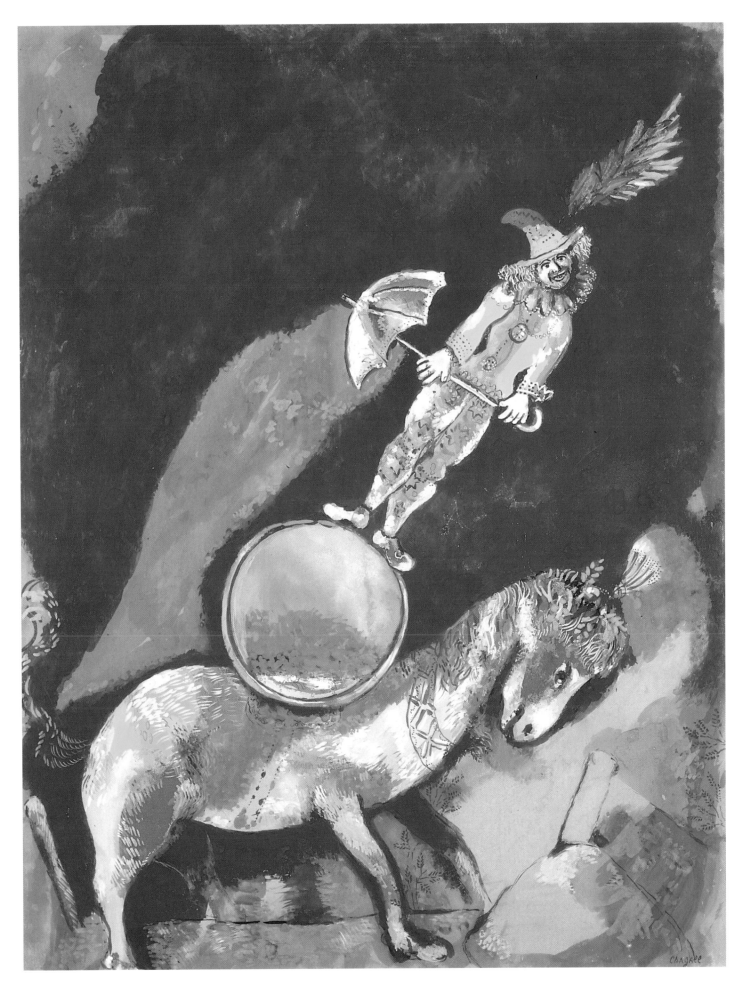

96 **Clown on a Horse,** 1927. *Cat. 102*

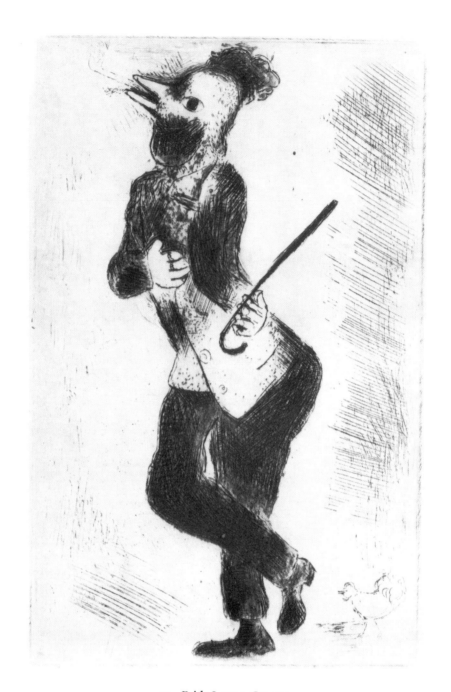

97　**Pride I,** 1925. *Cat. 103*

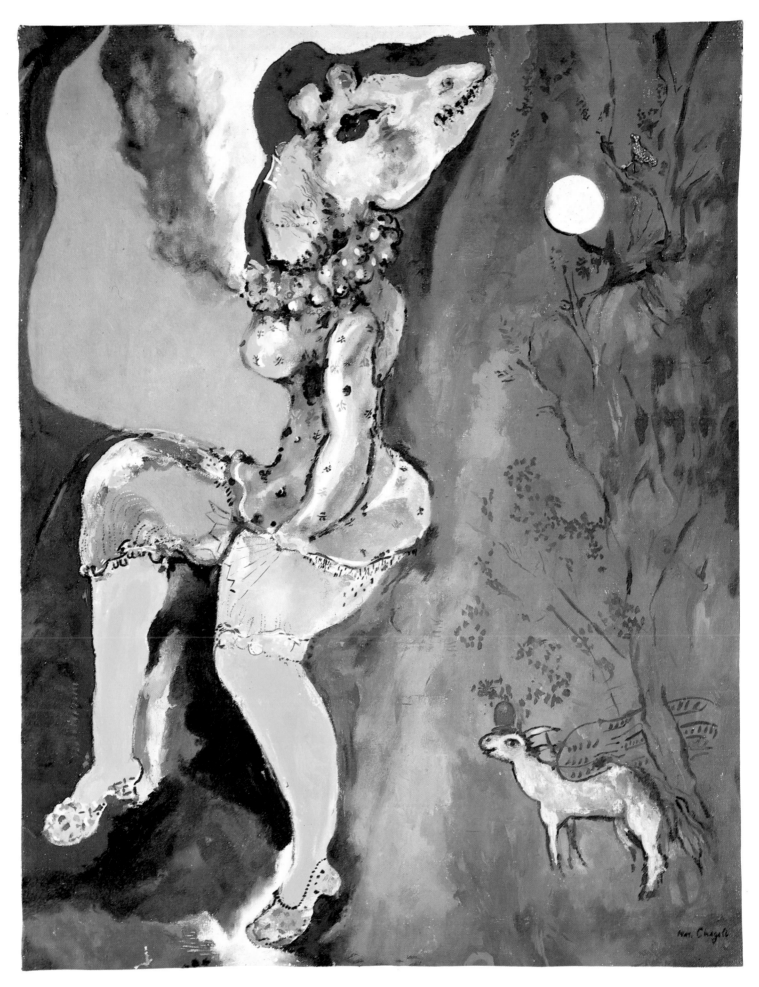

98 **Woman-Donkey,** *c. 1927. Cat. 104*

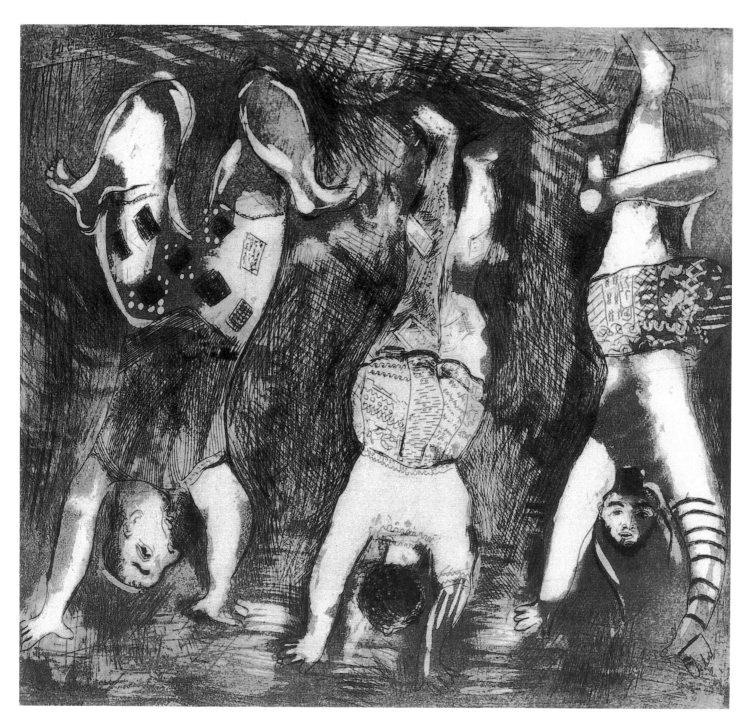

99 The Three Acrobats, 1923. *Cat. 105*

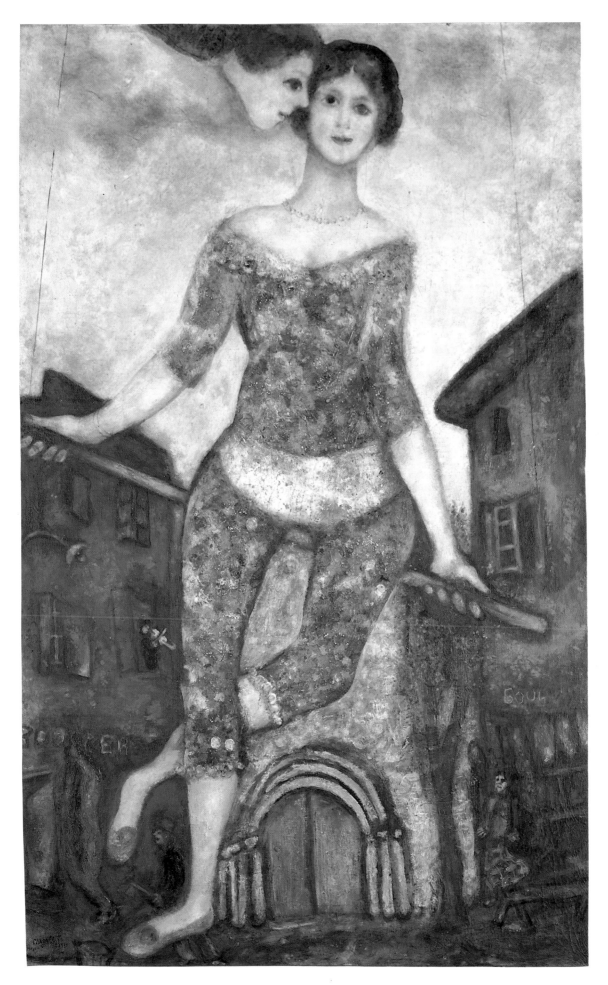

100 **The Girl Acrobat,** 1930. *Cat. 106*

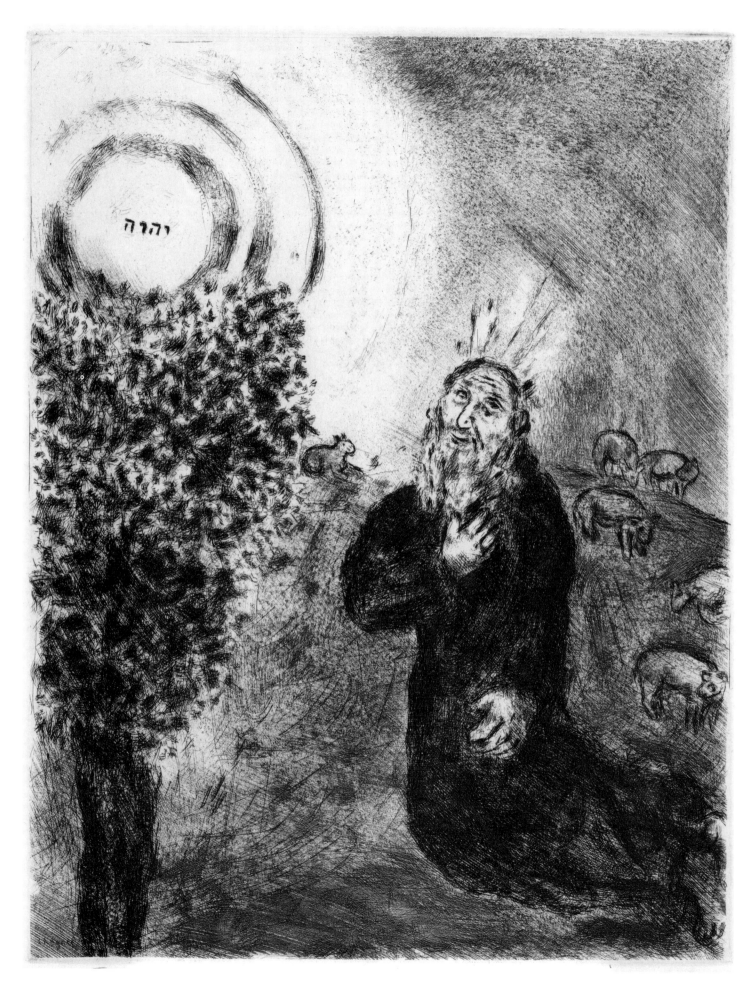

101　**The Burning Bush,** Bible, sheet 27. *Cat. 108*

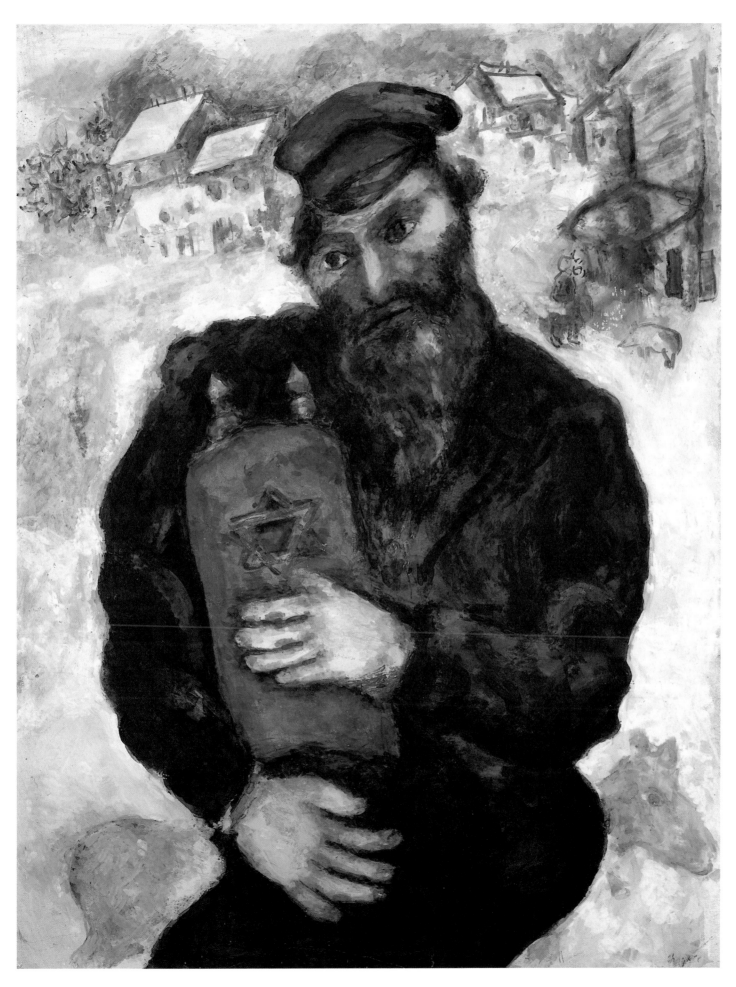

102　**Jew with the Scroll of Law,** 1925. *Cat. 109*

103 **Rachel's Tomb,** Bible, sheet 17. *Cat. 110*

104 The Wailing Wall, 1932. *Cat. 111*

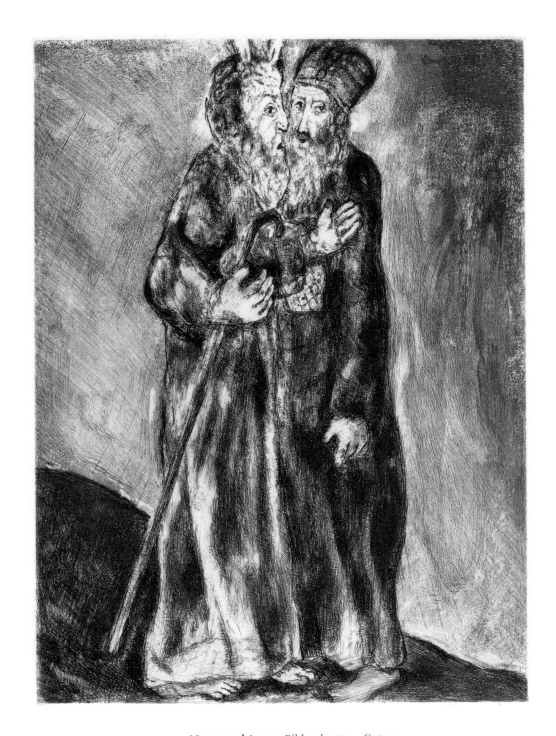

105 **Moses and Aaron,** Bible, sheet 29. *Cat. 112*

106 **Synagogue at Safed,** 1931. *Cat. 113*

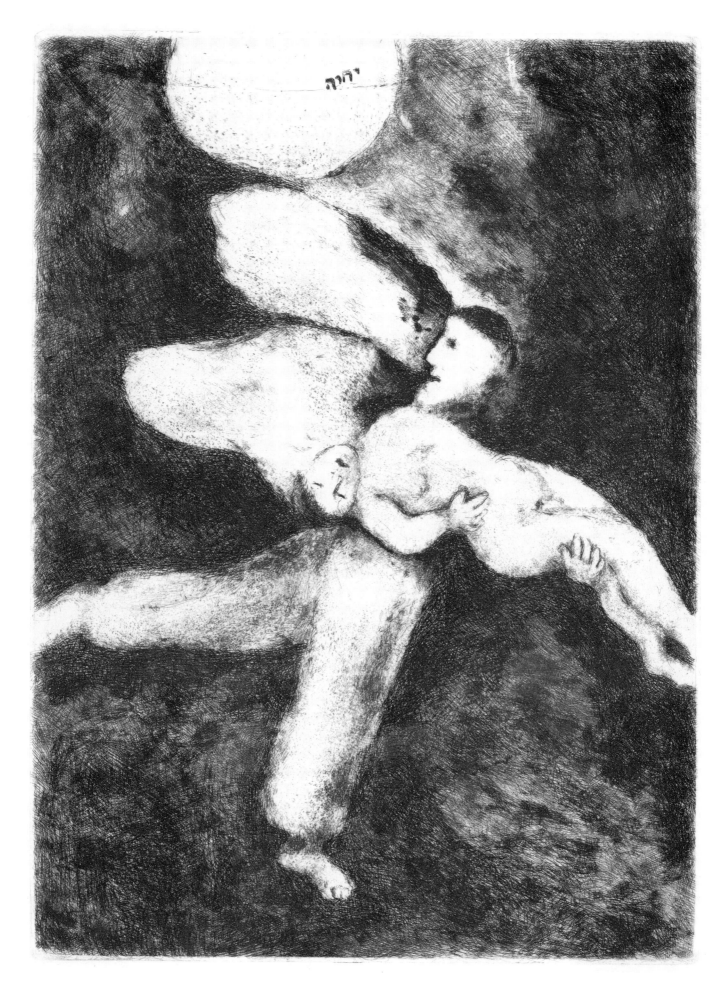

107 **The Creation of Man,** Bible, sheet 1. *Cat. 114*

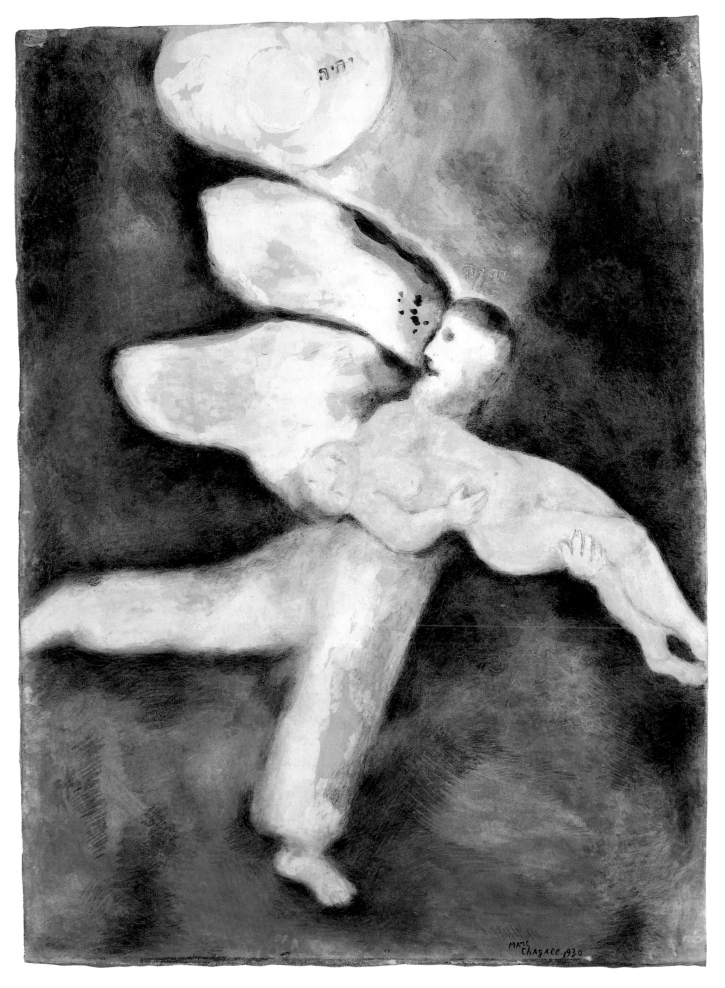

108 **The Creation of Man**, 1930. *Cat. 115*

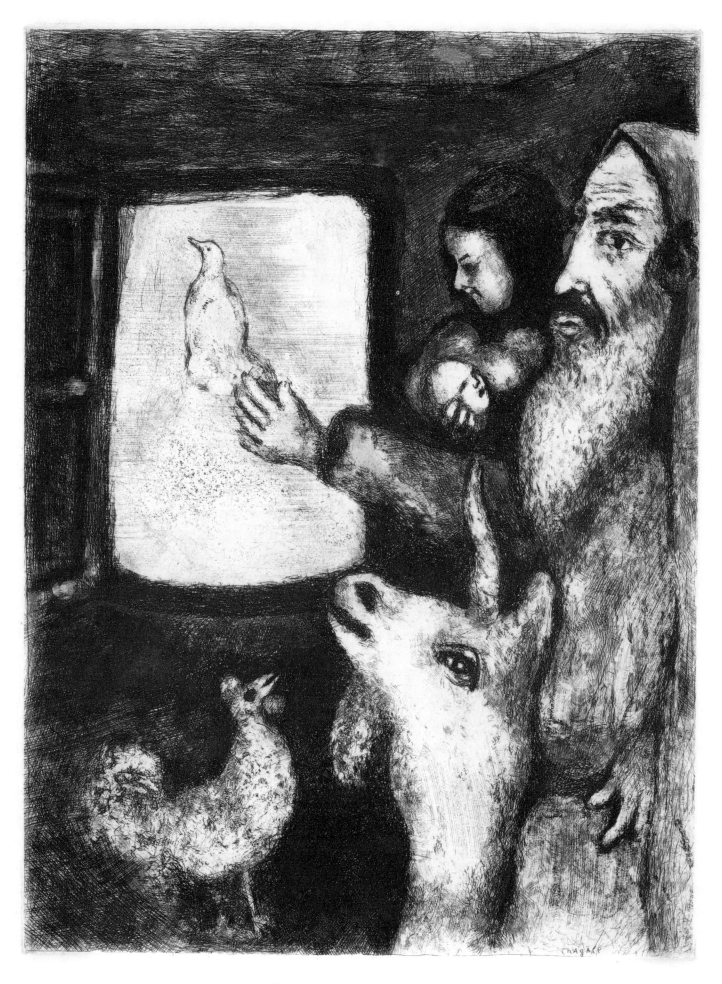

109 **Noah dispatching the Dove,** Bible, sheet 2. *Cat. 116*

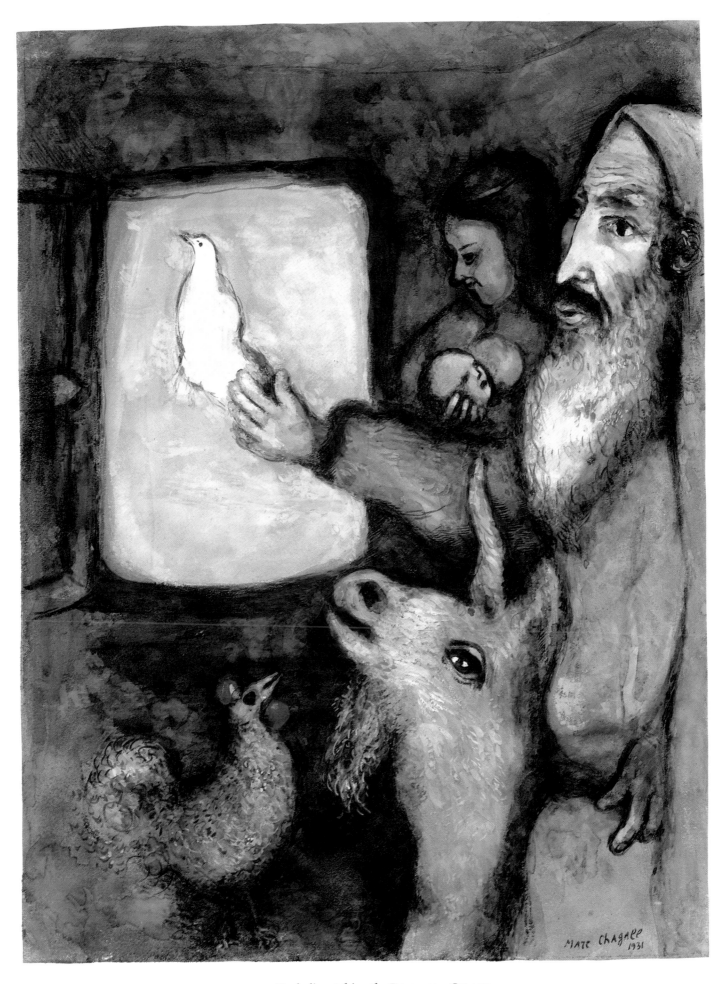

110 **Noah dispatching the Dove,** 1931. *Cat. 117*

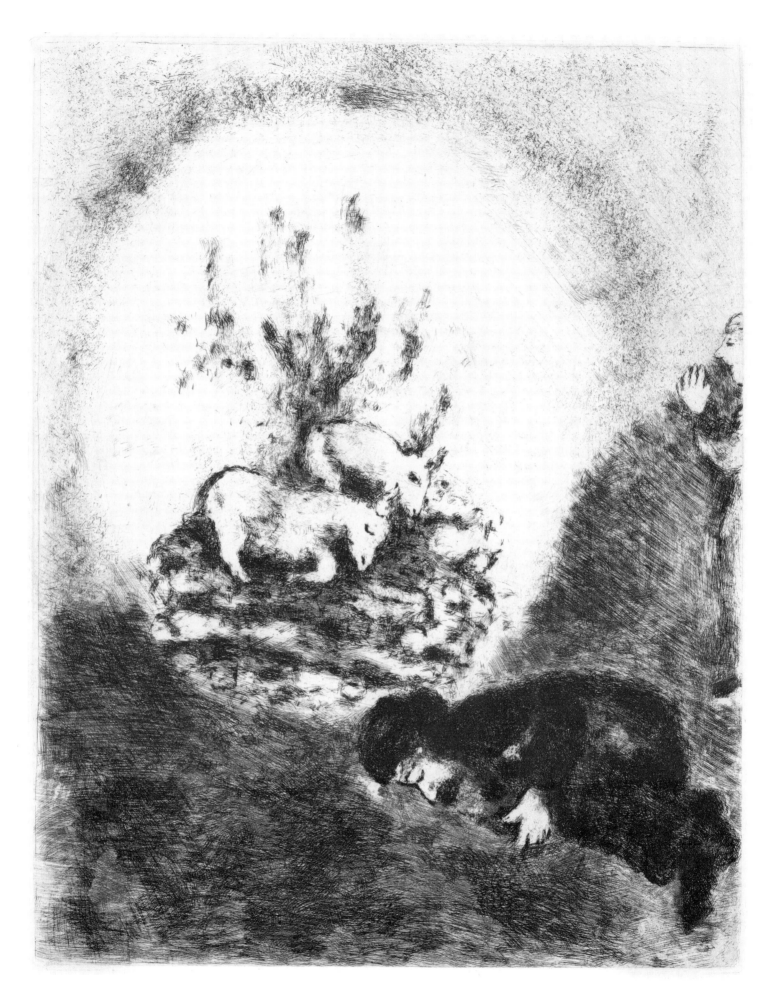

111 **Noah's Sacrifice,** Bible, sheet 3. *Cat. 118*

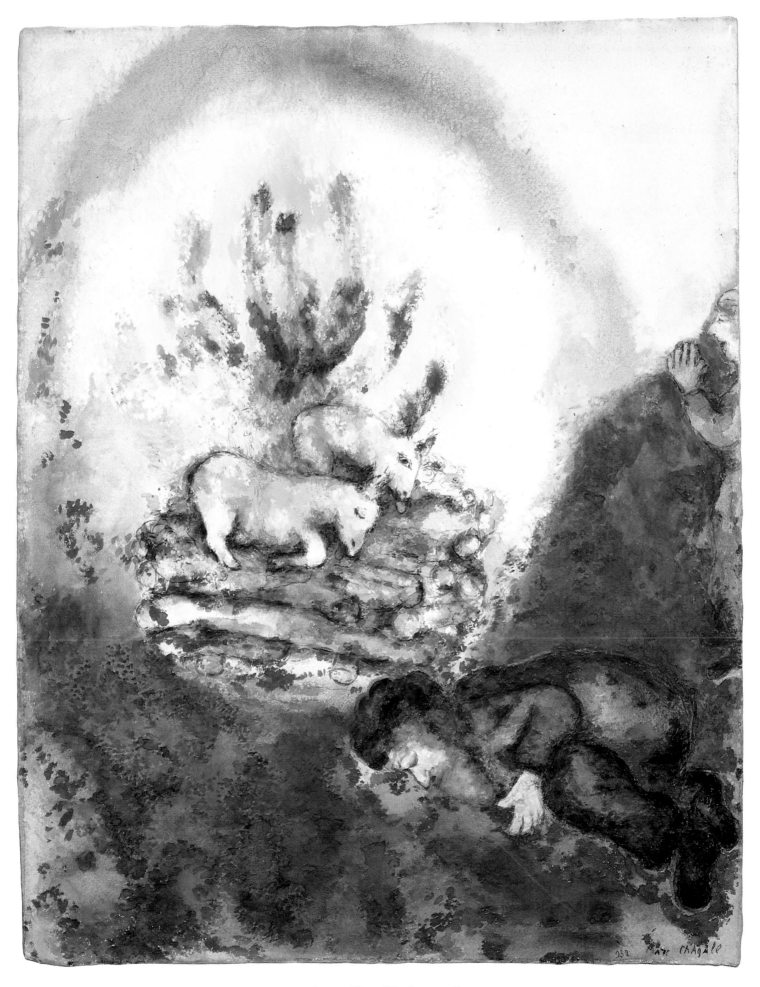

112 The Sacrifice of Noah, 1932. *Cat. 119*

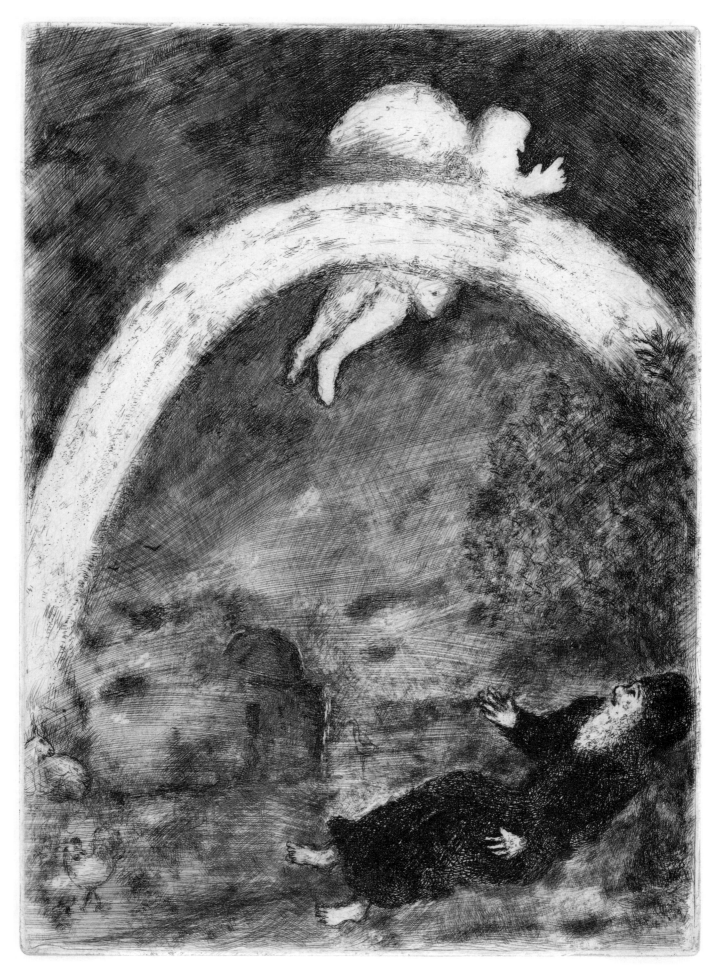

113　**The Rainbow,** Bible, sheet 4. *Cat. 120*

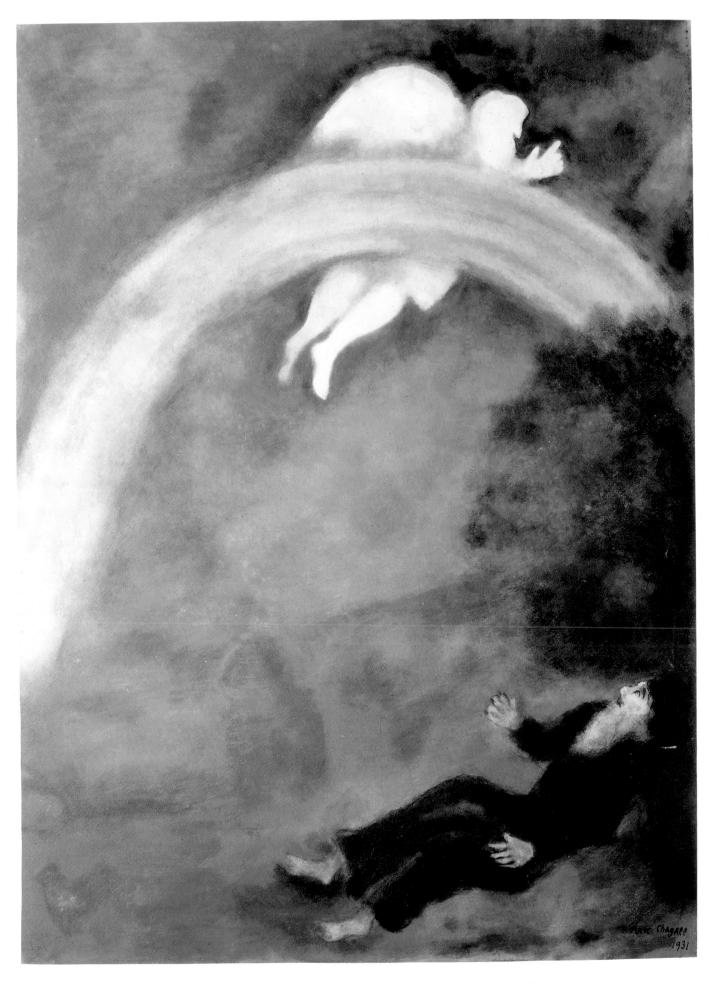

114 The Rainbow, Sign of Covenant between God and the World, 1931. *Cat. 121*

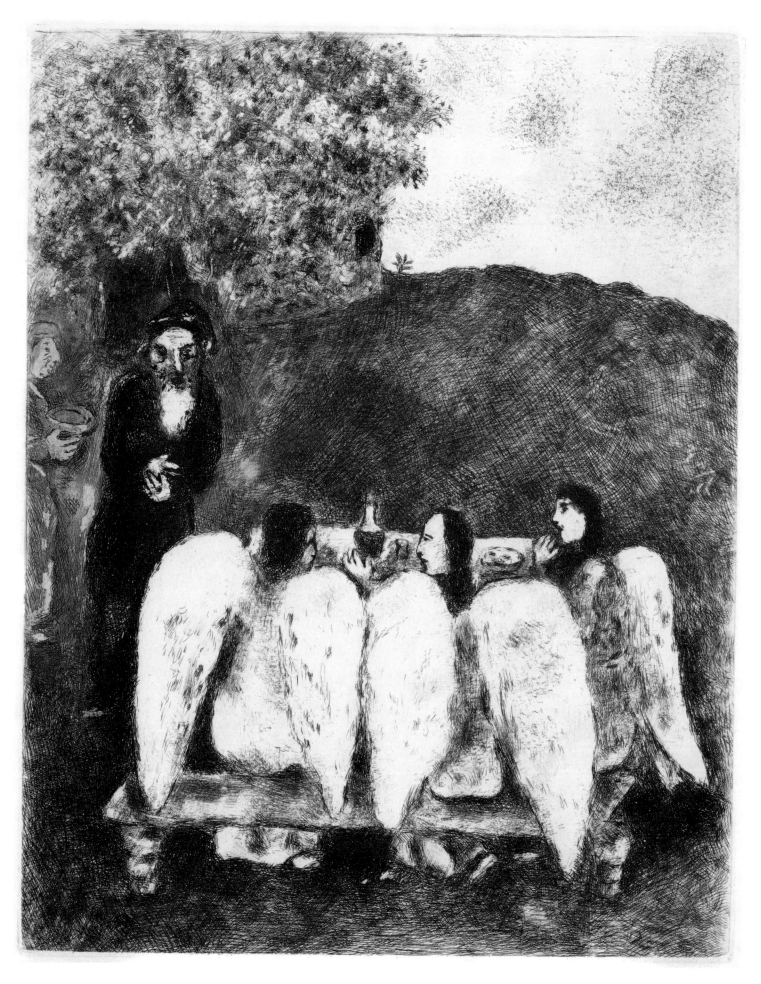

115 **Abraham entertaining the three Angels,** Bible, sheet *7. Cat. 122*

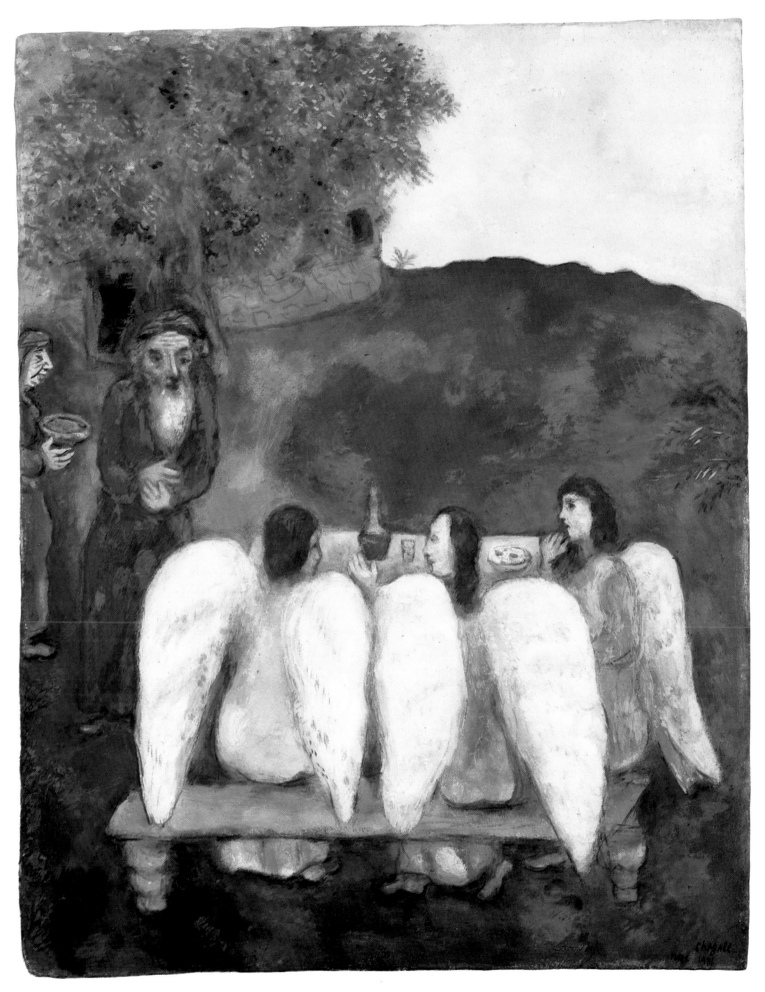

116 **Abraham entertaining the three Angels,** *1931. Cat. 123*

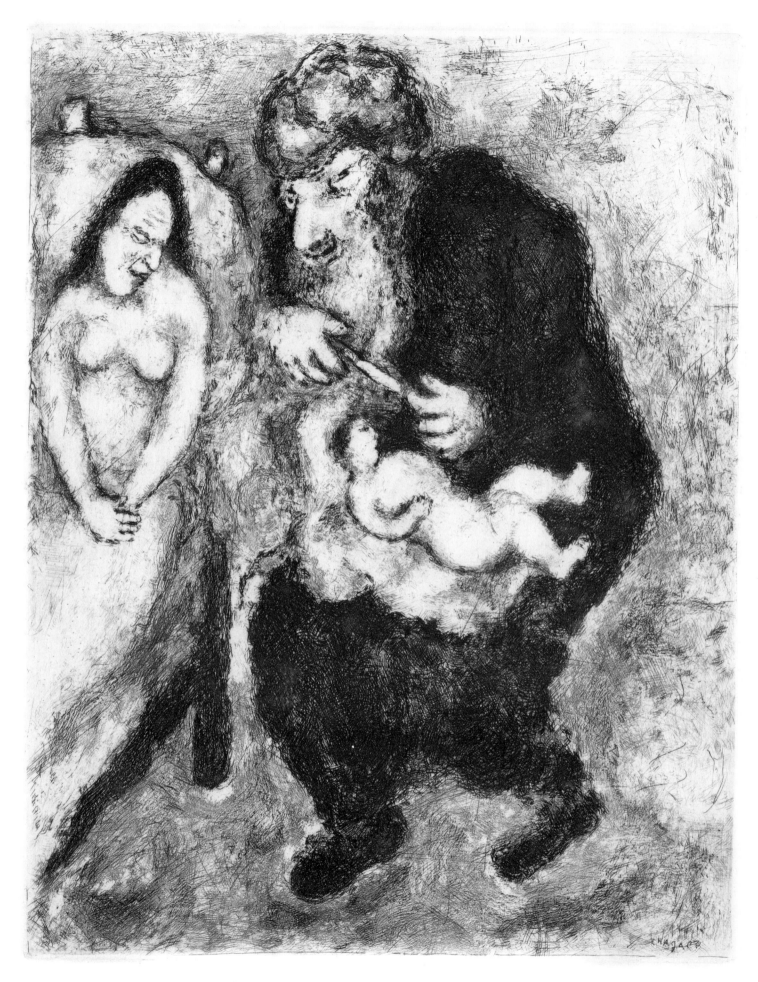

117 **The Circumcision,** Bible, sheet 6. *Cat. 124*

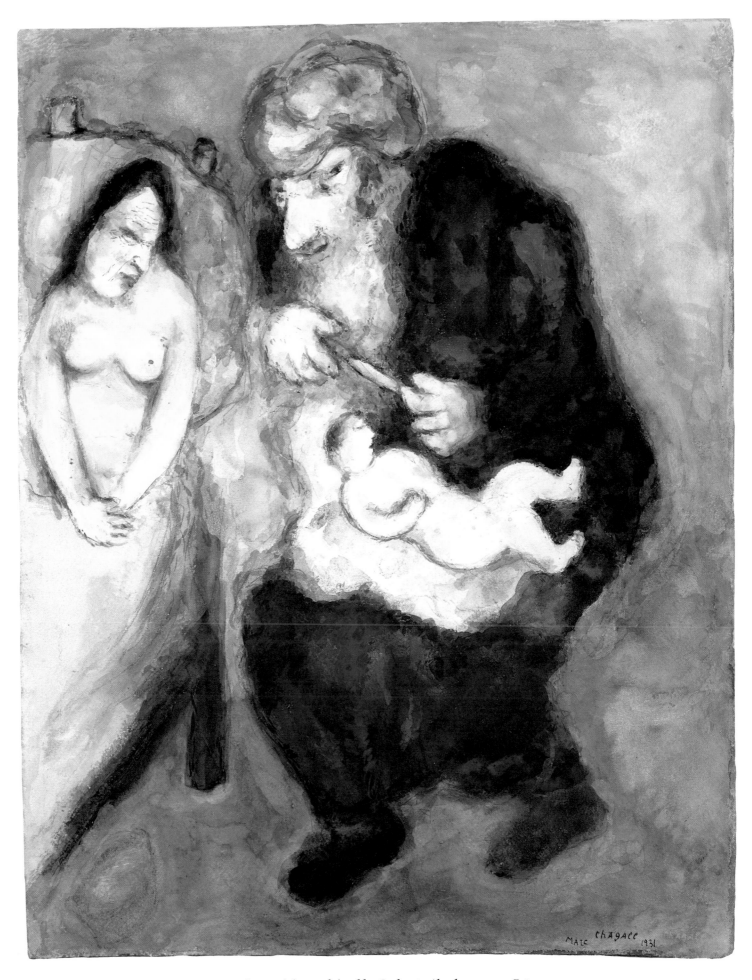

118　Circumcision ordained by God unto Abraham, 1931. *Cat. 125*

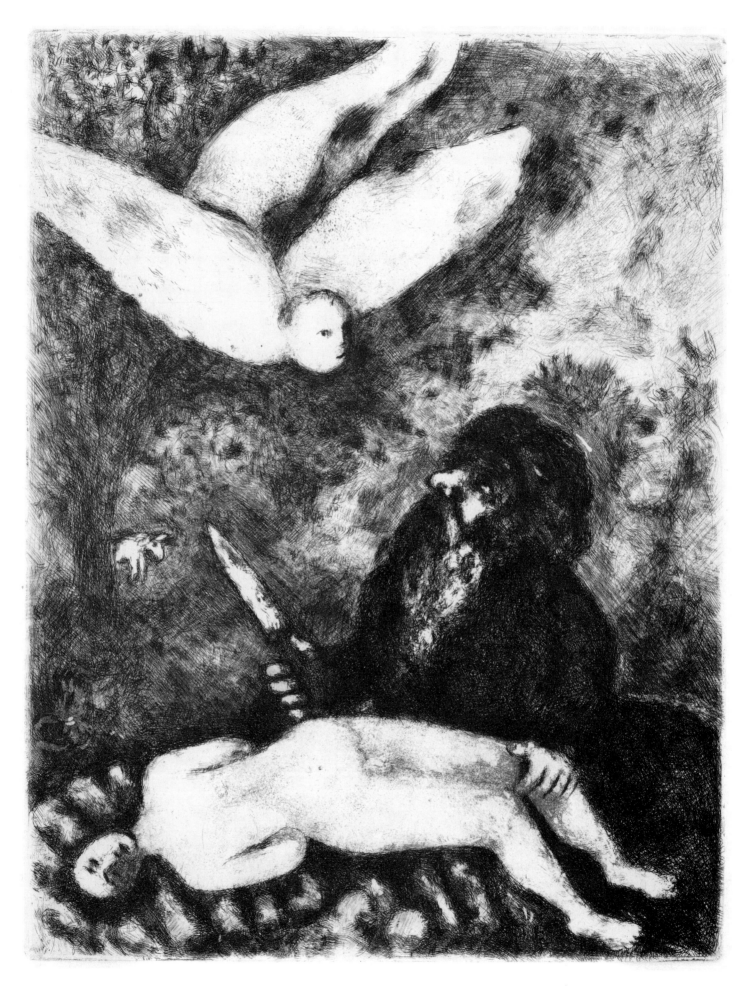

119 **The Sacrifice of Abraham,** Bible, sheet 10. *Cat. 126*

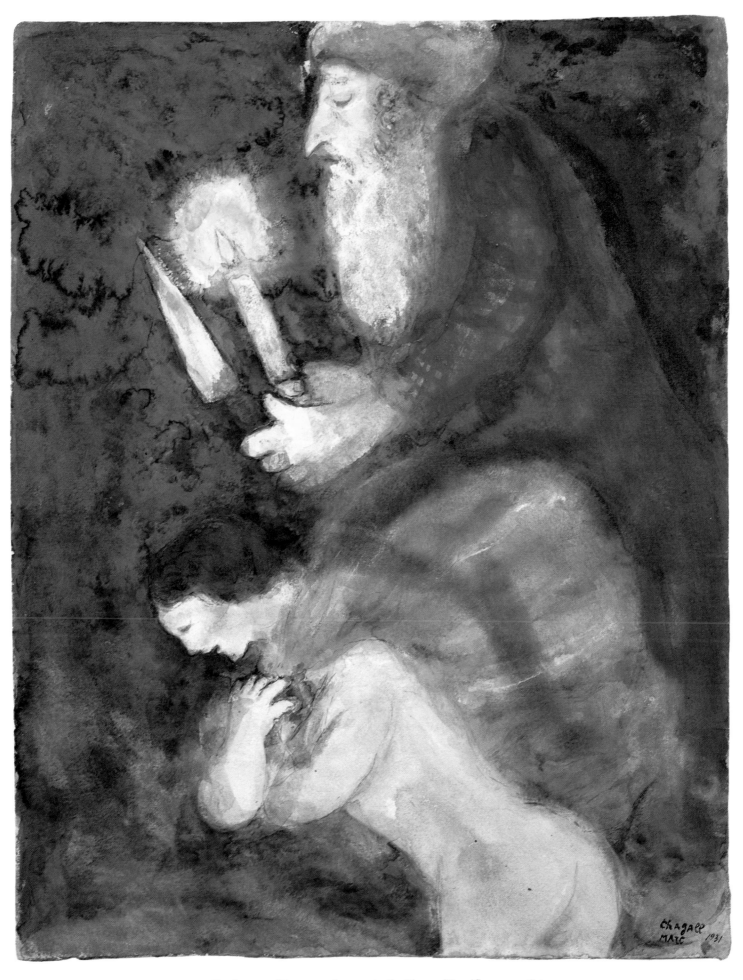

120 **Abraham and Isaac on the way to the Place of Sacrifice,** 1931. *Cat. 127*

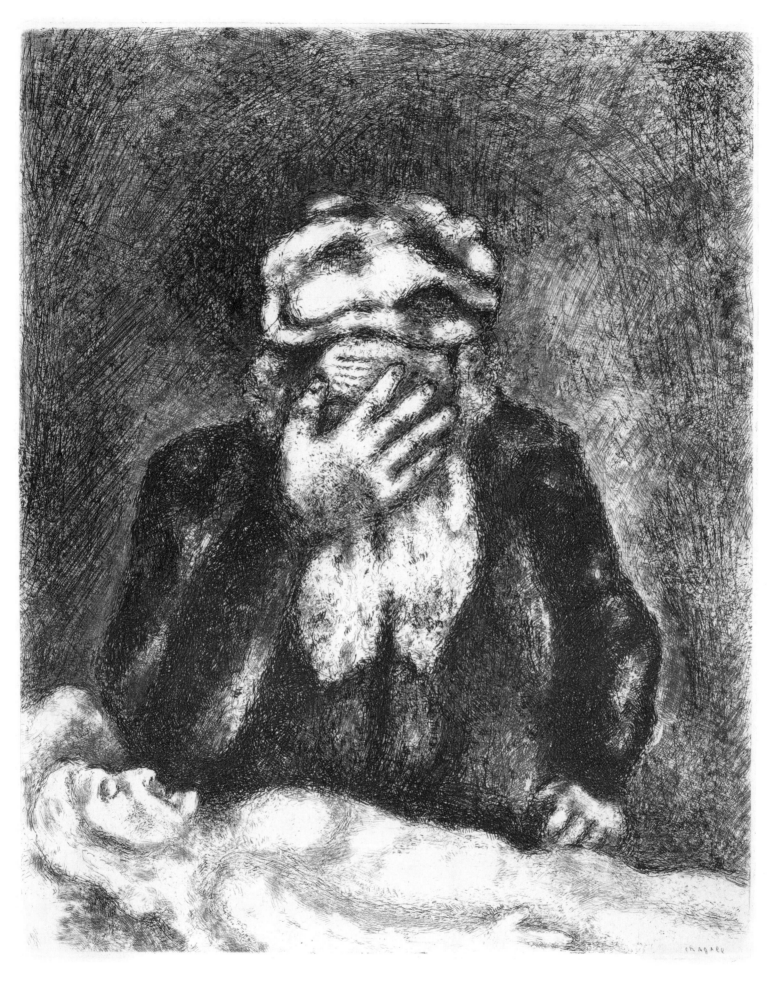

121 **Abraham weeps over Sarah,** Bible, sheet 11. *Cat. 128*

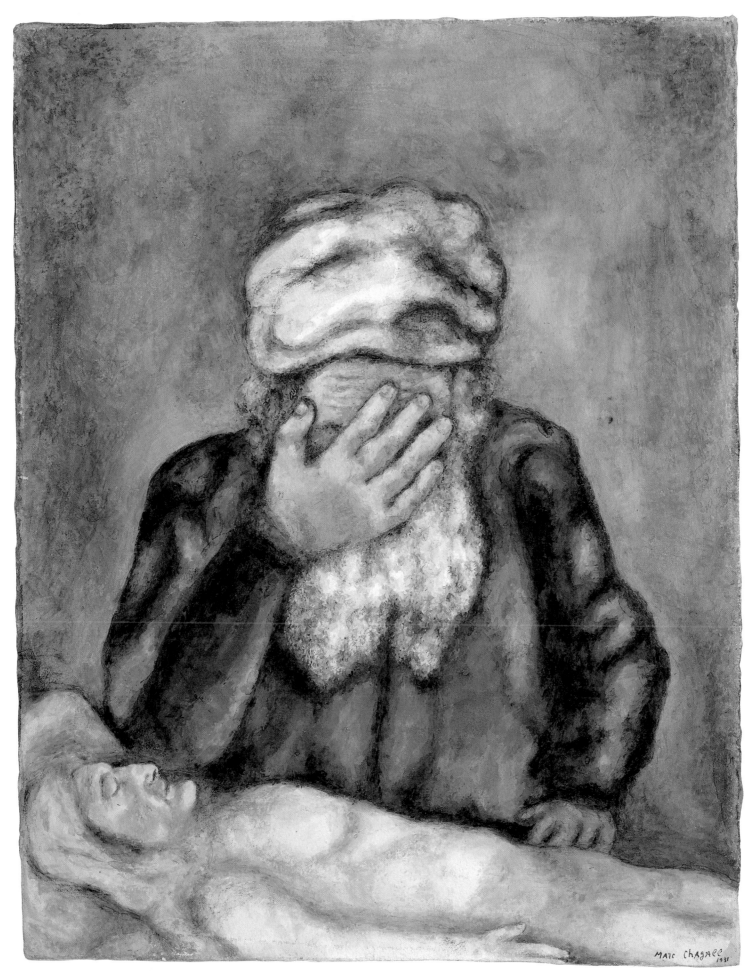

122 **Abraham weeps over Sarah,** 1931. *Cat. 129*

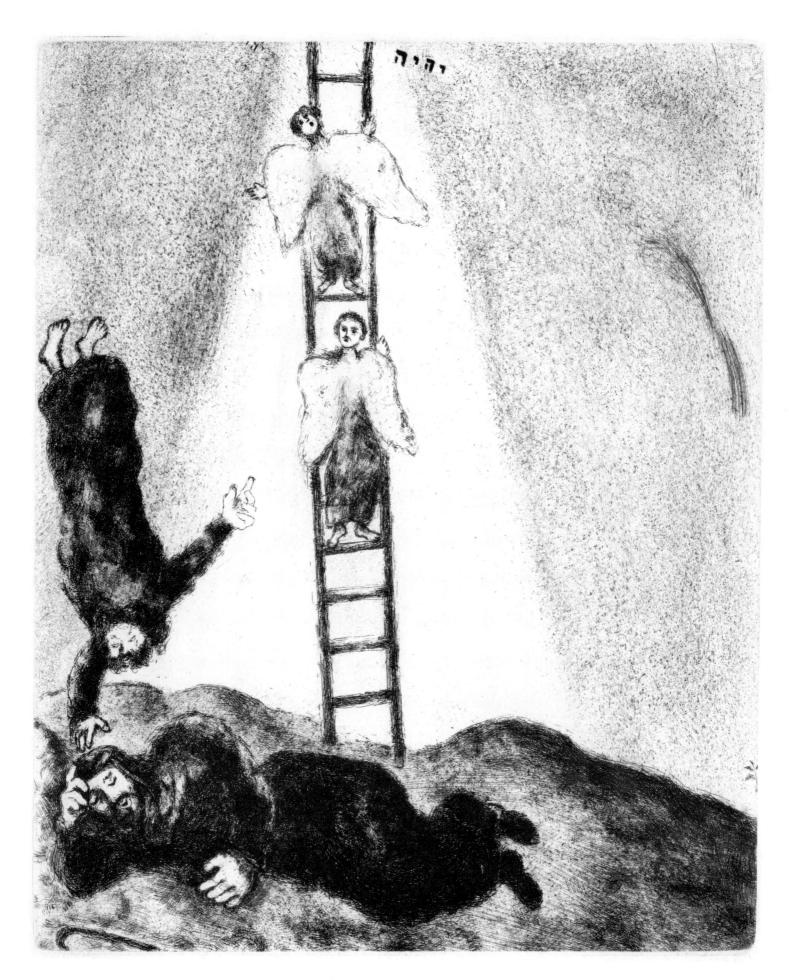

123 **Jacob's Ladder,** Bible, sheet 14. *Cat. 130*

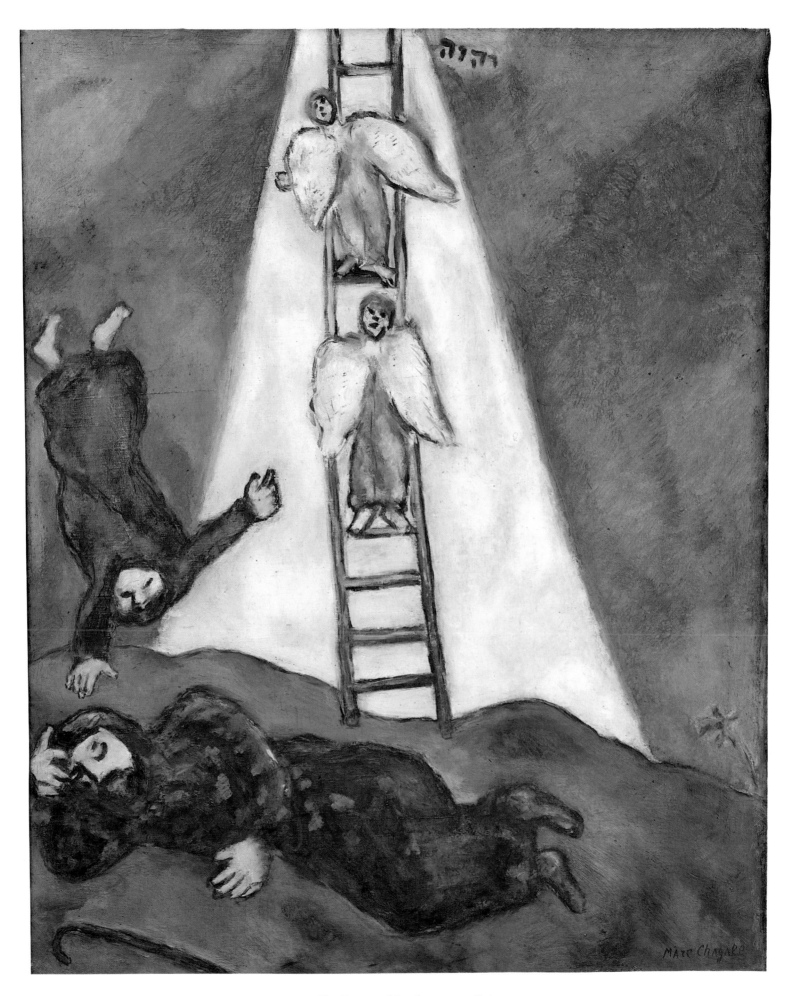

124 **The Dream of Jacob,** 1930-32. *Cat. 131*

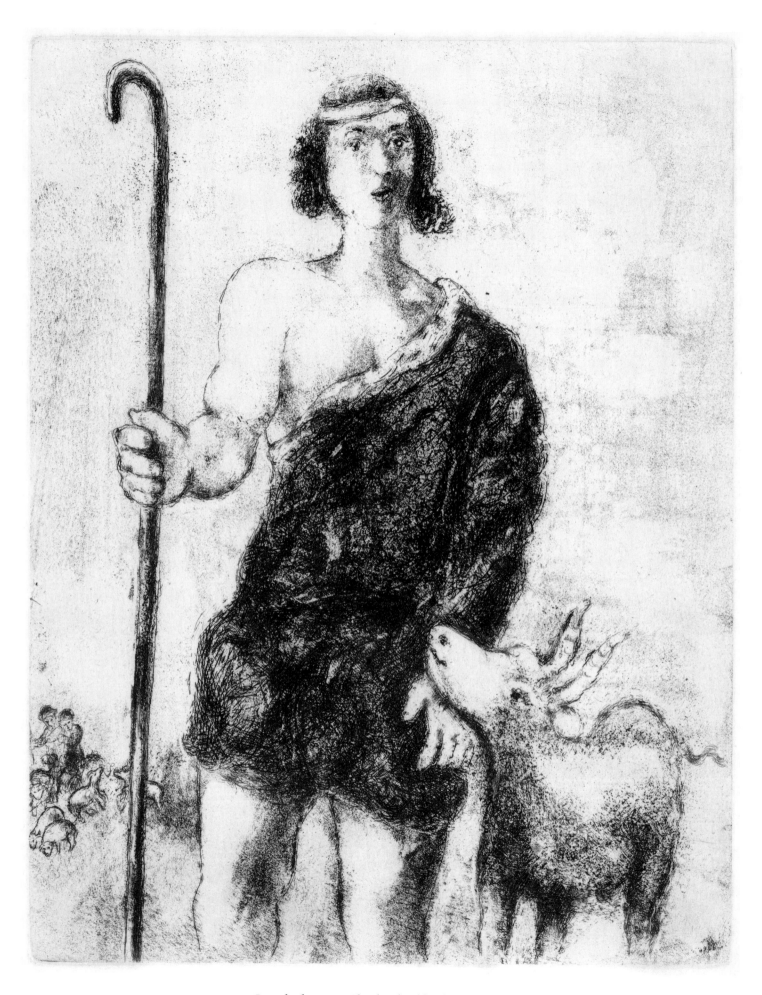

125 **Joseph, the young Shepherd,** Bible, sheet 18. *Cat. 132*

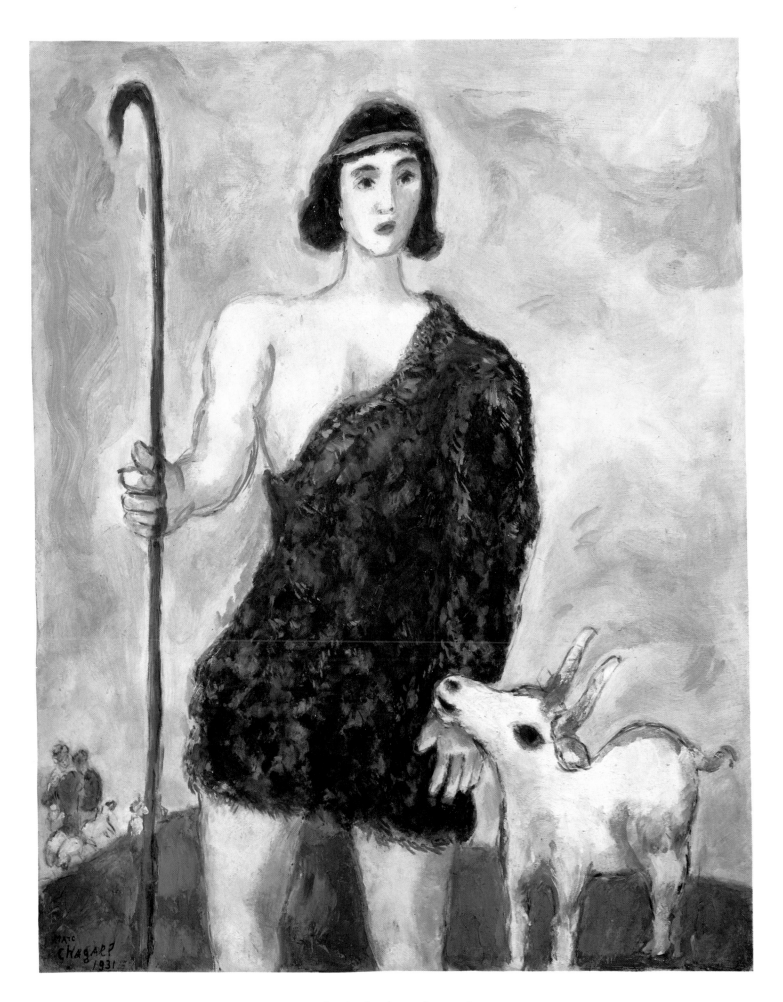

126 **The Shepherd Joseph,** *1931. Cat. 133*

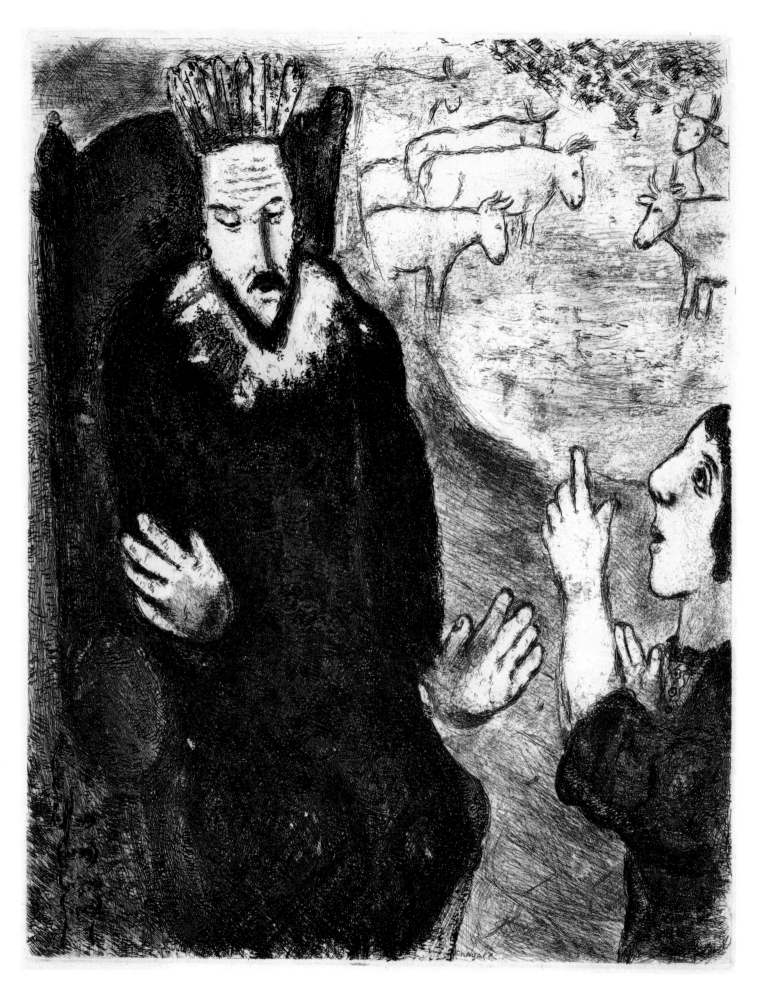

127 **Pharaoh's Dream**, Bible, sheet 22. *Cat. 134*

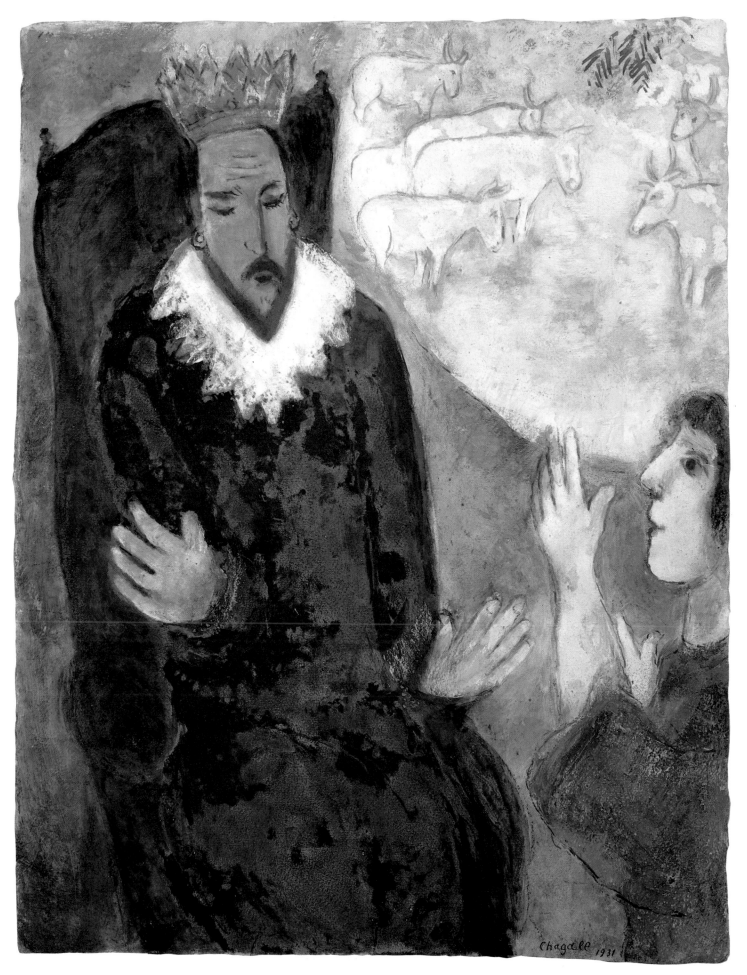

128 **Joseph interprets Pharoah's Dreams,** 1931. *Cat. 135*

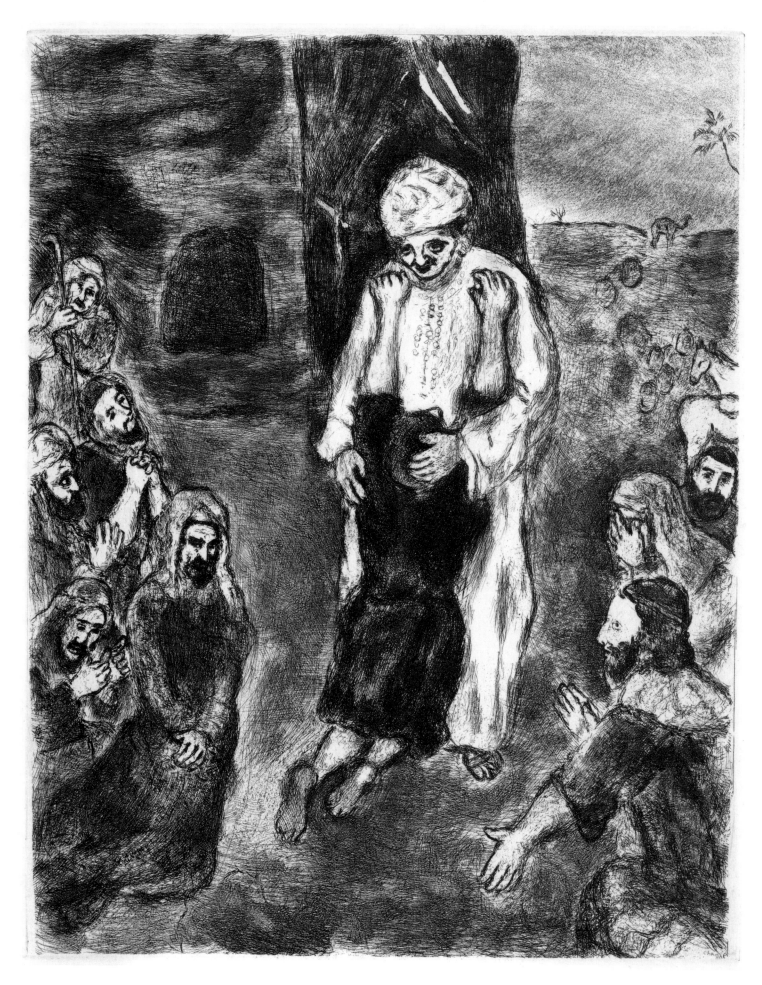

129 **Joseph recognized by his Brothers,** Bible, sheet 23. *Cat. 136*

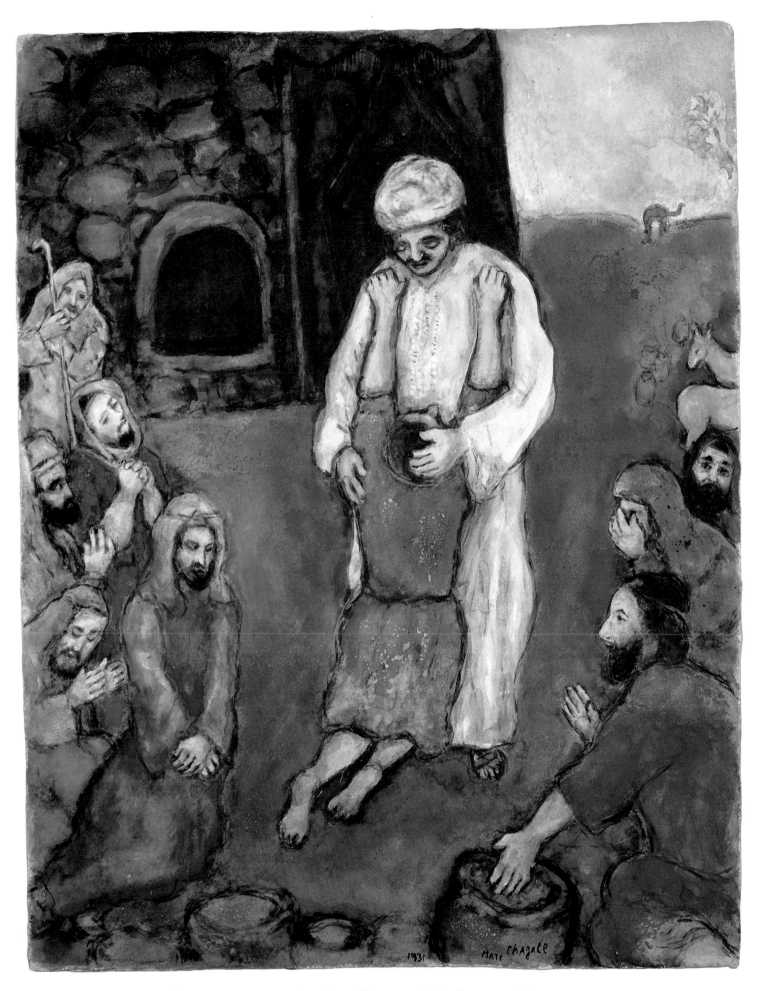

130 **Joseph making himself known to his Brothers,** *1931. Cat. 137*

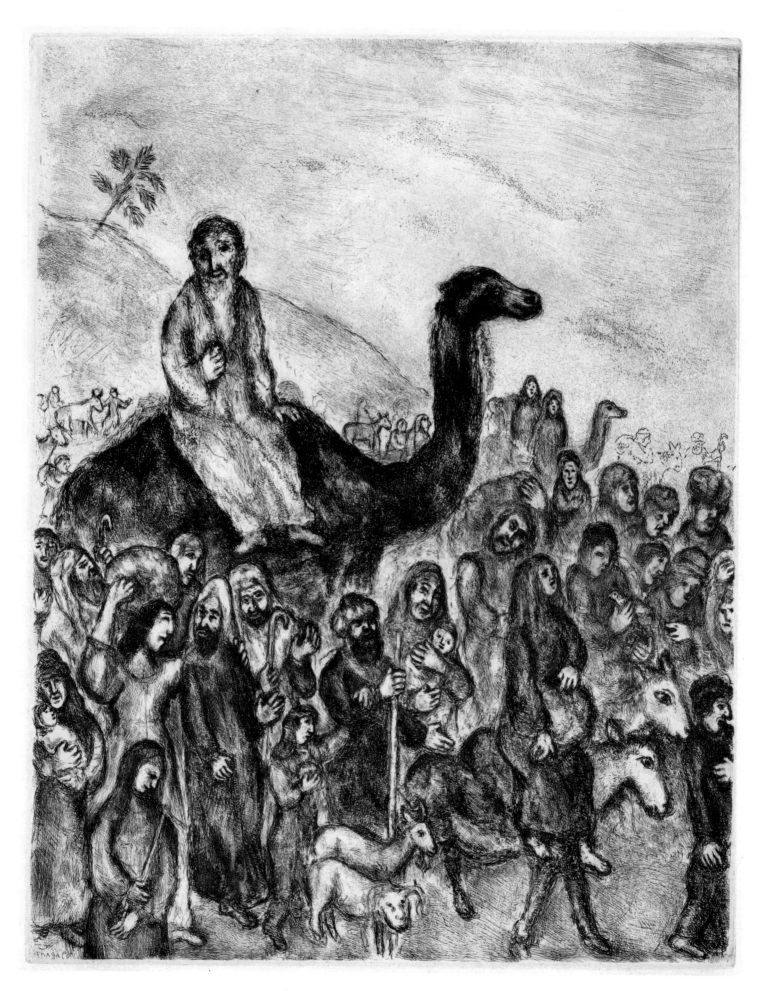

131 **Jacob's Departure for Egypt,** Bible, sheet 24. *Cat. 138*

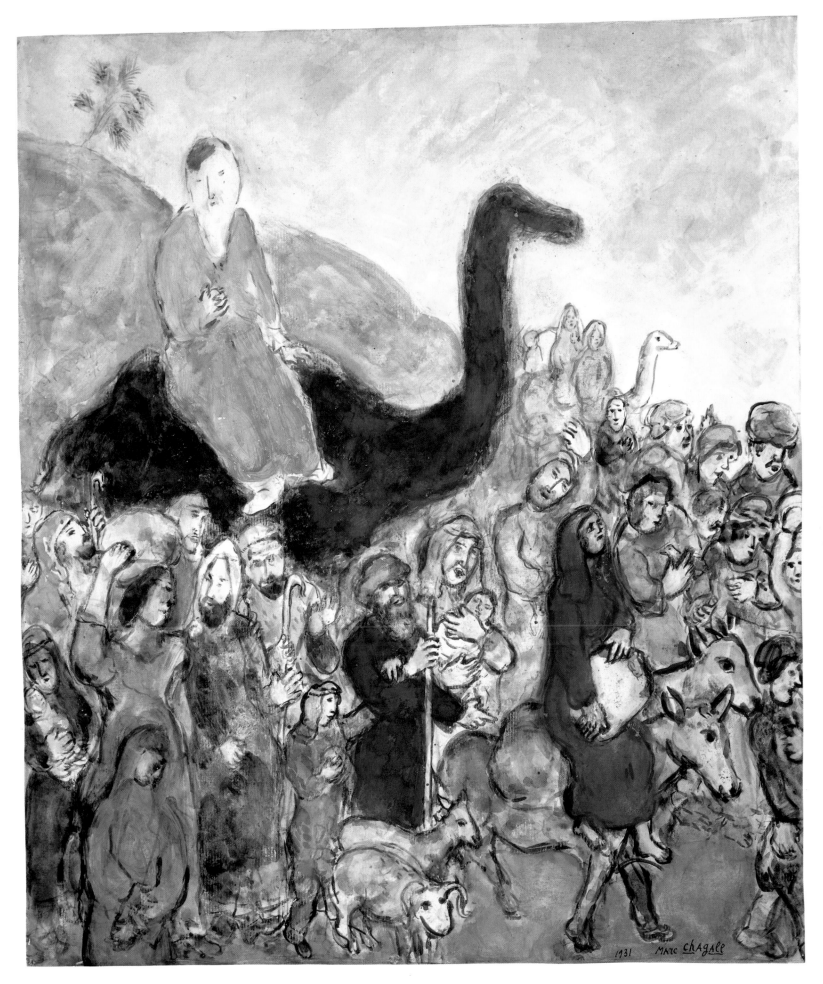

132 Jacob leaves his Homeland to go down to Egpyt, 1931. *Cat. 139*

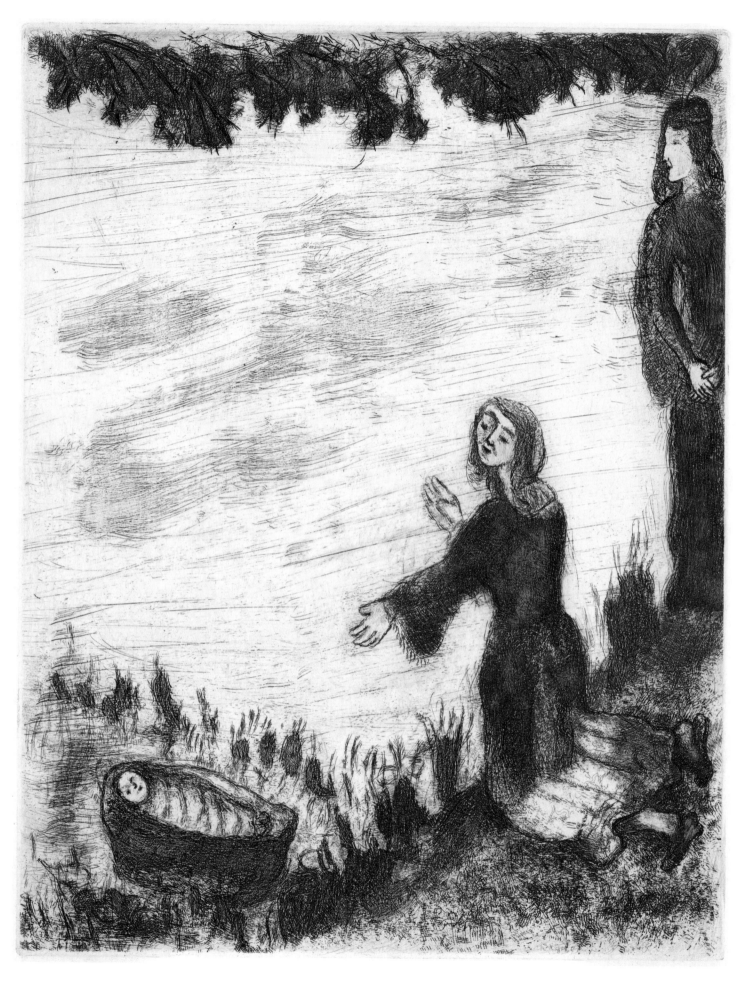

133 **Moses saved from the Water,** Bible, sheet 26. *Cat. 140*

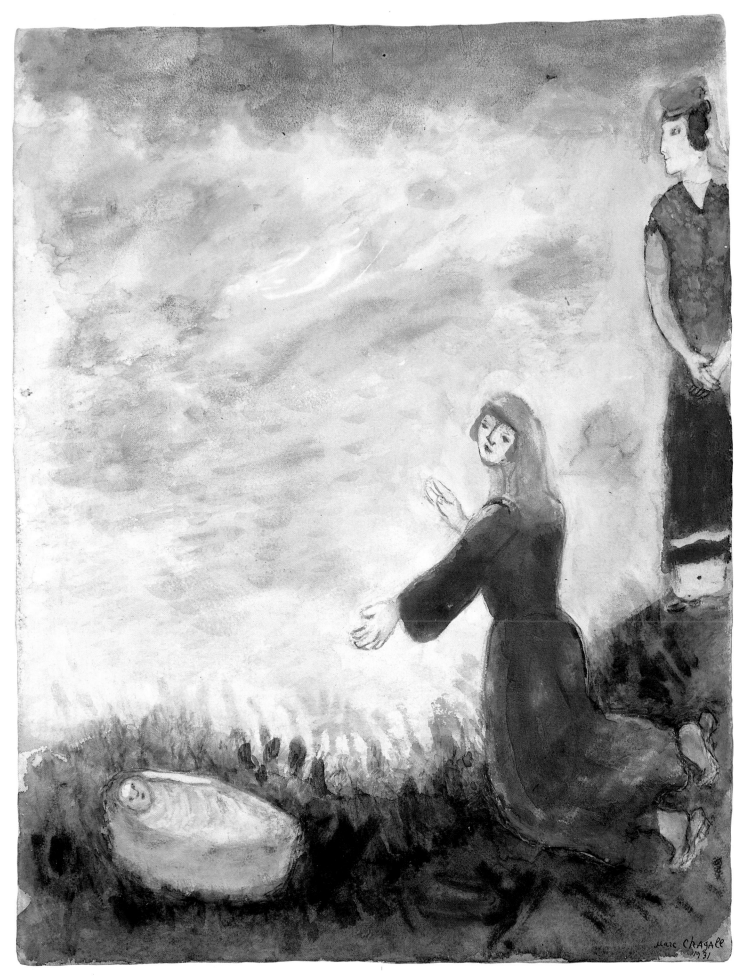

134 **Moses saved from the Water,** 1931. *Cat. 141*

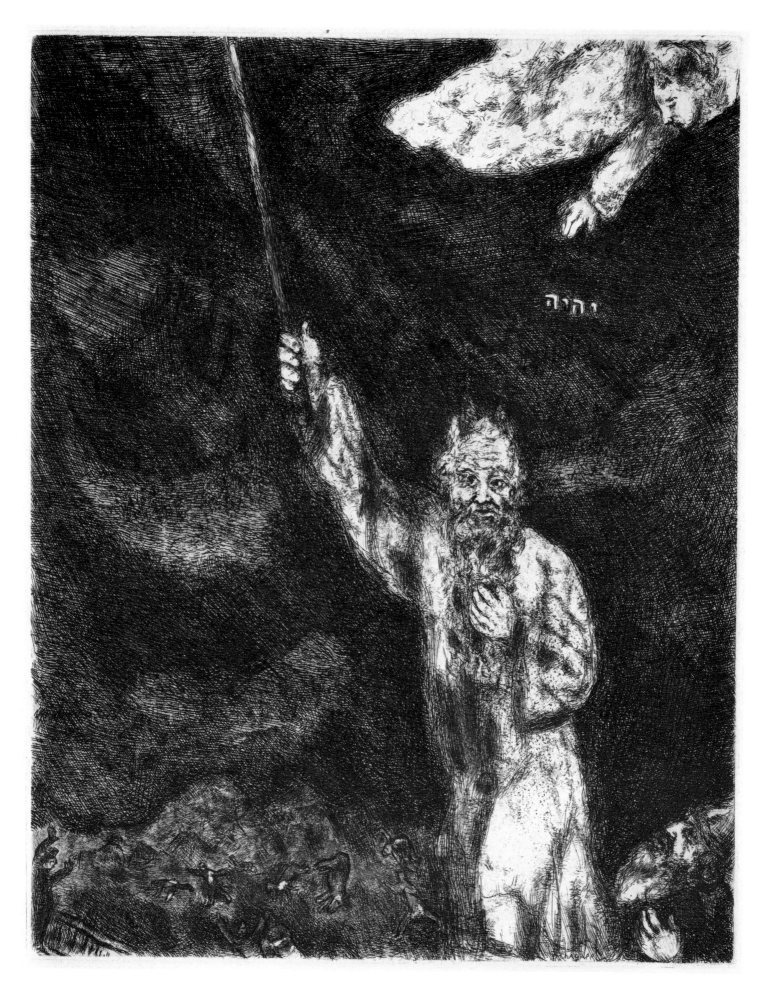

135 **Darkness over Egypt,** Bible, sheet 31. *Cat. 142*

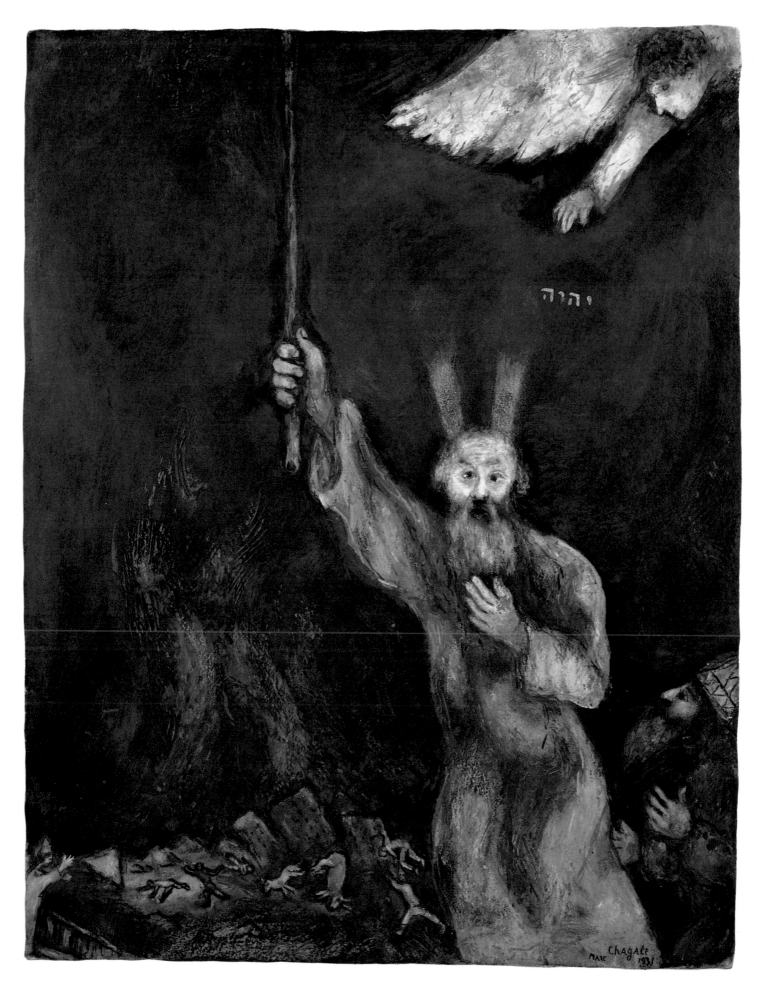

136 **Moses spreads Darkness**, 1931. *Cat. 143*

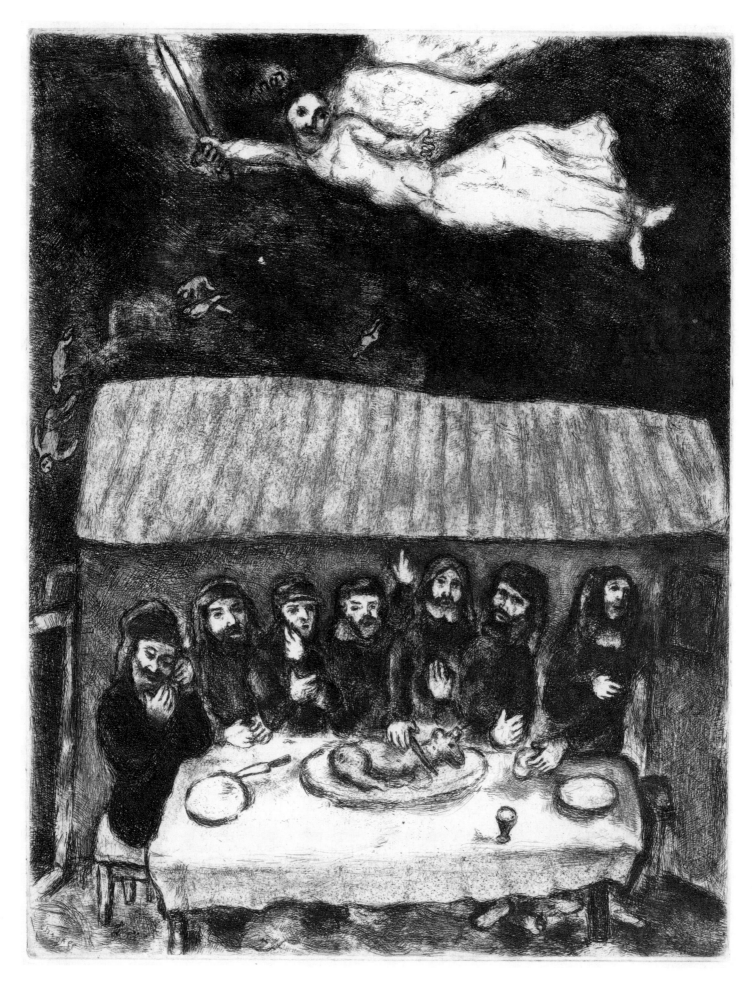

137 **The Passover,** Bible, sheet 32. *Cat. 144*

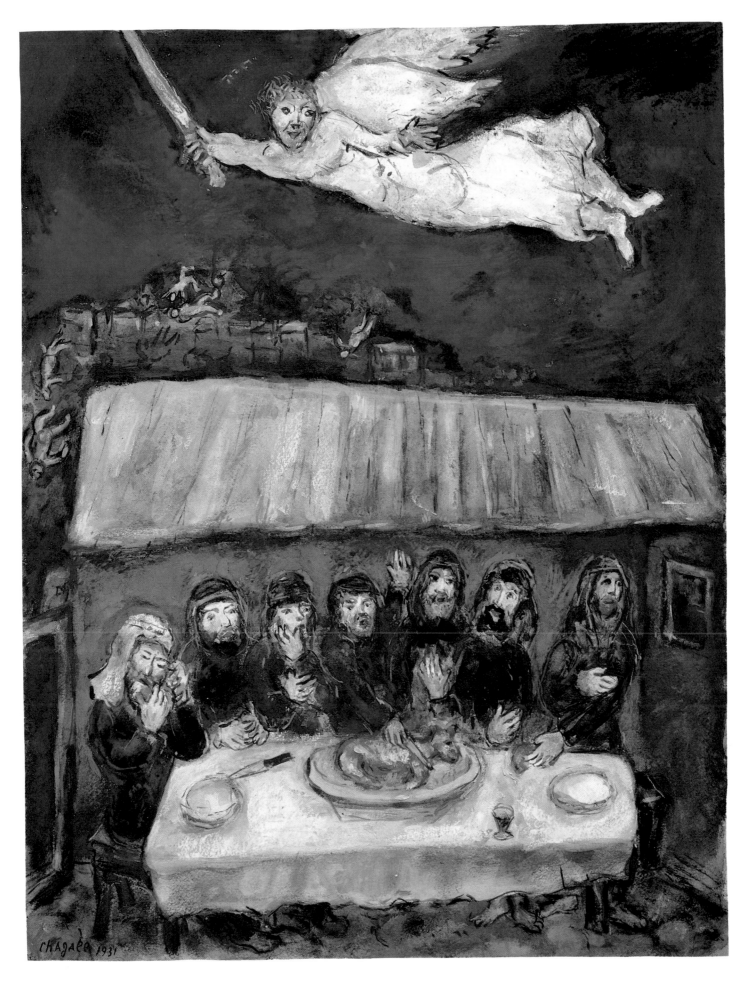

138 The Israelites eat the Passover Lamb, 1931. *Cat. 145*

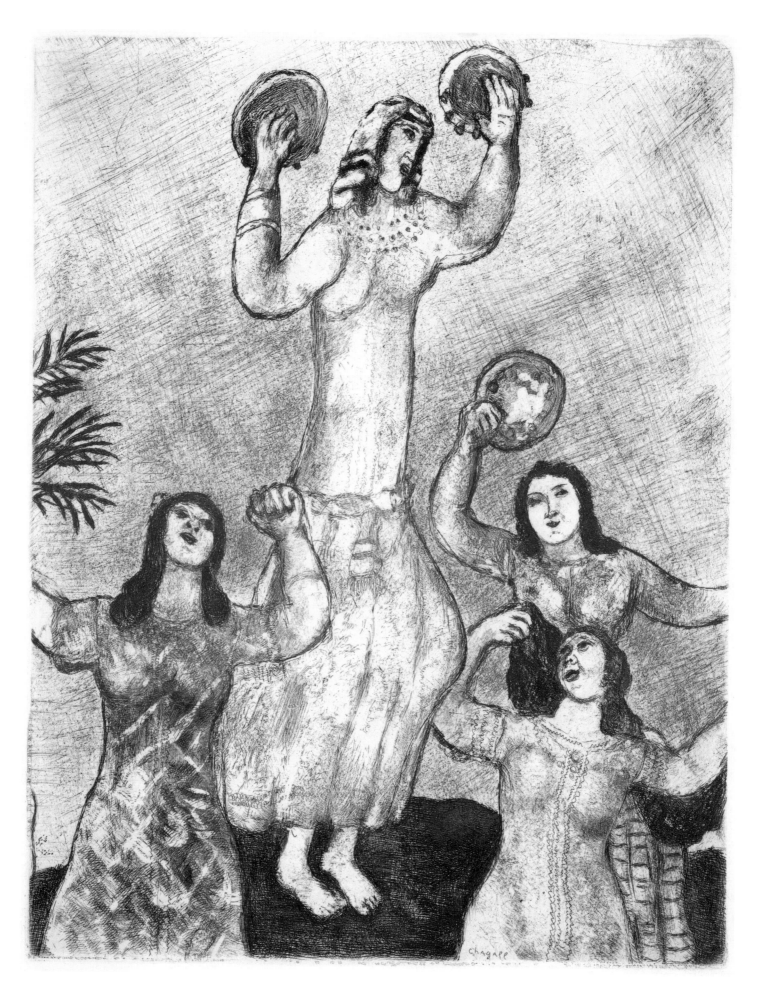

139 **Dance of Miriam, Sister of Moses,** Bible, sheet 35. *Cat. 146*

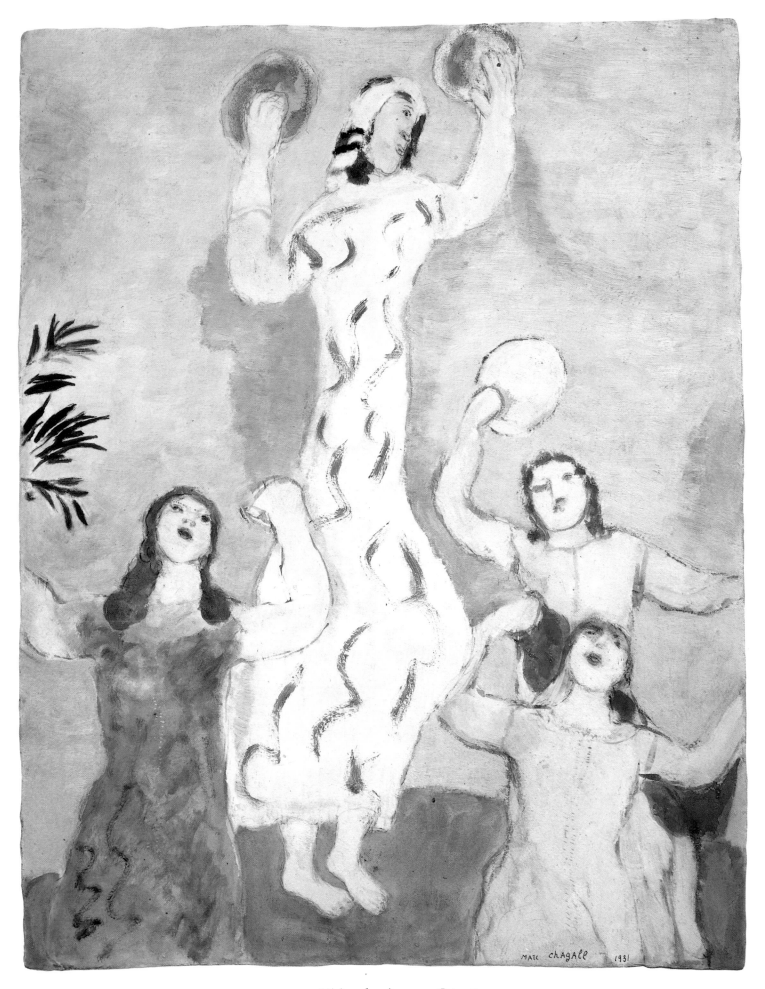

140 **Miriam dancing**, 1931. *Cat. 147*

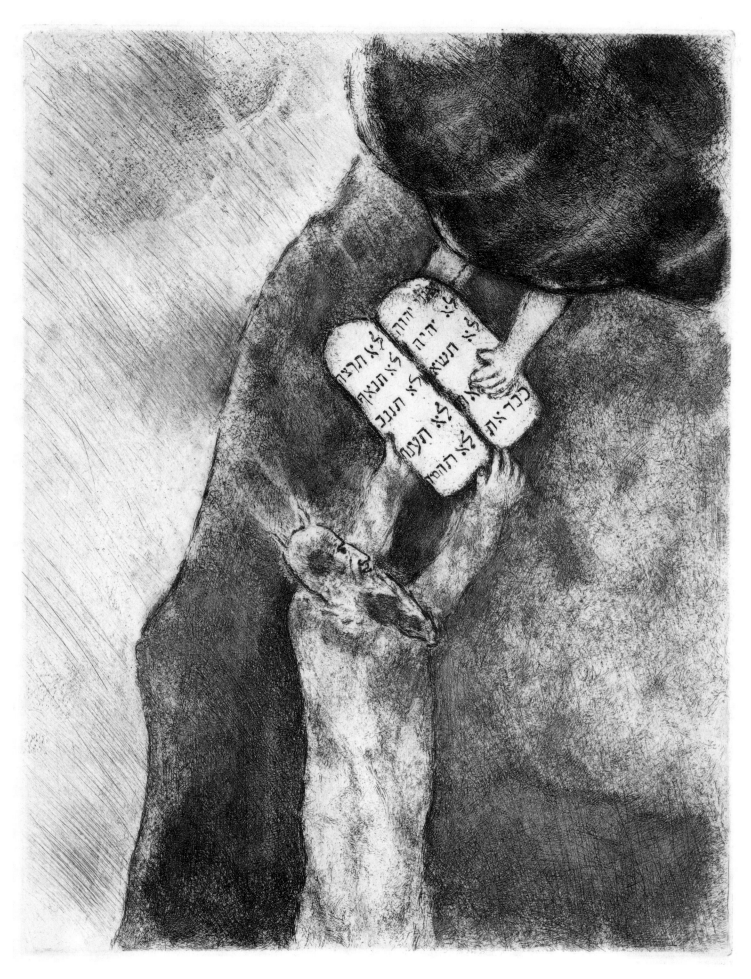

141 **Moses receiving the Tablets of the Law**, Bible, sheet 37. *Cat. 148*

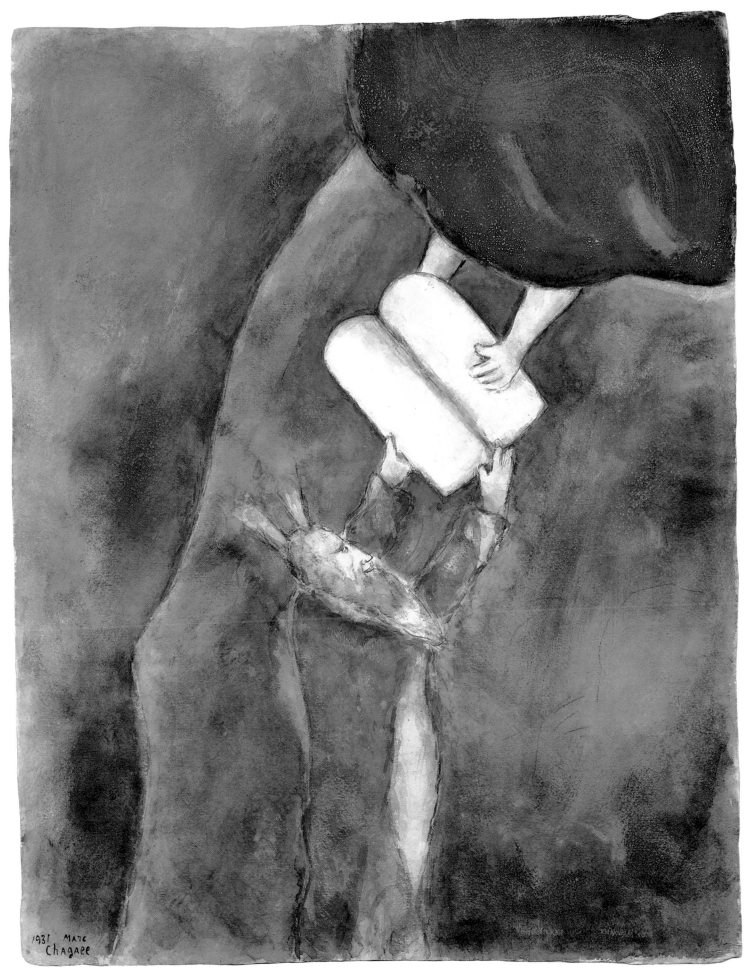

142 Moses receiving the Tablets of the Law, 1931. *Cat. 149*

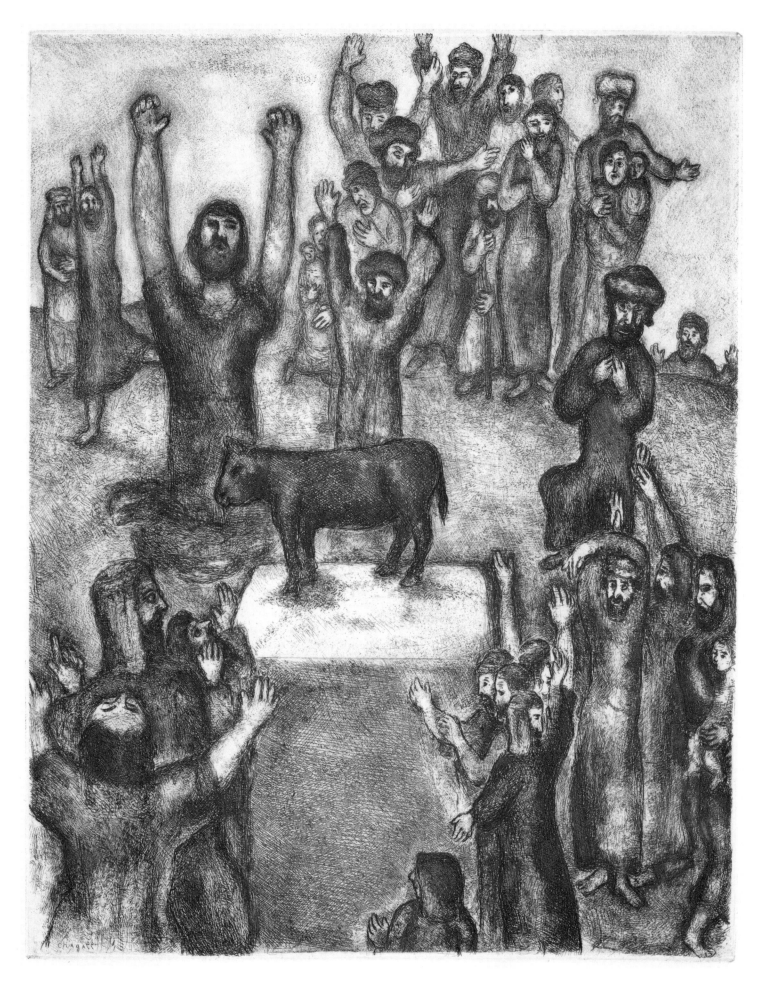

143 **The Golden Calf,** Bible, sheet 38. *Cat. 150*

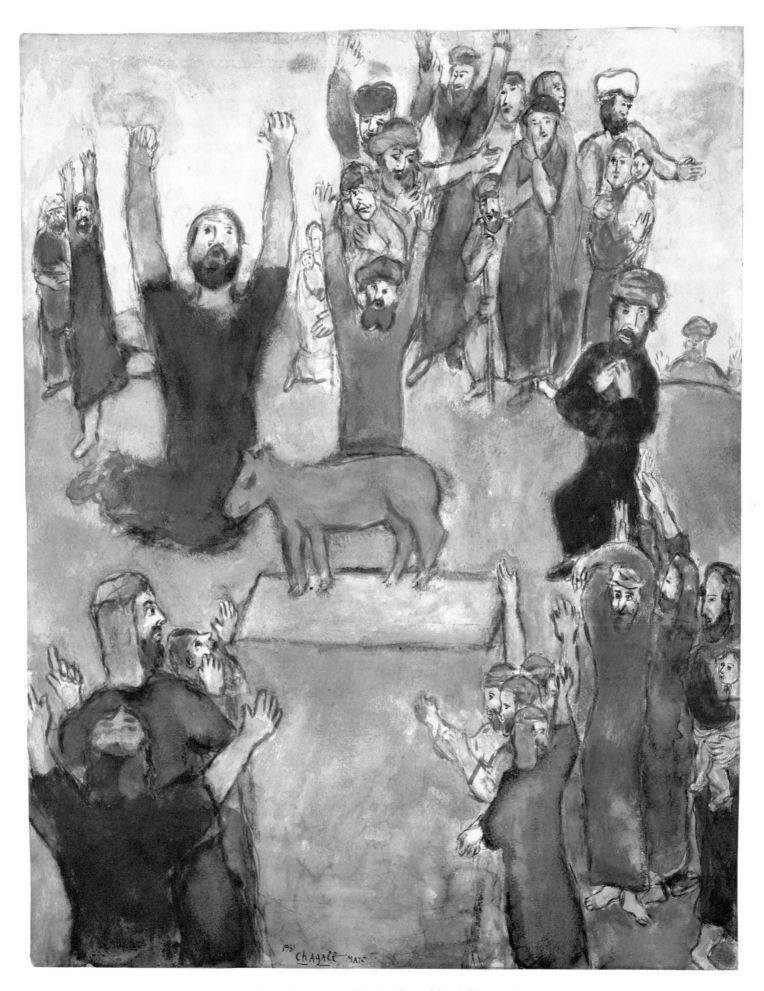

144 The Hebrews worshipping the Golden Calf, 1931. *Cat. 151*

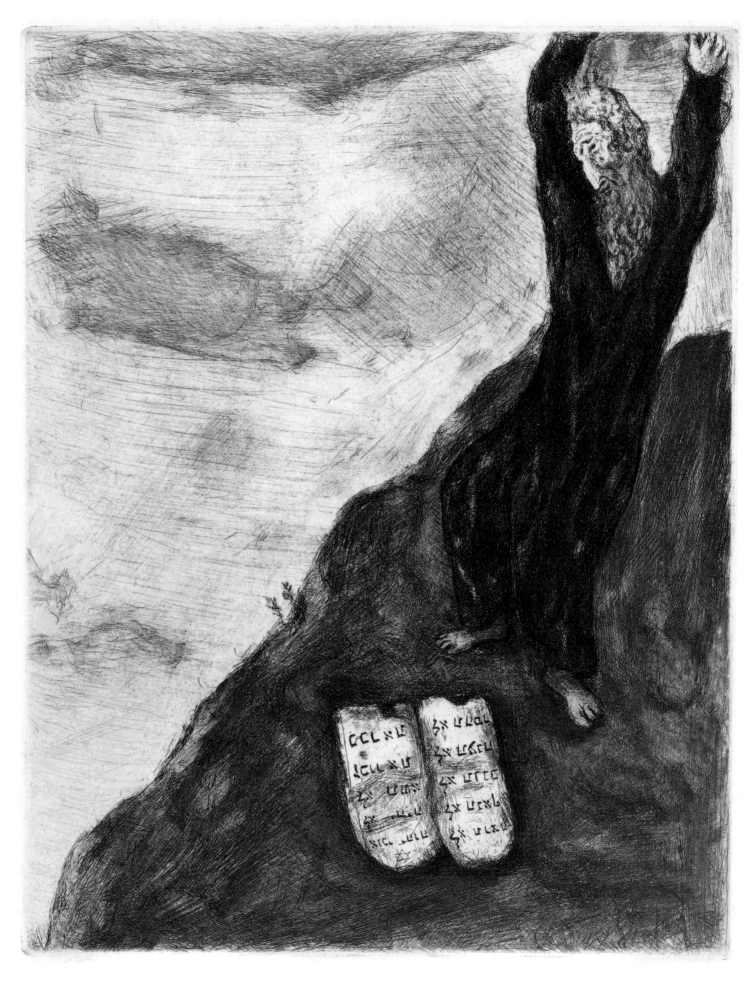

145　**Moses breaks the Tablets of the Law,** Bible, sheet 39. *Cat. 152*

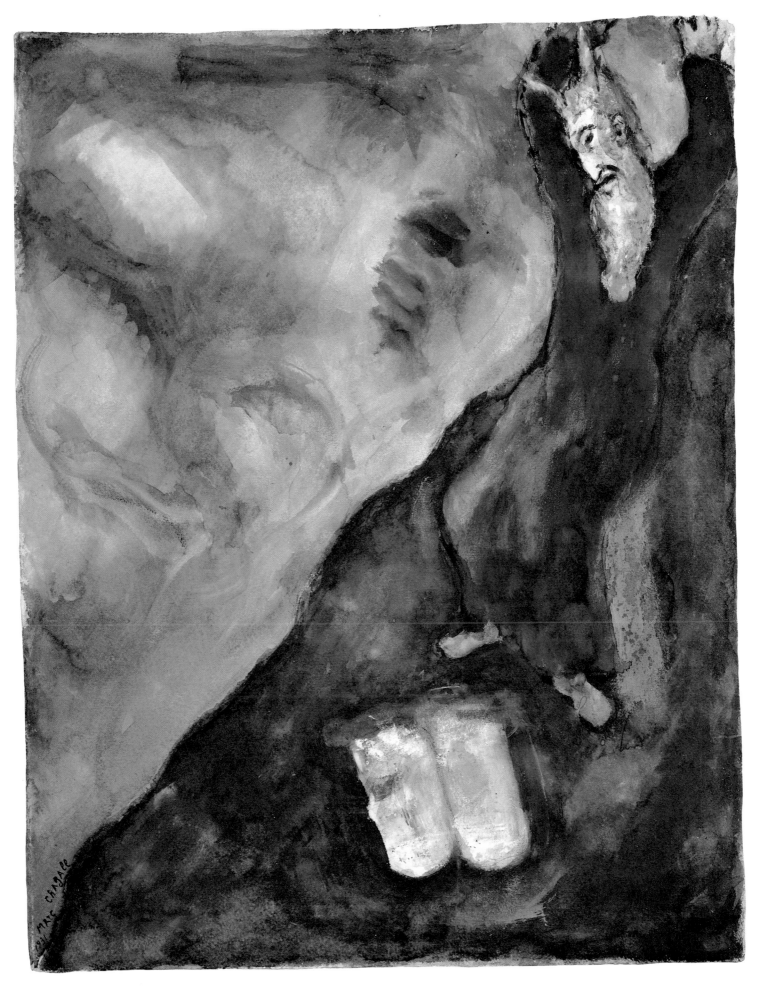

146 Moses breaks the Tablets of the Law, 1931. *Cat. 153*

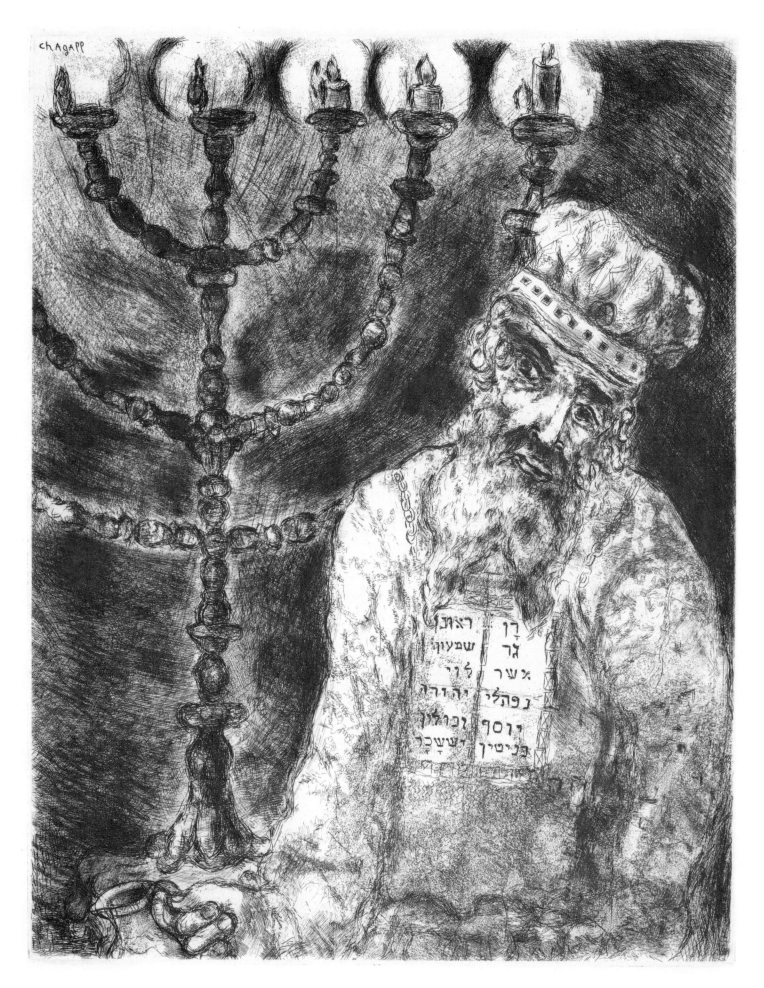

147 **Aaron and the seven-branched Candlestick,** Bible, sheet 40. *Cat. 154*

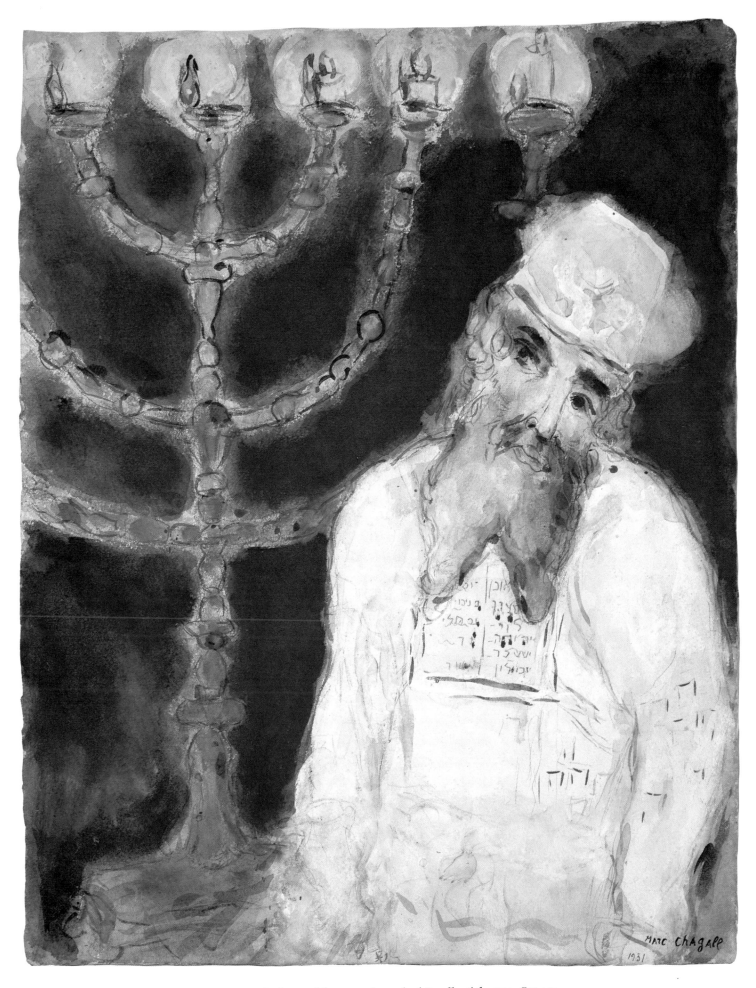

148 Aaron in front of the seven-branched Candlestick, 1931. *Cat. 155*

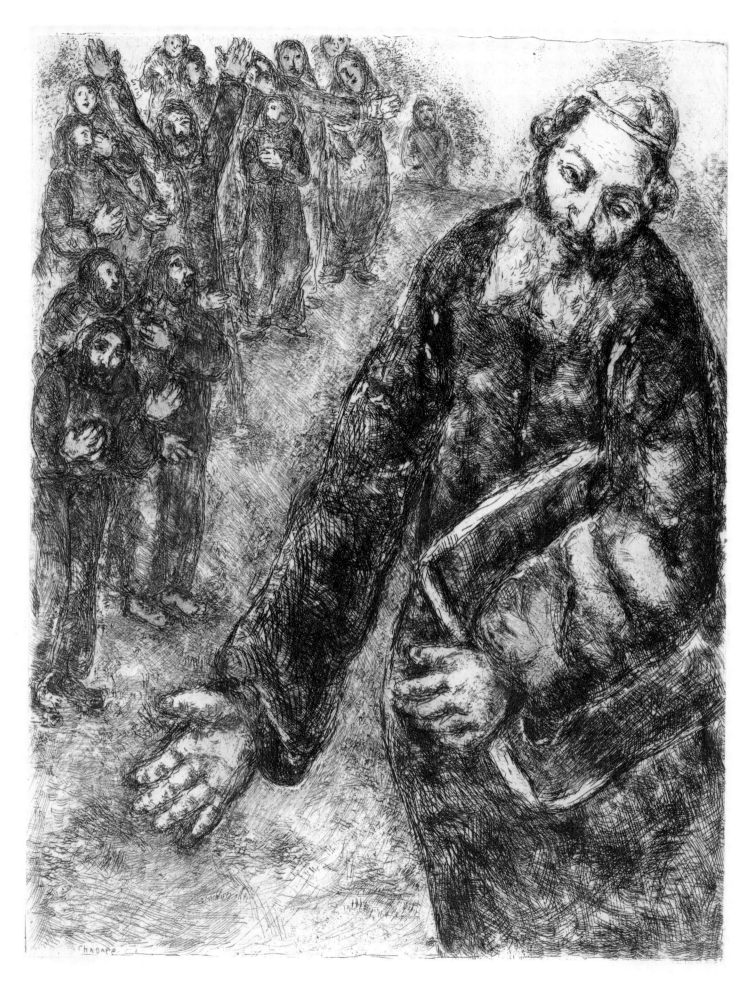

149 **Joshua reads the Word of the Law,** Bible, sheet 47. *Cat. 156*

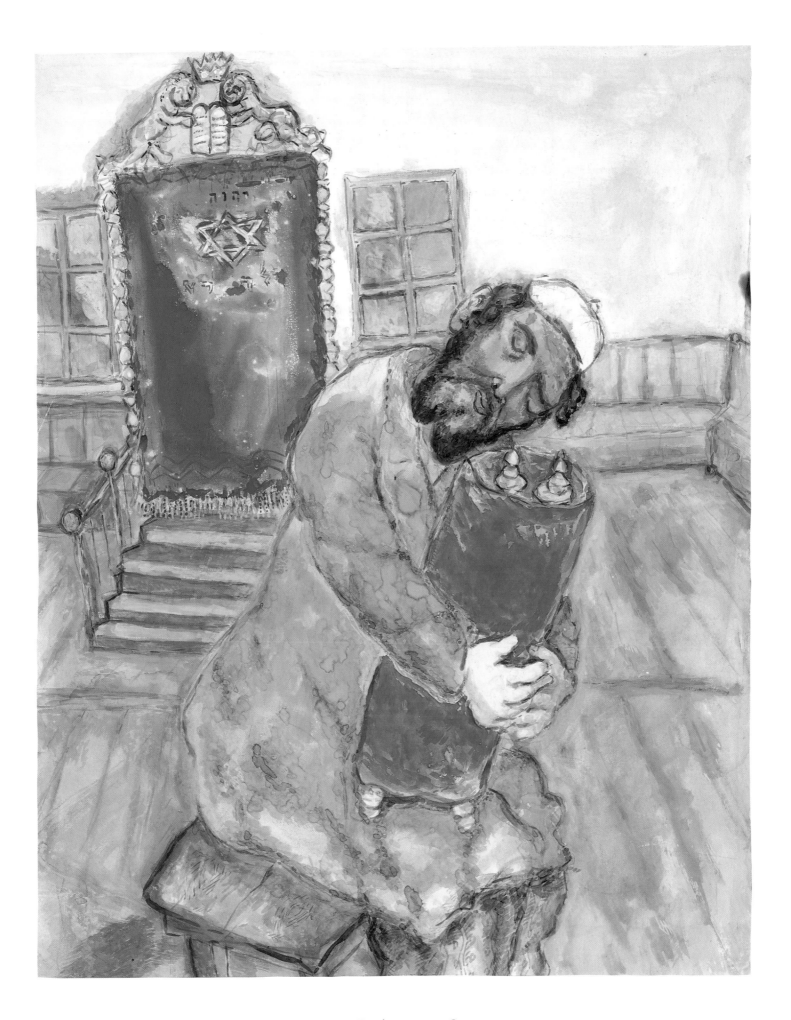

150 **Man Praying,** 1934-35. *Cat. 157*

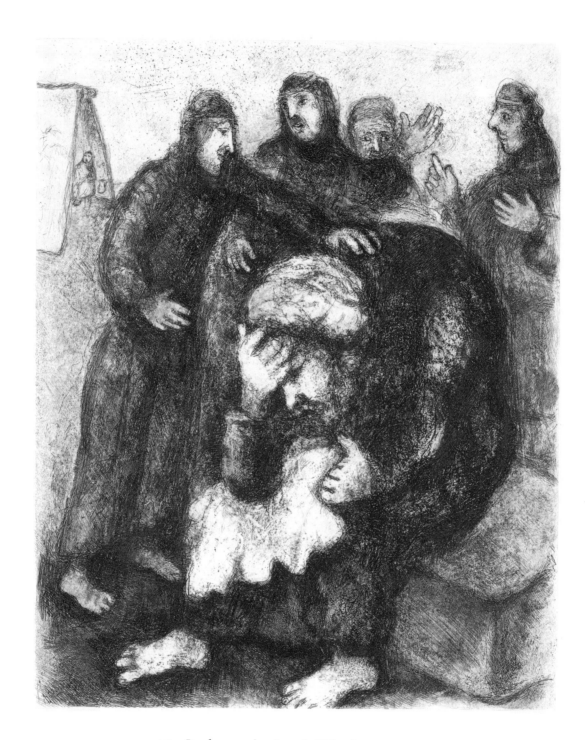

151 **Jacob mourning Joseph,** Bible, sheet 20. *Cat. 158*

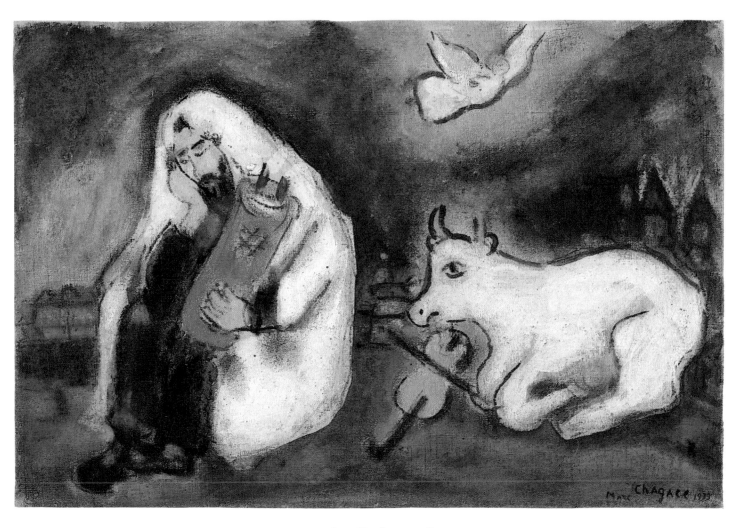

152 Study for **Solitude,** 1933. *Cat. 159*

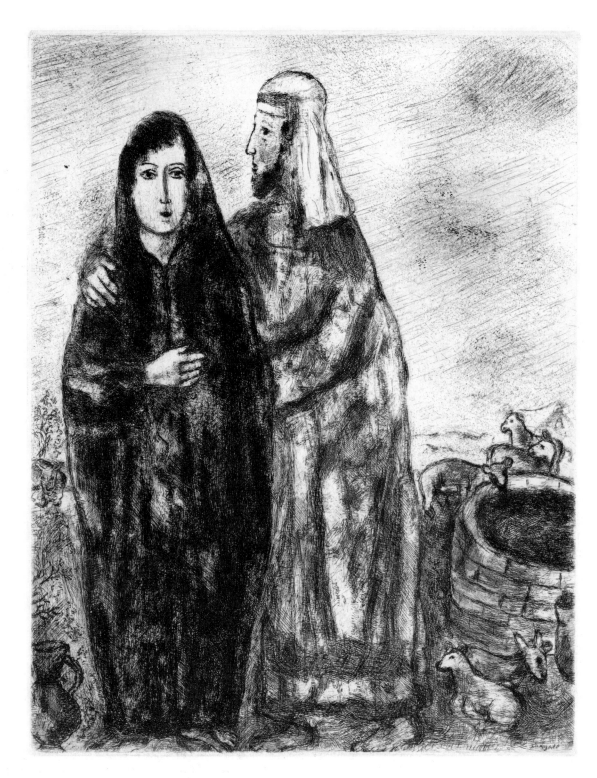

153 **Meeting of Jacob and Rachel,** Bible, sheet 15. *Cat. 160*

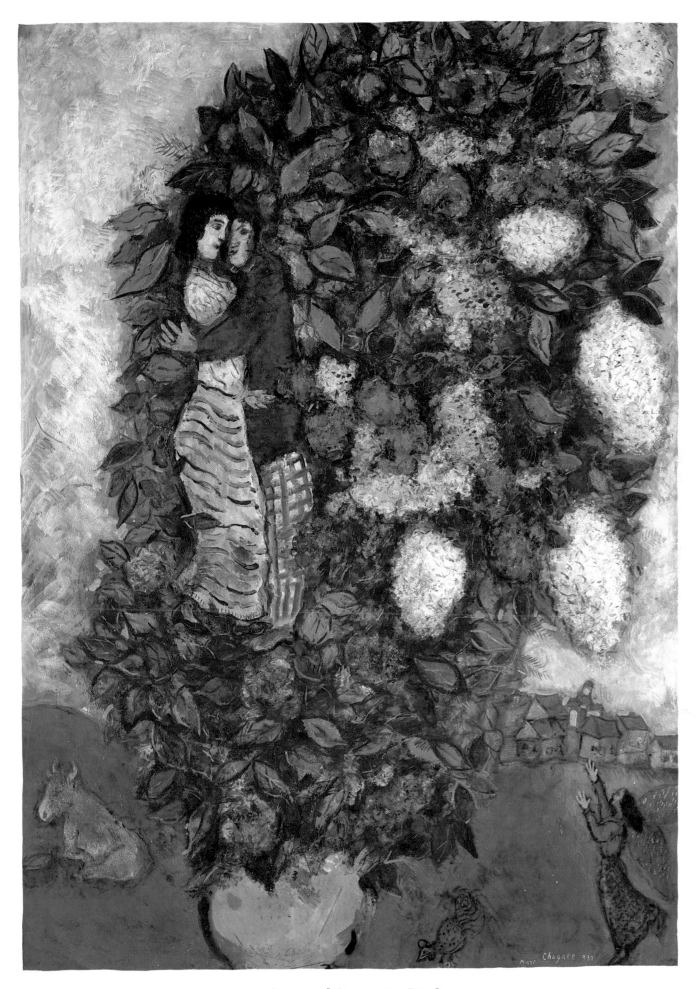

154　**Bouquet of Flowers**, 1937. *Cat. 161*

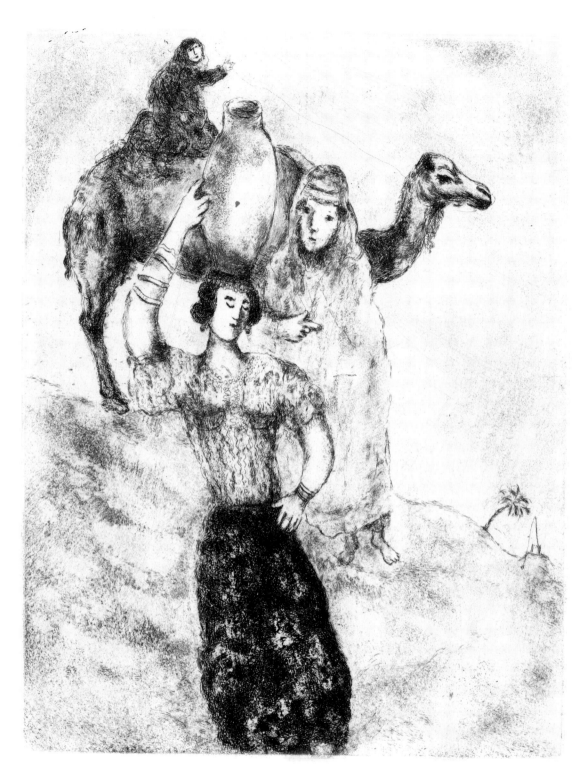

155 **Rebecca at the Well,** Bible, sheet 12. *Cat. 162*

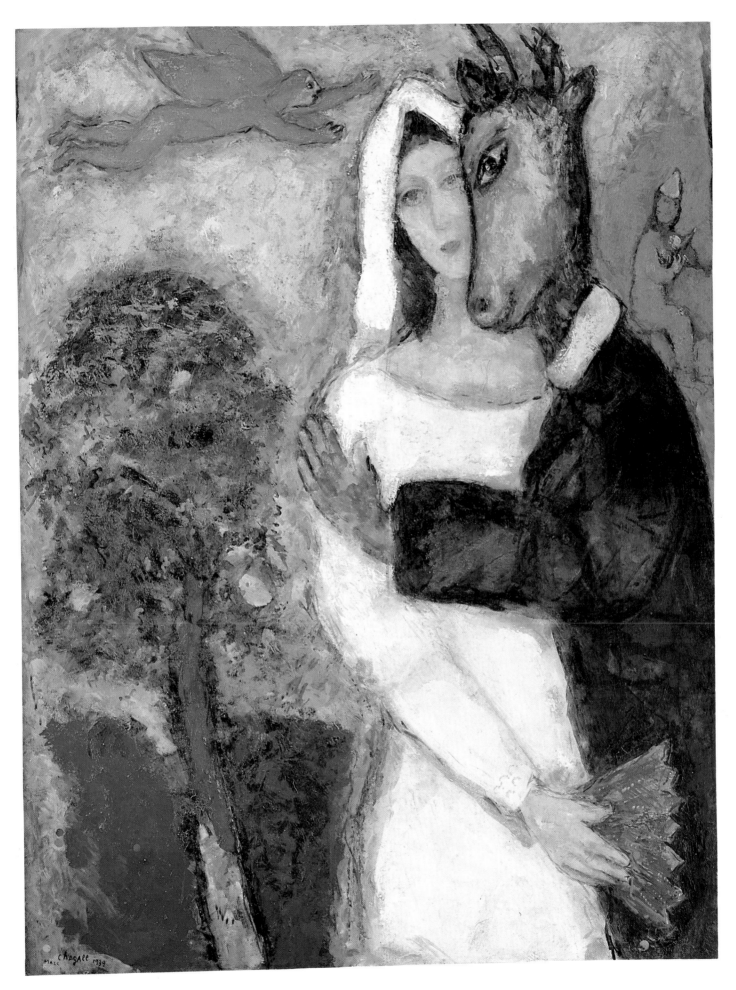

156　**A Midsummer Night's Dream,** 1939. *Cat. 163*

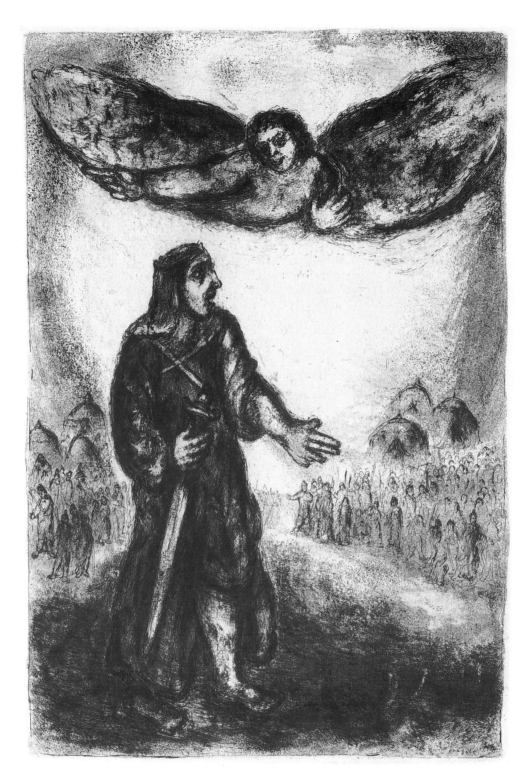

157 **Joshua before Jericho,** Bible, sheet 46. *Cat. 164*

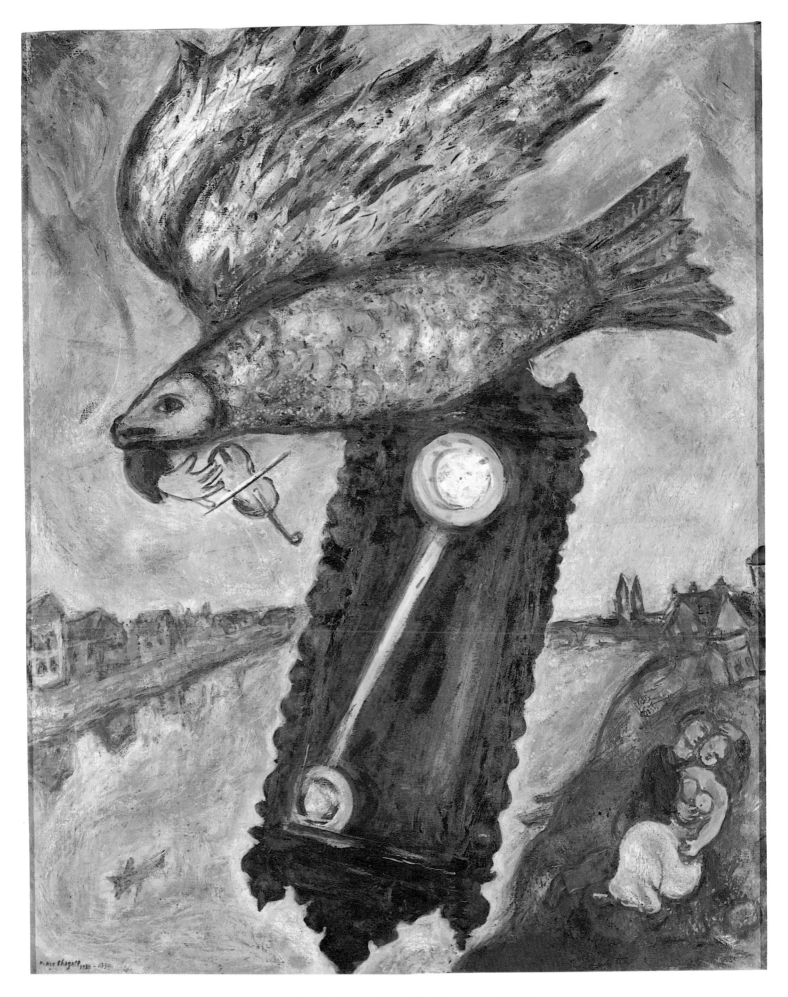

158 Time is a River without Banks, 1930-39. *Cat. 165*

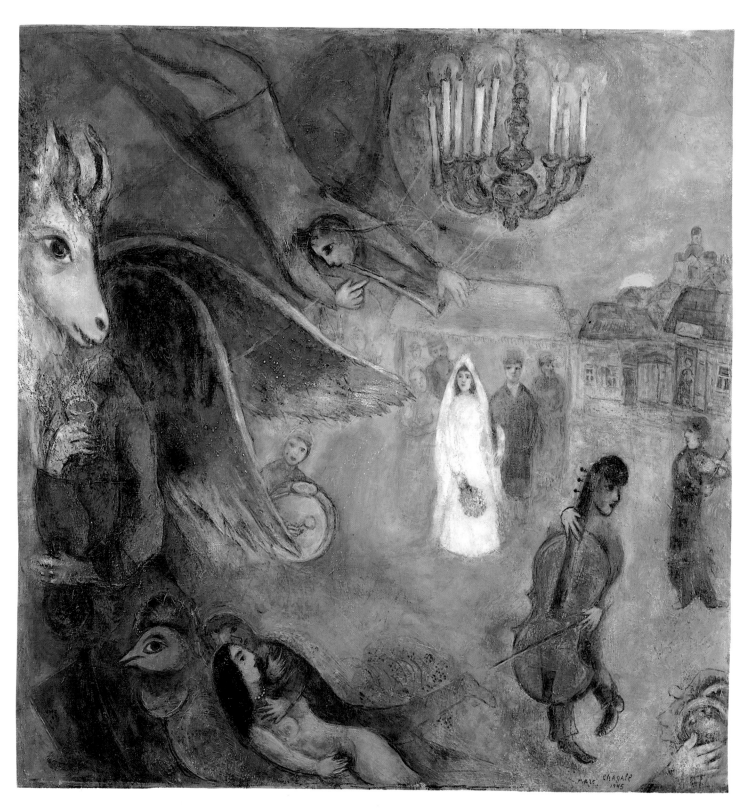

159 **The Wedding Candles,** 1934-45. *Cat. 166*

Catalogue

Note

Unless otherwise stated, all engravings are in the Sprengel Museum, Hanover.

All dimensions are given in centimetres, height before width.

Where possible, titles of works follow those established by Meyer (see below).

Passages from La Fontaine's *Fables* have been quoted from *La Fontaine: Selected Fables*, trans. James Michie, introduction by Geoffrey Grigson, Harmondsworth, Middx, 1989. Quotations from the Scriptures have been taken from *The New English Bible*, London, 1970.

The following publications are cited in abbreviated form:

Amishai-Maisels: Ziva Amishai-Maisels, 'Chagall and the Jewish Revival: Center or Periphery?', in *Tradition and Revolution: The Jewish Renaissance in Russian Avant-Garde Art 1912-1928*, Jerusalem, 1987, pp. 71-100.

Compton: Susan Compton, *Chagall*, London and New York, 1985.

Crespelle: Jean-Paul Crespelle, *Chagall: L'amour, le rêve et la vie*, Paris, 1969.

Haftmann: Werner Haftmann, *Marc Chagall*, New York, 1972.

Kamensky: Aleksandr Kamensky, *Chagall: The Russian Years 1907-1922*, London, 1989.

Kornfeld: Eberhard W. Kornfeld, *Verzeichnis der Kupferstiche, Radierungen und Holzschnitte von Marc Chagall*, Vol. 1: *Werke 1922-1966*, Berne, 1970.

Meyer: Franz Meyer, trans. Robert Allen, *Marc Chagall: Life and Work*, New York, n.d. [1964].

My Life: Marc Chagall, trans. Dorothy Williams, *My Life*, Oxford, 1989.

Rosensaft: Jean Bloch Rosensaft, *Chagall and the Bible*, New York, 1987.

Mein Leben and related works,
Berlin, 1922-23

In 1923 the gallery owner Paul Cassirer published twenty of the etchings which Chagall had made under the guidance of Hermann Struck, the master etcher who taught him the technique during his year in Berlin. The etchings were issued in a portfolio entitled *Mein Leben* (My Life), in a numbered edition of one hundred and ten copies. With the publication of six supplementary etchings (see Cat. 25 and Fig. 8) and a few lithographs (see Fig. 3), the portfolio was the principal work that Chagall made in Germany. Some of the prints are reproduced in this book with related earlier and later works which help to show how vivid memories of his upbringing coloured his creative imagination.

The title 'My Life' was taken from autobiographical writings which Chagall had brought from Russia: beginning with drawings of his father and mother (Plates 1, 7, Cat. 2, 8), the etchings included representations of significant events, such as his birth (page 217, *Mein Leben*, sheet 6), his place of birth (Plate 17, Cat. 18), the fire which meant that his mother had to be carried down the street with the newborn baby on the end of her bed (page 217, *Mein Leben*, sheet 7), and the artist's courtship and subsequent marriage to his sweetheart, Bella Rosenfeld (Plate 9, Cat. 10, and Fig. 5). These untitled scenes can be identified with the help of *Ma Vie*, the 1931 French translation of Chagall's autobiography made from the Russian by Bella, who went over the text line by line with the artist in order to produce a version which satisfied him. As has been noted above (see p. 11), in 1923 Cassirer had failed to publish a German translation of the text with the etchings as illustrations, because Chagall's unusual literary style had proved too difficult for Cassirer's gallery manager, Walter Feilchenfeldt, to translate.

Since the first edition of 1931, *Ma Vie* has been translated into several languages, including German in 1959[1] and English in 1960,[2] though no one has attempted a re-translation from the Russian and some passages were omitted in later editions. The 1931 text has recently been analysed by Ziva Amishai-Maisels, who elucidated many of Chagall's references to his contacts in Russia.[3] With the exhibition 'The Jewish Renaissance in Russian Avant-Garde Art', shown in 1989 in Frankfurt and 1990 in Los Angeles, it has become clear that Chagall's work before he left Russia should be seen in relation to the attempt by a wide group of artists and critics to create a genuinely Jewish modern art. It is necessary, therefore, to consider Chagall's 1917 *The Synagogue* (Plate 12, Cat. 13) in the context of contemporary documentation by El Lissitzky and Issachar Ber Ryback of decorative details from Jewish synagogue buildings,[4] though in his characteristic way Chagall transformed history into personal memories. *The Synagogue* is paired here with the etching from

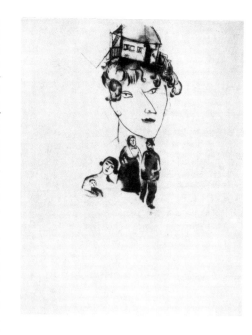

Cat. 1

Mein Leben in which he imagined his scripture teacher as a clown-like figure (Plate 11, Cat. 12).

Chagall had given his opinion of 'Jewish' art in an article in a new Yiddish journal published before he left Russia,[5] where he dated the waning of national boundaries in art to the Renaissance and made it clear that international art is what counts in our times. Paradoxically, and typically for Chagall, he ended: 'And then I think to myself: If I weren't a Jew (with the content that I give this word), I would never have become an artist, or I would have become a different one.'[6] These mixed feelings may have contributed to the lack of new works from his year in Berlin. There were also practical reasons: he moved four times in the year; he had no studio; and he spent a great deal of time trying to recover the paintings which he had left at Herwarth Walden's Galerie Der Sturm in 1914 (see pp. 16, 261).

Although the images collected as *Mein Leben* can be interpreted as Chagall's way of keeping alive memories of his life in Vitebsk, where sixty per cent of the population were Jews, the portfolio was equally the result of his learning a traditional graphic technique, at the time unfashionable in Western Europe and Russia. Chagall had previously worked in black and white: his ability to make strong images easily reproduced by mechanical means (collotype) is shown by *Peasant Eating* (Plate 4, Cat. 5). However, in the second decade of the century most of Chagall's Russian contemporaries were using transfer lithography for their illustrations; the technique gave their drawings, transferred on to a stone or zinc plate and printed in a few hundred copies, the look of art works

rather than mechanical reproductions. In Berlin Chagall first explored that technique (Cat. 26), but he clearly found engraving more rewarding. The plates of *Mein Leben* show the wide range of inventive marks which he scratched directly on the copper plate with varying sized needles. They gave a crisper and livelier effect when printed than that which he achieved with lithography or pen and ink drawing, which he none the less continued to use in Berlin (see Plate 16, Cat. 17).

The *Mein Leben* etchings proved a turning point in Chagall's career, since they resulted in the Parisian dealer Ambroise Vollard commissioning Chagall to make book illustrations. Although this was a result rather than the aim of learning etching, when Chagall left Berlin for Paris he had equipped himself with the means to support his family for the next eighteen years.

1 Marc Chagall, *Mein Leben*, trans. Lothar Klunner, Stuttgart, 1959.
2 Marc Chagall, *My Life*, New York, 1960.
3 Amishai-Maisels, passim.
4 See *Tradition and Revolution: The Jewish Renaissance in Russian Avant-Garde Art 1912-1928*, Jerusalem (The Israel Museum), 1987, cat. nos 67-71, 119.
5 Marc Chagall, 'Bletlakh', *Shtrom*, No 1, 1922, pp. 44-6; republished, with minor changes, as 'Eygens', *Die Zukunft*, June 1925, pp. 409-10 (both articles in Yiddish).
6 Translated in full in Amishai-Maisels, pp. 71-2; this quotation, p. 72.

1 *Self-Portrait*
Mein Leben, sheet 17, 33/110
Etching and drypoint
27.5 x 21.5 on leaf, 44.5 x 35

This self-portrait gives the essence of Chagall; he has imagined himself with his nearest and dearest, who continued to provide the inspiration for his art. It is a modern 'group portrait' which owes nothing to photography and everything to the freedom of manipulating shapes and scale practised by contemporary abstract artists. Yet the viewer is deceived because the elements are completely recognizable although the composition is modernist. Chagall's head emerges above tiny figures of his father and mother, with his wife holding his little daughter next to them. By reducing Bella and Ida to head and shoulders only, he subtly suggests his present family group, the three of them alone in Berlin. Yet he was still bound psychologically to Vitebsk, for, instead of a hat, the artist wears a modest house, his childhood home.

2 *Father* Plate 1

Mein Leben, sheet 1, 103/110
Etching and drypoint
27.8 x 21.8 on leaf, 44.5 x 35

3 *My Village*, 1923-24 Plate 2

Gouache, 48.6 x 61.9
Katz Collection, Milwaukee, Wisconsin

The view in this gouache is a new version of a
more factual painting, reproduced in colour as
the frontispiece to Herwarth Walden's *Die Neue
Malerei* (Berlin, 1919), which Chagall recreated
with a deliberate disregard for laws of gravity or
perspective. The effect is traumatic, particu-
larly where a man sits on the roof of a house,
which may be the synagogue, with its windows
awry. The beardless face is more like that of the
artist than his grandfather, who used to retreat
to the roof (see p. 218, *Mein Leben*, sheet 12).
The gouache is paired with the etching of his
father, who had been accidently knocked down
and killed by a lorry in Vitebsk. The artist had
been doubly grieved because 'They hid the
letter announcing his death from me' (*My Life*,
p. 145). Even if the man in the road is not an
evocation of this event but only a staggering
drunkard, the scene conveys the dramas which
peopled Chagall's memories of his home town.

4 *Grandmother* Plate 3

Mein Leben, sheet 4, 75/110
Etching and drypoint
20.9 x 16 on leaf, 37.3 x 26

5 *Peasant Eating*, c. 1913 Plate 4

Indian ink, 29 x 22
Collection Marcus Diener, Basle

This drawing records the artist's mastery of
black and white before he began using engrav-
ing techniques. With Indian ink and pen and
brush he has conveyed a vivid record of an
everyday scene in spite of transforming many
of the elements – the sleeves, the table and even
the spoon – into modernist shapes; the styliza-
tions are closest to those in his oil *The Appari-
tion I* (Plate 23, Cat. 27), now usually dated 1917-
18. *Peasant Eating* and *Grandmother* record his
attempts to combine a degree of realism with a
modern style, though the etching is more inti-
mate. The artist has playfully married his own
features to the body of the little animal to illus-
trate a Yiddish expression of endearment, 'My
little monkey', used for children. A gouache
version is in the collection of the Hiroshima
Museum of Art (reproduced *Chagall*, Tokyo
[Bunkamura Museum of Art], 1989-90, cat. no
20); though dated 1914, the size and handling
suggest it was painted in the 1920s.

6 *Dining-Room* Plate 5

Mein Leben, sheet 10, 29/110
Etching and drypoint
27.6 x 21.7 on leaf, 35.5 x 44.5

7 *In the Prison*, 1914-15 Plate 6

Gouache, 37.5 x 48.9
Private Collection

Chagall was locked up when he was a student in
St Petersburg for not having the correct permit
allowing a Jew to reside in the capital. Later he
remembered that prison had given him a
chance to work in peace, with regular food and
some space (*My Life*, p. 85). In this quiet scene
the artist himself is looking out of the barred
window towards freedom, while three other
prisoners seem resigned to their fate, thinking
and day-dreaming. Curiously, the artist remem-
bered family meals as equally oppressive; in
this etching he has exaggerated the claus-
trophobia of the dining-room, and the scene
conveys a prison-like ennui (see also p. 15).

8 *Mother and Son* Plate 7

Mein Leben, sheet 2, 63/110
Etching and drypoint
27.8 x 21.8 on leaf, 44 x 35

9 *Baby-Carriage Indoors* Plate 8

Sketch for mural, 1916-17
Indian ink and wash, 46.5 x 63
Ida Chagall, Paris

The gouache is one of four sketches which
Chagall made for murals for a secondary school
attached to the chief synagogue in Petrograd
(Meyer, p. 246). The murals were not carried
out, but this sketch gives a delightful picture of
a family scene. Curiously, the father with his
hand on the perambulator looks rather like
Chagall, whereas the woman sitting at a table
drawing a goat resembles his wife, Bella. This
suggests a fanciful role-reversal, as Chagall
admitted in *My Life* (p. 148) that he was impa-
tient with small children. He remembered his
mother with fondness and admiration and gave
her a prominent place in the portfolio of etch-
ings. He showed her proudly bringing forward
a reluctant small figure – recognizably himself
as a child – watched curiously by a faint
bearded profile visible over her shoulder.

10 *Wedding* Plate 9

Mein Leben, sheet 16, state III
Etching and drypoint
14.4 x 16.2 on Japan, 27 x 35.5

11 *Purim* Plate 10

Sketch for mural, 1916-17
Indian ink and wash, 47.5 x 64.5
Ida Chagall, Paris

Like Plate 8, Cat. 9, this precisely coloured
composition is one of four sketches for murals
commissioned early in 1917 for the secondary
school attached to the chief synagogue in
Petrograd. It shows the celebration of *Pur*, the
casting of lots for the destruction of the Jewish
people in ancient times. They were saved by the
bravery of Queen Esther and her Uncle
Mordecai: 'This is why isolated Jews who live in
remote villages keep the fourteenth day of the
month Adar in joy and feasting as a holiday on
which they send presents of food to one
another' (Esther, ix: 19). In Vitebsk the feast
was a children's favourite, because gifts of
sweetmeats, formed into little horses, dolls and

fiddles, were exchanged in celebration. There is
a related oil painting in the Philadelphia
Museum of Art (reproduced Compton, p. 89),
but this simpler version with its large- and
small-scale figures anticipates the spatial inven-
tions of Chagall's *Mein Leben* etchings, where
there are also 'shorthand' accounts of
festivities, though the stylizations are different.
For instance, in *Wedding* the figures on the right
lack outlines and the bride's dress is simply a
silhouette between the black clothes of the
bridegroom and mother. Including few details,
Chagall has none the less conveyed the essence
of the occasion, which he described in his
autobiography as disappointing to the wealthy
Rosenfeld family, who had expected a better
match for their only daughter (*My Life*, pp. 119-
22).

12 *The Talmud Teacher* Plate 11

Mein Leben, sheet 9, 97/110
Etching and drypoint
24.6 x 18.8 on leaf, 44.5 x 35

13 *The Synagogue*, 1917 Plate 12

Gouache, 40 x 35
Collection Marcus Diener, Basle

The synagogue played an important role in
Chagall's early life, when his fine voice meant
that he sang in services (*My Life*, p. 41). Here he
has portrayed himself sitting in the foreground
with another child beside him. In the 1930s he
made even more faithful records of
synagogues, leaving out any anecdotal refer-
ences (see Plate 106, Cat. 113). In 1917 Chagall
was concerned with creating Jewish art; he was
named in a newspaper with El Lissitzky and
Nathan Al'tman as an organizer of an exhibi-
tion held at the Galerie Lemercier in April by
the Union of Moscow Jews (*Utro Rossii*, Janu-
ary 1917). The same year Chagall made sketches
for murals for the school attached to the princi-
pal synagogue in Petrograd (see Plates 8, 10,
Cat. 9, 11), so he was much involved with Jewish
life, which he remembered with some humour
in *Mein Leben*, where he depicted his childhood
Talmud teacher – from whom he had learned
the scriptures by rote – mysteriously naming
him 'Raskin the Melamed' on the sheet.

14 *House in Vitebsk* Plate 13

Mein Leben, sheet 11, 87/110
Etching and drypoint
18.9 x 24.9 on leaf, 35 x 45

15 *The Red Gateway*, 1917 Plate 14

Oil on card, 49.5 x 66
Staatsgalerie, Stuttgart

In this painting from 1917 Chagall concentrated
on a feature of street scenes in Vitebsk: the gate-
way which no doubt gave access for carts to the
courtyard beyond, which can be seen through
an open door in the etching. A similar, though
less imposing, gateway can be found in the
street scene *Pokrovskaia in Vitebsk* (Plate 19,
Cat. 20). The style of *The Red Gateway* links it
with *The Grey House* (Thyssen-Bornemisza

Collection, Lugano), which depicts a house on the outskirts of Vitebsk and is also dated 1917. In the etching he combined the house with the motif of a flying cart, less extreme than that in *The Flying Carriage* (The Solomon R. Guggenheim Museum, New York), painted in Paris some four years earlier.

16 *The Grandfathers* Plate 15
Mein Leben, sheet 3, 80/110
Etching and drypoint
27.8 x 21.7 on leaf, 44 x 35

17 *Remembrance, c.* 1918 Plate 16
Gouache, Indian ink and pencil, 31.7 x 22.3
The Solomon R. Guggenheim Museum, New York, Gift of Solomon R. Guggenheim, 1941

The Russian author Aleksandr Kamensky believes that *Remembrance* dates from Chagall's year in Berlin (Kamensky, p. 211). Signature and dates seem to have been added later, though the careful lettering of the word 'Erinnerung' may show Chagall having to become familiar with Western orthography. Kamensky links the subject to an old saying, 'Everything I have I carry with me.' A similar motif, transferred to the artist himself, is found in *Self-Portrait* (Cat. 1), but the style of *Remembrance* is close to the etching *The Grandfathers*. Chagall's text makes clear the importance his grandfathers held for him: his father's father was a teacher of religion; his mother's father held a respected position as a ritual butcher. He gives each one his emblem: the leather arm straps and box containing scriptures (phylacteries) worn on arms and forehead by the faithful at prayer, and a tiny axe and an animal for slaughter.

18 *House in Peskovatik* Plate 17
Mein Leben, sheet 8, 35/110
Etching and drypoint
17.9 x 21 on leaf, 35.5 x 44.5

19 *Little Red Houses*, 1922 Plate 18
Oil on canvas, 80 x 90
Private Collection, on loan to the Australian National Gallery, Canberra

This is one of Chagall's rare canvases dated 1922, so it was probably painted in Berlin, using almost the same motifs as the etching, brightly coloured and reversed. Homely details in the oil differ from those in the etching, which curiously bears the Russian inscription '*tut*', meaning 'here'. The title of the etching identifies the little house as the one in which Chagall was born, described in *My Life* (p. 10) as 'the little house near the Peskowatik [sic] Road' which Chagall had seen 'not long ago': 'My father sold it as soon as he was a little better off. It reminds me of the lump on the head of the rabbi in green whom I painted, or a potato thrown into a barrel of herrings and soaked in brine. Looking down on this little house from my new-found "stature" I winced and asked myself, "How could I possibly have been born there? How can one breathe in such a hole?"' The lavish use of reds for house and yard in the oil version

conveys the trauma of the fire which had occurred shortly after his birth (p. 217, *Mein Leben*, sheet 7).

20 *Pokrovskaia in Vitebsk* Plate 19
Mein Leben, sheet 5, 27/110
Etching and drypoint
17.9 x 21, on Japan, 35 x 44.5

21 *Blue Cow in front of White House,
 c.* 1923-26 Plate 20
Watercolour, 19.5 x 30
Sprengel Museum, Hanover

Chagall often returned to specific themes, and here, in a watercolour, he has depicted a street scene similar to the one in the etching, which is also like a sketch. In a letter about this watercolour sent to W. Grosshennig, Chagall later wrote: 'This sketch is by me, made between 1923 and 1926, I believe. At this time the French art critic Louis de Vauxelles had the idea for an exhibition of pictures of trade signs. Each artist could choose his speciality: I chose a dairy' (Sprengel Collection, 1,37). According to his autobiography (*My Life*, p. 87), Chagall had trained as a sign painter – Kamensky (p. 40) adds in St Petersburg – and had enjoyed seeing his signs hanging outside shops. When Chagall was Commissar for Arts in Vitebsk, he had arranged for the traditional signs to be removed and for the painting of modernist ones to replace them. This indistinct street scene in no way resembles a shop sign, though; with its blue cow and ducks on the roof, it suggests a private joke, extended, perhaps, by many other depictions of cows from the early 1920s (see Plates 32, 34, 72, 74, Cat. 36, 38, 77, 79).

22 *Father's Grave* Plate 21
Mein Leben, sheet 20, 104/110
Etching and drypoint
11 x 14.9 on leaf, 26.5 x 35

23 *In the Snow*, 1922/*c.* 1930 Plate 22
Gouache over lithographic ink, 23.6 x 31.4
The Solomon R. Guggenheim Museum, New York, Gift of Solomon R. Guggenheim, 1941

During his year in Berlin Chagall made several sketches in lithographic chalk on paper for transfer lithographs. Vivian Barnett, Curator at

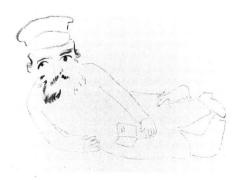

Man with a Book, 1922;
lithograph, 13.6 x 21.1.
Bibliothèque Nationale, Paris, Cabinet d'Estampes

the Guggenheim Museum, believes that the underlying design of this gouache may be one of them, *Man with a Book* (Fig.), to which Chagall has added painted outlines and body colour as well as such details as the sledge and the houses. The head of the curiously proportioned old man is related to several other heads that Chagall made in Berlin, when he was no doubt homesick for Vitebsk. The gouache belonged to Hilla Rebay, and Vivian Barnett recalls that it used to be dated 1930, which perhaps refers to the date of the gouache additions. Here it is paired with the final etching from *Mein Leben*, an evocation of the grave of Chagall's father. He wrote: 'I shall see your grave later.... I shall lie down full length on your grave. Even so you will not come back to life. And when I am old (or perhaps before) I shall lie down at your side' (*My Life*, p. 145). He thus ended his memories of Vitebsk, which he dreamt so vividly with his etching needle.

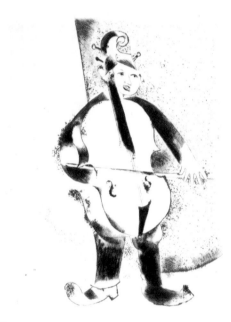

Cat. 24

24 *Musician*, 1922
Supplementary sheet to *Mein Leben*, 91/110
Etching and drypoint
27.5 x 21.6 on leaf, 44.5 x 35

25 *Man and Pig*, 1922-23
Lithograph
46.5 x 32.5 on Japan, 55.5 x 45
Edition of 13 copies published by Paul Cassirer
Sprengel-Museum, Hanover

The large lithograph is based directly on a motif in the right-hand corner of the huge canvas that Chagall had painted for the Jewish State Chamber Theatre in Moscow (see Fig. 2). He described painting it in *My Life* (p. 158): in appalling conditions he created humorous images, such as this one, where the peasant makes water on the pig, an unclean animal for Jews. The image appears the same way round as the original, because the artist's sketch, drawn in lithographic chalk on special paper,

Etchings for Nikolai Gogol, *Dead Souls*, and related works, Paris, 1923-27

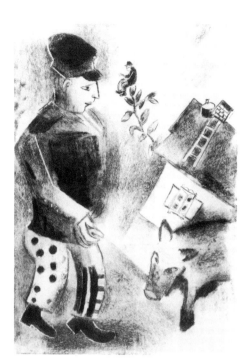

Cat. 25

was transferred by the printer to the stone, which was then inked before the paper was pressed on to it. In Berlin Paul Cassirer first gave Chagall transfer paper to make illustrations for his autobiography. Few lithographs survive, as Chagall soon learned etching, a technique which he evidently preferred, as can be inferred from the dramatic *Musician*, where he contrasted areas of strong black and white with spattered dots for texture. The 'cello has replaced the player's body, an idea to which Chagall returned later (see Plate 159, Cat. 166).

On his arrival in Paris in September 1923, Chagall's initial arrangement with Ambroise Vollard was to provide him with illustrations for Gogol's *Dead Souls* on copper plates, for which Vollard was to pay him five hundred francs each on delivery. This money provided a regular means for Chagall to support his family and he worked quickly on the project, finishing at least thirty-seven illustrations by December 1924 and all ninety-six by the end of 1925. However, the etchings were not published with the text until 1948, when the two volumes, Nicolas Gogol, *Les Ames Mortes*, translated from the Russian by Henri Mongault, were published by Tériade in Paris. The majority follow the technique of the *Mein Leben* series, in which Chagall used drypoint. When drypoint is combined with etching, lines are made with varying sized needles on a polished copper plate which has first been coated with a layer of varnish and then blackened by smoke, so that the artist can see his marks. When he has finished the initial drawing, he immerses the plate in a bath of nitric acid, which penetrates the marks in the varnish. He then removes the varnish with turpentine and makes a trial proof. At this stage further marks can be added to suggest shading; they are scratched directly on to the copper – hence the name 'drypoint'. Chagall rarely resorted to aquatint, a method for rendering overall tone; for some reason he used it only in the second half of the Gogol series, a good example being Plate 53, Cat. 57.

Chagall must have known that Gogol had imagined his story while an exile in Italy, so it was easy for the artist to reinterpret his own memories of St Petersburg and Vitebsk. He relied on his imagination to transpose his hand into the nineteenth century, though, as has been suggested above (see pp. 17-18), he revitalized his figures by observations of local – French – types. He apparently began work at once, but it must have become more convenient when, during his first year in Paris, Chagall and his family moved into a traditional artist's studio with a mezzanine. A photograph reproduced in the Chronology (p. 261) shows the room covered with paintings which Chagall had brought from Russia. Behind them are the same hangings with which Bella had enlivened the walls of Chagall's room in Vitebsk, which he recaptured in a replica of *The Birthday* (The Solomon R. Guggenheim Museum, New York). Indeed, as well as work on the etchings in 1923-24, much of his time was taken up with creating new versions of early works.

Chagall seems to have begun a new type of work on paper when he discovered Montchauvet, a little village where he rented two rooms for some months. There he continued to work on the Gogol etchings, but

he also painted what he could see, in such freshly coloured gouaches as the view of a farm-yard (see Plate 30, Cat. 34). Travelling further afield became an important feature of the Chagalls' life; each year they spent some months away from Paris, mainly in small towns and villages, where the artist continued to make fanciful gouaches of the local scenery, usually painting buildings rather than landscapes. An unidentified church appears in a gouache which formerly belonged to the museum in Zagreb (Fig.); it unfortunately disappeared in 1968.

Although Chagall had apparently finished the plates for Gogol by the end of 1925 and, judging by contemporary exhibition catalogues, prints were pulled in batches as they were completed, Vollard did not proceed to publish them with the text, nor even to sell sets of prints. Chagall sent one set to the Tretiakov Gallery in Moscow in 1927; he gave another (incomplete) set to the Tel Aviv Museum in 1931. The Curator of Prints and Drawings at that museum, Edna Moshenson, has compared the plates from 1931 with a set donated to the museum after the publication by Tériade in 1948, and she has found variations between them. It is known that, when Tériade acquired the copper plates from Vollard's estate, Chagall had to rework some of them, but there has not yet been a systematic publication of the variations, which are minor. Chagall's increasing mastery of synthesis is apparent in works made after the Gogol series, such as *The Dream* (Plate 52, Cat. 56), which heralds a new stage of poetic invention in his oeuvre.

'View of a Village', *c.* 1920–30;
gouache, 65 x 51.
Formerly Museum of the City of Zagreb

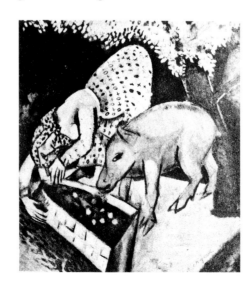

Cat. 26

26 Gogol and Chagall
Gogol, sheet 48
27.5 x 21.1

As this etching is signed 'Marc Chagall' on the plate, it may have been reworked in 1948, when it was used as the frontispiece for Volume 2 of the complete publication of the Gogol illustrations. It is, however, among the ninety-six images which had been printed by 1927, and it serves as an ideal introduction to the second section of this catalogue. Chagall made himself look as much like Gogol as possible by drawing his own profile, which he usually avoided (see Cat. 59, 107). In his self-portrait, Cat. 1, he had clustered images around the focal point, his head; here he has scattered random tokens of Russia diagonally across the centre of the sheet, as though conjured up by himself and Gogol. Chagall has freely marked the copper plate with scratches as well as images, leaving very little white space. This is characteristic of his later Gogol etchings.

27 The Apparition I Plate 23
Etching, drypoint and aquatint
37.2 x 27.3 on Vélin d'Arches, 57.5 x 45
State IIIa
Edition of 100 copies

28 The Apparition I,
1924-25/c. 1937 Plate 24
Etching and aquatint, hand-coloured in gouache and pastel
36.8 x 26.7 on sheet, 48.8 x 38.3
The Trustees of the Tate Gallery, London

Like so many of Chagall's prints from the early 1920s, The Apparition I is based on an oil painting of the same title (Collection Zinaida Gordeeva, Leningrad), now usually dated 1917-18. It is close in style to Nathan Al'tman's Portrait of Anna Akhmatova (Russian Museum, Leningrad) and is one of Chagall's most Cubistic compositions. When making the etching, he reduced the stylizations, thus emphasizing the dependence on earlier 'apparitions' which had probably inspired the original version. Chagall's solemn angel recalls the seventeenth-century Guardian Angel in Narbonne (Fig. 18) which, later in the 1920s, inspired Chagall's Angel with a Palette (Fig. 19). Around 1937 Chagall hand-coloured the Tate Gallery etching for Lady Clerk, wife of the British Ambassador in Paris, whom he was teaching drawing; the strong dark green and purple remove the composition even further from the original oil, which is painted entirely in blue and white.

29 The Trough, 1924
Lithograph, 30.5 x 24
Galerie Jeanne Bucher, Paris, 7/100
Collection E. W. K., Berne

30 Drinking Pig, c. 1925 Plate 26
Gouache, 63 x 48
Stedelijk Museum, Amsterdam,
P. A. Regnault Collection

Chagall had invented this composition before 1922, when a version (probably in gouache) belonging to a collector named Garvens was reproduced in the monograph by Theodor Däubler (Marc Chagall, Rome) (Fig.). Following Meyer, Haftmann (p. 104) maintains that it dates from 1912. The lithograph shows the composition reversed, and was therefore probably drawn on the stone; it was published by a Paris gallery in 1924, and the following year Chagall made two oil paintings of the theme (Vicomtesse de Noailles, Paris, and Philadelphia Museum of Art, Louis E. Stern Collection). In these oils the peasant woman's white dress reveals little of the patterning to be seen in the lithograph; however, all three versions follow the earlier composition. The figure of a man entering from the right is unique to the Stedelijk Museum gouache and, with the crescent moon appearing through the tree branches, on which a little bird is perched, gives it something of the flavour of a fable.

The Watering Trough;
illustration in Theodor Däubler, Marc Chagall,
Rome, 1922

31 Entrance to the Inn Plate 27
Gogol, sheet 20
27.9 x 20

32 The Inn (Traktir), 1923-4 Plate 28
Gouache, 66 x 51
Private Collection, Monte Carlo

In this pairing the gouache is an enlargement of, and an embroidery on, the etching, which was intended as the frontispiece for Gogol's Dead Souls. The scene illustrates a passage quite far on in the story, when, after a tiring journey, Chichikov arrives at a modest country inn. In the gouache Chagall has picked out details – including the owner – with purple, to which the green grass provides a welcome contrast. The narrow range of colour suggests that a coloured frontispiece may have been considered, although when he came to make gouaches for La Fontaine's Fables he used a wider spectrum of hues. Everything about this imaginary Russian scene is different from his observations of French hostelries in the 1920s (see Plate 40, Cat. 44).

33 Asking the Way Plate 29
Gogol, sheet 19
28.4 x 22.3

34 Montchauvet, 1925 Plate 30
Gouache and watercolour, 63 x 47.8
Collection Marcus Diener, Basle

Chagall took the opportunity to capture in gouache characteristic French buildings, such as this farmhouse, painted, according to the memory of his daughter, when he took two rooms in a policeman's house at Montchauvet in 1925. The small village was much closer to Paris than Normandy and Brittany, where he had stayed with his family the year before. He may have painted the scene from a window, looking down on to the farm cart and the yard beyond. Typical for Chagall are the enlivening details of the small child leaning out of the ground-floor window and the cut-off horse in the foreground, which is matched in the Gogol etching by the headless animals. By omitting the horses' heads, Chagall has emphasized the relationship between the coachman and the peasant girl, whose distorted figures mime 'asking the way'.

35 The Barn Yard Plate 31
Gogol, sheet 17
22.5 x 29.3

36 Maternity, 1925 Plate 32
Gouache, 51 x 66
Musée national d'art moderne,
Centre Georges Pompidou, Paris

Compared with many of Chagall's fanciful depictions of farm animals, the animals in the etching and the cow with her calf are relatively naturalistic. The artist enjoyed leaving Paris for the tranquillity of the countryside and, no doubt, he recaptured his boyhood experiences of holidays with his grandfather in Lyozno.

There, cows had been tied up in his grand-father's yard awaiting slaughter; at Mont-chauvet they were kept in farmyards, which inspired the etching of the barn yard that Chichikov observed through his window when he awoke at Madame Korobochka's house. In 1926 the gouache was the first work by Chagall to be bought by the French State; it belonged to the Musée du Luxembourg when it was repro-duced in 1928 by Waldemar George with the title *La vache* and the date '1925' (*Marc Chagall*, Paris, 1928).

37 *Uncle Mitiai and Uncle Miniai* Plate 33
Gogol, sheet 29
27.8 x 21.6

38 *The Cow*, 1926 Plate 34
Gouache, 64 x 49
Private Collection, Switzerland

Using a buff-coloured paper, Chagall has freely sketched a close-up view of a mythical cow's head, with one horn and its neck firmly grasped by a bronzed peasant, whose grinning face is caricatured in the same way as those of the sailors that Chagall drew at Toulon in the summer of 1926 and as his *Self-Portrait with Grimace* (Cat. 59). In addition to the underlying preliminary drawing in blue, traces of a coarse grid – also in blue – can still be seen under the freely applied gouache. It is here paired with an etching from Gogol's *Dead Souls*, where a horse and his owner are likewise observed with wry humour. It would have been equally suitable to place *The Cow* among the preparatory gouaches for La Fontaine's *Fables*, because of the extreme freedom with which Chagall has applied the patches of colour.

39 *They meet a Peasant* Plate 35
Gogol, sheet 37/4
27.8 x 21.5

40 *The Goat on the Shoulders*,
 1926-27 Plate 36
Gouache, 50.5 x 35.5
Private Collection, Switzerland

A peasant carrying a goat is a familiar sight in the countryside, but here the blue goat hovers above the shoulders of a man, whose green face, obscured by a red beard, links him with the Jews that Chagall had painted in Vitebsk in 1914–15. Amishai-Maisels (pp. 81-3) has related these pictures to prototypes by Israels and Rembrandt as well as by Chagall's teacher, Jehuda Pen. Pen was in Chagall's mind early in 1927, when he devoted an article, 'My First Teacher', to him in the Parisian Russian news-paper (*Rassviet*, No 4, 1927, pp. 6-7). Although there may not be a particular prototype for this image, it is closer to Chagall's continuing attempts to make paintings reflecting his Jewish roots than to the Russian types that he imagined for *Dead Souls*. This is especially clear in this etching, where a comical peasant threatens to block the way with a huge pole which he can barely carry.

41 *A Mob of Peasants* Plate 37
Gogol, sheet 28
27.7 x 21.3

42 *French Village, c.* 1926 Plate 38
Gouache, 52.5 x 66.5
The Israel Museum, Jerusalem,
Gift of Oscar Fischer, Tel Aviv

The view of the church past a dilapidated barn is closest to that in an equally fresh gouache belonging to the Boymans-van Beuningen Museum in Rotterdam (Meyer, cat. no 404), which has been identified as a view of the church featured in Plate 42, Cat. 46. Without visiting Chambon-sur-Lac it is not possible to be sure of the location. As in the Boymans-van Beuningen gouache, Chagall enjoyed rendering the textures of rough ground and stonework, and here he has carried his stylizations into the blue sky, which is enlivened by repeated brush-strokes. The foreground figures near the ladder – no doubt based on village folk – are in a simi-lar style to those in the etching, where Chagall has shown the group of peasants who gathered round when the horses pulling Chichikov's troika became entangled with those of an oncoming carriage.

43 *Prochka* Plate 39
Gogol, sheet 43
27.6 x 21

44 *Hôtel de la Poste*, 1926 Plate 40
Gouache, 65 x 50
Private Collection, Monte Carlo

Chagall has allowed a cow to stray on to the roof instead of grazing on the green pastures in the background of this view. Moreover, he has placed a runaway beast in the village square, unremarked by the villagers. Also unexpected is Chagall's treatment of the sky in irregular stripes of colour, similar to those used by the Post-Impressionists. Like the rogue animals, they pass almost unnoticed because most of the view seems so conventional. Many gouaches from these years appear to have been painted from a window, and in the etching Chagall depicted Chichikov's servant looking through an opening (ambiguously, a door or two windows) at a scene in a room beyond. No doubt he found a model in the homely dining-rooms of modest hotels in provincial France.

45 *Sobakevich near an Armchair* Plate 41
Gogol, sheet 37/2
27.8 x 21.5

46 *Church*, 1926 Plate 42
Gouache, 67 x 52
Musée de Peinture et de Sculpture, Grenoble

This Romanesque church with its magnificent tower no doubt reminded Chagall of the church in Vitebsk, which had dominated so many of his early compositions, particularly the many versions of *Over Vitebsk* (reproduced Kamensky, pp. 214, 215). Although the Grenoble

museum cites several paintings of the church at Chambon (Meyer, cat. nos 404, 409, 413), this view of the church by itself differs from them. The gouache was bought from an exhibition held at the Galerie Le Portique in June 1928. Living among French people, Chagall seems to have found it easy to find models for his Gogol figures, such as the portly Sobakevich, whom he placed in an unreal indoor setting, staring at a scene which he sees beyond.

47 *Chichikov and Sobakevich*
 discussing Business Plate 43
Gogol, sheet 37
21.2 x 27.8

48 *The Reader*, 1925 Plate 44
Gouache, 44.5 x 28.5
Private Collection

Chagall has homed in on his figure in a curi-ously proportioned gouache which looks, at first sight, as though it might have been cut down from a larger work. Its asymmetry allows a glimpse of a house window over the sitter's left shoulder and conveys a memory of Vitebsk. For his reader, or Rabbi, or scholar (the gouache has borne all three titles) Chagall has echoed Van Gogh's postman – *Le Facteur Roulin* (Rijksmuseum Kröller-Müller, Otterlo) – of which he later kept a colour reproduction in his studio. The complex decorative surface that he has created with colour and superimposed white makes a strong contrast with the patterns in his contemporary engravings. For them he chose very different facial types; in this etching the two figures seen in close-up seem to embody, on the one hand, the coarseness and, on the other, the refinement typical of the author's characters.

49 *Sobakevich* Plate 45
Gogol, sheet 32
Etching and drypoint, 27.8 x 21.1

50 *The Violinist*, 1926 Plate 46
Gouache, 49 x 49
Collection Marcus Diener, Basle

Chagall's Uncle Neuch had played the violin; as a boy Chagall had a few lessons himself, in case a talent for music would lift him out of the rut of repetitive labour for which he was destined unless he could save himself by one of the arts (*My Life*, pp. 25, 41). In 1923-24 he had made a variant of his powerful player entitled *Music* (Tretiakov Gallery, Moscow): *Green Violinist* (The Solomon R. Guggenheim Museum, New York). In the present gouache he repeated the little animal which looks up from the lower left corner and the tree and fence from the right and added an unexpected oil lamp and teapot. Kamensky quotes Sholom Aleichem's descrip-tion of a violinist: 'He took his violin, caressed it with his bow, and the violin began to speak. And how it spoke! A live, truly human voice. And in this voice was both a prayer and a reproach, a heart-rending sigh, an agonized cry, straight from the heart' (Kamensky, p. 145). In contrast, Sobakevich clutches his heart in a welcoming

gesture which is confused by the capricious position of his legs, shown in profile. Chagall has used etching in an amazingly fluent way, spots and spatterings combining with forceful lines. He had no hesitation in cutting off the figure's head, so that he has space to include a ridiculous little animal beside his signature.

51 *Sobakevich's House* Plate 47
Gogol, sheet 31
21.1 x 27.6

52 *The Violinist*, 1926-27 Plate 48
Gouache, 49 x 64
Private Collection, Switzerland

This gouache includes the oil lamp and small animal from the previous 'violinist' (Plate 46, Cat. 50). Here the player's black coat has been painted on top of a small, emerald green house, so he resembles the bent-over figure entitled *Remembrance* (Plate 16, Cat. 17), who carries his family on his back. Close inspection reveals the work to be an allegory, for the player bends over a little Tree of Life in a blue realm of sky or heaven, whereas his sketched-in paramour is hemmed in by the fence. Does the musician tempt her with strains of earthly or heavenly music? Clearly the artist leaves the viewer to decide. His arrangement of people and houses in the etching is equally unexpected, since traditional perspective is almost completely lacking. The result is an unreal world which matches Gogol's preposterous tale.

53 *Pliushkin's old Garden* Plate 49
Gogol, sheet 39
27.6 x 21.1

54 *Lovers with Half-Moon,*
 c. 1926-27 Plate 50
Gouache, 63 x 40
Stedelijk Museum, Amsterdam

Chagall has used minimal colour to create his dazzling fantasy, developed from the theme of lovers in close-up that he had explored at least five times in Russia (reproduced Kamensky, pp. 223, 233, 252, 253). Here he has outlined a little bird in the sky and given the woman a beret, using a fine brush loaded with white gouache on top of his blue background in a parody of the strokes of the etching needle that he used to produce fine patterning on copper plates. In the Gogol etchings he usually created lines which would print black on white, as in the myriad lines which make up the trees in *Pliushkin's old Garden.*

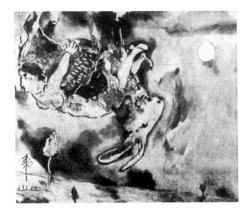

The Dream, 1927; illustrated upside down as *Le lapin* in *Sélection*, 3rd series, Vol. 8, No 6

55 *Selifan the Coachman* Plate 51
Gogol, sheet 6
22.1 x 28.6

56 *The Dream*, 1927 Plate 52
Oil on canvas, 81 x 100
Musée d'art moderne de la ville de Paris

When the oil painting was reproduced in 1929 the other way up with the title *Le lapin* (The Rabbit) (Fig.), the landscape appeared 'normal' and the figure seemed to hold up the oversize animal, dropping with her to the ground. The dream might then have been inspired by that of Lewis Carroll's Alice, who reached 'Wonderland' by falling through a hole after a rabbit: 'I wonder if I shall fall right through the earth! How funny it'll seem to come out among the people that walk with their heads downwards!' she said. Chagall's unlikely pair defies logic as well as gravity. He often worked from all sides when making a picture, but here he perhaps intended the ambiguity to rival contemporary paintings by Surrealist artists, who were attempting to create purely from the unconscious. Chagall's invention is closer to the 'trans-sense' of Russian Futurist poets, who had sought to widen conventional response by breaking and extending the rules which normally govern language. Chagall broke pictorial convention in *Selifan the Coachman*, where the figure overlaps the outline of a horse, which thus appears to stand behind him. The artist, however, introduces a hamper at an angle to the viewer which subtly suggests depth in the otherwise flattened surface.

57 *Troika at Night* Plate 53
Gogol, sheet 85
Etching, drypoint and aquatint, 21 x 27.5

58 *Celebration in the Village*, 1929 Plate 54
Gouache, 50 x 65
Collection Marcus Diener, Basle

Most windows in France open inwards, but in this gouache Chagall reverted to views through windows which he had painted in Russia – for instance, *The Window* of 1914-15 (Collection Zinaida Gordeeva, Leningrad), where a similar flower vase stands on the sill with open windows looking out beyond a board fence on to a green sward fringed by little houses (reproduced Kamensky, p. 38). The dark colours of that view contrast with the light colours of this fantasy. Little figures of the artist and his wife, watched by a quiet cow, embrace in an imaginary indoor space, anchored by the window frame, while, outside, the coachman Selifan drives through the street of an archetypal Russian village. This carries echoes of streets in *Mein Leben*, but is peopled by characters from Gogol's *Dead Souls*, where, in the last etching in the book, with the help of aquatint (see pp. 19-20), Chagall shows a close-up of the hero being driven through the Russian countryside at night. Appropriately, in the text Gogol evokes his motherland; in etching and gouache Chagall also dreams of his lost homeland.

Etchings for La Fontaine's *Fables,* and paintings, 1926-31

In 1926, when Chagall had finished the copper plates for Gogol's *Dead Souls*, Vollard invited him to embark on illustrating La Fontaine's *Fables*. The genre was familiar to Chagall from the fables written by the Russian Ivan Krylov in the first half of the nineteenth century, though few of these are identical with those that La Fontaine had put into verse in the seventeenth century. Furthermore, although Russian children knew Krylov's verses, they were not universally learnt by heart in school as the Frenchman's *Fables* were, even in this century. La Fontaine wrote twelve books, each averaging twenty fables; there are some two hundred and forty, and Chagall illustrated a selection. When it became known that Vollard had chosen a foreign artist for the project, Frenchmen were incensed, but Vollard defended his choice by pointing to La Fontaine's sources, which include Eastern as well as Classical fables.

Vollard wanted to publish the *Fables* with colour illustrations, so Chagall first made one hundred preparatory gouaches. The methods by which Vollard proposed to have the gouaches reproduced as hand-made prints are not well documented, though it is known that he intended to revive techniques from the eighteenth century. These attempts have been described above, with the failures (see page 23, especially note 70). The most important change was the decision against colour, but even black and white etchings by other hands proved unsatisfactory. When Chagall finally decided to make the etchings himself, it is not clear whether he began with fresh plates, or whether there were already lines etched on them. Chagall's biographer Jean-Paul Crespelle recorded that Chagall had received five hundred francs for each of the Gogol plates and that Vollard paid him one thousand each for the *Fables*; he did not mention whether this sum was for the gouaches or for the copper plates. The story is further complicated by the fact that Vollard certainly owned the gouaches when he exhibited and began to sell them in spring 1930, apparently more than a year before Chagall had finished the etchings. It remains possible that he was making the etchings from black and white photographs of the gouaches. The etchings were not exhibited in the 1930s and were finally published by Tériade in 1952, in two unbound volumes with text, as well as unnumbered sets of impressions.

A surprising element of the etchings is that the images print the same way round as the gouaches, so they must have been reversed on the copper plates. This was normal practice before the advent of photography when etchings were used as reproductions of paintings, which had to appear the right way round, but it has not been customary for artists' original

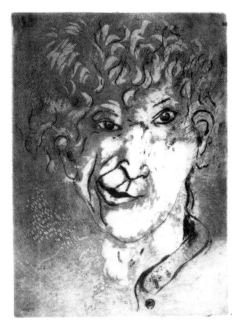

Cat. 59

etchings, particularly in the twentieth century. Chagall habitually worked from sketches which are often squared up; *The Cow* (Plate 34, Cat. 38) has traces of a blue grid as though intended for reproduction. It was painted in 1926, when Chagall began the *Fables* gouaches, which do not show traces of grids, but the etchings are less than half the size of the gouaches, so considerable reduction was needed. It is possible that either Chagall or one of the previous printers used a mechanical method, such as an epidiascope, for transferring the outlines from the gouaches on to the much smaller copper plates, for the compositions are remarkably similar.

What makes the etchings unique in Chagall's oeuvre, however, is the extraordinary painterly effects he achieved with the black and white. It was the first time he had used black to such advantage and the variety of marking is exceptional. The same freedom is found in the other gouaches that he made at the same time; some can be seen in the colour plates in the previous section, as well as in this one. Chagall's output was by no means confined to works on paper, and the group of oils discussed here reveals that he explored a variety of techniques in that medium. His subject-matter was influenced by his friendships with poets and writers, discussed above (see p. 22). Several compositions reflect his new love of dramatic mountain scenery; he discovered the Mont Blanc region in 1927 and thereafter paid regular visits to mountain areas.

59 *Self-Portrait with Grimace,* 1925
Etching and aquatint,
37.4 x 27.4 on Vélin d'Arches, 58 x 45.7
State VI 93/100

Chagall worked up this portrait from a squared-up pencil drawing that he had made in 1917 (Musée national d'art moderne, Centre Georges Pompidou, Paris). Another version was used as the cover for *Ma Vie* in 1931 (Fig. 1). There exist six stages in the etching process, begun in 1924, with proofs from each stage, described by Kornfeld (p. 94, no 43). Aquatint gives variation in grey tones and a more even background texture to this portrait; most of the *Fables* prints have a greater assortment of marks, which Chagall scratched on to the surface of the copper plate to lend 'colour' to the black and white, using drypoint instead of aquatint. The highlights on the face and in the mop of hair make this portrait one of the most striking and painterly prints that Chagall ever created.

60 *The Bird wounded by an Arrow*
Plate 55
La Fontaine, sheet 15
29.4 x 23.5

61 *The Bird wounded by an Arrow,*
c. 1927 Plate 56
Gouache, 51.4 x 41.1
Stedelijk Museum, Amsterdam

The resemblance of the wounded bird which Chagall drew for La Fontaine's Fable vi from Book II to a vignette by Karl Girardet (Fig. 15) has been discussed above (see p. 24). Chagall transformed his source in both of his versions – in the gouache by incomparable use of colour, in the etching by the textures on the copper plate. Girardet had made his vignettes using wood engraving, a method of reproduction which was successfully used in the nineteenth century. Chagall and Vollard had chosen etching as a method of making just over one hundred copies of what was intended to be a de luxe illustrated book.

62 *The Cat transformed*
into a Woman Plate 57
La Fontaine, sheet 25
Etching and drypoint, 29.7 x 24

63 *The Cat transformed into a Woman,*
c. 1928-31/1937 Plate 58
Etching and drypoint, hand-coloured in oil,
29.5 x 24.1
The Trustees of the Tate Gallery, London

This fable is xviii from La Fontaine's Book II, the tale of a man whose beloved cat was trans-

formed into a woman. Chagall has captured some of the frustration of the feline, whose undoing in the verse was that mice no longer recognized her as a cat. In this hand-coloured version, by covering most of the underlying print with oil paint Chagall has disguised the texture which is such a feature of his *Fables* etchings and of the gouaches which preceded them. He has left a small amount of pattern on the skirt and the wall, but the rich, dark colours are from the scale that he adopted in the 1930s. Like Plate 24, Cat. 28, he hand-coloured this print for Lady Clerk, the wife of the English Ambassador in Paris, to whom he gave drawing lessons in the 1930s.

64 *The Drunkard and his Wife* Plate 59
La Fontaine, sheet 33
29.6 x 23.7

65 *The Drunkard and his Wife,*
c. 1926-27 Plate 60
Gouache on black paper, 51.3 x 40.8
Galerie Rosengart, Lucerne

Chagall's sombrely coloured gouache matches the gloom of Fable vii from La Fontaine's Book III, described above (see p. 24). As in *The Satyr and the Wanderer* (Plate 63, Cat. 68), the story is set in a gloomy place, in this instance a cellar, which Chagall has imagined with lumpy sacks covering the floor. In the etching he has cleverly rendered the gloom penetrated by a faint light from a hanging lamp and a brighter supernatural light from the drunkard's wife, disguised as the Fury Alecto.

66 *The Wolf, the Mother*
and the Child Plate 61
La Fontaine, sheet 48
29.1 x 23.3

67 *The Wolf, the Mother*
and the Child, 1926 Plate 62
Gouache, 50.5 x 40.5
Private Collection, Geneva

Wolves play an important role in the fabulist's repertoire of talking animals, reinforcing the fear that humans traditionally feel for the dog-like creature. In Fable xvi from Book IV La Fontaine allows the mother to tell her child that she will give it to the wolf if it does not stop crying; in the next breath she begs it to cease, reassuring it that they will kill the wolf if it comes. The gouache, with the mother and child rendered in simple bright colours, is unusually realistic, and seems a reminder of drawings the artist had made when his daughter was a baby. The etching, with its sophisticated translation of blocks of colour into black and white, is, however, far more refined than Chagall's early attempts in the medium.

68 *The Satyr and the Wanderer* Plate 63
La Fontaine, sheet 57
29.5 x 23.9

69 *The Satyr and the Wanderer,*
1926-27 Plate 64
Gouache, 51.5 x 41.3
Private Collection, Monte Carlo

Although Chagall has enjoyed combining the human, ill-at-ease in a cave, with a family of satyrs, from La Fontaine, Book V, Fable vii, he could not hope to convey the story, in spite of the wit of his design. The freezing Wanderer first blew on his hands to warm them and then on his soup to cool it; in disgust, his half-human host bade him leave, because he could not share his cave with someone whose mouth blew hot and cold. In order to strengthen the colour in the gouache, Chagall worked on coloured paper; in his etching he used large areas of cross-hatched scratching to convey the dimness of the cave, and created even blacker areas for the Wanderer's clothes.

70 *The Priest and the dead Man* Plate 65
La Fontaine, sheet 76
29.3 x 23.8

71 *The Priest and the dead Man,*
1926 Plate 66
Gouache, 50 x 40
Musée d'art moderne de la ville de Paris

Chagall has transferred almost every detail of the gouache from colour to black and white in his etching for La Fontaine's Fable xi from Book VII: only the bouquet of flowers loses credibility in the etching, while the priest is without the toes on his right foot in both. The story is discussed above (see p. 23), as is the unusual fact that all of Chagall's etchings are the same way round as his gouaches (p. 203). Chagall signed this plate twice, once in the corner, as in the gouache, and once at the base, indicating perhaps that he reworked it in 1952, when the etchings were published by Tériade.

72 *The Rat and the Elephant* Plate 67
La Fontaine, sheet 85
29.4 x 24.1

73 *The Rat and the Elephant,*
c. 1926-27 Plate 68
Gouache, 51 x 40
Private Collection

This fable, La Fontaine, Book VIII, xv, has been discussed above (see pp. 22-3). Comparison of the gouache and the etching shows Chagall's ability to translate brilliant colour into black and white. In the gouache random areas of colour interrupt the black outlines of man and animal, in a manner similar to the handling of *The Peasant and the Cow* (Plate 72, Cat. 77). However, Chagall has used a wider range, with red, orange, yellow, green and blues, to give an oriental splendour to his story.

74 *The Bear and the two Schemers* Plate 69
La Fontaine, sheet 63
Etching and drypoint, 29.7 x 23.8

75 *The Bear and the two Schemers,*
c. 1926-27 Plate 70
Gouache, 51 x 41
Private Collection

In this unusually faithful illustration of La Fontaine's twentieth fable from Book V, Chagall shows the bear turning over the frightened hunter, who feigns death to save himself, while his friend hides in a tree – the men have sold the bearskin before killing the bear and are horrified when they see how large he is. In preparatory gouache and etching alike Chagall has mercilessly cut the figure of the hunter, thereby increasing our feeling of contempt for the coward. He has shown his mastery of the medium by capturing in drypoint the texture of the bear's fur and the woodland in apparently random marks, with which he rivalled the free-dom of abstract art, while remaining always in control of his message.

76 *The Horse who wanted Revenge*
on the Stag Plate 71
La Fontaine, sheet 45
30.8 x 24.7

77 *The Peasant and the Cow,*
1926-27 Plate 72
Gouache, 50 x 65.5
National Museum, Belgrade

In a remarkably freely painted gouache Chagall imagined the peasant trying his hardest to move an obstinate cow; in a remarkably dynamic etching he showed a man standing upon a willing horse. The story is from La Fontaine's Book IV, Fable xiii, in which, in ancient times, a horse enlisted man's help to kill his enemy, a stag, and thereby lost his free-dom. Chagall's animals on their dense black ground seem to have strayed from a manu-script or tapestry; they make a strong contrast with the multiple brush-strokes of the gouache. Chagall sometimes achieved far greater fluidity of handling in this medium than in either etch-ing or oil.

78 *The Shepherd and his Flock* Plate 73
La Fontaine, sheet 92
Etching and drypoint, 29.4 x 26.5

79 *The Butcher,* 1928-29 Plate 74
Tempera on card, 65 x 53
Kunsthaus, Zurich

Both these compositions show man and his domestic animals: in the etching the man protects his beasts, in the gouache the butcher slaughters them. The shepherd unaccountably herds miscellaneous animals, suggesting that the original intention was to illustrate 'The Pig, the Goat and the Sheep' – all herded into the same cart – Fable xii from Book VIII, instead of Fable xix from Book IX. In the gouache Chagall vividly remembered childhood holidays at his

grandfather's house, described in *My Life* (pp. 19-20): 'The butcher, in black and white, knife in hand, is rolling up his sleeves. The prayer is hardly over before he holds her neck back and runs the steel into her throat.... Impassively, the dogs and hens wait around for a drop of blood, a morsel that might accidentally fall to the ground.' Colour conveys a deceptively joyful mood: freely applied red disguises the carnage; a complementary blue-green creates shadows; spots of colour decorate the birds on the beam above; the red on the grandfather's hands and face becomes decorative. No doubt Chagall based his composition on traditional depictions of flayed animals, a subject explored at the same date by Chaim Soutine; it prefigures Chagall's *Flayed Ox* (Ida Chagall, Paris) of 1947, where an innocent animal seems to drink its own blood in a moving allegory of suffering and death.

80 *The Master's Eye* Plate 75
La Fontaine, sheet 50
29.9 x 23.9

81 *The Window*, 1927-28 Plate 76
Gouache, 65 x 50
Koninklijk Museum voor schone Kunsten,
Antwerp

In his dramatic etching Chagall seems to have emphasized the eyes of the unwilling bullocks with whom the stag is stabled, more than the eye of their master, which gives the title to Fable xxi in La Fontaine's fourth book. *The Window* is equally dramatic, but with story unknown; it clearly concerns a woman pleading with her playful kitten, yet everything else is ambiguous. Is the scene lit by moon- or sunlight? Is it a snow scene or summer-time? Is the tiny man standing on the window-sill or beside the tree? Exactly where is his companion: falling between window and wall? The larger winged figure, outlined in blue, must be magical – he traverses the wall and upper corner of the window. The gouache is enriched with spots of colour, red, blue and white, which provide patches of patterning reminiscent of those in many of the *Fables* etchings.

82 *The Monkey and the Leopard* Plate 77
La Fontaine, sheet 88
Etching and drypoint, 29.8 x 24.5

83 *Still Life at the Window*, 1929 Plate 78
Oil on canvas, 100 x 81
Konstmuseum, Gothenburg

The leaping monkey and flying herbivore provide links between these images, which each disclose figures at first sight unseen. In the still life Chagall himself flies down with a bouquet of flowers to join the array of bunches on the table; in the *Fables* etching (La Fontaine,

Book IX, Fable iii) three tiny clowns watch the monkey at his tricks. Chagall worked on twenty-eight copper plates for the *Fables* while painting this still life at Céret (see note 56, p. 21). He evidently enjoyed painting with brushes and thin layers of oil paint to create texture on the canvas, as a contrast to working with needles to create texture on the copper plates.

84 *The Lion in Love* Plate 79
La Fontaine, sheet 40
Etching and drypoint, 29.8 x 24.2

85 *Lovers*, 1929 Plate 80
Oil on canvas, 55 x 38
The Tel Aviv Museum of Art,
Gift of Oscar Fischer, 1940

In contrast with two similar pairs of lovers in etchings 14 and 15 of *Mein Leben* (reproduced p. 218 and Fig. 5), which Chagall suggested with sparse lines, these later lovers leave less to the viewer's imagination. In the *Fables* etching, where the artist has worked his copper plate with a dense mass of lines, the shepherdess is overwhelmed by the ardour of her suitor. The illustration is fanciful, for we learn from the first fable in La Fontaine's Book IV that, blinded by his love, the lion had permitted the shepherdess's father to remove his claws and teeth, lest he unwittingly harm her with his caresses. In the painting the lovers, watched by an angel or Cupid, are more sentimental. They are outlined in blue, which is overpainted except for the hands. Texture is important in both works: in the oil it is emphasized by blobs of thick reddish-orange and yellow paint, contrasting with the thinly applied purple and green. At the end of the 1920s Chagall explored complementary colours in several paintings, inspired, no doubt, by his friend Robert Delaunay.

86 *The Cock and the Pearl* Plate 81
La Fontaine, sheet 11
Etching and drypoint, 30.1 x 22.8

87 *In the Mountain*, 1930 Plate 82
Oil on canvas, 71.9 x 59.4
Allen Memorial Art Museum, Oberlin College,
Gift of Joseph and Enid Bissett, 1956

Chagall's animals are often difficult to identify, but in these two compositions the cock and the cow present no problems. If the cock is the more recognizable of the two, it is because Chagall had a source – a vignette by Karl Girardet from an earlier edition of La Fontaine, from which he has even borrowed the broom (*Fables de La Fontaine*, Tours, 1858, p. 57). However, unlike Girardet, Chagall has set his bird in a hilly landscape. This is related to the one seen from the window in *In the Mountain*, where he demonstrates his skill at painting rugged scenery, which he enlivens with poetic figures.

88 *The two Parrots, the King and
 his Son* Plate 83
La Fontaine, sheet 96
Etching and drypoint, 29.4 x 23.7

89 *Landscape at Peïra-Cava; The Cloud*,
 1930 Plate 84
Oil on canvas, 73 x 60.3
Marlborough Fine Art, (London) Ltd

The genres of pure landscape and ornithological study are unusual in Chagall's oeuvre, but, not surprisingly, neither of these works is what it seems. Elsewhere in this volume the motif of cloud and window has been linked to poetry (see p. 22), and the connection with imagery used by Pierre Reverdy's cloud and cry is reinforced by the shadowy figures of a mother and child almost hidden on the left. They suggest an unseen tragedy, as does the illustration to La Fontaine's Fable xii, Book X, for, although we can recognize that the gaudy parrot belongs to a king and its son to a prince, only the lurid darkness suggests the dreadful outcome – a quarrel with a sparrow which leads the prince to kill his young parrot. The king's head, which matches the parrot's plumage with its crown and curly beard, is related to Chagall's *The Reader* (Plate 44, Cat. 48), with which this *Fables* illustration might equally well have been paired.

90 *The Tortoise and the two Ducks* Plate 85
La Fontaine, sheet 93
Etching, 29.3 x 24.2

91 *Bella and Ida at Peïra-Cava*,
 1931 Plate 86
Oil on canvas, 45 x 60
Ida Chagall, Paris

The artist hides in thick foliage above his wife and daughter, imagined in front of the mountains at Peïra-Cava. If there is a hidden story, it may concern Russia, for Chagall has remembered still-life compositions by his friend David Shterenberg in his curiously observed table. It remains an unusually private painting, with a naive flavour that also marks the illustration for La Fontaine, Book X, Fable iii. This is a singularly painterly etching, with large blotches of white enlivening background and ducks alike: the arrangement suggests decorative pottery. According to La Fontaine, the ducks are proposing travel to the tortoise, which remains little more than a black mark.

Cirque Vollard, 1926-27, and other circus themes

While Chagall was still involved with the *Fables* project, Vollard suggested that he make a series of etchings on circus subjects. Chagall had already done preliminary gouaches intended for reproduction as coloured etchings in a print workshop (see p. 23) and he may have begun circus gouaches with a similar purpose in mind. In the winter of 1926-27 Chagall made nineteen gouaches, some of them based on sketches which he drew from Vollard's box at the Cirque d'Hiver. Several were reproduced by André de Ridder in the Antwerp periodical *Sélection*, whose issue No 6 of 1929 was devoted to Chagall. All are entitled *Le Cirque* and the captions note that they belonged to Vollard, who must therefore have bought the circus gouaches, as well as those for the *Fables*. It is usually said that none of them was etched, but a gouache from *Sélection* is here reproduced with an etching (Plate 95, Cat. 101, Fig.). Chagall had painted trapeze artists in his *Village Fair*[1] before he left Russia for the first time, and in 1920-21 he painted clowns with animals in his *Introduction to the Jewish Theatre* (see Fig. 2 and Cat. 105). He began this soon after the artist Iurii Annenkov had incorporated clowns and trapeze artists in a play by Tolstoy in Petrograd and he also borrowed ideas from Marinetti's *Manifesto of Variety Theatre* (1913) for his own manifesto, *Merry Sanatorium* (published under the pseudonym B. Till).[2] Chagall continued to produce works on circus themes after he moved to Paris, where another artist close to Vollard, Georges Rouault, was painting clowns and circus figures who seem to exemplify tragedy rather than comedy.

Chagall later said that he experienced circus performers as tragic, feeling that they brought him close to 'other horizons'. He wrote some autobiographical passages about the circus in 1967, remembering that, as a child, he had seen a man with a little boy in pink tights and a girl wearing a multi-coloured dress, performing in front of a few spectators on the street in Vitebsk. The man, dressed in an acrobat's costume, had laid an earth-coloured rug on the dusty ground and propped a three- or four-metre pole against his belt, which was climbed first by the boy, then the girl. Another time he saw a little girl wearing transparent tights, who seemed like a circus rider without a horse.[3] These early 'visions' imprinted themselves on his memory, though to a cynical art historian they seem very like Picasso's Harlequin paintings from his Pink Period. Chagall's circus subjects often have an element of sharp satire, giving them an unexpected degree of toughness.

1 Reproduced Compton, cat. no 2, p. 54.
2 Published in 1919 in *Zhizn iskusstva*, English trans., L. Ball, *The Drama Review*, Vol. 19, No 4 (T-68), December 1975, pp. 110-2.
3 *Marc Chagall: Le Cirque*, New York (Pierre Matisse Gallery), 1981.

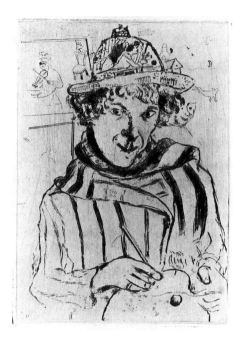

92 *Self-Portrait in an Ornate Hat*, 1928
Etching, 20.5 x 14.5 on sheet, 28.5 x 22.5
The Tel Aviv Museum of Art

In 1922, when he had no fixed abode, Chagall had imagined himself with a house on his head (Cat. 1); when he made this etching he had moved into a house with his family for the first time and he transformed a decorated hat into a house. The crown of the hat has thus become the roof, with a chimney perched on top; lovers kiss; the brim of the hat hides a fence; the little church of Vitebsk appears instead of a feather; and, on the other side, a chair-back has metamorphosed into a person looking at a nude playing a violin. The latter scene could also be read as a picture on a wall or easel behind the artist, who is wearing a favourite striped jacket seen in contemporary photographs (see pp. 262, 263). It is easy to miss the second head – probably Bella's – on the right, nestling in Chagall's hair. This copy of the etching is inscribed 80/100, though the authority on Chagall's prints, Eberhard W. Kornfeld, gave the edition number as sixty and attributed all copies printed before 1957 to the frontispiece of the de luxe edition of André Salmon's monograph on Chagall, published in 1928.

93 *Acrobat with Violin*, 1924 Plate 87
Etching and drypoint, 41.8 x 31.8 on Vélin, 57.5 x 45.2
State III b – 'Bon à tirer, Marc Chagall'
Edition of about 100 copies, planned by Vollard for his third, unpublished, *Album des Peintres-Graveurs*

94 *Man with a Violin*, c. 1920 Plate 88
Watercolour and pencil, 31.9 x 22.9
The Tel Aviv Museum of Art,
Gift of Mr. Arieh Shenkar, 1951

The motif of the acrobat with a violin apparently originated in Russia in a pen and Indian ink version (reproduced Haftmann, Fig. 66, p. 50) usually dated 1918. The sketchbook page was also drawn in Russia, as it is inscribed at the top '*utrom*' (morning) and has further faded pencil notations in Russian on the right. The bands of colour seem to relate it to Chagall's murals for the Jewish theatre; indeed, a pair of feet above a violin on a segment of a circle appear left of centre in the preparatory sketch for one of these (Fig. 2). Drawn on a sheet the same size as this one, the sketch includes clowns dressed in a similar way. There is, however, no trace of this figure, nor of the one in the related etching, in the panel as completed. As this sketchbook page is also the same size as drawings for banners used for decorating Vitebsk in 1918 (*The Promenade*, Israel Museum, Jerusalem; *War on Palaces*, Tretiakov Gallery, Moscow), it may have been intended as a banner design. The faint words may bear out this supposition, as they include 'near the tramway', 'Orthodox church', 'Protestant church' (with diagrams) and 'bridges', as well as colour notations.

95 *The Sentry*, 1923-24 Plate 89
Etching and drypoint with aquatint, 20.9 x 15.8
3 examples of 3 states, 1923-24
4th state without hat, 1 proof;
12 copies printed 1957

96 *Clown with Horse*, 1925 Plate 90
Gouache and watercolour, 55.8 x 66.8
Private Collection, Geneva

In both these works an animal is paired with a person: in the wash drawing with a clown, in the etching with the artist himself. The etching, which includes aquatint, is the more complicated design, especially as the title refers to the tiny outline of a sentry, striding forwards in front of a small, Russian house. This must refer to Vitebsk and, by implication, to events described in *My Life* (p. 151), when soldiers of the Cheka came to search the house by night.

Chagall said in 1967 that he regarded the circus as 'a magic show that appears and disappears like a world. A circus is disturbing. It is profound.' He added, 'A revolution that does not lead to its ideal is, perhaps, a circus too' (*Marc Chagall: Le Cirque,* New York [Pierre Matisse Gallery], 1981). Thus etching and gouache can both be interpreted as circus themes. The drawing, traditionally ascribed to 1925, shows a clown on an animal standing improbably on a table. Executed in predominantly blue wash, it relates more clearly to the circus. Toulouse-Lautrec had used random spattering to give texture to his prints; perhaps Chagall explored the device for similar reasons.

97 *The Circus Rider,* 1926-27 Plate 91
Etching and drypoint, 32.9 x 24
6 proofs 1926-27, newly printed 1963, 2/50
Collection E. W. K., Berne

98 *Lovers/Lady with a Bird,*
c. 1926-27 Plate 92
Gouache, 66 x 51
Museum of the City of Zagreb

Chagall's circus themes are at their most lyrical in this gouache and etching. The simply outlined bareback rider poses gracefully on her horse, as though inspired by a neo-classical sculpture by Aristide Maillol, whom Chagall visited in Banyuls at about the time he made the etching. The Pierrot- and Columbine-like figures in the gouache are equally precisely conceived, but with a bitter-sweet note. Harking back to his pre-1914 hermaphrodite entitled *Homage to Apollinaire* (Stedelijk Van Abbemuseum, Eindhoven), Chagall has given the torsos one pair of legs. Their faces are not unlike those of his poet-friends Clare and Ivan Goll, well known in Paris in the 1920s for their dramatic lovers' quarrels; Chagall had drown portraits for their book *Duo d'amour: Poèmes d'amour* (Paris, 1925). The gouache formerly belonged to the actress Tilla Durieux, wife of Paul Cassirer, who succeeded in transporting her art collection to Yugoslavia after her emigration from Germany in 1938. Maurice Potin, who had printed Chagall's Gogol plates, made at least five proofs of the first state of the etching for the artist in 1926-27. At that time the plate measured 37.1 x 29.8 cm; it was later reduced to the present size and seventy-eight copies were printed by Paul Haasen in 1963 – this is No 2 of the fifty printed on 'Richard de Bas' paper.

99 *Man with Umbrella,* 1926-27 Plate 93
Etching with sugar-lift aquatint, 36.6 x 29.7
4 proofs 1926-27; newly printed 1963, 2/50
Collection E. W. K., Berne

100 *Chicken (Cirque Vollard),*
1926-27 Plate 94
Gouache, 50 x 64
Private Collection

These two motifs share a note of touching self-confidence: the man balances on an umbrella and his legs form a curious parallel to the feathered body in the gouache. The bird clearly has a man's head, in spite of the title given by Franz Meyer, 'Chicken', which is disputed by the owner, who has always called it 'The Cock'. The confusion may have been intended by the artist, whose cocks, lacking lavish tail feathers, so often resemble chickens (see Plates 109, 110, Cat. 116, 117). In this case, the man's beard must be read as the cock's wattle, and his cap as the cock's comb, which was also the English name for a cap worn by jesters. Meyer's classification of the gouache among Chagall's original *Cirque Vollard* series of 1926-27 has been followed here. The etching is a rare example in Chagall's work of the sugar-lift technique; printing details are the same as those given for Cat. 97.

101 *Horse with Umbrella,* 1930 Plate 95
Etching, 20.8 x 16.3
Printed 1930 and 1957
Collection E. W. K., Berne

102 *Clown on a Horse,* 1927 Plate 96
Gouache, 66 x 50.7
Collection Herbert Black, Canada

Rarely for Chagall's circus etchings, Plate 95, Cat. 101 is based on a gouache from 1927, published in 1929 (Fig.), though this does not include the phallic Eiffel Tower and housetops; instead, a tiny clown's head, bottom right, balances the horse. Fifty numbered copies printed by Louis Fort were included in the Parisian Russian journal *Chisla* (No 1, 1930) and seventeen more proofs were printed in 1957. The related gouache was not included in Franz Meyer's classified catalogue and its present whereabouts are unknown. The theme is more fanciful than that of *Clown on a Horse,* which may have been based on the sketches Chagall made from Vollard's box at the Cirque d'Hiver. The nearly abstract use of colour is extremely dramatic and Chagall has added texture with black as well as white markings. This is a characteristic found in the *Fables* gouaches and is an indication that Chagall intended to make an etching from the composition.

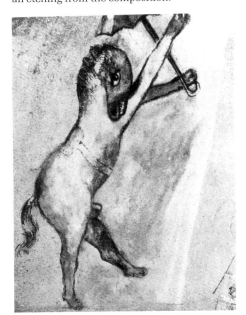

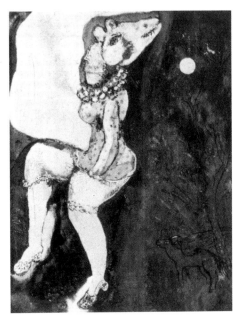

The Circus, 1927; illustration in *Sélection,*
3rd series, Vol. 8, No 6

103 *Pride I,* 1925 Plate 97
Etching and drypoint, 16.5 x 10.8
Sheet 2 from *Les Sept Péchés Capitaux,*
Paris, 1926

104 *Woman-Donkey, c.* 1927 Plate 98
Oil on canvas, 65 x 50.8
Collection Mr. and Mrs. Arnold A. Saltzman,
New York City

Chagall much enjoyed marrying the head of an animal to a human body. To represent 'pride' in a book entitled 'The Seven Deadly Sins', he chose a cock, which, in English, suggests the terms 'cocky' or 'cock-sure'. In total contrast, in scale as well as medium, the oil painting of a donkey-headed woman has a sinister joyfulness, increased by the unlikely proximity of the moon. The composition is related to a gouache from the original series of circus gouaches, then belonging to Vollard, which was reproduced in *Sélection,* No 6, in 1929 (Fig.). *Woman-Donkey* has all the freshness of Chagall's gouaches. His witty juxtaposition of another quadruped, winged and possibly a horse, gives the composition a humour which contrasts with the fiercely toothed donkey's head.

105 *The Three Acrobats,* 1923 Plate 99
Etching and aquatint, 34.2 x 37.3
Plate from 1923, reprinted 1957; 47/50
Collection E. W. K., Berne

106 *The Girl Acrobat,* 1930 Plate 100
Oil on canvas, 65 x 52
Musée national d'art moderne, Centre Georges Pompidou, Paris, Ancien fonds du Musée du Jeu de Paume, 1934

The theme of acrobats remained a favourite with Chagall. The three clowns of the etching

The Circus, 1927; illustration in *Sélection,*
3rd series, Vol. 8, No 6

are based on the *Introduction to the Jewish Theatre* of 1921 (see Fig. 2); a first proof was taken by Louis Fort soon after Chagall arrived in Paris. In 1922 he had begun a small oil of a related subject, which he did not complete until 1944 (Musée national d'art moderne, Centre Georges Pompidou, Paris). The etching is paired here with a major circus oil painting which Chagall made seven years later. The painting is unusual in his oeuvre, for the artiste leans on her trapeze against a French townscape. On a tall building on the right he has written 'Boulanger', and on another on the left 'Boucher', though it is surprising to see a butcher killing an animal on the pavement. The arch formed by the acrobat's thighs and the tiny closed doorway below seem to be the subject of witty ambiguity. The colour scale is deeper than that which Chagall had used in the late 1920s, and he has modified the contrast of red and green by speckling. It has been suggested above (p. 28) that Delacroix influenced Chagall's work in 1930, and this may account for the change of style represented by this painting.

Bible Years, 1931-39

Chagall's illustrations for the Bible (originally conceived as etchings to the Books of the Prophets) span the years when the 'Roaring Twenties' had given way to darker years of economic depression and political unrest. His love of travel took him abroad, to Palestine and Poland, to Holland and England, to Switzerland and Spain and, finally, to Italy in 1937. The precise date when Vollard commissioned him to illustrate the Bible is not clear, but it seems to have been in 1930, before Chagall had finished the last etchings for the *Fables.* Only sixty-six of the Bible etchings had been printed by 1939. Chagall finished a further thirty-nine plates between 1952 and 1956. The etchings were finally issued by Tériade in 1956, in two unbound volumes with excerpts from the translation of the Bible made from the Hebrew text by pastors and professors of the church of Geneva, published in that city in 1638 (the fifty-seven etchings included in Tériade's first volume are reproduced here on pp. 251–9). In addition, numbered sets of impressions were printed and issued without text; some of these sets were hand-coloured by the artist.

In 1930 Chagall had been invited, along with Moïse Kisling, Chaim Soutine and Chana Orloff, to exhibit as a guest in a pavilion devoted to art from Eretz Israel in the Parisian Colonial exhibition. Owing to disagreement with the appointment of a French organizer, this pavilion was not included in the exhibition, but the invitation led Chagall seriously to consider creating contemporary Jewish art, a matter which had preoccupied him before he left Russia. The beginning of the new project was also closely tied to Chagall's visit to Palestine as the guest of Meir Dizengoff, whose plan for a Tel Aviv Museum included 'A department of biblical reproductions or Bible Gallery'. This was envisaged as 'A collection of photographs, reproductions and prints of masterpieces depicting biblical heroes and events.' In Palestine Chagall documented Jewish historical sites – for instance, Rachel's tomb (see Plate 103, Cat. 110) and the Wailing Wall (Plate 104, Cat. 111). These may originally have been conceived as fitting into Dizengoff's plan, though, on his return to Paris, Chagall took issue with him, especially on the inclusion of reproductions. He felt convinced that a museum for Eretz Israel must stand comparison with major art galleries throughout the world and include only carefully selected original works. The full story of Chagall's involvement was published only on the fiftieth anniversary of the opening of the Tel Aviv Museum[1] and it shows how deeply he cared about the project. I believe that the forty or so gouaches (twenty of which are reproduced here) that he made in preparation for the Bible etchings were inspired by Dizengoff's plan for a biblical element in the museum and that, later on, Dizengoff's ideas helped to inspire Chagall's own Museum of the Biblical Message, which opened in Nice in 1972.

The cycle of biblical illustrations has often been described as humanist, but, if Michelangelo's Creation cycle for the ceiling of the Sistine Chapel in the Vatican can be said to embody a humanist viewpoint, then Chagall's vision results from his Hasidic upbringing. In particular, his choice of equating God with His name, written in Hebrew script, is in total contrast to Michelangelo's God fleshed out as man, especially in the well-known scene in which His finger electrifies Adam into life. Chagall's illustrations have been recognized as deeply personal, but they can be seen in the tradition of Hebrew manuscript painting, which survives from all centuries in many styles. He was aware of such prototypes, because in *My Life* (p. 44) he mentions his annual childhood pleasure when the illustrated Passover Haggadah was read. None the less, he did not set out to illustrate Hebrew scrolls; his illustrations were intended for all lovers of the Scriptures.

In 1934 in *Cahiers d'Art* (Vol. 9, Nos 1-4, p. 84) the Roman Catholic philosopher Jacques Maritain wrote about the forty etchings of the Genesis story which were already finished. He found that his friend Chagall 'had not *wanted* to be Jewish', but 'I suppose he doesn't even really know what Jewish or Christian doctrine the Old Testament illustrated by him offers us. It is the poetry of the Bible that he has listened to; it's that alone which he wanted to convey, but this poetry is the voice of someone....' The sentence he left unfinished should alert us to the deep spirituality of Chagall's illustrations. Furthermore, study of his life's work reveals that Chagall was familiar with a wide range of Jewish interpretations. His friendship with the French Jew Edmund Fleg, author of *The Life of Moses* and *Why I am a Jew* (English translations, London, 1928, and New York, 1929, respectively), no doubt revitalized memories of his own religious upbringing, when, like other Jewish children, he had learned the Scriptures by rote from the Talmud teacher. Fleg's books, together with *Jewish Mythology* by David Goldstein (London, 1987) and the catalogue *Chagall and the Bible*, written by Jean Bloch Rosensaft when the Bible etchings were exhibited at the Jewish Museum in New York in 1987, have contributed to the notes in this section.

Of course, Chagall's work during these years was not confined to the Bible, and the decade is important for the large canvases which he painted from 1933 onwards. He also developed a new style using gouache and pastel on paper; the combination has proved fugitive and such works are generally not available for loan to exhibitions. The oils included here show a new compositional strength combined with poetic subject-matter, and Chagall must have felt disappointed not to be called upon to provide any work for the 'Exposition Universelle' of 1937. The previous year he had moved into Paris to an address near the site of the exhibition, possibly in the hope that he would be invited to provide wall decorations, like his friend Delaunay. Commissions were given to French artists only, and Chagall did not gain French citizenship until 1937. None the less, when his large exhibition opened in Paris in 1940 (see Fig. 25), eighteen years in Berlin and Paris had transformed him into an artist of international stature.

1 Tami Katz-Freiman, 'Founding the Tel Aviv Museum 1930-1936', *The Tel Aviv Museum Annual Review*, Vol. 1, 1982, pp. 9-48.

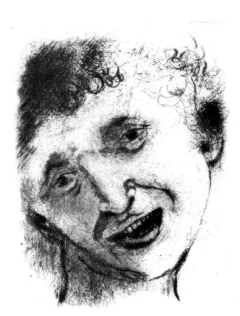

Cat. 107

107 *Self-Portrait with Smile*, 1924-25
Etching and drypoint, 1924-25
27.5 x 21.5 on sheet, 38 x 28
State II

Although he had made this self-portrait six years before, Chagall took copies with him to Palestine and dedicated them as gifts. He must have been particularly pleased with it as he gave one copy to his etching teacher, Hermann Struck, when he visited him in Haifa; he gave another to his host, Meir Dizengoff, in Tel Aviv (both are now in the collection of the Tel Aviv Museum of Art). The composition derives from a pencil study (reproduced Meyer, cat. no 277) made in 1917 for the *Double Portrait with a Wineglass* (Musée national d'art moderne, Centre Georges Pompidou, Paris). In the etched version Chagall softened the rather harsh pencil shading by using drypoint. 'Chagall's smile' was the caption for a photograph published in a Paris newspaper article in 1934 (reproduced here on p. 266).

108 *The Burning Bush* Plate 101
Bible, sheet 27, 28.9 x 22.7

109 *Jew with the Scroll of Law*,
 1925 Plate 102
Gouache, 68 x 51
The Tel Aviv Museum of Art,
Gift of the artist, 1931

Chagall gave this *Jew with the Scroll of Law* to the Tel Aviv Museum before its opening in 1932, when it received the inventory number '1'. The artist dated the gouache 1925, but the houses in the background are chalets in the Swiss Alps, where Chagall spent a few months each winter from 1927 onwards. The peasants with a pig make a sharp contrast with the solemn Jew, who clutches his Torah scroll in a possessive gesture. During 1930 Chagall began work on illustrations for the Bible: the etching showing the joyful ardour of Moses, as God revealed

Himself in a burning bush, is poignant for all lovers of the Scriptures of whatever faith. It is placed here as an introduction to Chagall's Bible.

110 *Rachel's Tomb* Plate 103
Bible, sheet 17, 23.7 x 30.5

111 *The Wailing Wall*, 1932 Plate 104
Oil on canvas, 73 x 92
The Tel Aviv Museum of Art,
Gift of the artist, 1948

Later in life Chagall implied that he had been present for the opening of the Tel Aviv Museum in April 1932, and, before giving this view of the Wailing Wall to the museum, he signed and dated it 'Palestine, 1932'. In reality, his visit had taken place in 1931, when the museum was still under discussion. Chagall painted a number of faithful views in Palestine: the etching of the tomb of Rachel is a transcription of an oil, painted out of doors. Although some might think this modern view irrelevant to the biblical story, it is a place of pilgrimage for women, especially those who sorrow and mourn. His *Wailing Wall* has historical significance because he has conveyed the narrowness of the alley in front of the Wall at that time, long before the recent creation of a piazza, which has given rise to a wide space in front of the historic stones surviving from Solomon's Temple.

112 *Moses and Aaron* Plate 105
Bible, sheet 29, 28.9 x 22.1

113 *Synagogue at Safed*, 1931 Plate 106
Oil on canvas, 73 x 92
Stedelijk Museum, Amsterdam

Chagall conveyed the closeness of the brothers, as Moses, distinguished by the rays of light and rod, kissed Aaron at the mountain of God and told him of God's plans (Exodus iv: 27-28). Something of the same spiritual joy pervades his view of the synagogue at Safed, which glows with light, rendered with paint applied in a freer, more sketchy manner than reproductions suggest. The Hebrew root of the name Safed means to look – to observe – or to look for – to hope. It is the highest town in Israel, situated in the mountains in the north, made famous as a Cabbalist centre by Spanish exiles in the sixteenth century; disciples of the founder of Hasidism – the sect in which Chagall had been raised – settled there in the eighteenth century.

114 *The Creation of Man* Plate 107
Bible, sheet 1, 30.6 x 22.8

115 *The Creation of Man*, 1930 Plate 108
Gouache, 64 x 48
Musée National Message Biblique
Marc Chagall, Nice

This is the first of about forty gouaches which Chagall made in preparation for the Bible etch-

ings. He began the cycle by invoking an angel as intermediary between God and newly created man, thereby following the plural phrase 'Let us make man' (Genesis i: 26), which led to the rabbinical interpretation that God was inviting His angels to join Him in creating man. By means of this unusual device, Chagall avoided the personification of God, who is depicted in the Hebrew letters of His name. In the gouache colour allows an extension, for God's name is written on the moon, which, in thirteenth-century Jewish mystical writings – the Zohar – is a symbol of the divine presence, Shekhinah, the aspect of divinity most closely involved with the world.

116 *Noah dispatching the Dove* Plate 109
Bible, sheet 2, 31.5 x 23.7
Etching and drypoint

117 *Noah dispatching the Dove*,
 1931 Plate 110
Oil and gouache, 63.5 x 47.5
Musée National Message Biblique
Marc Chagall, Nice

The cycle of Bible etchings moves directly from the creation of Adam to the end of the Flood which threatened to destroy God's creation, though Chagall had made gouaches of two intervening events, *The Creation of Eve* (Fig. 20) and *Noah receiving the Order to construct the Ark*, from which he made no copper plates. In this scene Chagall suggests the claustrophobia of the ark, and the dove as a sign of hope for Noah and his family sheltering inside. New life is implied by the young mother feeding her baby, forgiveness by the symbolic goat (not a heifer as occasionally interpreted) and generative power by the cock, which, as so often in Chagall's work, looks more like a chicken. In the story told in Genesis viii Noah sent out the dove three times at seven-day intervals – the first time she returned, unable to find a resting place; the second, she brought back an olive leaf; the third time she did not return, signalling to Noah that the earth was dry. Chagall's 'window' composition is in strong contrast to ones he had made in the 1920s, such as Plate 76, Cat. 81, and Plate 84, Cat. 89.

118 *Noah's Sacrifice* Plate 111
Bible, sheet 3, 29.7 x 23.8

119 *The Sacrifice of Noah*,
 1932 Plate 112
Gouache, 62 x 49.5
Musée National Message Biblique
Marc Chagall, Nice

The account of Noah's first action when he left the ark is given in Genesis viii: 20-22, and Chagall has imbued the sacrifice with a mysterious light, which consumes the animals without destroying them. In the gouache the curved edge of the fiery light prefigures the rainbow; Noah's son, outlined in the unreal space above the patriarch, predicts generations to come. Chagall has suggested landscape with dark,

leaf-like forms, built up with many greens, which become myriads of tiny lines in the etching. In general, little credence can be given to Chagall's dating, and this is the only gouache which he inscribed 1932.

120 *The Rainbow* Plate 113
Bible, sheet 4, 30.3 x 23

121 *The Rainbow, Sign of Covenant
 between God and the World,*
 1931 Plate 114
Gouache, 63.5 x 47.5
Musée National Message Biblique
Marc Chagall, Nice

In the etching Noah reclines on the ground, with a shadowy dwelling (akin to the tomb of Rachel, Plate 103, Cat. 110) visible in front of a white rainbow, with the same goat and cockerel found inside the ark in Plate 109, Cat. 116, and Plate 110, Cat. 117, now safely on land. Chagall made two preparatory gouaches, and the one shown here is closest to the etching; the other includes palm trees which the artist must have seen in 1931 along the coast of Palestine. In Genesis ix: 8-17 God tells Noah that the rainbow is a sign of the covenant between them that the waters shall never again become a flood to destroy all living creatures.

122 *Abraham entertaining
 the three Angels* Plate 115
Bible, sheet 7, 30.4 x 24.3

123 *Abraham entertaining
 the three Angels,* 1931 Plate 116
Oil and gouache, 62.5 x 49
Musée National Message Biblique
Marc Chagall, Nice

Two accounts of God telling Abram that his wife, Sarai, would give birth in spite of her old age are found in Genesis. In the first, God renamed him Abraham and his wife Sarah, saying, 'I am God Almighty. Live always in my presence and be perfect, so that I may set my covenant between myself and you and multiply your descendants' and predicting the birth of a son (xvii: 1-22). In the second account (Genesis xviii), illustrated by Chagall in this gouache and etching, three angels visited Abraham, who entertained them to a meal and heard their news that Sarah would bear a son. The relationship of Chagall's composition to Russian icon painting has been described above (see pp. 27-8); in the gouache the reddish-brown colour suggests earth, but Chagall's space is just as unreal as that of Russian icons.

124 *The Circumcision* Plate 117
Bible, sheet 6, 29.9 x 23.6

125 *Circumcision ordained by God
 unto Abraham,* 1931 Plate 118
Gouache, 62 x 49
Musée National Message Biblique
Marc Chagall, Nice

Chagall chose to depict a particular event, the circumcision of Abraham's son, Isaac, emphasizing the age of the mother, giving her the wrinkles of extreme old age and touchingly showing the frailty of the human condition. Chagall particularized the more general text from Genesis xvii, which tells of the circumcision of Abraham and his family as the physical sign that his descendants were to be God's people. He had already illustrated the subject before 1910 (see Fig. 21).

126 *The Sacrifice of Abraham* Plate 119
Bible, sheet 10, 30.4 x 23.7

127 *Abraham and Isaac on the way to
 the Place of Sacrifice,* 1931 Plate 120
Gouache, 62 x 48.5
Musée National Message Biblique
Marc Chagall, Nice

Although there is a gouache version of *The Sacrifice of Abraham*, the etching is paired here with one showing the scene which preceded it, for which Chagall did not make an etching. The pair thus tell of the demand for unyielding loyalty which God demanded of Abraham, when, according to Genesis xxii: 1-18, he was asked to offer Sarah's son, for whom they had waited most of their lives, as a human sacrifice. In the gouache Isaac is carrying the faggots for his pyre, but the etching shows how, at the last moment, an angel stayed the hand of Abraham, who saw a ram caught by its horns in a thicket and sacrificed it instead. The figure of Isaac in the gouache is one of the most tender nudes that Chagall painted.

128 *Abraham weeps over Sarah* Plate 121
Bible, sheet 11
Etching and drypoint, 29.3 x 24

129 *Abraham weeps over Sarah,*
 1931 Plate 122
Gouache, 62.5 x 49.5
Musée National Message Biblique
Marc Chagall, Nice

In a close-up view of remarkable gravity Chagall showed Abraham grieving over the corpse of his beloved wife. The gouache is distinguished by the use of green, which gives a rich warmth to the sad scene. Chagall admitted his admiration for Rembrandt, whose house he visited in Amsterdam in 1932 (see p. 31). On that occasion he went to the Mauritshuis in The Hague, where he saw Rembrandt's *Anatomy Lesson of Dr Tulp*, which seems to have inspired the figure of Sarah. In addition, the venerable figure of Abraham is a reminder of the Dutch artist's self-portraits, disguised by a typical Chagall hand, which hides the face.

130 *Jacob's Ladder* Plate 123
Bible, sheet 14, 29.5 x 24.3

131 *The Dream of Jacob,* 1930-32 Plate 124
Oil on canvas, 74 x 60
Ida Chagall, Paris

In this powerful scene, paired here with a related oil painting rather than a preparatory gouache, the patriarch Jacob reclines in a deep sleep, with the angels of his dream poised on a ladder leading from earth to the name of God, from which shines a great radiance. Chagall has added an unknown figure calling Jacob's attention to the Lord, who told him that, as the descendant of Abraham and Isaac, he would inherit the land and that God would remain with him (Genesis xxviii: 12-15). Chagall identified with the story, which inspired two of his own poems. Jean Bloch Rosensaft noticed the resemblance between Chagall's Jacob and one by Ribera, seen reversed (Fig.); as the etching was reproduced in *Cahiers d'Art* early in 1934 (Vol. 9, Nos 1-4, pp. 84-92), it seems likely that Chagall visited Spain twice in 1933 and 1934, as suggested in a chronology by Charles Sorlier (*Chagall by Chagall*, New York, 1979, p. 243).

132 *Joseph, the young Shepherd* Plate 125
Bible, sheet 18, 30 x 23.5

133 *The Shepherd Joseph,* 1931 Plate 126
Oil and gouache, 64.5 x 51
Musée National Message Biblique
Marc Chagall, Nice

Jacob's youngest son is seen in the foreground with a fanciful young goat beside him, no doubt a symbol of the seventeen-year-old's forthcoming fate as a victim of his brothers, who jealously despised him as a dreamer. (The story of Joseph is told in Genesis xxxvii.) Although Chagall had used white light behind the ladder in Plate 123, Cat. 130, and Plate 124, Cat. 131, this is the first example in the Bible series of a figure silhouetted in front of a light background, blue in the gouache and barely marked white in the etching.

José de Ribera, *The Dream of Jacob,* 1639. Prado, Madrid

134 *Pharaoh's Dream* Plate 127

Bible, sheet 22, 28.7 x 22.6

135 *Joseph interprets*
Pharaoh's Dream, 1931 Plate 128

Oil and gouache, 62 x 49
Musée National Message Biblique
Marc Chagall, Nice

Leaving out the illustrations that Chagall made
of Joseph being sold by his brothers to traders,
who subsequently sold him into slavery in
Egypt; of the grief of Jacob who presumed his
son murdered (Plate 151, Cat. 158); and of
Joseph's rejection of the advances of Potiphar's
wife, this next etching and gouache in the
sequence show Joseph interpreting Pharaoh's
dream. Chagall has placed the cows of the
dream, which signified seven fat years followed
by seven lean years (Genesis xli: 25-32), inside
a globe. This serves to lighten the dark throne
and robe of Pharaoh, who, as Rosensaft (p. 133)
noticed, has affinities with characters in paint-
ings by El Greco, whose work Chagall admired
in Spain. As a result of Joseph's predicting
plenty followed by famine, Pharaoh appointed
him to be ruler in Egypt and to control the
harvest and sale of corn in order to avoid
famine.

136 *Joseph recognized by*
his Brothers Plate 129

Bible, sheet 23, 29.4 x 23.3

137 *Joseph making himself known*
to his Brothers, 1931 Plate 130

Oil and gouache, 62 x 49
Musée National Message Biblique
Marc Chagall, Nice

When his ten brothers arrived in Egypt to buy
corn, Joseph tested them by imprisoning them
as spies before sending all but one back to
Canaan to fetch their brother Benjamin.
Chagall illustrated the dramatic moment when
Joseph finally revealed himself to his brothers,
now including Benjamin. The artist could not
convey the testing that Joseph had put them
through (Genesis xlii), but he showed the
brothers dumbfounded at recognizing him in
his position of authority. The text is from
Genesis xlv, where Joseph tells them not to
reproach themselves for their evil deed, for God
had sent him ahead to enable him to save life.

138 *Jacob's Departure for Egypt* Plate 131

Bible, sheet 24, 30.1 x 23.8

139 *Jacob leaves his Homeland*
to go down to Egypt, 1931 Plate 132

Oil and gouache, 56.5 x 49
Musée National Message Biblique
Marc Chagall, Nice

As soon as Pharaoh learned that Jacob's
brothers were visiting him, he invited them to
bring their father and all their households from
Canaan to settle in Egypt. Thus, the outcome of
Joseph's prediction of the famine in Egypt

(Plates 127, 128, Cat. 134, 135) and his
subsequent role as controller of grain through
years of plenty and famine led eventually to the
migration of the whole family of Jacob – by
then renamed Israel – to Egypt. In the gouache
the patriarch's face is barely indicated, but in
the etching Chagall filled in the details, as well
as including smaller figures behind the camel,
thus increasing the numbers of immigrants to
half of the seventy of tradition.

140 *Moses saved from the Water* Plate 133

Bible, sheet 26, 28.7 x 22.6

141 *Moses saved from the Water*,
1931 Plate 134

Gouache, 63 x 49
Musée National Message Biblique
Marc Chagall, Nice

By 1934 Chagall had completed the etchings for
Genesis; as they were not exhibited at the time,
it is not clear whether he had already made the
gouaches for the story of Moses, which is told in
Exodus. The first chapter tells of Pharaoh's fear
of the numbers of descendants of Jacob – the
Israelites. In spite of his enslaving them and
increasing their workload, they continued to
increase, so he decided that all new-born Israel-
ite boys must be drowned in the Nile. This gives
the background to Chagall's illustration, where
Pharaoh's daughter sees the child lying in a
tarred basket floating safely in the bullrushes.
As told in Exodus ii, she rescues him, and, at
the prompting of his older sister, Miriam, gives
him back to his mother to nurse before bring-
ing him up herself. The overhead trees, so clear
in the etching, seem to have faded in the
gouache.

142 *Darkness over Egypt* Plate 135

Bible, sheet 31, 29.1 x 22.8

143 *Moses spreads Darkness*,
1931 Plate 136

Oil and gouache, 62 x 49
Musée National Message Biblique
Marc Chagall, Nice

Only some of the gouaches showing the story of
how Moses saved his people from slavery in
Egypt are included here, though two etchings,
Plate 101, Cat. 108, and Plate 105, Cat. 112, fill
gaps in the story. The battle between Pharaoh
and Moses, who, with God's help, inflicted
plagues on Egypt to encourage Pharaoh to let
the Israelites go, reached a turning point when
Moses spread darkness over the land for three
days. Chagall used the dark background of the
first gouaches together with the Hebrew letters
of the name of God, but he added to the biblical
narrative (Exodus x: 21-23) the helping hand of
an angel in the upper right corner. He included
Aaron's head at the lower right and helpless
men and animals, confused by the palpable
darkness, on the left.

144 *The Passover* Plate 137

Bible, sheet 32, 29.2 x 22.9

145 *The Israelites eat the Passover*
Lamb, 1931 Plate 138

Oil and gouache, 62.5 x 49
Musée National Message Biblique
Marc Chagall, Nice

Chagall has purposely confused the reading of
his illustration of the eating of the Paschal lamb
so that it could be read as the prototype of a
later Passover meal. The occasion is timeless,
except for the flying angel, who is perhaps
defending the Israelites from the hand of God,
which that night killed the first-born in every
Egyptian house. This was the final calamity,
through which Moses and the Israelites were at
last permitted to leave Egypt. Chagall had been
in the Holy Land at the time of the annual feast
of the Passover in 1931. Edmond Fleg described
his own moving experience of the feast in
Jerusalem on that occasion (*The Land of Prom-
ise*, New York, 1933, pp. 107-16), though it is not
known whether Chagall and his family also
observed the feast, fulfilling the annual refrain
of Jews of the diaspora, 'Next year in
Jerusalem!'

146 *Dance of Miriam, Sister of*
Moses Plate 139

Bible, sheet 35, 29.6 x 23.1

147 *Miriam dancing*, 1931
Plate 140

Oil and gouache, 62 x 49
Musée National Message Biblique
Marc Chagall, Nice

After the Israelites had safely crossed the Red
Sea and escaped from their Egyptian pursuers,
Moses and the people sang praises. With his
brightly coloured gouache and joyful composi-
tion, Chagall celebrated the sequel: 'And
Miriam the prophetess, Aaron's sister, took up
her tambourine, and all the women followed
her, dancing to the sound of tambourines; and
Miriam sang them this refrain: "Sing to the
Lord, for he has risen up in triumph; the horse
and his rider he has hurled into the sea"'
(Exodus xv: 20-21). A relationship between this
design and groups of dancers by Nataliya
Goncharova has been suggested above (see
p. 31).

148 *Moses receiving the Tablets*
of the Law Plate 141

Bible, sheet 37, 28.3 x 22.7

149 *Moses receiving the Tablets*
of the Law, 1931 Plate 142

Oil and gouache, 61 x 48.5
Musée National Message Biblique
Marc Chagall, Nice

In total contrast to the last gouache, Chagall
here used a sombre background, characteristic
of the most solemn moments in his Bible story.
Chagall depicted Moses on Mount Sinai, with

his head shining with rays of light, receiving the tablets of stone inscribed with the Ten Commandments (Exodus xx: 1-17) given by hands emerging from behind a cloud. He shows Moses alone, perhaps inspired by the Exodus Rabbah 29:9: 'When God revealed the Torah, no bird sang, no fowl beat its wings, no ox bellowed, the angels did not sing their songs of praise, the sea did not roar, no creature uttered a sound; the world was silent and still, waiting for the echoless divine voice which proclaimed: I am the Lord, thy God' (David Goldstein, *Jewish Mythology*, London, 1987, p. 96).

150 *The Golden Calf* Plate 143
Bible, sheet 38, 28.9 x 22.9

151 *The Hebrews worshipping the Golden Calf*, 1931 Plate 144
Oil and gouache, 61.5 x 48.5
Musée National Message Biblique
Marc Chagall, Nice

In another dramatic composition Chagall showed the sequel to Plate 141, Cat. 148, and Plate 142, Cat. 149. After the Ten Commandments, Moses received chapters of further observances, and the people of Israel, tired of waiting for him to come down from the mountain, persuaded Aaron to let them have an idol to worship (Exodus xxxii: 1-17). In the gouache the animal looks more like a golden pig than a calf, but by the time Chagall made the etching he had found a better model and produced a more accurate representation of the bull-calf of the story.

152 *Moses breaks the Tablets of the Law* Plate 145
Bible, sheet 39, 29.4 x 23.1

153 *Moses breaks the Tablets of the Law*, 1931 Plate 146
Oil and gouache, 62 x 48.5
Musée National Message Biblique
Marc Chagall, Nice

'As he approached the camp, Moses saw the bull-calf and the dancing, and he was angry; he flung the tablets down, and they were scattered to pieces at the foot of the mountain' (Exodus xxii: 19). Chagall shows Moses in an attitude of disappointed anger. However, he has not shattered the tablets; they are shown on the ground, chipped, with, as Rosensaft (p. 138) noticed, an anachronistic star of David added to one of them. This is one of Chagall's lasting images; he used the figure again in an oil painting of the same title (1955-56; Museum Ludwig, Cologne).

154 *Aaron and the seven-branched Candlestick* Plate 147
Bible, sheet 40, 29.1 x 22.9

155 *Aaron in front of the seven-branched Candlestick*, 1931 Plate 148
Oil and gouache, 60 x 49
Musée National Message Biblique
Marc Chagall, Nice

The verses which Chagall illustrated are from the book of Numbers, viii: 1-4, where Aaron, in his function as high priest, is instructed to cause seven lamps to give light at the front of the lampstand, which was made from the pattern that the Lord had shown Moses. This seven-branched candlestick, the menorah, is a potent symbol of Judaism, and is found inscribed on ancient Jewish tombs, in mosaic synagogue floors and on Jewish coins at the time of the Romans. This is another instance in which Chagall's etching is more detailed than the gouache: in black and white he filled in more detail in Aaron's head-dress and hung the now carefully inscribed breastplate by a chain round his neck. He added jewels round the breastplate, but more than the twelve which, according to medieval mystics, had esoteric significance.

156 *Joshua reads the Word of the Law* Plate 149
Bible, sheet 47, 29.7 x 23.2

157 *Man Praying*, 1934-35 Plate 150
Gouache, 60 x 48
Private Collection

At the beginning of this section a Jew holding a Torah scroll is paired with Moses's vision of God which led him to receive the law (Plates 101, 102, Cat. 108, 109). A man at prayer is paired here with Joshua, seen as spiritual leader, keeping alive the teachings of his friend and master, Moses (Joshua, viii: 33-35). Chagall seems, anachronistically, to have given Joshua a book, but it is no doubt meant to be one of the altar stones on which Joshua had newly inscribed the law. The present-day Jew in the gouache is a reminder of Chagall's documentation of Jewish religious life in his paintings of synagogues in Palestine (see Plate 106, Cat. 113), which he continued on his visit to Poland in 1935. Indeed, Franz Meyer classified *Man Praying* with synagogue interiors that Chagall recorded in Vilnius (Meyer, cat. nos 624, 625). The pious man clings to the Torah scroll – the five books of Moses: Genesis, Exodus, Leviticus, Deuteronomy and Numbers.

158 *Jacob mourning Joseph* Plate 151
Bible, sheet 20, 30.2 x 24.6

159 Study for *Solitude*, 1933 Plate 152
Oil and pastel on canvas, 27 x 40
Mrs. Pearl and Mr. Joseph Boxenbaum

Jacob mourning the loss of his youngest son, Joseph, is out of sequence here (see Cat. 134)

because his bowed figure complements the musing Jew in this study for a larger painting now in the Tel Aviv Museum of Art. The scholar Mira Friedman has identified the title, *Solitude*, as referring to Lamentations, i : 1: 'How doth the city sit solitary', connecting it with the Prophet Jeremiah. She linked Chagall's figure with Rembrandt's *The Prophet Jeremiah Lamenting the Destruction of Jerusalem* (Rijksmuseum, Amsterdam), but also pointed out a closer prototype, *John the Baptist in the Wilderness* by the fifteenth-century Netherlandish painter Geertgen tot Sint Jans (Berlin-Dahlem, Gemäldegalerie), where the cloaked figure sits, like Chagall's, on the ground. She believes that he had seen the painting in Berlin ('Marc Chagall's Portrayal of the Prophet Jeremiah', *Zeitschrift für Kunstgeschichte*, Vol. 47, No 1, 1984, pp. 384-90) and adduces Chagall's substitution of John the Baptist and his attribute, a sheep representing Christ, for Jeremiah with a cow, which, in the Midrash, foretold the birth of the Messiah. In the etching Jacob, with his bare feet, is like a caricature of the early Netherlandish figure, his low stool taking the place of the basket behind the Baptist.

160 *Meeting of Jacob and Rachel* Plate 153
Bible, sheet 15
Etching and drypoint, 29.2 x 22.9

161 *Bouquet of Flowers*, 1937 Plate 154
Oil on canvas, 99 x 71
Private Collection

The etching shows a story of enduring love, because Jacob agreed to work for Rachel's father for seven years to win her hand. Chagall may have seen a parallel in his own life, if we can believe the account in *My Life*, because he waited seven years to marry his own love, Bella, whom he first met in 1909. He has shown Jacob and Rachel at their first meeting beside the well, though her expression also conveys her disappointment when Jacob was deceived into marrying her sister Leah rather than herself, thus forcing him to work a further seven years. In the secular love story Chagall shows his love for Bella after twenty years, as intense as a bunch of fresh flowers. They are surrounded by a blue, dream-like space, a memory of Vitebsk inhabited by a winged figure and symbolic animals, a cow and a cock.

162 *Rebecca at the Well* Plate 155
Bible, sheet 12, 30.1 x 23.6

163 *A Midsummer Night's Dream*, 1939 Plate 156
Oil on canvas, 117 x 89
Musée de Peinture et de Sculpture, Grenoble, Gift of the artist, 1951

Among Chagall's Bible illustrations are several love stories, including the one when Abraham's servant stopped by the well at Nahor during his search for a bride for Isaac, and Rebecca came out to water the camels (Genesis xxiv: 10-21).

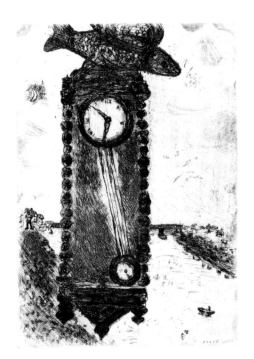

The Clock, 1928-30; etching, 20.3 x 14.4

The scene was influenced by Chagall's visit to the Middle East in 1931, though, as has been suggested above (see p. 28), the facial types also resemble heads by Delacroix. Paired with it here is an oil painting of a classical love story from Shakespeare. Chagall's reason for choosing the subject is probably connected with the 'Exposition Universelle' held at the Trocadéro in Paris in 1937. Among the oil paintings decorating the Palais de Chaillot was a large panel of the subject by Luc-Albert Moreau, *Shakespeare's Theatre* or *A Midsummer Night's Dream,* and another by Edouard Vuillard, *Comedy,* which included Titania and Bottom shown in a glade (both reproduced *Paris 1937 Cinquantenaire de l'exposition internationale des arts et des techniques dans la vie moderne,* Institut Français d'Architecture / Paris-Musées, 1987, pp. 366, 375). Chagall had often painted figures with animal heads (see Plate 98, Cat. 104), but here he has reacted to these French paintings and given his own, far more timeless evocaton of Shakespeare's dream.

164 *Joshua before Jericho* Plate 157
Bible, sheet 46, 32.8 x 22.5

165 *Time is a River without Banks,* 1930-39 Plate 158

Oil on canvas, 100 x 81.3
The Museum of Modern Art, New York, Given anonymously, 1943

For religious and secular theme alike Chagall has used flying figures to balance a strong vertical in a classical composition. Joshua is depicted as the spiritual successor to Moses in Plate 149, Cat. 156; in the present illustration he is seen as a military leader, relying on the word of God for the defeat of Jericho (Joshua vi: 1-7). The composition used in the oil painting was not always so strong: it is based on an etching

(Fig.) intended for René Schwob's *Chagall et l'âme juive* (Paris, 1931). The etching, *The Clock,* remained in proof stage, for when the book was published in 1931 the frontispiece was a reproduction of the oil (Fig.) with, unusually for Chagall, his design in reverse. He also changed the angle of the clock, which no longer overlaps the river bank, and allows a change of title to Ovid's line 'Time is a river without banks'. Metamorphosis is the essence of Chagall's poetic idea, described above (see p. 34). The fish playing a little violin and the couple now blessed with a child make the further transformation of 1939, seen here, into a magical evocation of Chagall's life-dream.

166 *The Wedding Candles,* 1934-45 Plate 159

Oil on canvas, 123 x 120
Kunsthaus, Zurich,
Gift of the estate of Ernst Göhner

While creating the Bible illustrations in the 1930s, Chagall found time to work on several large oil paintings. He chose a horizontal format, combining figures and episodes in different scales in an attempted marriage of memories on the canvas. *The Wedding Candles* painting is half of the large *Composition* (entitled *Circus People* by Meyer) from 1934, which he cut in 1945, subsequently altering both parts. This is not immediately obvious, because the other half, *Around Her* (Musée national d'art moderne, Centre Georges Pompidou, Paris), is not a pair to this, as it measures ten centimetres less in both dimensions.
In March 1935 Chagall changed the right side of *Composition.* His alterations were noted in the caption to a photograph published in *Cahiers d'Art* (Vol. 10, Nos 1-4, 1935): chair, chicken, small people, foreground woman with raised hands and clarinet player (seen in Fig. 24) had already gone, making space for the present street setting and a 'cello player, based on a

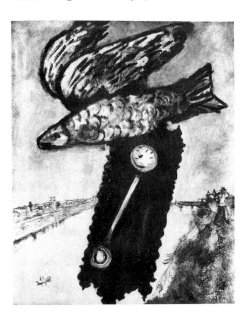

Time is a River without Banks, first state, 1930; frontispiece to René Schwob, *Chagall et l'âme juive,* Paris, 1931

supplementary sheet to *Mein Leben* (Cat. 24). No doubt the death of Bella in the United States in 1944 caused Chagall to recast his celebration as a memory of 1935, for in *Around Her* Bella resembles the portrait he painted of her in 1935 (Stedelijk Museum, Amsterdam). In *The Wedding Candles* Chagall resolved technical problems he had experienced with the large painting and allowed his dream to mellow with the passage of time.

The Cycles of Etchings

Mein Leben
Nikolai Gogol, *Dead Souls*
La Fontaine, *Fables*
The Bible

Mein Leben

Marc Chagall, *Mein Leben: 20 Radierungen*,
Berlin, Paul Cassirer, 1923. Portfolio. 110
numbered copies, 26 on Japan, 84 on Bütten.

20 numbered leaves and proofs from various
sets.
Sprengel Collection I, 341-60
Sprengel Museum, Hanover

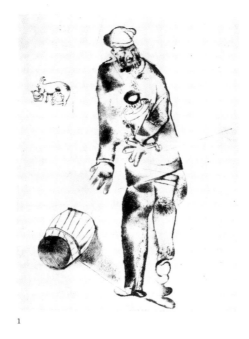

1

2

1 **Father**
Der Vater
Etching and drypoint, 1922
27.8 x 21.8 on leaf, 44.5 x 35
Inscribed: 103/110 Marc Chagall
Sprengel I, 344

2 **Mother and Son**
Mutter und Sohn
Etching and drypoint, 1922
27.8 x 21.8 on leaf, 44 x 35
Inscribed: 63/110 Marc Chagall
Sprengel I, 349

3 **The Grandfathers**
Die Grossväter
Etching and drypoint, 1922
27.8 x 21.7 on leaf, 44 x 35
Inscribed: 80/110 Marc Chagall
Sprengel I, 353

4 **Grandmother**
Die Grossmutter
Etching and drypoint, 1922
20.9 x 16 on leaf, 37.3 x 26
Inscribed: 75/110 Marc Chagall
Sprengel I, 352

5 **Pokrovskaia in Vitebsk**
Pokrowskaja in Witebsk
Etching and drypoint, 1922
17.9 x 21 on leaf, 35 x 44.5
Inscribed: 27/110 Marc Chagall
Sprengel I, 346

6 **Birth**
Geburt
Etching, 1922
12.9 x 17.8 on leaf, 26.5 x 35.5
Inscribed: 88/110 Marc Chagall
Sprengel I, 358

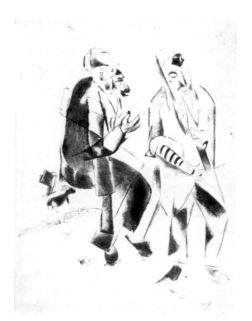

3

4

5

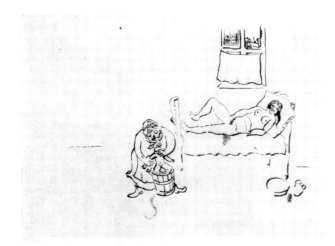

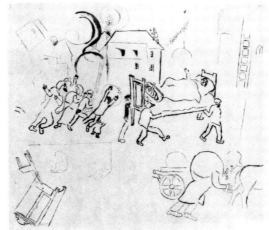

6

7

8

9

7 **Fire in the City**
Feuer in der Stadt
Etching, 1922
18 x 20.9 on leaf, 35 x 45
Inscribed: 95/110 Marc Chagall
Sprengel I, 341

8 **House in Peskovatik**
Haus in Peskowatik
Etching and drypoint, 1922
17.9 x 21 on leaf, 35.5 x 44.5
Inscribed: 35/110 Marc Chagall
Sprengel I, 356

9 **The Talmud Teacher**
Der Talmudlehrer
Etching and drypoint, 1922
24.6 x 18.8 on leaf, 44.5 x 35
Inscribed: 97/110 Marc Chagall
Sprengel I, 348

10 **Dining-Room**
Speisezimmer
Etching and drypoint, 1922
27.6 x 21.7 on leaf, 35.5 x 44.5
Inscribed: 29/110 Marc Chagall
Sprengel I, 345

11 **House in Vitebsk**
Haus in Witebsk
Etching and drypoint, 1922
18.9 x 24.9 on leaf, 35 x 45
Inscribed: 87/110 Marc Chagall
Sprengel I, 359

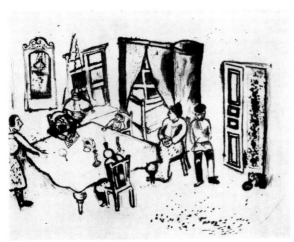

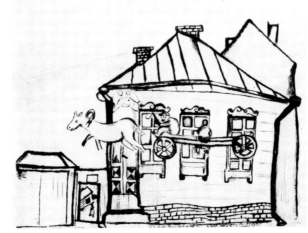

10

11

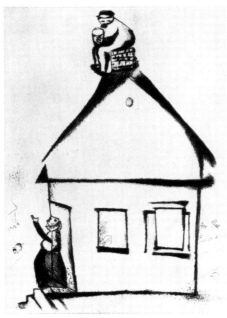

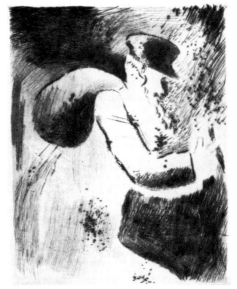

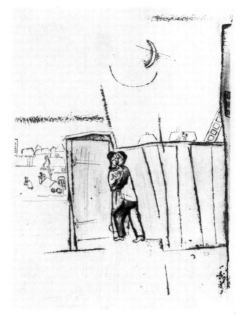

12

13

14

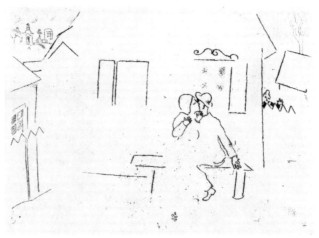

15

12 **Grandfather's House**
Haus des Grossvaters
Etching and drypoint, 1922
20.9 x 16 on leaf, 35 x 27
Inscribed: 97/110 Marc Chagall
Sprengel I, 343

13 **An old Jew**
Ein alter Jude
Etching and drypoint, 1922
12 x 9.8 on leaf, 35 x 26.5
Inscribed: 110/110 Marc Chagall
Sprengel I, 347

14 **At the Gate**
Vor dem Tore
Etching, 1922
20.9 x 15.8 on leaf, 35 x 27
Inscribed: 78/110 Marc Chagall
Sprengel I, 350

15 **Lovers on the Bench**
Liebende auf der Bank
Etching, 1922
13 x 18 on leaf, 36 x 44
Inscribed: 49/110 Marc Chagall
Sprengel I, 351

16 **Wedding**
Hochzeit
Etching and drypoint, 1922
14.4 x 16.2 on Japan, 27 x 35.5
State III, inscribed: Marc Chagall
Sprengel I, 355

17 **Self-Porträt**
Selbstporträt
Etching and drypoint, 1922
27.5 x 21.5 on leaf, 44.5 x 35
Inscribed: 33/110 Marc Chagall
Sprengel I, 360

16

17

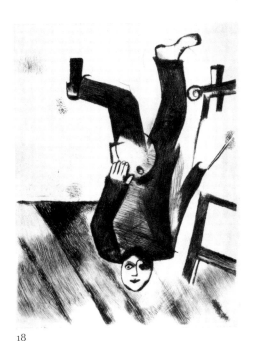

18

19

18 **At the Easel**
An der Staffelei
Etching and drypoint, 1922
24.7 x 19 on leaf, 45 x 30
Inscribed: 101/110 Marc Chagall
Sprengel I, 354

19 **At Mother's Grave**
Am Grabstein der Mutter
Etching, 1922
11.7 x 8.8 on leaf, 36.5 x 22
Inscribed: 37/110 Marc Chagall
Sprengel I, 342

20 **Father's Grave**
Grab des Vaters
Etching and drypoint, 1922
11 x 14.9 on leaf, 26.5 x 35
Inscribed: 104/110 Marc Chagall
Sprengel I, 357

20

Nikolai Gogol, Dead Souls

Nicolas Gogol, *Les Ames Mortes.* Traduction de Henri Mongault. Paris, Tériade, 1948. 2 volumes of unbound gatherings plus 96 etchings. Sheet size, 38 x 28.

The plates were executed between 1923 and 1927 and printed in 1927 under the supervision of Ambroise Vollard and the printer Louis Fort. The book was completed in 1947 for the publisher Tériade with the collaboration of Ida Chagall. The 11 etchings for the chapter headings date from 1948 and were printed by Raymond Haasen.

Edition of 335 numbered copies on Vélin d'Arches with the watermark 'Ames Mortes'. Copies 1-50 contain a set of etchings on Japon nacré. In addition, 33 copies were printed marked 'hors commerce' and numbered I-XXXIII. All copies were signed by the artist in the colophon.

Copy 98/335
Sprengel Collection I, 367ff
Sprengel Museum, Hanover

1 **Chichikov's Arrival**
 L'arrivée de Tchitchikov
 22.1 x 28.6; Sprengel I, 367ff/1

2 **The Inn**
 Le traktir
 22 x 28.5; Sprengel I, 367ff/2

3 **The Little Town**
 La petite ville
 22.1 x 28.6; Sprengel I, 367ff/3

4 **The Evening at the Governor's**
 La soirée chez le gouverneur
 22.2 x 28.7; Sprengel I, 367ff/4

5 **Petrushka**
 Pétrouchka
 22.1 x 28.6; Sprengel I, 367ff/5

1

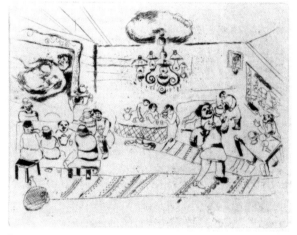

2

3

4

5

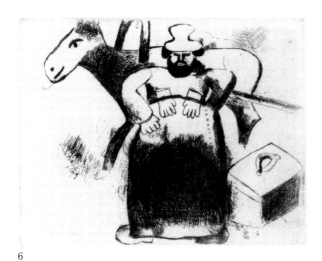

6

7

8

9

6 **Selifan the Coachman**
Le cocher Sélifane
22.1 x 28.6; Sprengel I, 367ff/6

7 **On the Way**
En chemin
21.9 x 28.7; Sprengel I, 367ff/7

8 **Manilov**
28.6 x 22.5; Sprengel I, 367ff/8

9 **Manilov and Chichikov on the Threshold**
Manilov et Tchitchikov sur le seuil de la porte
28.6 x 22.1; Sprengel I, 367ff/9

10 **Meal at Manilov's**
Repas chez Manilov
22.1 x 28.6; Sprengel I, 367ff/10

11 **The Overseer**
L'intendant
28.8 x 19.3; Sprengel I, 367ff/11

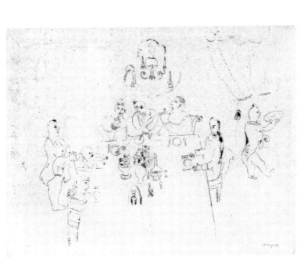

10

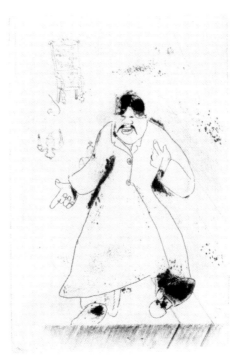

11

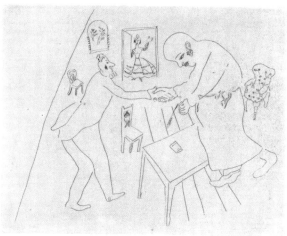

12

13

12 **Chichikov bids Farewell to Manilov**
Les adieux de Tchitchikov à Manilov
22.7 x 29.4; Sprengel I, 367ff/12

13 **On the Way to Sobakevich**
En route vers Sobakévitch
22 x 29.7; Sprengel I, 367ff/13

14 **The Britchka overturns**
La britchka s'est renversée
22.7 x 29.6; Sprengel I, 367ff/14

15 **Madame Korobochka**
Madame Korbotchka
30 x 22.6; Sprengel I, 367ff/15

16 **Chichikov on his Bed**
Tchitchikov sur le lit
19.9 x 28.4; Sprengel I, 367ff/16

17 **The Barn Yard**
La basse-cour
22.5 x 29.3; Sprengel I, 367ff/17

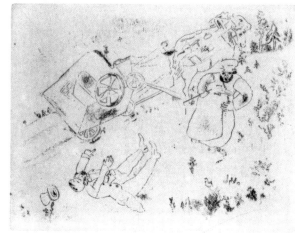

14

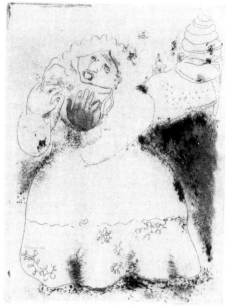

15

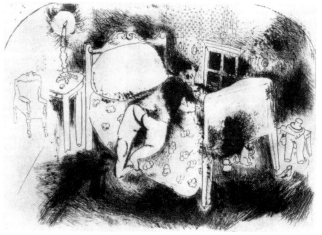

16

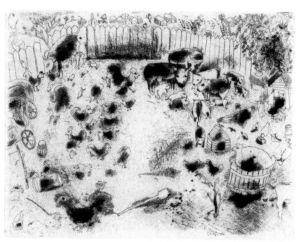

17

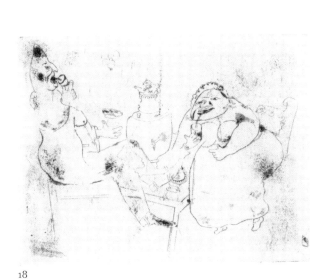

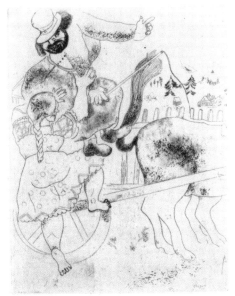

18

19

20

21

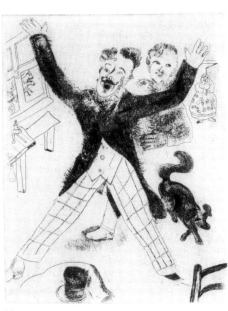

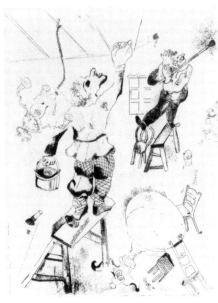

22

23

18 **Morning Tea**
Le thé du matin
22.5 x 29.6; Sprengel I, 367ff/18

19 **Asking the Way**
L'indication de la route
28.4 x 22.3; Sprengel I, 367ff/19

20 **Entrance to the Inn**
La maison du traktir
27.9 x 23; Sprengel I, 367ff/20

21 **Meal at the Inn**
Repas dans le traktir
21.5 x 28.8; Sprengel I, 367ff/21

22 **Nozdrev**
Nozdriov
28.9 x 23.2; Sprengel I, 367ff/22

23 **The House Painters**
Les peintres
29.1 x 22.9; Sprengel I, 367ff/23

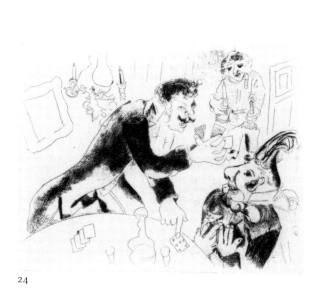

24

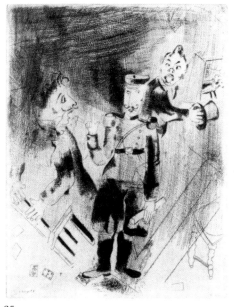

25

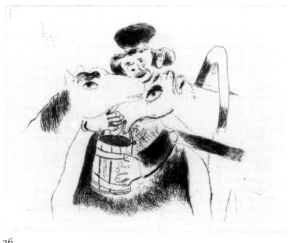

26

27

24 **The Playing Cards**
Les cartes à jouer
22 x 28.5; Sprengel I, 367ff/24

25 **The Police arrive**
Apparition des policiers
28.7 x 22.1; Sprengel I, 367ff/25

26 **The Coachman feeds the Horses**
Le cocher donne à manger aux chevaux
21.7 x 27.9; Sprengel I, 367ff/26

27 **Collision on the Way**
Collision en chemin
21.9 x 28.5; Sprengel I, 367ff/27

28 **A Mob of Peasants**
Attroupement des paysans
27.7 x 21.3; Sprengel I, 367ff/28

29 **Uncle Mitiai and Uncle Miniai**
Le père Mitiaï et le père Miniaï
27.8 x 21.6; Sprengel I, 367ff/29

28

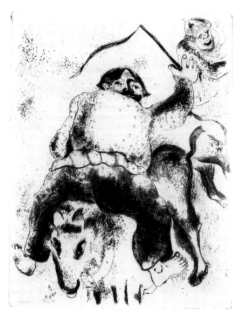

29

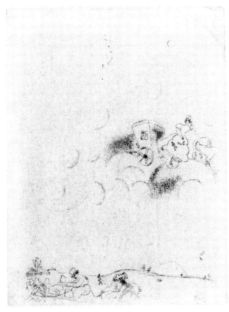

30

31

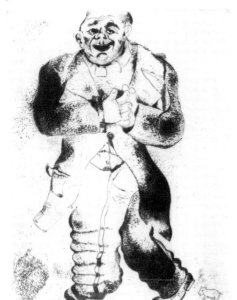

32

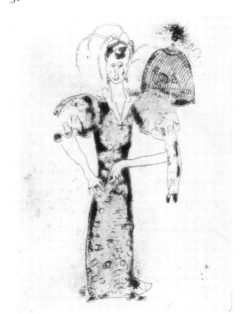

33

30 **Chichikov's Dreams**
Les rêves de Tchitchikov
27.9 x 21.3; Sprengel I, 367ff/30

31 **Sobakevich's House**
La maison de Sobakévitch
21.1 x 27.6; Sprengel I, 367ff/31

32 **Sobakevich**
Sobakévitch
27.8 x 21.1; Sprengel I, 367ff/32

33 **Madame Sobakevich**
Madame Sobakévitch
27.7 x 21.1; Sprengel I, 367ff/33

34 **They go to Table**
On passe à table
21.3 x 27.9; Sprengel I, 367ff/34

35 **The groaning Table**
La table chargée de victuailles
27.7 x 21.4; Sprengel I, 367ff/35

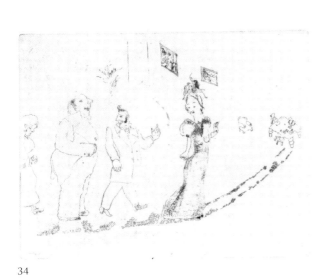

34

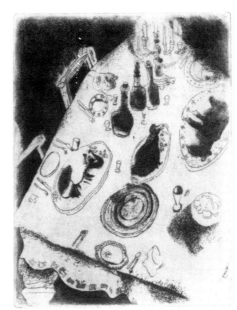

35

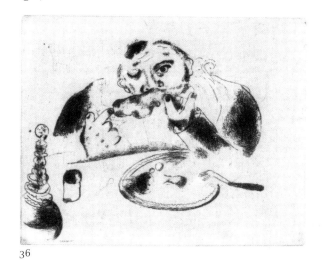

36

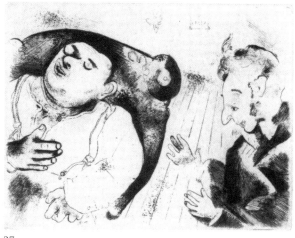

37

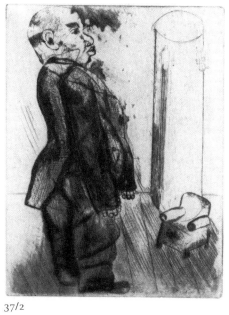

37/2

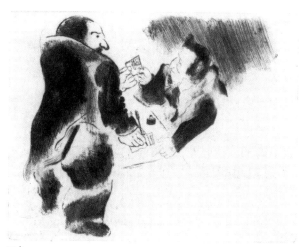

37/3

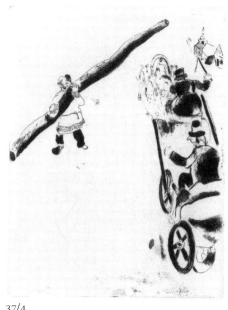

37/4

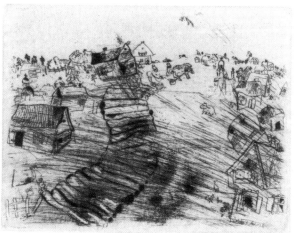

38

39

40

41

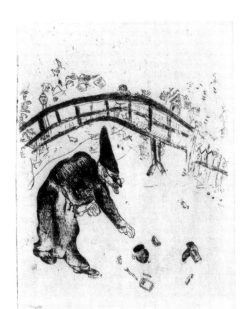

42

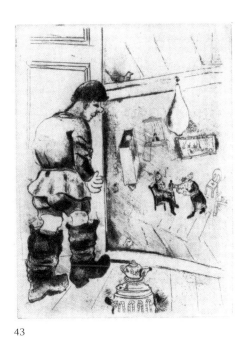

43

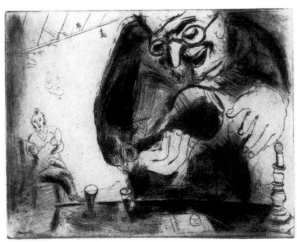

44

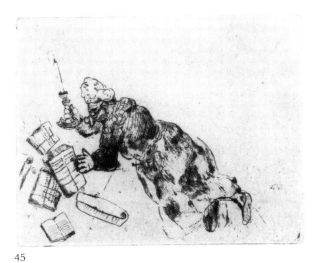

45

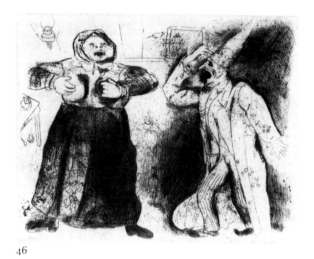

46

47

46 **Pliushkin and Mavra arguing**
Dispute de Pliouchkine et de Mavra
21.4 x 27.6; Sprengel I, 367ff/49

47 **At the Town Gate**
A la barrière de la ville
21.3 x 27.7; Sprengel I, 367ff/50

48 **Gogol and Chagall**
Gogol et Chagall
27.5 x 21.1; Sprengel I, 367ff/51

49 **Chichikov triumphant in his Shirt**
Tchitchikov triomphe en chemise
27.6 x 21; Sprengel I, 367ff/52

49/2 **Work in the Fields**
Labourage
21.1 x 27.7; Sprengel I, 367ff/53

49/3 **Death of Putting-his-foot-in-it**
Mort de mets-les-pieds-dans-le-plat
20.9 x 27.4; Sprengel I, 367ff/54

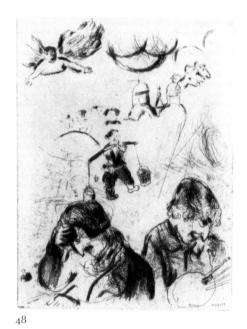

48

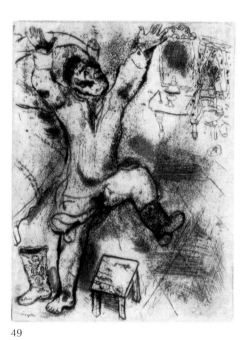

49

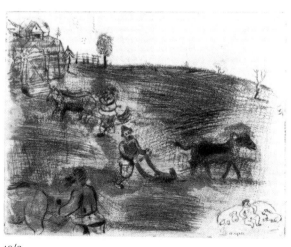

49/2

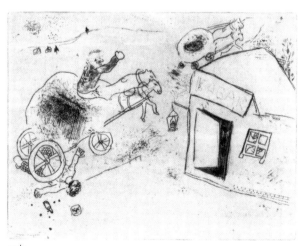

49/3

Nikolai Gogol, *Dead Souls* 229

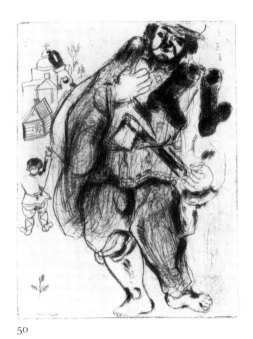

50

51

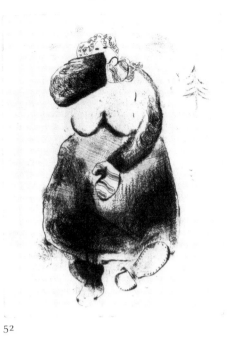

52

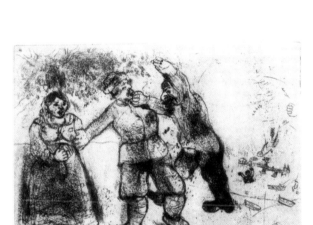

53

54

50 **Stepan Cork, Carpenter**
Stéphane Bouchon, charpentier
27.7 x 21.2; Sprengel I, 367ff/55

51 **Maxim Teliatnikov, Bootmaker**
Maxime Téliatnikov, savetier
28.5 x 21.2; Sprengel I, 367ff/56

52 **Madame Sparrow**
Madame Moineau
27.7 x 21; Sprengel I, 367ff/57

53 **Grigorii Always-on-the-go-
but-never-getting-there**
Grigori va-toujours-et-tu-n'arriveras-pas
22 x 28.6; Sprengel I, 367ff/58

54 **The Man without a Passport
before the Captain of Rural Police**
*L'homme sans passeport devant
le Capitain-Ispravnik*
27.3 x 21.1; Sprengel I, 367ff/59

55 **The Corn Port**
Le port au blé
21.1 x 27.7; Sprengel I, 367ff/60

55/2 **The Hauliers**
Les haleurs
21.8 x 28.4; Sprengel I, 367ff/61

55

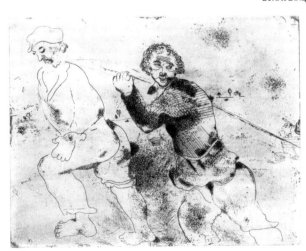

55/2

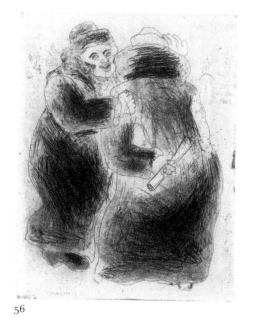

56

57

58

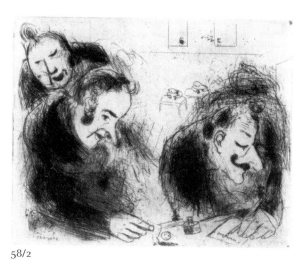

58/2

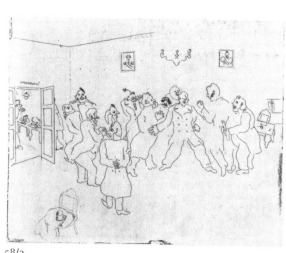

58/3

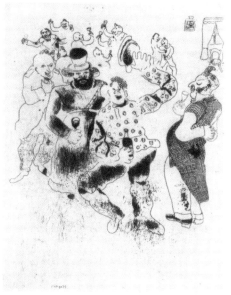

59

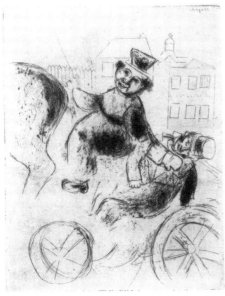

59/2

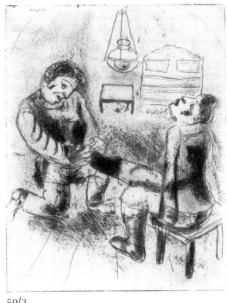

59/3

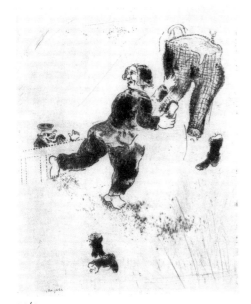

59/4

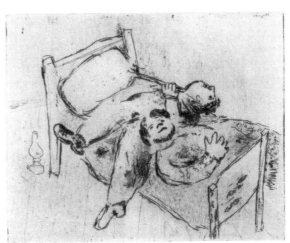

60

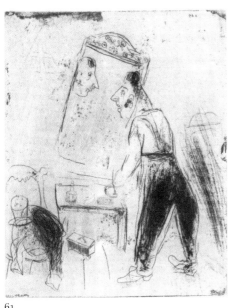

61

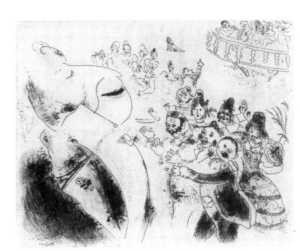

62

63

64

65

66

63 **The Governor's Ball**
Bal chez le gouverneur
21.3 x 30.5; Sprengel I, 367ff/74

64 **Nozdrev's Revelations**
Révélations de Nozdriov
27.7 x 21.1; Sprengel I, 367ff/75

65 **The Guard near the Street-lamp**
Le garde au réverbère
27.7 x 22; Sprengel I, 367ff/76

66 **The charming Lady and
the Lady charming in every Way**
Dames charmante et charmante à tous égards
27.8 x 21.1; Sprengel I, 367ff/77

67 **The Governor's Wife scolds her Daughter**
La femme du gouverneur gronde sa fille
27.5 x 21.2; Sprengel I, 367ff/78

68 **The Revelry degenerates into a Brawl**
L'orgie dégénère en rixe
23.5 x 27.7; Sprengel I, 367ff/79

67

68

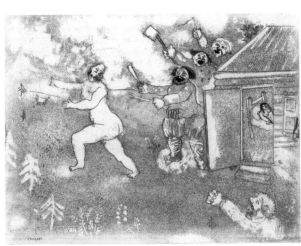

69

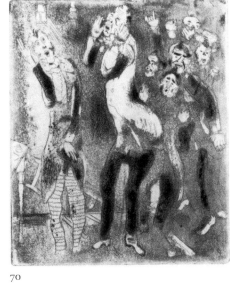

70

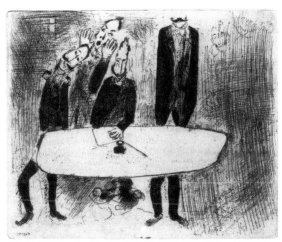

71

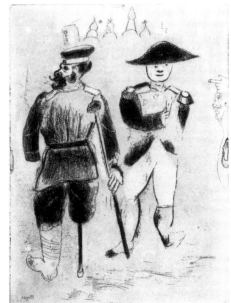

72

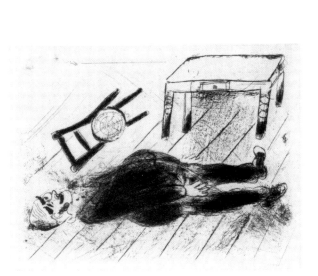

73

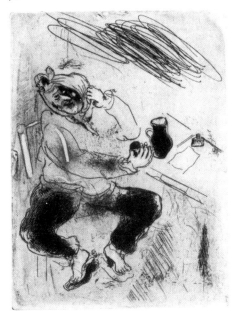

74

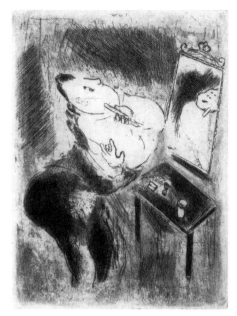

75

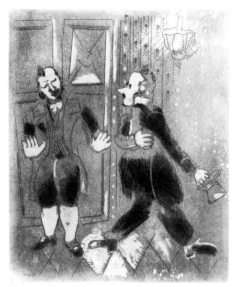

76

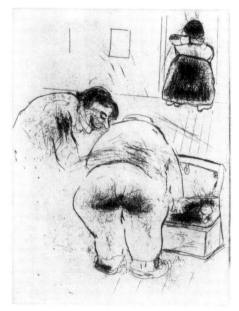

77

75 **Chichikov shaving**
Tchitchikov se rase
27.7 x 20.9; Sprengel I, 367ff/86

76 **The Swiss Footman refuses to allow Chichikov to enter**
Le suisse ne laisse pas entrer Tchitchikov
27.6 x 23.5; Sprengel I, 367ff/87

77 **Our Hero is getting ready**
Notres héros tenait à être prêt
27.8 x 21.1; Sprengel I, 367ff/88

78 **The Public Prosecutor's Funeral Procession**
L'enterrement du procureur
21.1 x 27.7; Sprengel I, 367ff/89

79 **Chichikov's Birth**
La naissance de Tchitchikov
27.8 x 20.4; Sprengel I, 367ff/90

80 **Chichikov's Father teaches him a Lesson**
Le père de Tchitchikov lui donne une correction
27.7 x 21; Sprengel I, 367ff/91

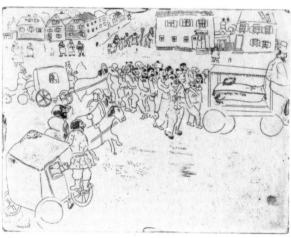

78

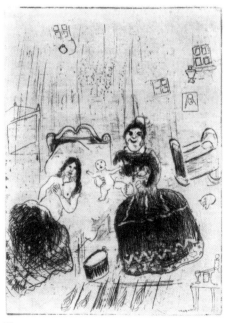

79

80

81

82

83

81 **Chichikov sleeping in the Office**
Tchitchikov couchait au bureau
21.1 x 27.7; Sprengel I, 367ff/92

82 **In Church**
A l'église
27.6 x 21; Sprengel I, 367ff/93

83 **In the Treasury: the new Boss**
A la trésorerie, le nouveau chef
21.1 x 27.7; Sprengel I, 367ff/94

84 **Chichikov as Customs Officer**
Tchitchikov douanier
21.1 x 27.6; Sprengel I, 367ff/95

85 **Troika at Night**
La troïke au soir
21 x 27.5; Sprengel I, 367ff/96

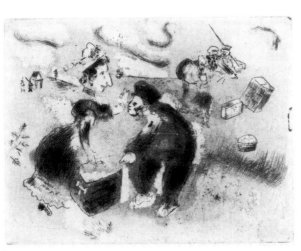

84

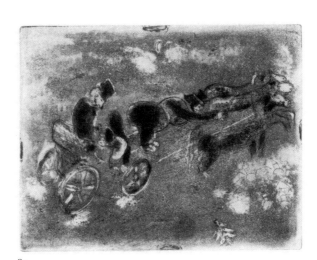

85

La Fontaine, Fables

Paris, Tériade, 1952. 2 volumes of unbound leaves plus 100 etchings and 1 etching for each cover. Sheet size, 39 x 30.

The 100 full-page etchings were executed between 1927 and 1930 and printed by Maurice Potin under the supervision of Ambroise Vollard. In 1950 the work was completed for the publisher Tériade. The two etchings for the covers were executed in 1952 and printed by Raymond Haasen.

Edition of 200 numbered copies with text, all signed by the artist in the colophon. 85 copies hand-coloured by the artist and 100 in black and white on Japon nacré or Montval; Nos I-XV *hors commerce.*

The Sprengel copy is No 39 of the additional 100 numbered portfolios without text, the etchings printed on Montval, numbered lower left and signed 'Marc Chagall' lower right. Title page and list of titles.

Portfolio 39/100
Sprengel Collection I, 378ff
Sprengel Museum, Hanover

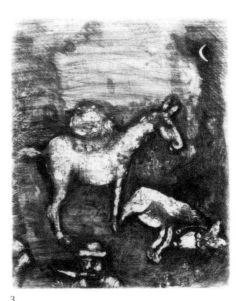

1

2

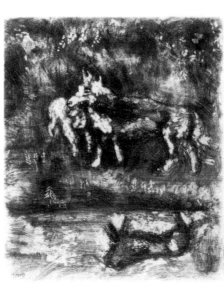

3

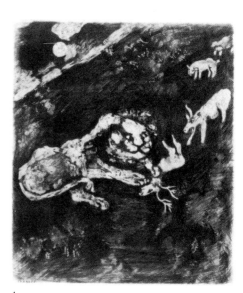

4

1 **The Crow and the Fox**
Le Corbeau et le Renard
29.2 x 24.6; Sprengel I, 378ff/1

2 **The Frog who wanted to be as big as the Ox**
La Grenouille qui se veut faire aussi grosse que le Bœuf
29.7 x 23.5; Sprengel I, 378ff/2

3 **The two Mules**
Les deux Mulets
29.7 x 24.9; Sprengel I, 378ff/3

4 **The Heifer, the Nanny-Goat and the Sheep in Partnership with the Lion**
La Génisse, la Chèvre et la Brebis en société avec le Lion
28.9 x 25; Sprengel I, 378ff/4

5 **The Wolf and the Lamb**
Le Loup et l'Agneau
28.3 x 24.6; Sprengel I, 378ff/5

6 **The Man and his Reflection**
L'Homme et son image
29.3 x 23.9; Sprengel I, 378ff/6

5

6

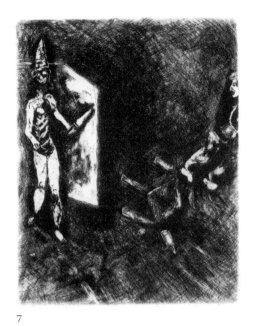

7

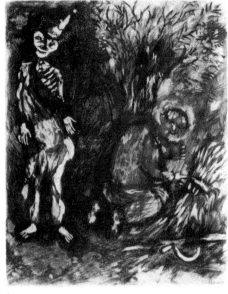

8

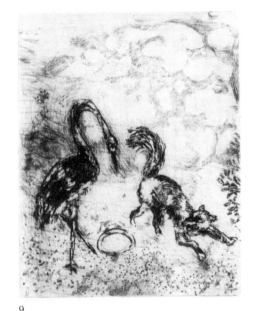

9

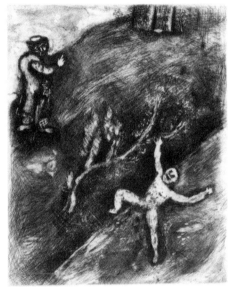

10

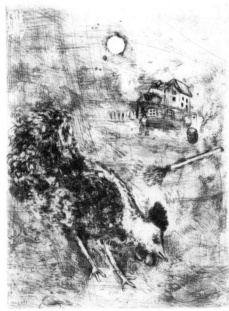

11

12

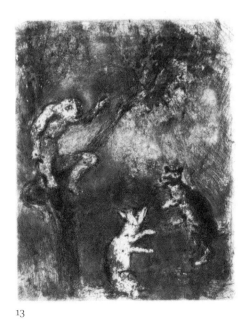

13

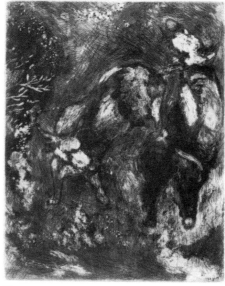
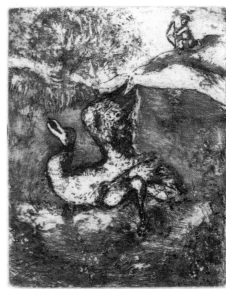

14

15

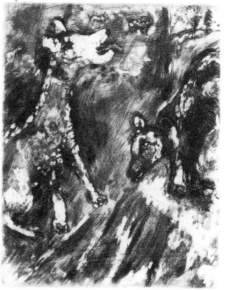

16

17

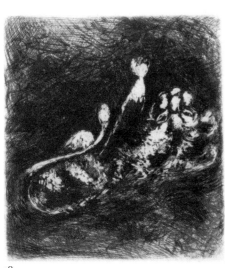
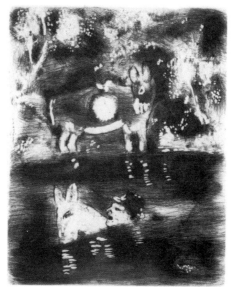
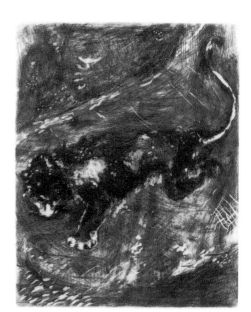

18

19

20

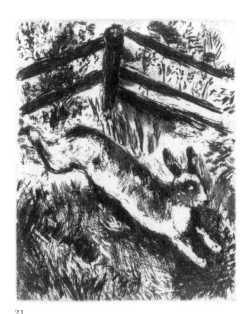

21

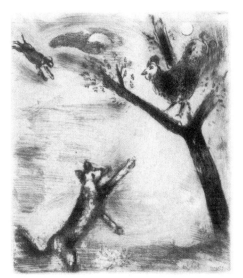

22

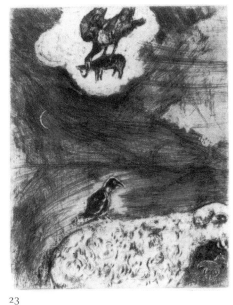

23

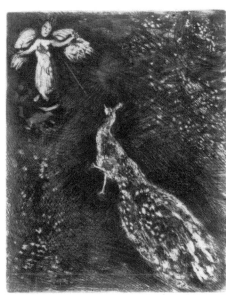

24

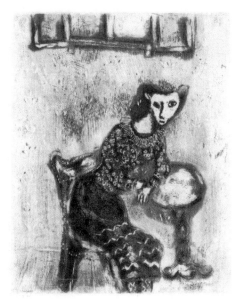

25

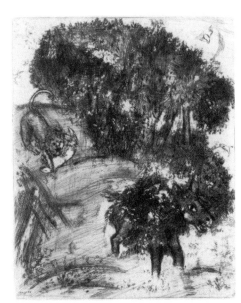

26

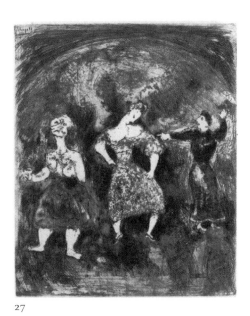

27

21 **The Hare and the Frogs**
Le Lièvre et les Grenouilles
29.6 x 23.8; Sprengel I, 378ff/21

22 **The Cock and the Fox**
Le Coq et le Renard
28.7 x 24.7; Sprengel I, 378ff/22

23 **The Crow who copied the Eagle**
Le Corbeau voulant imiter l'Aigle
29.6 x 23.9; Sprengel I, 378ff/23

24 **The Peacock who complained to Juno**
Le Paon se plaignant à Junou
29.9 x 24.2; Sprengel I, 378ff/24

25 **The Cat transformed into a Woman**
La Chatte métamorphosée en femme
29.7 x 24; Sprengel I, 378ff/25

26 **The Lion and the Donkey hunting**
Le Lion et l'Ané chassant
29.7 x 24.1; Sprengel I, 378ff/26

27 **Aesop explains a Will**
Testament expliqué par Esope
29.5 x 24.8; Sprengel I, 378ff/27

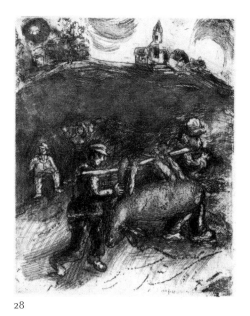

28

29

30

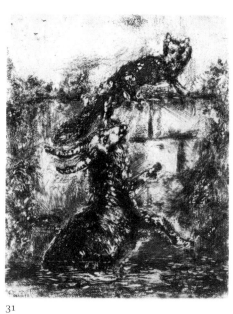

31

28 **The Miller, his Son and the Donkey**
Le Meunier, son Fils et l'Ane
30 x 24.6; Sprengel I, 378ff/28

29 **The Wolf turned Shepherd**
Le Loup devenu berger
29.7 x 23.9; Sprengel I, 378ff/29

30 **The Frogs who asked for a King**
Les Grenouilles qui demandent un roi
29.5 x 23.6; Sprengel I, 378ff/30

31 **The Fox and the Goat**
Le Renard et le Bouc
29.7 x 24.1; Sprengel I, 378ff/31

32 **The Eagle, the Sow and the Cat**
L'Aigle, la Laie et la Chatte
29.6 x 23.8; Sprengel I, 378ff/32

33 **The Drunkard and his Wife**
L'Ivrogne et sa Femme
29.6 x 23.7; Sprengel I, 378ff/33

32

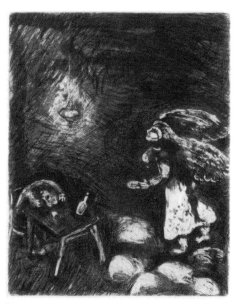

33

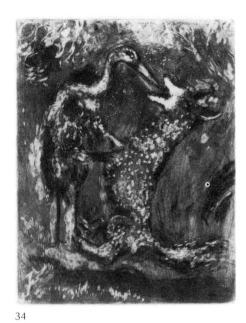

34

35

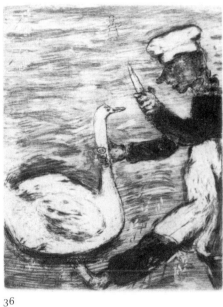

36

37

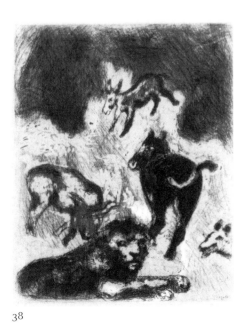

38

39

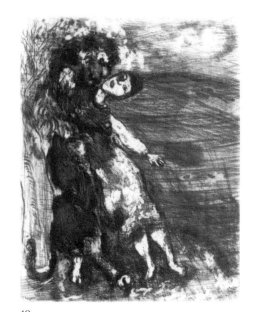

40

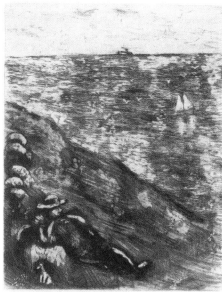

41

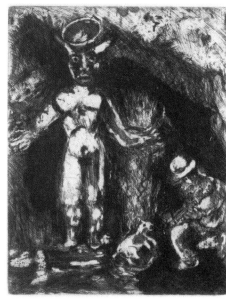

42

43

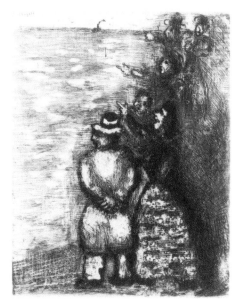

44

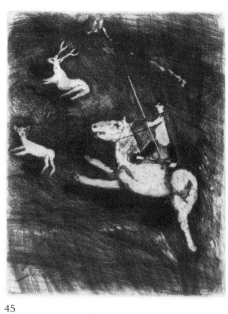

45

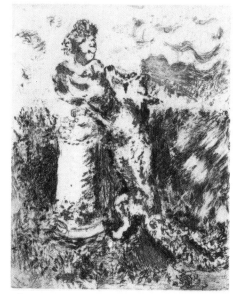

46

47

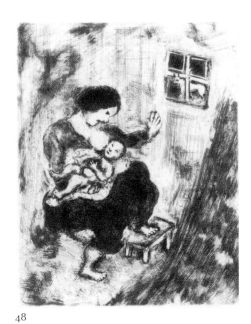

48

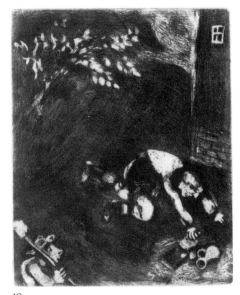

49

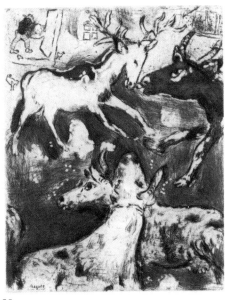

50

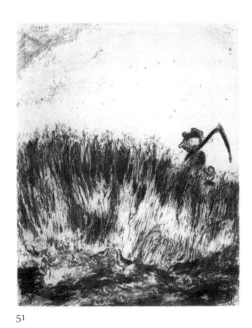

51

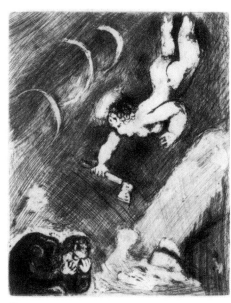

52

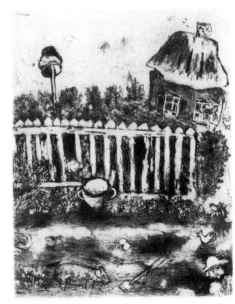

53

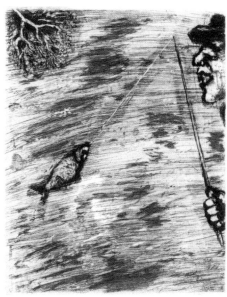

54

48 **The Wolf, the Mother and the Child**
Le Loup, la Mère et l'Enfant
29.1 x 23.3; Sprengel I, 378ff/48

49 **The Miser who lost his Hoard**
L'Avare qui a perdu son trésor
29.6 x 24.4; Sprengel I, 378ff/49

50 **The Master's Eye**
L'Œil du Maître
29.9 x 23.9; Sprengel I, 378ff/50

51 **The Lark and its Young with the Farmer**
L'Alouette et ses Petits avec le Maître d'un Champ
29.9 x 24.1; Sprengel I, 378ff/51

52 **The Woodcutter and Mercury**
Le Bûcheron et Mercure
29.8 x 24; Sprengel I, 378ff/52

53 **The clay Pot and the iron Pot**
Le Pot de terre et le Pot de fer
30.1 x 23.6; Sprengel I, 378ff/53

54 **The little Fish and the Angler**
Le petit Poisson et le Pêcheur
29.7 x 23.8; Sprengel I, 378ff/54

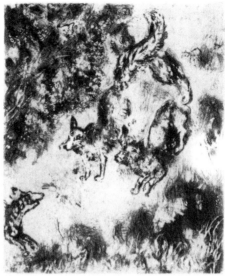

55

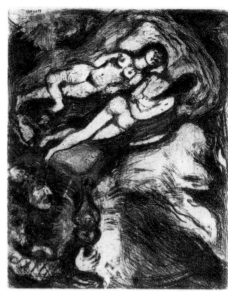

56

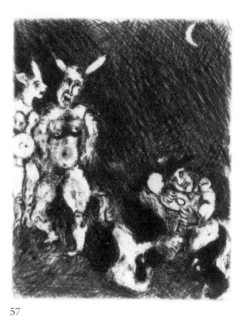

57

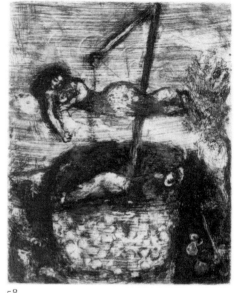

58

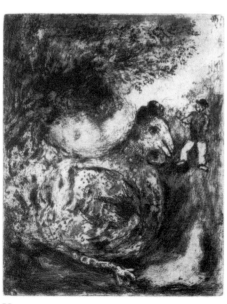

59

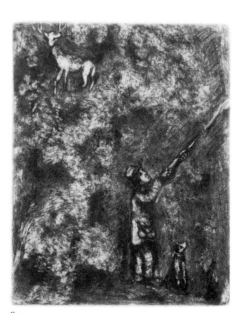

60

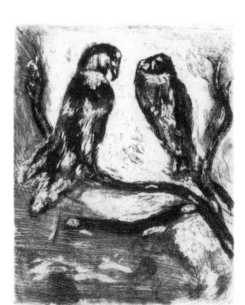

61

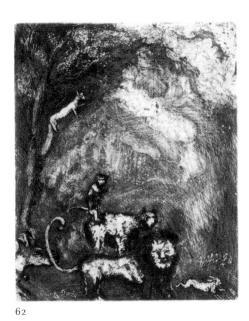

62

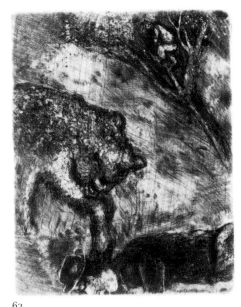

63

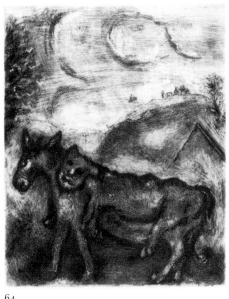

64

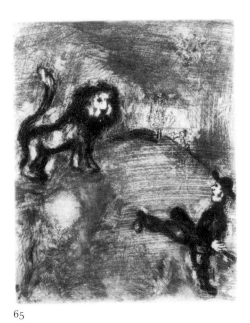

65

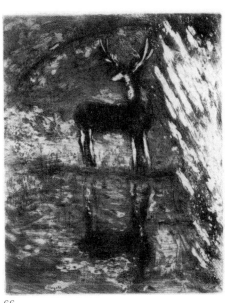

66

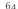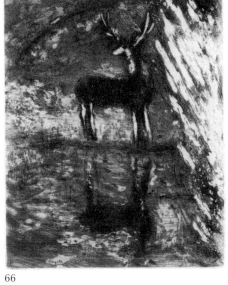

67

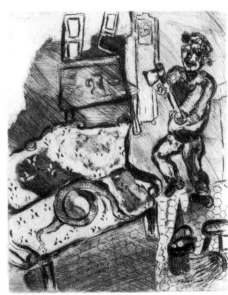

68

62 **The Lion goes to War**
Le Lion s'en allant en guerre
29.8 x 24.6; Sprengel I, 378ff/62

63 **The Bear and the two Schemers**
L'Ours et les deux Compagnons
29.7 x 23.8; Sprengel I, 378ff/63

64 **The Donkey clothed in the Lion's Hide**
L'Ane vêtu de la peau du lion
29.6 x 24.1; Sprengel I, 378ff/64

65 **The Lion and the Hunters**
Le Lion et les Chasseurs
29.7 x 24; Sprengel I, 378ff/65

66 **The Stag who saw himself in the Water**
Le Cerf se voyant dans l'eau
30.1 x 24.2; Sprengel I, 378ff/66

67 **The Sun and the Frogs**
Le Soleil et les Grenouilles
29.5 x 23.9; Sprengel I, 378ff/67

68 **The Peasant and the Snake**
Le Villageois et le Serpent
29.4 x 24; Sprengel I, 378ff/68

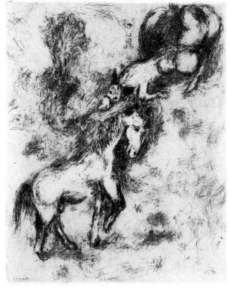

69

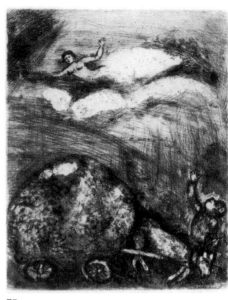

70

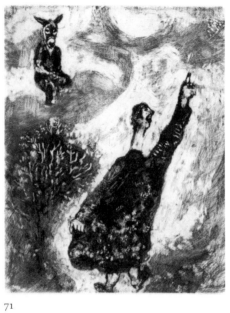

71

72

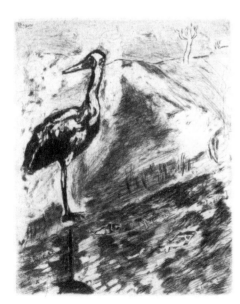

73

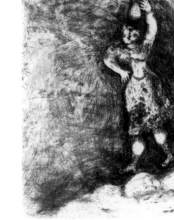

74

75

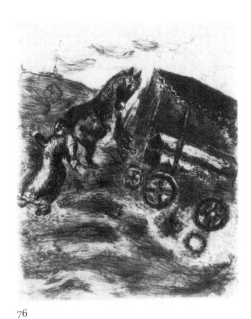

76

77

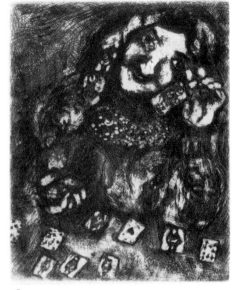

78

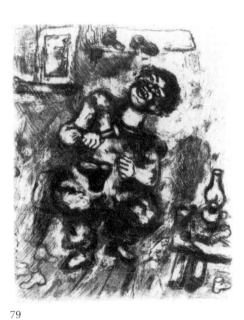

79

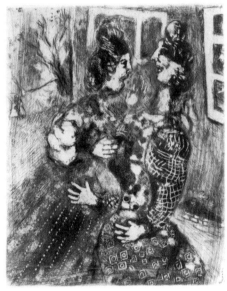

80

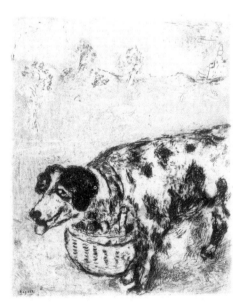

81

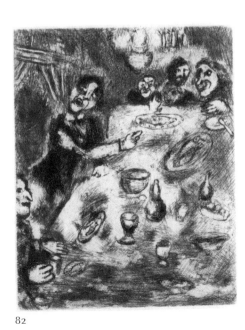

82

76 **The Priest and the dead Man**
Le Curé et le Mort
29.3 x 23.8; Sprengel I, 378ff/76

77 **The two Cocks**
Les deux Coqs
29.8 x 24.2; Sprengel I, 378ff/77

78 **The Fortune-Tellers**
Les Devineresses
29.9 x 23.8; Sprengel I, 378ff/78

79 **The Cobbler and the Business Man**
Le Savetier et le Financier
30 x 24.6; Sprengel I, 378ff/79

80 **How Women kept a Secret**
Les Femmes et le secret
29.6 x 23.9; Sprengel I, 378ff/80

81 **The Dog who carried his Master's
Dinner around his Neck**
*Le Chien qui porte à son cou le diner
de son maitre*
29.5 x 23.9; Sprengel I, 378ff/81

82 **The Joker and the Fish**
Le Rieur et les Poissons
29.3 x 23.9; Sprengel I, 378ff/82

83

84

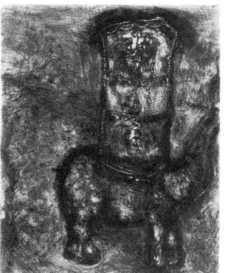

85

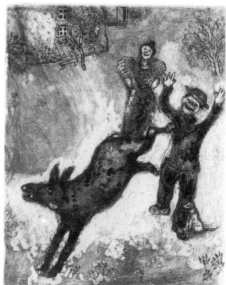

86

83 **The Bear and the Garden-Lover**
L'Ours et l'Amateur des jardins
29.5 x 23.9; Sprengel I, 378ff/83

84 **The Obsequies of the Lioness**
Les obsèques de la Lionne
29.6 x 23.8; Sprengel I, 378ff/84

85 **The Rat and the Elephant**
Le Rat et l'Eléphant
29.4 x 24.1; Sprengel I, 378ff/85

86 **The Donkey and the Dog**
L'Ane et le Chien
29.6 x 23.8; Sprengel I, 378ff/86

87 **The two Pigeons**
Les deux Pigeons
29.6 x 24; Sprengel I, 378ff/87

88 **The Monkey and the Leopard**
Le Singe et le Léopard
29.8 x 24.5; Sprengel I, 378ff/88

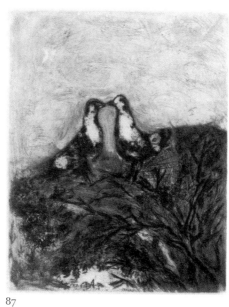

87

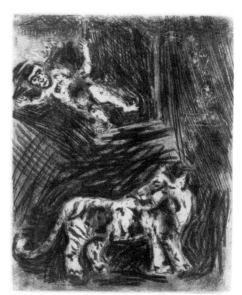

88

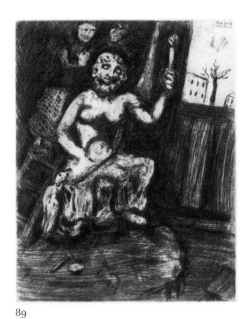

89

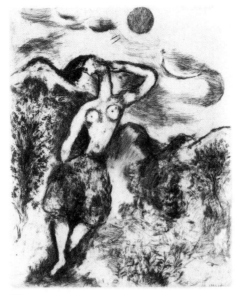

90

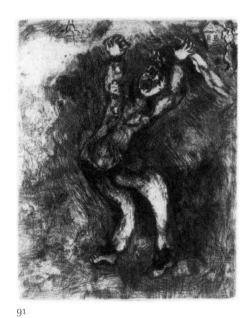

91

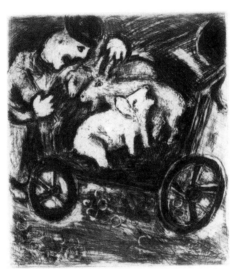

92

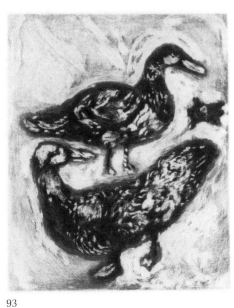

93

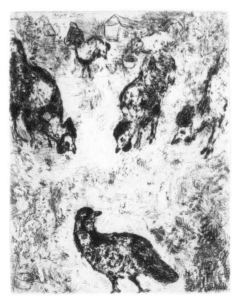

94

89 **The Sculptor and the Statue of Jupiter**
Le Statuaire et la statue de Jupiter
29.6 x 23.7; Sprengel I, 378ff/89

90 **The Mouse transformed into a Maiden**
La Souris métamorphosée en fille
29.3 x 23.9; Sprengel I, 378ff/90

91 **The Madman who sold Wisdom**
Le Fou qui vend la sagesse
29.4 x 23.7; Sprengel I, 378ff/91

92 **The Shepherd and his Flock**
Le Berger et son troupeau
29.4 x 26.5; Sprengel I, 378ff/92

93 **The Tortoise and the two Ducks**
La Tortue et les deux Canards
29.3 x 24.2; Sprengel I, 378ff/93

94 **The Partridge and the Cocks**
La Perdrix et les Coqs
29.9 x 24.2; Sprengel I, 378ff/94

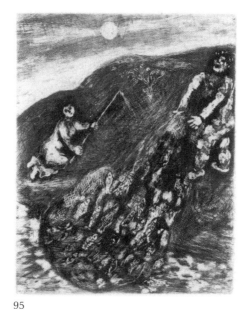

95

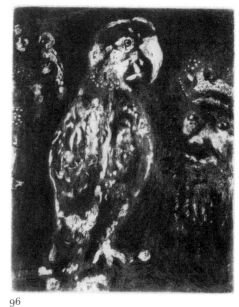

96

97

98

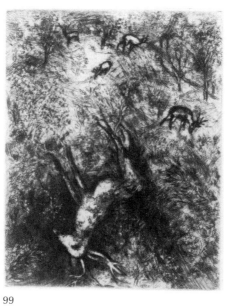

99

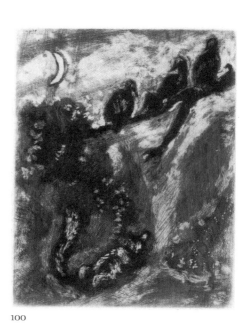

100

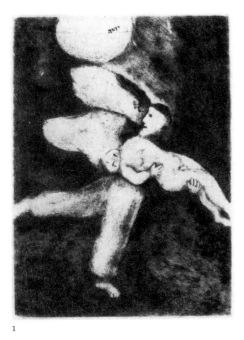

1

2

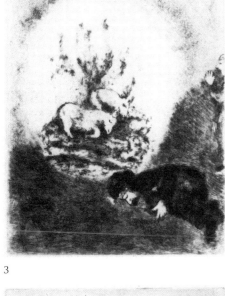

3

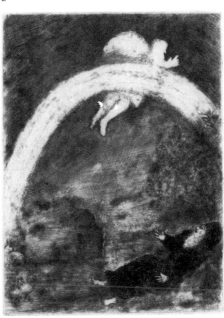

4

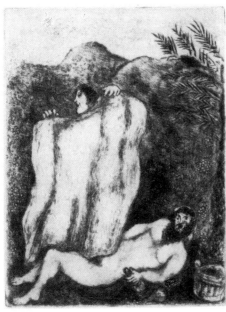

5

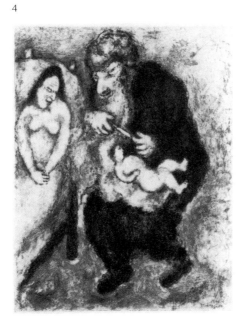

6

The Bible

Bible. Paris, Tériade, 1956. 2 volumes of unbound leaves plus 105 etchings. Vol. 1: 33 double sheets and 57 etchings; vol. 2: 29 double sheets and 48 etchings. Sheet size, 44 x 34. Chagall etched 105 plates between 1931 and 1939. By 1939 66 had been printed by Maurice Potin; the remaining 39 were reworked and printed by Raymond Haasen between 1952 and 1956. The verses from the Bible are taken from a translation of the Hebrew texts, made by the clerics and teachers of Geneva and published in 1638.

Edition of 275 copies on Montval plus 20 copies *hors commerce,* numbered I-XX; all copies signed by the artist. In addition, there are 100 numbered portfolios containing 105 etchings, hand-coloured, signed and numbered by the artist, on Vélin d'Arches.

Copy 155/275, signed in the colophon; title double sheet bearing a drawing in pastel by Chagall and the dedication 'Pour Dr. Bernhard Sprengel Marc Chagall 1957. Vence'.
Sprengel Collection I, 385ff
Sprengel Museum, Hanover

The 57 etchings from the first volume of Tériade's publication are reproduced here.

1 **The Creation of Man**
Création de l'homme
30.6 x 22.8; Sprengel I, 385ff/1

2 **Noah dispatching the Dove**
La colombe de l'arche
31.5 x 23.7; Sprengel I, 385ff/2

3 **Noah's Sacrifice**
Sacrifice de Noé
29.7 x 23.8; Sprengel I, 385ff/3

4 **The Rainbow**
L'arc-en-ciel
30.3 x 23; Sprengel I, 385ff/4

5 **The Mantle of Noah**
Le manteau de Noé
30.4 x 23.1; Sprengel I, 385ff/5

6 **The Circumcision**
La circoncision
29.9 x 23.6; Sprengel I, 385ff/6

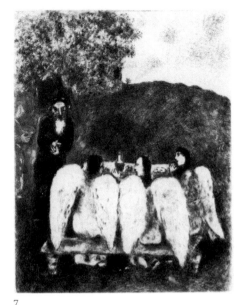

7

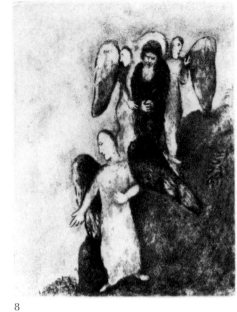

8

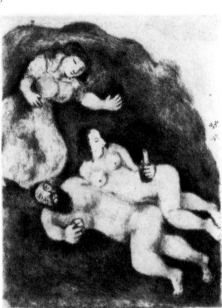

9

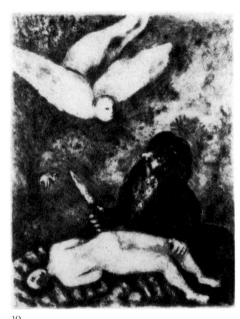

10

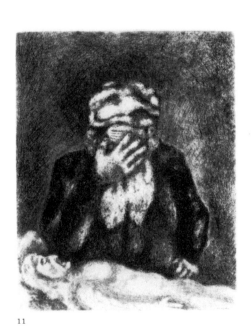

11

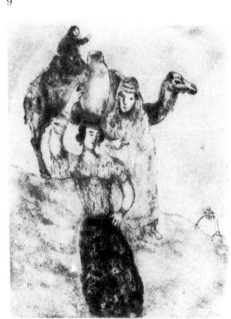

12

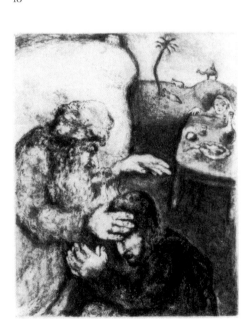

13

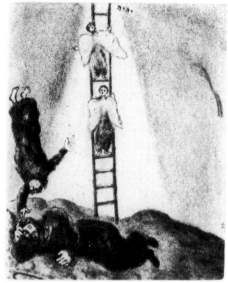

14

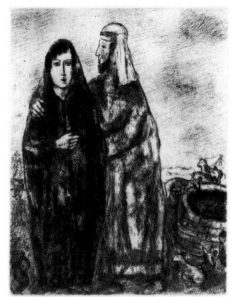

15

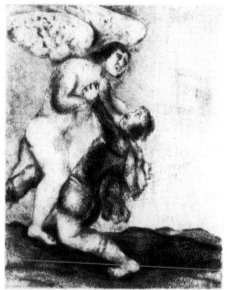

16

17

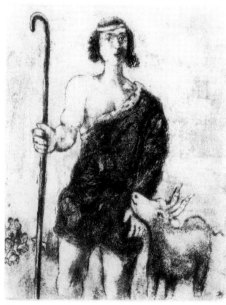

18

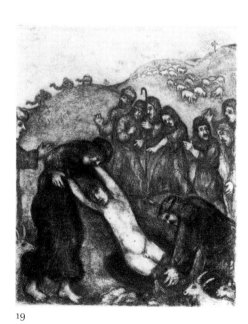

19

14 **Jacob's Ladder**
 L'échelle de Jacob
 29.5 x 24.3; Sprengel I, 385ff/14

15 **Meeting of Jacob and Rachel**
 Rencontre de Jacob et de Rachel
 29.2 x 22.9; Sprengel I, 385ff/15

16 **Jacob and the Angel**
 La lutte avec l'ange
 29.7 x 23.7; Sprengel I, 385ff/16

17 **Rachel's Tomb**
 La tombe de Rachel
 23.7 x 30.5; Sprengel I, 385ff/17

18 **Joseph, the young Shepherd**
 Joseph jeune berger
 30 x 23.5; Sprengel I, 385ff/18

19 **Joseph and his Brothers**
 Joseph et ses frères
 29.1 x 24; Sprengel I, 385ff/19

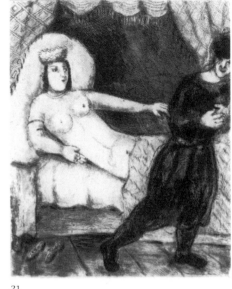

20

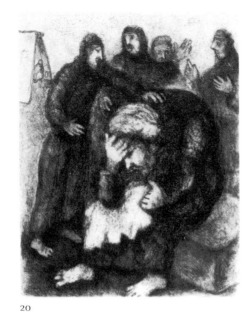

21

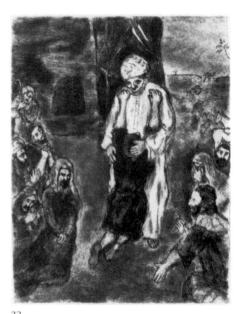

22

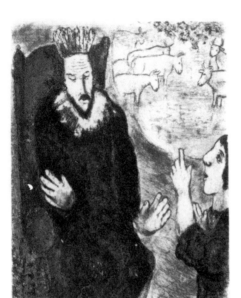

23

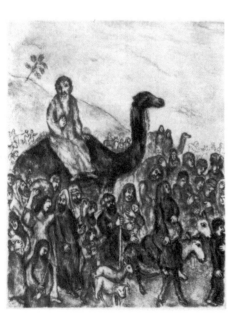

24

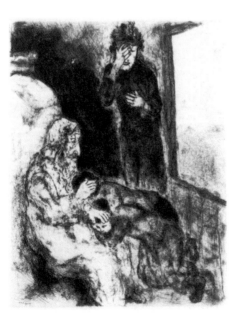

25

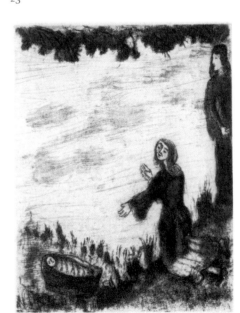

26

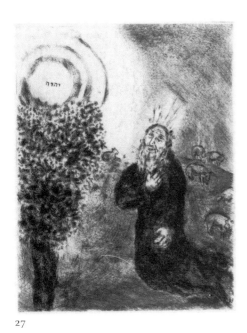

27

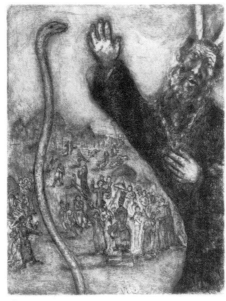

28

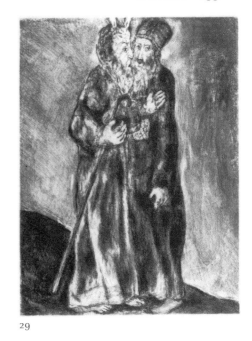

29

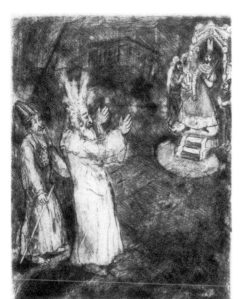

30

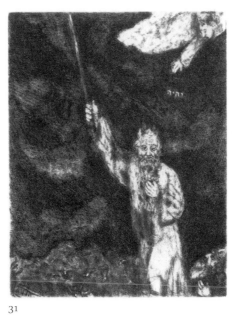

31

27 **The Burning Bush**
 Le buisson ardent
 28.9 x 22.7; Sprengel I, 385ff/27

28 **Moses and the Serpent**
 Moïse et le serpent
 29.5 x 23; Sprengel I, 385ff/28

29 **Meeting of Moses and Aaron**
 Rencontre de Moïse et d'Aaron
 28.9 x 22.1; Sprengel I, 385ff/29

30 **Moses and Aaron before Pharaoh**
 Moïse et Aaron devant Pharaon
 28.8 x 22.8; Sprengel I, 385ff/30

31 **Darkness over Egypt**
 Les ténèbres sur l'Egypte
 29.1 x 22.8; Sprengel I, 385ff/31

32 **The Passover**
 Le repas de la Pâque
 29.2 x 22.9; Sprengel I, 385ff/32

33 **The Exodus from Egypt**
 La sortie d'Egypte
 23.9 x 31.9; Sprengel I, 385ff/33

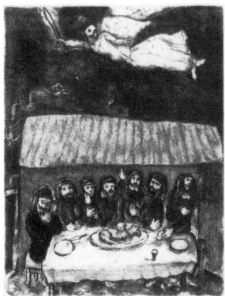

32

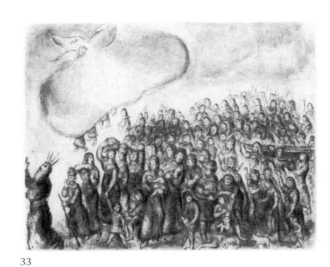

33

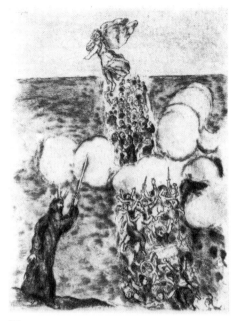

34

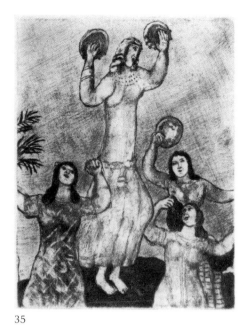

35

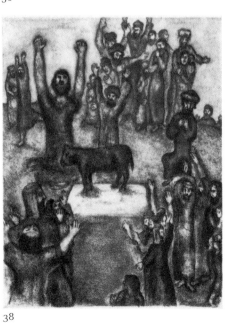

36

37

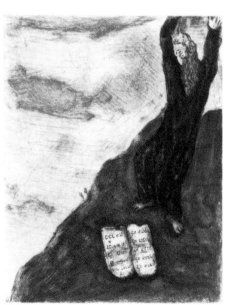

38

39

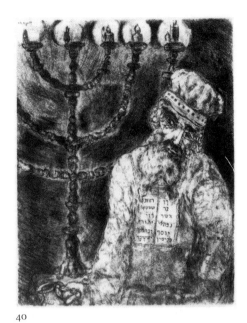

40

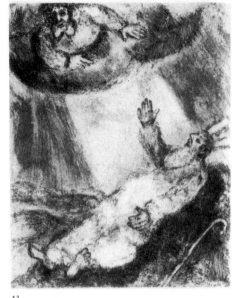

41

42

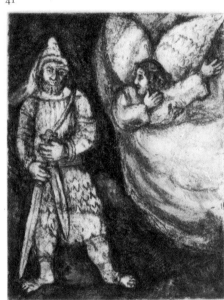

43

44

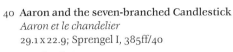

45

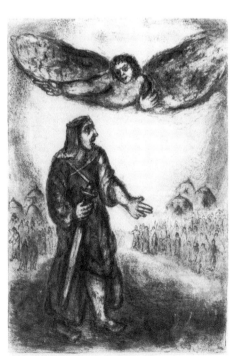

46

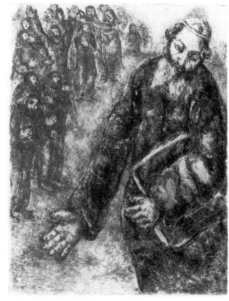

47

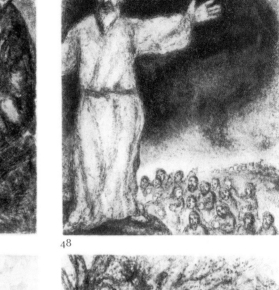

48

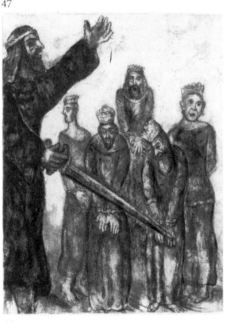

49

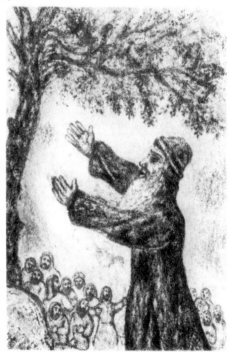

50

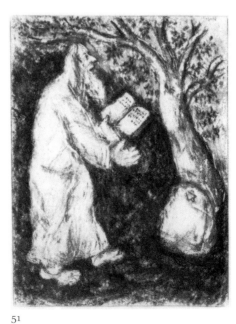

51

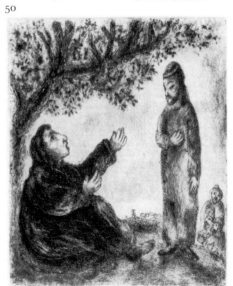

52

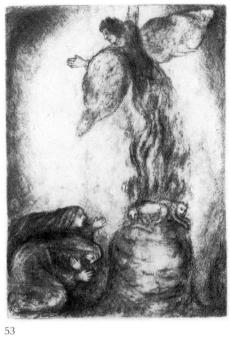

53

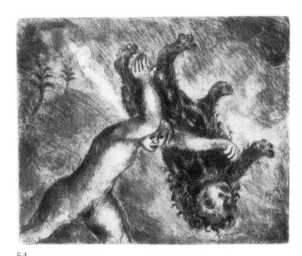

54

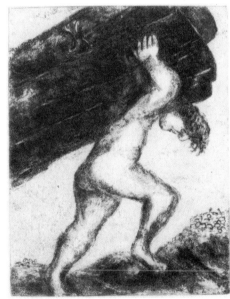

55

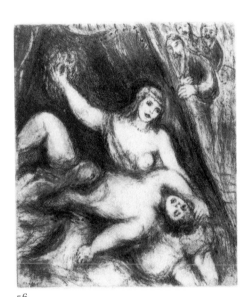

56

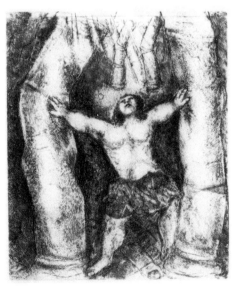

57

53 **Manoah's Sacrifice**
Sacrifice de Manoach
32.4 x 23.5; Sprengel I, 385ff/53

54 **Samson and the Lion**
Samson et le lion
32 x 25.9; Sprengel I, 385ff/54

55 **Samson carries off the Gates of Gaza**
Samson enlève les portes de Gaza
29.6 x 22.4; Sprengel I, 385ff/55

56 **Samson and Delilah**
Samson et Delila
28.1 x 24.2; Sprengel I, 385ff/56

57 **Samson destroying the Columns**
Samson renverse les colonnes
29.2 x 24.5; Sprengel I, 385ff/57

Chronology

Dates and facts in this documentation follow Chagall's principal biographers, Meyer and Crespelle; where possible, facts have been verified by the author and sometimes new information or dating has been provided. Where conflicting dates could not be checked, both are given.

1922

April: Chagall left Russia with an official passport provided by the Minister for Education, Anatoly Lunacharsky (through the writer Damian Bedny). In Kaunas he exhibited the 65 paintings and many drawings which had been sent from Moscow by the Lithuanian ambassador, the poet Jurgis Baltrusaitis, via diplomatic bag. Chagall read aloud from his manuscript 'My Life' at a soirée held during the exhibition, organized by his friend from Moscow, Dr Eliashev, and Max Kaganovich, brother of the writer 'Der Nister' whose stories Chagall had illustrated in 1917.

Summer: arrived in Berlin with all his pictures. His wife, Bella, who had been prevented from leaving Moscow because of a broken arm, joined him with their daughter Ida. They stayed for one year, living at four addresses, all except the last central and near Prager Platz, where many Russians lived. Dr Eliashev had found them a flat in Kantstrasse, between Bismarckstrasse and Kurfürstendamm; they moved to Pariser Strasse, running diagonally away from Kurfürstendamm; then to 29 Weimarer

Strasse, a smaller street running from Bismarckstrasse to Kantstrasse; finally, they lived at 6 Spessartstrasse, Wilmersdorf, just south of the river. None of these flats had a proper studio. Chagall was well known in Berlin because he had left 40 paintings and over 100 gouaches at the Galerie Der Sturm in 1914 and Herwarth Walden, the owner of the gallery, had continued to exhibit them; he had devoted volume one of the *Sturm-Bilderbücher* to Chagall in 1918. By 1922 nearly all his work had been sold, but the proceeds, lodged with a lawyer, had been reduced to nothing through inflation, so Chagall decided to sue Walden. A settlement was reached in 1926 when Chagall accepted 3 pictures from before 1914: *To Russia, Donkeys and Others, Half Past Three (The Poet)* and *I and the Village*.

Paul Cassirer planned to publish 'My Life' with illustrations, so Chagall first made woodcuts in the studio of Joseph Budko, then learned etching from Hermann Struck.

Chagall's friends included the Russian Jewish poet and Zionist Chaim Bialik, the painters George Grosz (whom he had known in Paris), Karl Hofer and Jankel Adler; David Shterenberg and his wife, Nadezhda – a friend of Bella's; and the sculptor Aleksandr Archipenko.

15 October – December: Berlin, 'Die erste russische Kunstausstellung', Galerie van Diemen: 2 paintings by Chagall were included in this exhibition of art lent from Soviet Russia.

Chagall, Bella and Ida in Berlin, 1923

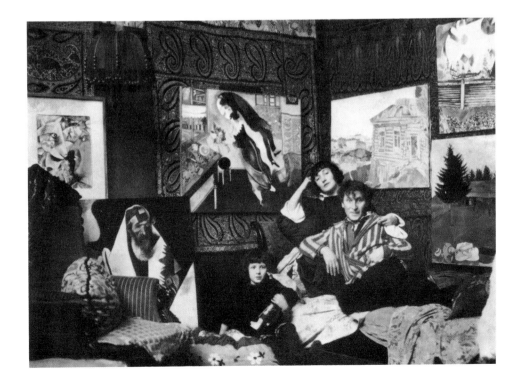

The Chagalls in the studio at 101 Avenue d'Orléans, 1924

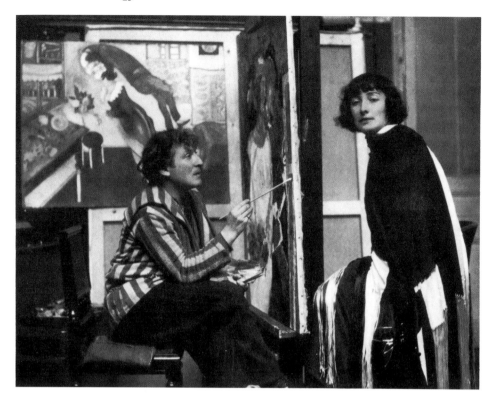

Chagall painting *Double Portrait* with Bella as model, 1923-24

1923

January: Galerie Lutz (formerly van Diemen), 'Sonderausstellung Marc Chagall', 164 works from 1914 to 1922. Publication of portfolio *Mein Leben: 20 Radierungen*, Berlin, Paul Cassirer.

Spring (probably): visit to the Black Forest.

July: visit to Bad Blankenburg, Thuringia. From Paris, Ambroise Vollard sent a message to Chagall in a letter from the poet Blaise Cendrars, saying that he wanted to commission Chagall to make book illustrations.

August: Chagall obtained French visas for himself and Bella.

September: arrived in Paris at the Gare de l'Est and lived at L'Hôtel Médicale, 28 rue du Faubourg Saint-Jacques. Vollard proposed that Chagall should illustrate a nineteenth-century children's book by La Comtesse du Ségur, but agreed to commission him instead to make etchings for Gogol's *Dead Souls*.

1923/24

Winter: the Chagalls often visited Robert Delaunay and his Russian wife, Sonia, at their weekend house at L'Isle-Adam, a small town about 30 kms north of Paris, known for its forest and beach on the River Oise.

1924

At the beginning of the year the Chagalls exchanged their hotel room for Eugène Zak's classic artist's studio with mezzanine and balcony at 101 Avenue d'Orléans (now Ave du Général-Leclerc), not far from L'Hôtel Médicale. In exile, Lenin had had a printing press in the building.

Spring: guests for Ida's eighth birthday party included Leon Bakst, André Levinson and Max Vinaver, who had supported Chagall in St Petersburg and enabled him to move to Paris in 1910.

Chagall was invited by Max Ernst, Paul Eluard and Gala to join the Surrealists when André Breton published the first Manifesto of Surrealism; Chagall declined, because he felt they were obsessed with automatism and the subconscious.

22 March-2 April: Brussels, Galerie Le Centaure, 'Œuvres de Marc Chagall', 50 works.

April: wrote to the Delaunays from Ault, a small resort on the Normandy coast near Abbeville: 'We are silly and happy here'.

June: visit to Bréhat, two islands united by a narrow strip of land, together 3.5 kms long and 1.5 kms wide, off the north coast of Brittany, reached by ferry from Arcouest near Paimpol. The coast is formed of rose granite rocks and the mild climate with little rain allows mimosas, myrtles and figs to grow in the open. Chagall's Gogol etchings illustrating Chichikov's visit to Manilov, Madame Korobochka and Nozdrev reflect the light of Brittany.

17-30 December: Paris, Galerie Barbazanges Hodebert, 'Œuvres de Marc Chagall de 1908 à 1924'; 116 exhibits, including 40 oils, 25 watercolours, 19 drawings (1914-17) and 38 engravings for *Dead Souls*.

1924/25

Winter: with Bella and Ida, Chagall spent a few months at L'Isle-Adam, where he painted *Bella with a Carnation*.

1925

Chagalls rented rooms at Montchauvet, about 60 kms west of Paris near Septeuil, where the Belgian critic Florent Fels had a house. Chagall painted *Peasant Life* (Fig. 12) there; he also etched two self-portraits (Cat. 59 and Cat. 107) as well as Gogol, *Escape in Nature's Garb* (p. 233, Gogol, sheet 69) and *Troika at Night* (Plate 53, Cat. 57).

April: Cologne, Kölnischer Kunstverein, 'Marc Chagall', 69 paintings plus illustrations for Gogol, *Dead Souls*.

Illustration by Chagall in the Yiddish periodical *Chalastre*, Vol. 2, 1924

May-June: Berlin, Galerie Ernst Arnold, 'Gemälde von Marc Chagall 1908-1925', 61 paintings, watercolours and drawings, plus illustrations for Gogol's *Dead Souls*.

December: Chagalls moved from the studio at Avenue d'Orléans to a rented house, 3 Allée des Pins, Boulogne-sur-Seine, near the Bois de Boulogne, not far from the extensive Jardin fleuriste, with its magnificent collections of flowers and regular floral exhibitions. Earlier in the year the sculptors Jacques Lipchitz and Oscar Miestchaninov had moved into the twin studio-houses they had commissioned from Le Corbusier in this suburb of Paris.

1926

9-30 January: New York, Reinhardt Galleries, 'Marc Chagall', 100 works.

Chagall and his family spent most of the year in the country.

Spring: on the Mediterranean coast at Mourillon, sited on a peninsula; it was then still a fishing village, with a few farmhouses and *pensions*, entirely outside Toulon, in which it is now embedded. The Chagalls stayed with Georges and Marguerite Duthuit-Matisse at La Réserve, close to the Fort St-Louis. Chagall visited Nice for the first time. Bella brought back bunches of flowers from the market each day.

They also spent a few months in the Auvergne, mostly at Chambon, 38 kms west of Clermont-Ferrand, in a house on the village square facing the church, but also in the Hôtel de la Poste; there is a curious round Romanesque chapel in the cemetery. Chagall made 30 gouaches for La Fontaine's *Fables* there, as Vollard had commissioned a cycle of La Fontaine illustrations on Chagall's completion of *Dead Souls*.

14 June-5 July: Galerie Katia Granoff, '30 peintures de Marc Chagall'.

20 July: Les Amis de *Sélection* gave a reception for Chagall at Afsnee aan de Leie in west Flanders, then a separate village, today a suburb of Ghent. Chagall was photographed with a group of Belgian artists, critics and writers in the artists' colony at the nearby village of Deurle.

Five engravings by Chagall published in Marcel Arland, *Maternité*, Paris, Au sans Pareil.

Fifteen engravings by Chagall published in Jean Giraudoux, Paul Morand, Pierre Mac Orlan, André Salmon, Max Jacob, Jacques de Lacretelle and Joseph Kessel, *Les Sept Péchés Capitaux*, Paris, Kra.

22 November-11 December: Galerie Katia Granoff, 'Marc Chagall: Travaux de l'été 1926', 16 paintings and gouaches.

1927

May-September: the Chagalls returned to the Auvergne, 21 kms north of Clermont-Ferrand to Châtelguyon, a spa town specializing in the treatment of intestinal complaints; Bella and Ida recovered from a severe attack of blood poisoning. Above the watering place is the old town, where the church contains an eighteenth-century reredos; above it stands a calvary and the ruins of a twelfth-century castle. At Châtelguyon Chagall met Soutine, who, he later told his biographer Crespelle, in contrast to himself had become a snob, wanting to be elegantly dressed and forget his East European birth-place, Vilnius.

The Chagalls also stayed near Saint-Jean-de-Luz, an historic town about 15 kms from Biarritz, with characterful old quarters. It was an important fishing port at the mouth of the River Nivelle, set in an almost circular bay, partly enclosed by a breakwater and piers, bounded by the Pointe Ste-Barbe and the small harbour of Socoa.

November (or, according to Sonia Delaunay, November 1926): Chagall went on a motoring trip with Robert Delaunay, through Montauban and Albi (north of Toulouse) to Limoux, a small place south of Carcassonne, to visit the writers Jean Girou and Joseph Delteil. Chagall and Delaunay drove on to Collioure on the Mediterranean coast, and then to Banyuls-sur-mer, the last French seaside resort before the Spanish border, where they called on Aristide Maillol. The journey lasted six days, apparently about as long as the two artists could stand each other's company.

Before the *Fables* gouaches were quite finished, Vollard suggested the circus as a subject, so Chagall often went to the Cirque d'Hiver, where Vollard had a box for the season. Chagall made 19 gouaches, now entitled *Cirque Vollard* to distinguish them from later ones.

Granovsky and his Jewish theatre company came from the USSR and played a season at the Porte Sainte Martin theatre; Chagall and Bella went there nearly every night and organized a reception for the actors and their friends.

Chagall sent 96 etchings for *Dead Souls* as a present to the Tretiakov Gallery in Moscow; this is the complete set, not counting the pictorial index.

The Paris dealers Bernheim-Jeune gave Chagall a contract. Chagall founder-member of the Association des Peintres-graveurs.

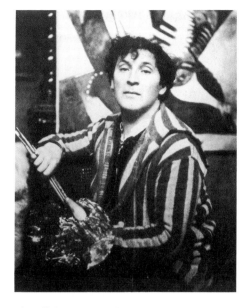

Chagall; frontispiece of the catalogue of his exhibition at Reinhardt Galleries, New York, 1926

Chagall with a group of Belgian artists, art critics and writers on his visit to the artists' colony at Deurle near Afsnee in 1926. From left to right: (front row) Luc Haeserts, Hippolyte Daye, Frans de Ridder ?, Frits van den Berghe, P.G. van Hecke, Chagall; (back row) Hubert Malfait, Gustave Desmet, G. Elslander, G. Marlier, ?, Frans de Ridder ?, André de Ridder ?, ?, Floris Jespers

Le mas Lloret (present state), the house at Céret in which Chagall worked in 1928-29

1927-28

Winter: while doing the last of the *Fables* gouaches, Chagall painted more circus pictures, replicas of *Cirque Vollard* and new subjects.

Probably went to Savoy, to Chamonix, Les Houches and Les Bossons, three mountain resorts on the slopes of Mont Blanc near the Swiss and Italian borders.

1928

10-17 March: Paris, Galerie Le Portique, 'Chagall: Gouaches et Illustrations', illustrations for Gogol's *Dead Souls* and presentation of André Salmon's monograph, *Chagall*, Paris, Chroniques du Jour.

Summer: Chagall went alone to Céret, a small town at the foot of the Pyrenees, 29 kms south east of Perpignan, inland from Collioure. As well as Le Vieux Pont or Pont du Diable, a fourteenth-century bridge with a single 45-metre arch spans the river Tech; two towers and a fortified gate remain from the ancient ramparts. Picasso and Braque had often stayed at Céret between 1911 and 1913 which has led the town to be dubbed 'the Mecca of Cubism'. Chagall's visit is dated 1929 by a mayor of Céret, who, in 1978, remembered Chagall preparing 28 La Fontaine plates and painting *Still Life at the Window* (Plate 78, Cat. 83) while staying alone in Le mas Lloret.

From 1928 onwards, Chagall formed a close association with the poets Jules Supervielle, Paul Eluard and René Schwob, who put the Chagalls in touch with the philosopher Jacques Maritain and his Russian wife, the poet Raïssa Maritain; for the next ten years the Chagalls were regular members of the circle which gathered at their home at Meudon (due south of Boulogne-sur-Seine) every Sunday afternoon.

André Salmon began translating 'My Life' from Russian; when Chagall found the result too French, Bella took over, going through the work sentence by sentence with Marc. Ida's French teacher smoothed out the French grammar mistakes and Jean Paulhan gave advice.

1929

March: Brussels, Galerie l'Epoque, 'Gouaches de Chagall'.

Autumn: went again to Céret, with Bella.

At the end of the year the Chagalls moved to 5 Avenue des Sycomores, a new house in the precincts of Villa Montmorency, close to Porte d'Auteuil, not far from the Jardin fleuriste (see 1925). The area includes Rue La Fontaine, Rue Poussin and Rue Michelange; Molière, Racine and La Fontaine had had country houses near the original twelfth-century church of Notre-Dame d'Auteuil (rebuilt in 1880). Wall Street Crash and cancellation of Chagall's contract with Bernheim-Jeune.

1929-30

Chagall now customarily spent part of the winter in Savoy, often in the Hôtel Soleil d'Or at Megève, which is on the route from Annecy to Chamonix and is a good centre for excursions.

1930

February: Paris, Galerie Bernheim-Jeune, 'La Fontaine par Chagall'.

1-19 March: Brussels, Galerie Le Centaure, 'La Fontaine par Marc Chagall'.

April: Berlin, Galerie Flechtheim, 'La Fontaine von Marc Chagall'; Chagall stayed in Berlin for the opening.

Early summer: Chagall spent a short time with his family at Neslé-la-Vallée, 42 kms from Paris and 5 kms from L'Isle-Adam; there he made gouaches and bought a plot of land on Delaunay's advice.

Meyerhold asked Chagall's advice about renting a Paris theatre for a season of Russian plays; this took place in July at the Théâtre Montparnasse.

Summer and autumn: the Chagalls spent a few weeks on the Mediterranean coast, then at Peïra-Cava, a beauty spot in the Alpes-Maritimes about 30 kms behind Nice.

10 November-6 December: New York, Demotte, 'Marc Chagall', 7 oils, 20 watercolours (16 were *Fables* gouaches).

End of the year: Meir Dizengoff, founder and mayor of Tel Aviv, was in Paris and was introduced to Chagall by the sculptor Chana Orloff.

Chagall began gouaches in preparation for illustrating the Books of the Prophets, having agreed to a new commission from Vollard.

1931

14 January: Chagall wrote enthusiastically to Meir Dizengoff about the proposed Tel Aviv Museum.

February: Chagall, with Bella and Ida, embarked at Marseilles for the Middle East with Edmond Fleg, the writer who, with Chagall, formed a Paris

Wolf versus Fox before Judge Monkey; cover of the catalogue accompanying the exhibition of Chagall's gouaches for La Fontaine's *Fables*, Berlin, 1930

6 April: Chagall made a speech at the Hebrew Writers' Association Ball, organized in Tel Aviv by Bialik. Chagall said he was 'speechless before all that I have seen' and wished for 'a life here among you'. His mood changed on his return to Paris, when, in the Russian-language newspaper *Rassviet*, 14 June, he pronounced the Tel Aviv Museum project a fiasco because the protagonists lacked artistic judgment. In August he resigned from the Paris committee, of which he was Chairman. Dizengoff sent Struck to Paris as a mediator and by February 1932 the disagreement had been resolved and works for the new museum were selected on grounds of quality, as Chagall had insisted. Chagall sent a warm greetings telegram for the opening of the Tel Aviv Museum, which took place in April 1932.

Marc Chagall, *Ma Vie*, preface by André Salmon, Paris, Stock, 1931: cover illustration, *Self-Portrait* (Fig. 1), plus reproductions of 31 early drawings.

13-30 June: Paris, Galerie Le Portique, '20 tableaux récents et quelques dessins de jeunesse inédits par Marc Chagall'.

Late summer: stayed in the steep, fir-clad Malsanne Valley in the Dauphiné mountains south east of Grenoble; the place is well known for the waterfall Cascade de Confolens.

1932

Chagall made sketches for stage and costume designs for Bronislava Nijinska's ballet *Beethoven Variations*.

12 March-3 April: Amsterdam, Maatschappij Arti et Amicitiae (Society of Dutch Artists) 'Marc Chagall', 55 works; Chagall visited Holland for the opening and was especially impressed by the Rembrandt paintings in the Rijksmuseum in Amsterdam and in the Mauritshuis in The Hague.

April: Budapest, exhibition of drawings.

Autumn: stayed with his family at Arcachon, a summer and winter health resort 50 kms from Bordeaux; the resort was formed in 1823 when a forest was created by planting the dunes with maritime pines to fix the sands on the shore of a natural basin fed by the Atlantic.

From left to right: the Israeli artist Reuven Rubin, his wife Esther, Bella and Marc Chagall, and the plantation owner Heifitz in Petach Tikva near Tel Aviv, 1931

An old house in Safed; postcard, *c.* 1931

committee to promote the Tel Aviv Museum. They travelled with Chaim Bialik, who was Honorary President of the Tel Aviv Museum Committee; they visited Alexandria, Cairo and the pyramids.

11 March: S.S. Champollion arrived in Haifa, where Chagall visited Hermann Struck; he went to Tel Aviv as the guest of Meir Dizengoff and paid an official visit to the exhibition of local artists held at the Old Post Office, 3-17 March. He visited Jerusalem, where he painted views, including the nearby Rachel's Tomb (see Plate 97, Cat. 103). He went to Safed and painted synagogue interiors (see Plate 100, Cat. 106).

Chagall in Palestine, 1931

1933

At Mannheim Kunsthalle the Nazis held an exhibition of 'Bolshevik culture' which included work by Chagall. Chagall's attempt to take out French citizenship failed because he had been a Commissar in Vitebsk. He was not successful until 1937, when Jean Paulhan had the dossier released and obtained a ministerial signature for the decree of naturalization.

Summer: Chagall visited Vézelay, an attractive small town with curious old streets on a hill bordered by a large wooded terrace. Vézelay is famous for the twelfth-century abbey church of La Madeleine, formerly a place of pilgrimage. Winding hilly roads ascend the Curé valley through a succession of lakes and woods with picturesque views.

4 November-3 December: Basle, Kunsthalle, 'Marc Chagall', 172 works. Chagall went to Basle for the opening.

1934

Ida Chagall married Michel Gordey, a young lawyer, the nephew of Charles Rappoport, a political émigré who had not returned to Russia in 1917. The wedding inspired the second version of *Bride and Groom of the Eiffel Tower* and *The Bride's Chair*, a painting of the armchair decorated with a flowered shawl on which Ida sat for the wedding ceremony.

July and August: Chagall and Bella went to Spain, to Tossa del Mar on the Costa Brava with painters and writers, among them Supervielle and Henri Michaux. From there Chagall visited Barcelona, Madrid and Toledo (this may have been Chagall's second visit to Spain).

November: Prague, Dra Feigla gallery, 52 works.

1935

April-May: London, The Leicester Galleries, 'Paintings and Gouaches by Marc Chagall', 44 works.

August: with Bella, Chagall went to Poland as guest of honour at the inauguration of the Jewish Cultural Institute at Vilnius (then Polish territory) with the exhibition 'Marc Chagall', 116 graphic works, illustrations for *Mein Leben*, Gogol's *Dead Souls*, La Fontaine's *Fables* and the Bible.

1936

Chagall went several times a month to Montparnasse, to join Picasso at the Café du Flore; while Picasso was painting *Guernica*, Chagall painted *White Crucifixion* (see Fig., p. 267).

July: stayed at Oyé-et-Pallet, near Lac de St-Point, 66 kms from Besançon and 7 kms from Pontarlier, on the plain of Doubs at the foot of the Jura Mountains near the Swiss border. Back in Paris, the Chagalls moved to 4 Villa Eugène Manuel near the Trocadéro, 16th Arrondissement.

30 November-31 December: New York, New Art Circle, 'Marc Chagall'.

1936/37

December-January: Paris, Galerie Beaux-Arts, 'Peintres instinctifs: naissance de l'expressionisme', 34 works.

Winter: Chagalls at Morzine, in Haute Savoie south of Lake Geneva.

1937

Stayed at Villars-Colmars in the Basses Alpes north of St.-André-les-Alpes.

29 April: letter to Raymond Escholier, director of the Musée du Petit Palais and organizer of the forthcoming exhibition 'Les Maîtres de l'Art Indépendant', addressed from Le Prieuré, then an artists' *pension* under the shadow of the old priory at Villeneuve-les-Avignon, a place where Corot had painted, 3 kms north of Avignon.

26 July-31 October: Musée de Jeu de Paume, 'Origines et développement de l'art international indépendant', 4 works by Chagall.

Chagall and Bella went to Italy, where Chagall made 15 Bible etchings and painted oils and gouaches in Tuscany. In Florence they were most impressed with Quattrocento sculpture, especially Donatello's. In a lecture in 1943 Chagall said: 'In Italy I found the peace of the museums, but illuminated by a sun that announces life.'

September: the Chagalls were in Venice, where they saw paintings by Bellini, Titian and Tintoretto.

Paris, Petit-Palais, 'Les Maîtres de l'Art Indépendant 1895-1937', 17 works by Chagall displayed in their own room. 'Exposition Universelle' at the

Vlaminck, Chagall and Vollard; illustration in *L'Intransigeant*, 8 January 1929

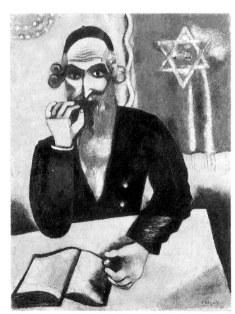

'Chagall's smile'; illustration in *Beaux-Arts*, 26 January 1934

Chagall, *The Pinch of Snuff*, 1912. Kunstmuseum, Basle. The painting was included in the 'Degenerate Art' exhibition in Munich in 1937

Trocadéro Gardens, a few yards from the Chagalls' home; they often dined at one of the international restaurants; they made new friends, among them the writer Raffael Alberti, who became a frequent visitor at the Chagalls' home.

26 October-13 November: Paris, Galerie Renou et Colle, 'Gouaches de Chagall'.

December: Chagall at Avignon.

1938

22 February-13 March: Brussels, Palais des Beaux-Arts, 'Marc Chagall', 62 works.

28 February-26 March: New York, Lilienfeld Galleries, 'Marc Chagall', 16 works.

September: Chagall at Lamotte-Beuvron, Loir-et-Cher, 36 kms south of Orléans and east of Blois.

13 October-14 December: Pittsburgh, Carnegie Institute, 'International Exhibition of Paintings';

Article on the Carnegie International Art Exhibition of 1939, in *Enquirer*, Cincinnati, Ohio, 20 October 1939; Chagall's *The Bridal Couple* is illustrated at lower left

single work, cat. no 187, *Red Wings* [*Angel with Red Wings*].

5 December-7 January 1939: New York, Lilienfeld Galleries, 'Marc Chagall', 16 works.

1939

Summer: Chagall and Bella stayed in an isolated farmhouse near Villentroy, Indre-et-Loire.

August: they moved to Saint-Dyé-sur-Loire, on the river due north of the château at Chambord; Chagall took all his pictures there from Paris.

October: Pittsburgh, Carnegie Institute, Chagall won third prize of $500 with *The Bridal Couple.* This was the fourth year that a painting by Chagall was exhibited at the Carnegie International and the only time he won a prize.

1940

26 January-24 February: Paris, Galerie Mai, 'Marc Chagall', 30 works. For this exhibition Chagall moved pictures back to Paris, but he continued to paint at Saint-Dyé.

April: Chagall in Paris.

Easter: Chagall and Bella went to Gordes on André Lhote's recommendation. Gordes is a picturesque village perched on a rock with a Renaissance château, 40 kms north east of Avignon in the Vaucluse Mountains.

May: they bought a former Catholic girls school at Gordes; Chagall and Bella hired a lorry at Cavaillon and fetched the pictures from Saint-Dyé; they lived at Gordes for nearly a year. Chagall received an invitation from the Museum of Modern Art, New York, to leave France for the United States.

Postscript

1941

Chagall and Bella moved to Marseilles, where, in April, Chagall was arrested but released on the intervention of the American Consul General and Head of Emergency Rescue Committee.

May: travelled to Lisbon with Bella.

23 June: landed in New York.

25 November-13 December: New York, Pierre Matisse Gallery, 'Marc Chagall. Retrospective… 1910-1941', 21 works.

White Crucifixion, 1938, on show in the exhibition 'Marc Chagall: Œuvres récentes', Galerie Mai, Paris; illustration in *Cahiers d'Art*, Vol. 15, Nos 1-2, 1940

Selected Bibliography

Arland, Marcel, *Maternité: Récits ornés de cinq gravures hors texte de Marc Chagall*, Paris, 1926

Aronson, Boris, *Marc Chagall,* Berlin, 1924

Bible, 2 vols, with 105 etchings by Chagall, Paris, 1956

Bidermanas, Izis, and Roy McMullen *The World of Marc Chagall,* London, 1968

Cain, Julien, *The Lithographs of Chagall,* notes and catalogue by Fernand Mourlot, Monte Carlo and London, 1960

Chagall, Bella, trans. Barbara Bray, *First Encounter,* New York, 1983

Chagall by Chagall, ed. Charles Sorlier, New York, 1979

Chagall, Marc, *Ma Vie,* trans. from the Russian by Bella Chagall, Paris, 1931

Chagall, Marc, *Mein Leben: 20 Radierungen,* Berlin, 1923

Chagall, Marc, *My Life,* trans. from the French by Dorothy Williams, Oxford, 1989

Chagall, Marc, *Poèmes,* with twenty-four coloured woodcuts by the artist, Geneva, 1968

Chagall, Marc, *Sturm-Bilderbücher,* Vol. 1: *Marc Chagall,* Berlin, 1923

Chatelain, Jean, *The Biblical Message of Marc Chagall,* New York, 1973

Compton, Susan, *Chagall,* London and New York (Royal Academy of Arts/Philadelphia Museum of Art), 1985

Crespelle, Jean-Paul, *Chagall: L'amour, le rêve et la vie,* Paris, 1969

Däubler, Theodor, *Marc Chagall,* Rome, 1922

Erben, Walter, trans. Michael Bullock, *Marc Chagall,* London, 1957

Fierens, Paul, *Marc Chagall,* de luxe edn with one etching by Chagall (*The Girl Acrobat*), Paris, 1929

George, Waldemar, *Marc Chagall,* Paris, 1928

Giraudoux, Jean, et al., *Les Sept Péchés Capitaux,* with fifteen etchings by Chagall, Paris, 1926

Gogol, Nicolas, *Les Ames Mortes,* trans. from the Russian by Henri Mongault, 2 vols, with 107 etchings by Chagall, Paris, 1948

Goll, Claire and Ivan, *Duo d'amour: Poèmes d'amour,* with four drawings by Chagall, Paris, 1925

Haftmann, Werner, *Marc Chagall,* New York, 1972

Haftmann, Werner, *Marc Chagall: Gouachen, Zeichnungen, Aquarelle,* Cologne, 1975

Hammacher, A. M., *Marc Chagall,* Antwerp, 1935

Kamensky, Aleksandr, *Chagall: The Russian Years 1907-1922,* London, 1989

Kornfeld, Eberhard W., *Verzeichnis der Kupferstiche, Radierungen und Holzschnitte von Marc Chagall,* Vol. 1: *Werke 1922-1966,* Berne, 1970

La Fontaine, Jean de, *Fables: Eaux-Fortes Originales de Marc Chagall,* 2 vols, Paris, 1952

Leymarie, Jean, *Marc Chagall: Works on Paper/ Selected Masterpieces,* New York (The Solomon R. Guggenheim Museum), 1975

Marc Chagall: Druckgraphische Folgen 1922-1966, Hanover (Kunstmuseum Hannover mit Sammlung Sprengel), 1981

Maritain, Raïssa, *Chagall ou l'orage enchanté,* Geneva, 1948

Meyer, Franz, *Marc Chagall: Life and Work,* New York, n.d. [1964]

Meyer, Franz, and Hans Bolliger, *Marc Chagall: The Graphic Work,* London, 1957

Provoyeur, Pierre, *Marc Chagall: Œuvres sur papier,* Paris (Musée national d'art moderne, Centre Georges Pompidou), 1984

Ridder, André de, 'La multiplicité de Chagall', *Sélection,* 3rd series, Vol. 8, No 6, 1929

Rosensaft, Jean Bloch, *Chagall and the Bible,* New York (The Jewish Museum), 1987

Salmon, André, *Chagall,* sixty de luxe copies with one etching by Chagall, Paris, 1928

Schwob, René, *Chagall et l'âme juive,* sixty-five de luxe copies with two etchings by Chagall, Paris, 1931

Soupault, Philippe, *Rose des Vents: Poèmes,* with four drawings by Chagall, Paris, 1920

Sweeney, James Johnson, *Marc Chagall,* New York (The Museum of Modern Art), 1946

Walt-Lessin, Abram, *Lieder und Poemen 1888-1938,* 3 vols, with thirty-two drawings by Chagall, New York, 1938

Photographic Acknowledgments

Photographs were provided by the owners of the works of art reproduced, except in the following cases:

Maurice Aeschimann, Geneva
plates 6, 150

Cahiers d'Art, Vol. 10, 1935, Vol. 15, 1940
p. 32, Fig. 24; p. 33, Fig. 25; p. 267 (bottom)

Jean Chatelain, *The Biblical Message of Marc Chagall,* New York, 1973
p. 27, Fig. 20

Susan Compton, *Chagall,* London and New York, 1985
p. 31, Fig. 23

Walter Erben, *Marc Chagall,* Munich, 1957
p. 26, Fig. 19

Claude Gaspari, Paris
plates 8, 10, 86, 124

Karl Girardet, *Fables de La Fontaine,* Tours, 1858
p. 24, Fig. 15, 16

Hanover, Kunstmuseum Hannover mit Sammlung Sprengel, *Marc Chagall: Druckgraphische Folgen 1922-1966,* exhibition catalogue, Hanover, 1981
p. 16, Fig. 8; p. 18, Fig. 10; p. 24, Fig. 17

Roger Hauret and André Verdet, *Les Grands Peintres: Marc Chagall,* Geneva, 1956
p. 261 (top); p. 262 (top)

Alexander Kamenski, *Chagall: Die russischen Jahre 1907-1922,* Stuttgart, 1989
p. 12, Fig. 2; p. 21, Fig. 13

Eberhard W. Kornfeld, *Verzeichnis der Kupferstiche, Radierungen und Holzschnitte von Marc Chagall,* Vol. 1: *Werke 1922-1966,* Berne, 1970
p. 13, Fig. 4; p. 14, Fig. 5

The British Library, London
p. 29, Fig. 22; p. 266 (top, bottom left)

Marlborough Fine Art, (London) Ltd.
p. 27, Fig. 21

Alain Malaval, Nice
plates 108, 122

Franz Meyer, *Marc Chagall: Leben und Werk,* Cologne, 1961
p. 19, Fig. 11, 12; p. 23, Fig. 14; p. 261 (bottom); p. 265 (bottom)

Munich, Villa Stuck, *Marc Chagall: Druckgraphik,* exhibition catalogue, ed. Ernst-Gerhard Güse, Munich, 1986
p. 13, Fig. 3

The Carnegie Museum of Art, Pittsburgh
p. 267 (top)

Elizabeth Prelinger, *Edvard Munch: Master Printmaker,* New York, n.d.
p. 15, Fig. 7

Photo Studio Pyrénée, Céret
p. 264 (top)

Rubin Museum Foundation, Tel Aviv
p. 265 (top)

The Tel Aviv Museum of Art
p. 15, Fig. 6